Above Scotland

The National
Collection of Aerial
Photography

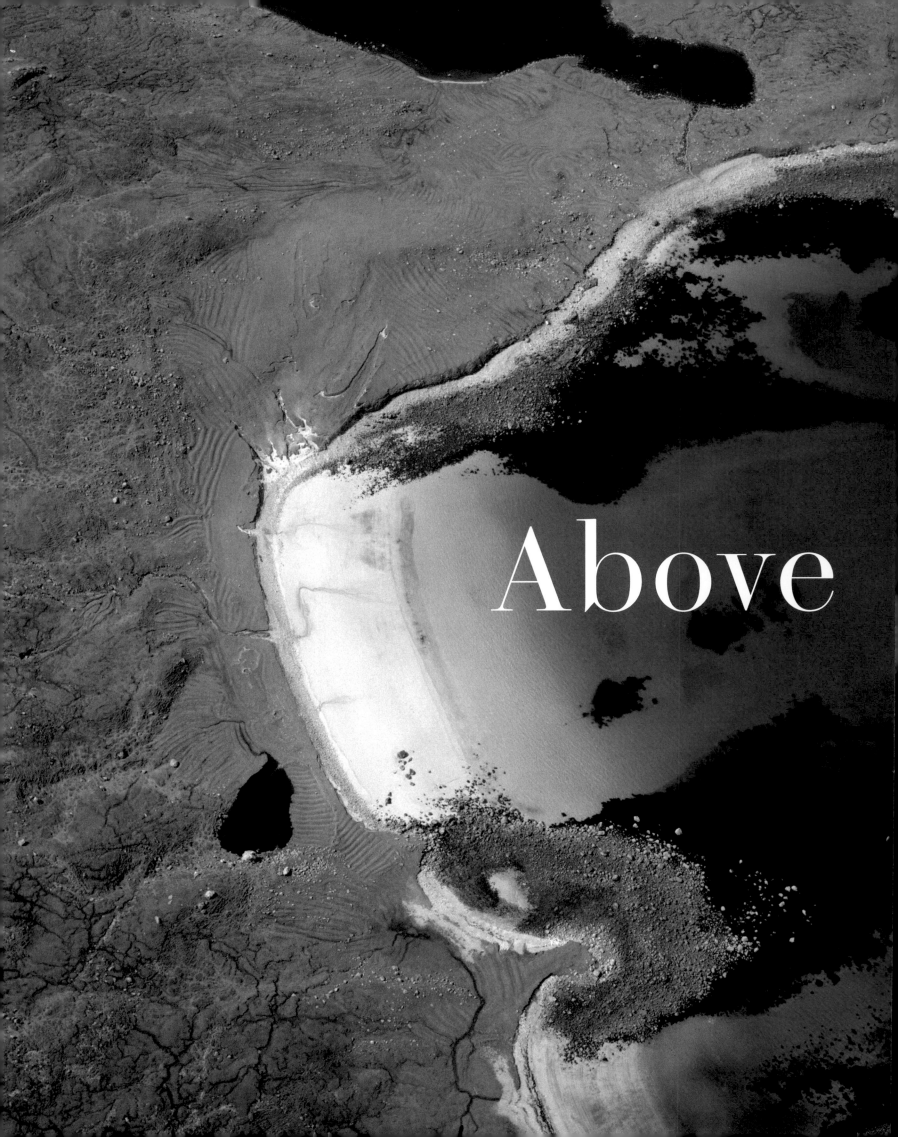

Above

David Cowley and James Crawford

Scotland The National Collection of Aerial Photography

Royal Commission on the
Ancient and Historical Monuments
of Scotland

Published in 2009 by the
Royal Commission on the Ancient and
Historical Monuments of Scotland.

Royal Commission on the Ancient and
Historical Monuments of Scotland (RCAHMS)
John Sinclair House · 16 Bernard Terrace
Edinburgh EH8 9NX

telephone +44 (0)131 662 1456
info@rcahms.gov.uk · www.rcahms.gov.uk

Registered Charity SC026749

British Library Cataloguing-in-Publication Data.
A catalogue record for this book is available
from the British Library.

ISBN 978 1 902419 62 6

Frontispiece: Between rock and sea, 'lazy bed'
cultivation ridges cling to the shore at Tharanais
on Harris. SC1007628 2005

Designed by Dalrymple
Typeset in Brunel, Frutiger and Minion
Printed in the UK by Beacon Press

Royal
Commission on the
Ancient and
Historical
Monuments of
Scotland

Contents

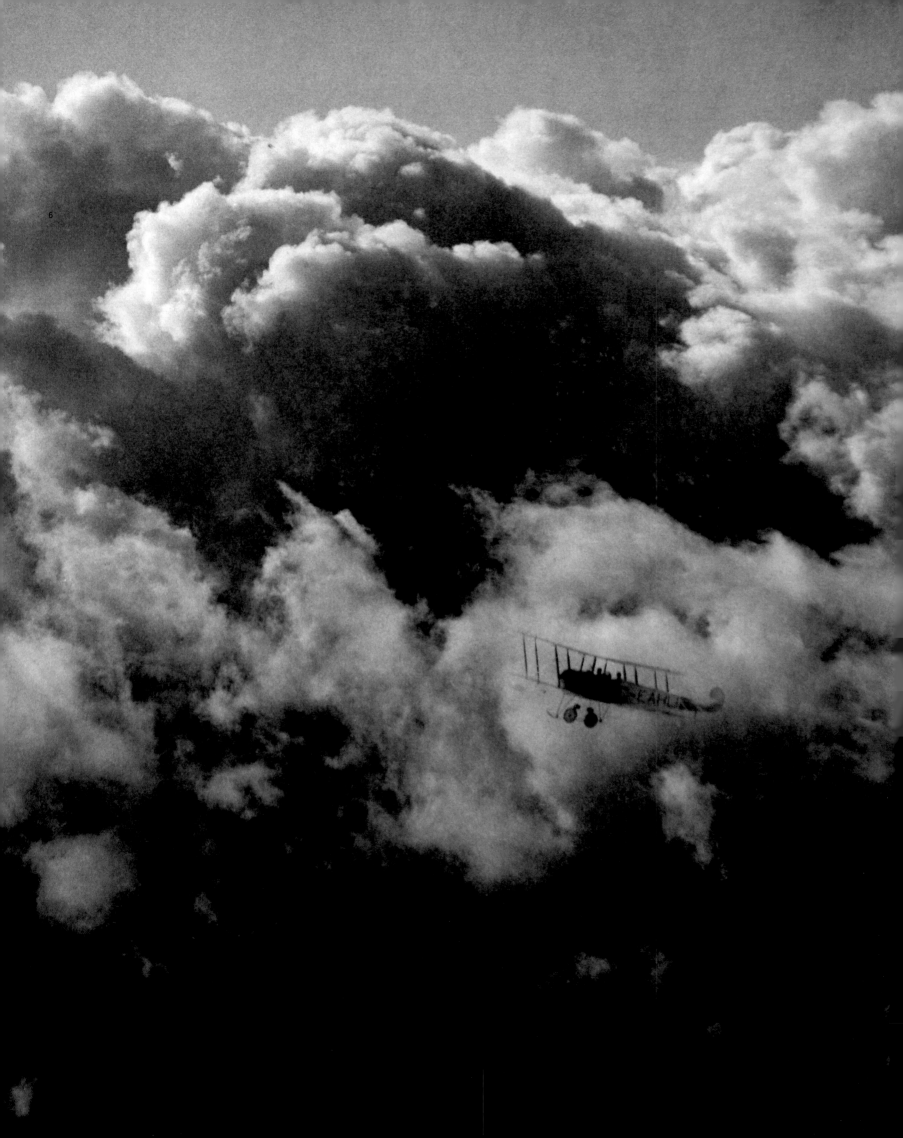

Moments of Time

Early in the twentieth century, a wooden-framed biplane rises up through a stack of storm clouds, and a heavy glass-plate camera held out of an open cockpit is steadied against a roaring wind.

On a spring day in 2009, a small Cessna aircraft banks above the blue waters of the Loch of Stenness and gazes into the ancient heart of an Orcadian stone circle.

In May 1941, a lone reconnaissance pilot powers a Spitfire away from Wick's camouflaged airbase, his mission to hunt the fjords of Norway for the most fearsome battleship in the German navy.

At the start of the new millennium, a photographer opens an aeroplane window to a furious rush of air, telescopic lens pointing down at four tall cranes poised over the skeleton of Edinburgh's emerging parliament building.

Separated by time and space, all of these incidents share a common factor. A camera is taken above Scotland, and, as a shutter opens and closes, a moment of time – an event, a people, a landscape – is frozen forever.

The National Collection of Aerial Photography is made up of millions of these images, unique split-second pictures of history stopped still. For nearly a hundred years, photographs from Scotland's skies have captured every aspect of a rapidly changing nation. The earliest aerial views in the Collection – from the years immediately after the First World War – bring to life the towns and cities of our grandparents, with horizons obscured by chimney smoke and vast factories and shipyards powering the British Empire. From the 1940s, thousands of Royal Air Force photographs witness the nation transformed into a military machine, its countryside and coastlines bearing the heavy boot-print of global conflict. Images spanning the second half of the twentieth century show the dramatic decline of the industries that dominated the Central Belt, and the diverse new communities, from utopian New Town experiments to huge glass and chrome retail outlets, which have risen to take their place.

Year-on-year the National Collection, curated by the Royal Commission on the Ancient and Historical Monuments of Scotland (RCAHMS), continues to grow. More historic photographs are discovered, more declassified military imagery is deposited, and the RCAHMS aerial survey team takes to the skies to record everything from glimpses of ancient settlements in crop marks to the gleaming new architecture and engineering of our constantly evolving landscape.

Every photograph tells a story. Each image is a window onto a scene of suspended time. Viewed together, the millions of moments of Scotland captured over the past century are transformed into a remarkable image reel – a moving, living, growing account of the making of a modern nation.

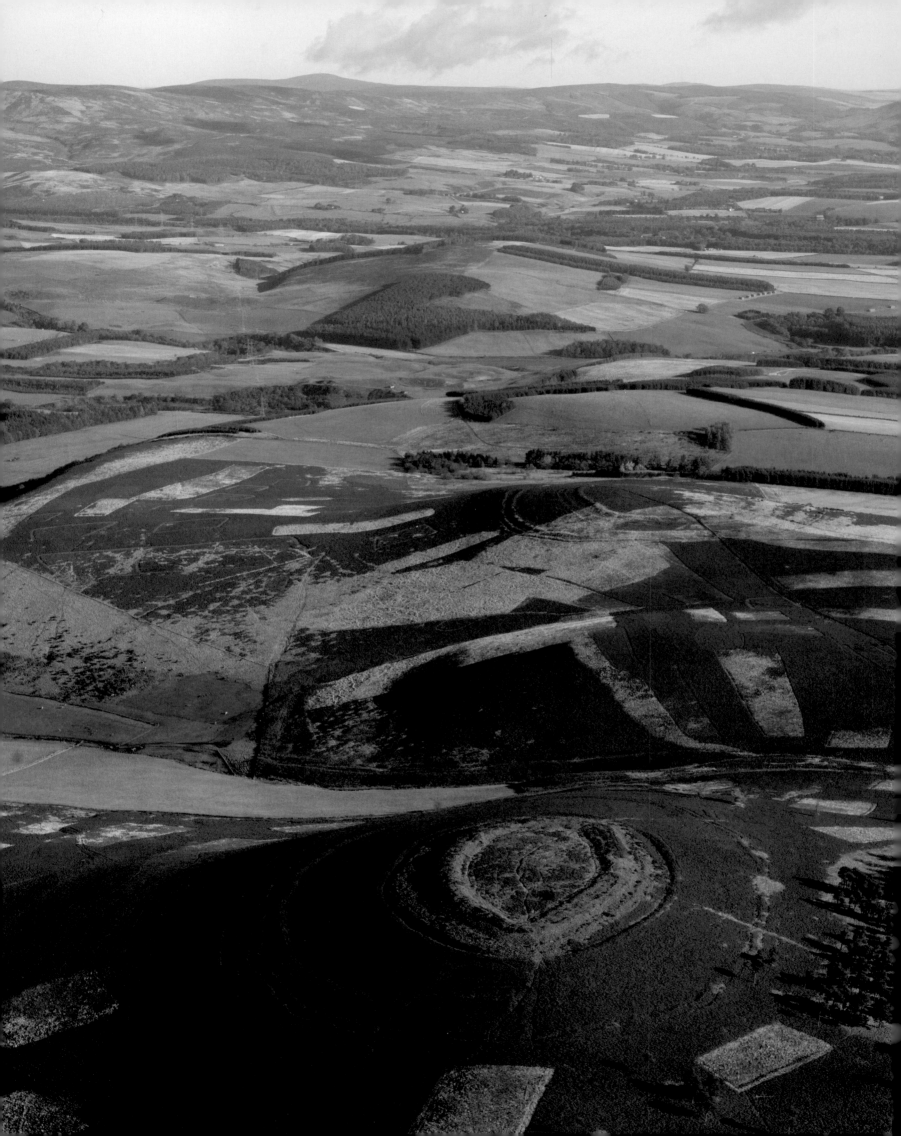

Defending the Land

At the end of a path through dense heather, on a line of high ground to the north of Strathmore, a band of pale stones crowns a deserted hilltop. This perimeter of rubble, in places almost 12m across and 4m high, encloses an area of nearly one hectare. It is all that remains of the walls of White Caterthun, a huge hill fort that commanded a wide sweep of Angus countryside over 2,000 years ago.

To the visitor on foot, taking in the view to the Highlands in one direction and the sea in another, the heaps of rocks and boulders are solid evidence of the reasons for the fort's existence. It demonstrated authority, power and ownership over the surrounding lands and, in unsettled times, provided security for those who lived inside. Seen from above, in the light of a low sun, White Caterthun is even more striking. Draped in threads of vegetation, long shadows are cast from the rings of rock and earthworks, conjuring up the impression of defences that once would have towered over attacking warriors. Here, the aerial view shows at a glance what remains. And, by giving

1 White Caterthun
2 Woden Law
3 Castle Law
4 Longcroft
5 Habchester
6 Nybster
7 Rough Castle
8 Dinvin Castle
9 Duffus Castle
10 Caerlaverock Castle
11 Tantallon Castle
12 Hermitage Castle
13 Castle Tioram
14 Castle Girnigoe
15 Roslin Castle
16 Craignethan Castle
17 Linlithgow
18 Castle Stalker
19 Slains Castle
20 Edinburgh Castle

an immediate sense of location and structure, it takes us back in time, allowing a full appreciation of the fort's place in the greater landscape.

From the giant fingerprint of White Caterthun to the great bulk of Edinburgh Castle, the inhabitants of Scotland have been building fortifications for many thousands of years. As a testament to the nation's turbulent history, their varied forms reflect the changing weaponry and warfare their defences had to repel, from warriors armed with spears and swords in the Iron Age, to massed troops and cannons in the Anglo-Scottish wars. Time has mellowed what were often brutal buildings into picturesque ruins set against spectacular scenery. But their modern popularity as tourist attractions can never fully obscure their true origins, and they stand as lonely sentinels, forever watching the horizon for impending danger.

A flight over Scotland brings many of these great fortifications back to life, even where they are barely visible on the ground or have deteriorated to dilapidated ruins. The view from above can effect remarkable transformations, showing the nation's castles and forts as they must have appeared in the past – formidable structures dominating landscapes forged by conflict.

PREVIOUS PAGES
White Caterthun and Brown Caterthun, two massive prehistoric fortifications, face each other across a shallow valley, a history of ancient rivalry preserved in the heaped stones and humped earthworks of their once towering ramparts. DP056577 2008

OPPOSITE
Caught by the rays of a setting winter sun, the complex remains of Woden Law hill fort still watch over the valley of the Kale Water in the Scottish Cheviots. When first built some 2,500 years ago, heavy timber fences kept the occupants secure and cast imposing shadows out over the surrounding landscape. SC677288 2000

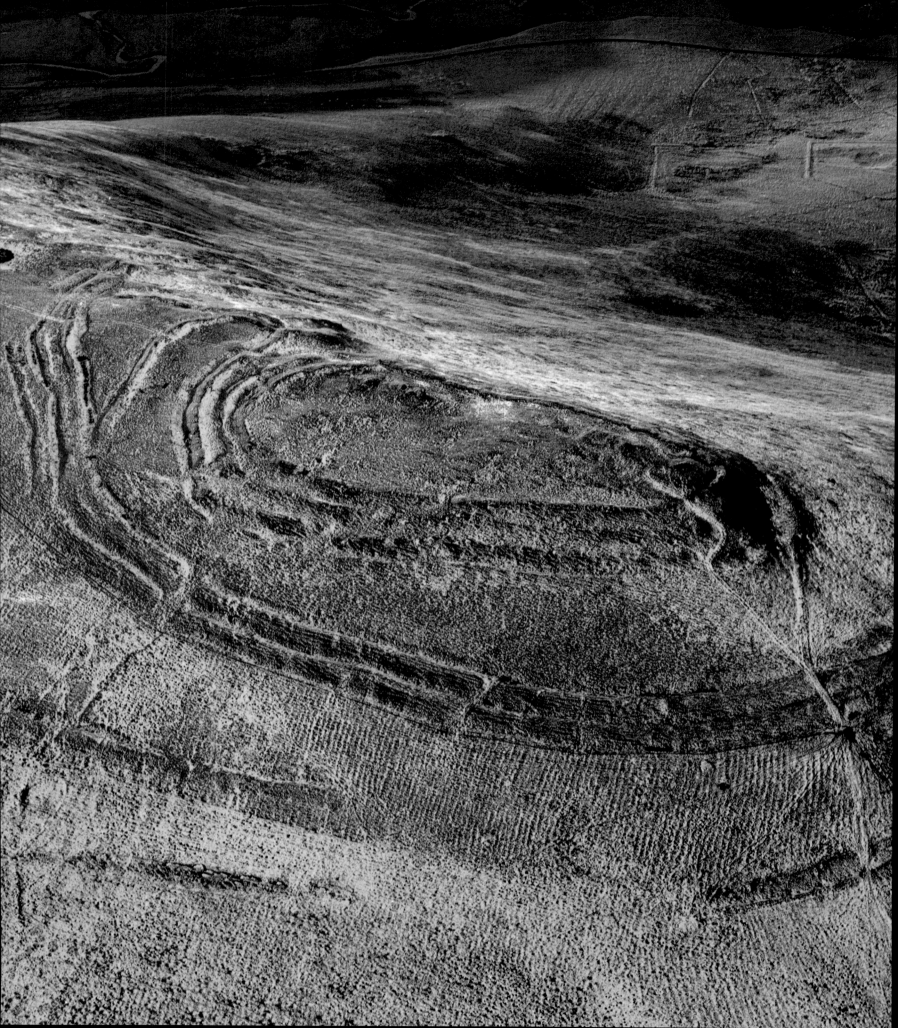

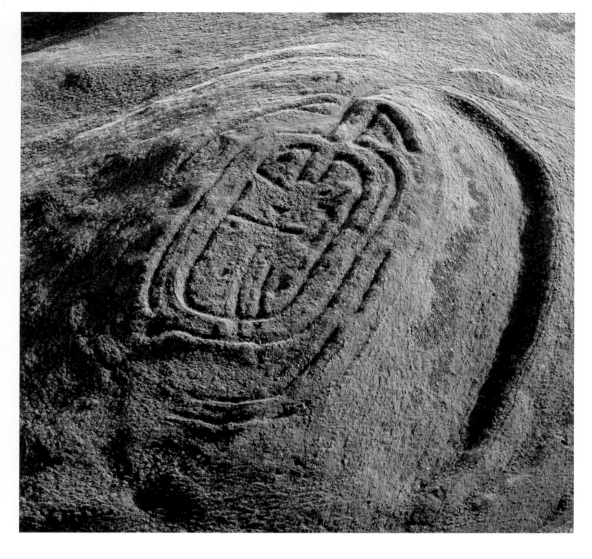

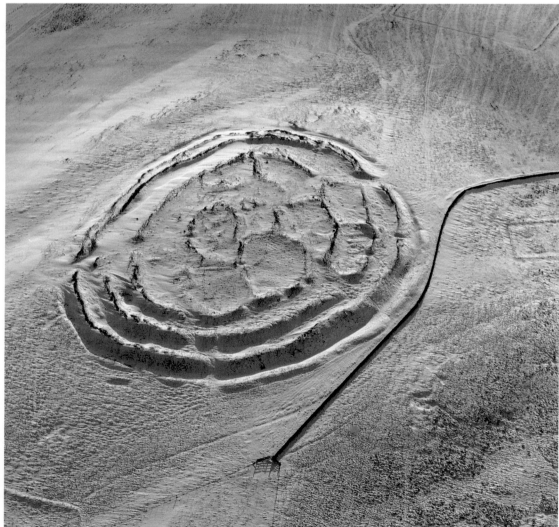

This strange hieroglyph on the summit of Castle Law near Perth was created at the end of the nineteenth century by the excavations of an enthusiastic antiquarian called Edwin Bell. His deep trenches, picked out here in shadow, unearthed the remains of the substantial stone ramparts of an Iron Age hill fort. Inspired by his discovery and its evocative location, Bell wrote in the summer of 1892 that, 'for a fort situation, nothing could be better, commanding as it does one of middle Scotland's most charming landscapes'. DP056544 2008

Never just military structures, the many small forts scattered across the Southern Uplands were often packed with houses. As times changed and the threat of attack decreased, ramparts deteriorated and homes and yards spread across the old defences, a pattern reflected here in the snow-covered landscape of Longcroft in Lauderdale. SC774875 1998

Centuries of ploughing have all but erased half of this fort at Habchester to the south of Ayton in the Borders. Neatly bisected by a drystone wall, the survival of even part of the ramparts is surprising in lowland Scotland, where intensive agriculture has often degraded and buried similar prehistoric remains. SC993205 2001

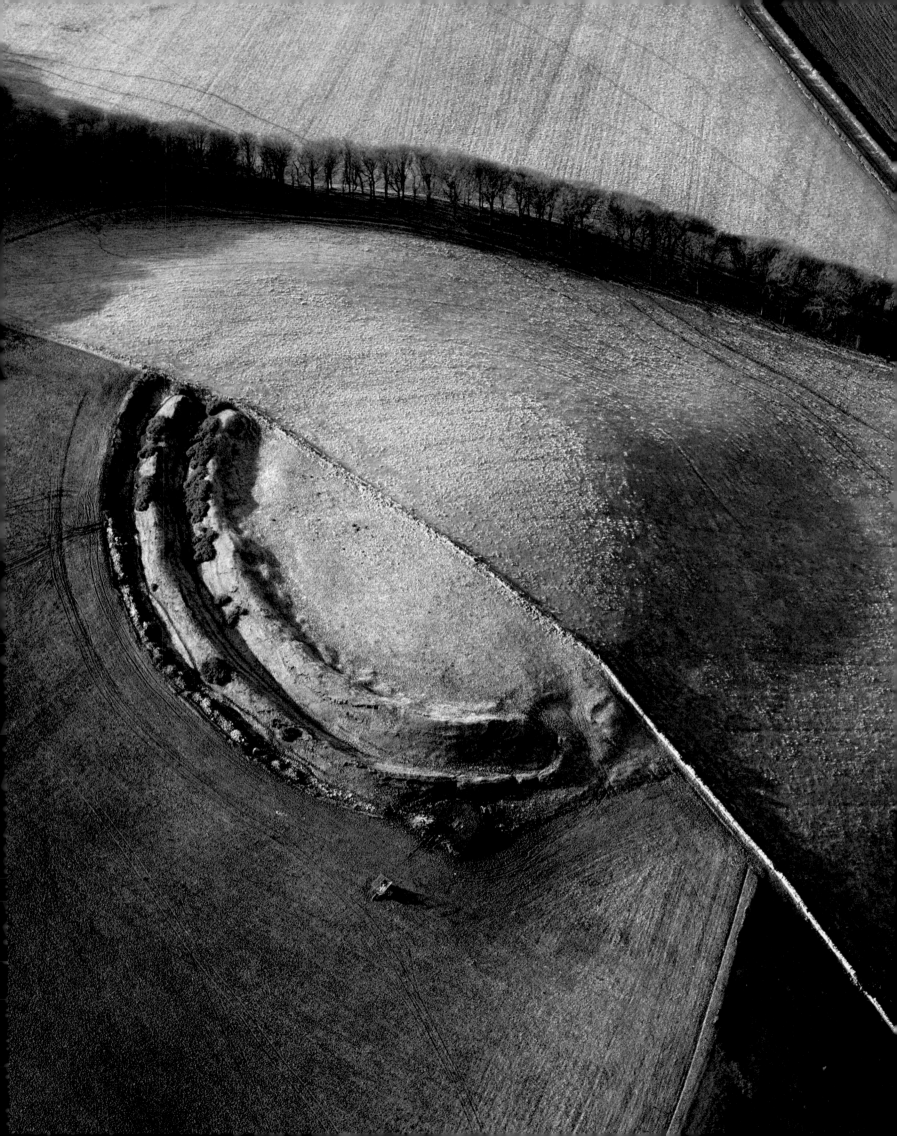

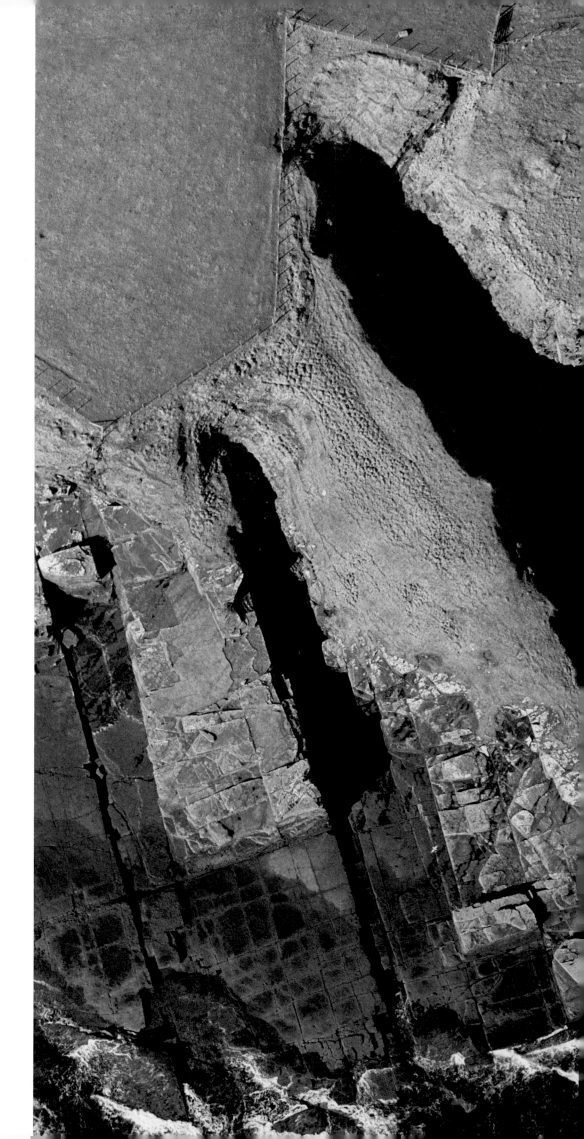

14 Protected by sheer cliffs on the storm-lashed Caithness coast, this curious pattern of remains at Nybster marks the site of the Iron Age equivalent of the tower house or small castle – the broch. With a name derived from the Old Norse word *borg*, meaning fort, brochs were huge round houses unique to Scotland, built using sophisticated drystone architecture. The Nybster broch was excavated at the end of the nineteenth century by the noted antiquary Sir Francis Tress Barry, and his work is commemorated by a monument, seen here at the top of the picture. SC1138562 2002

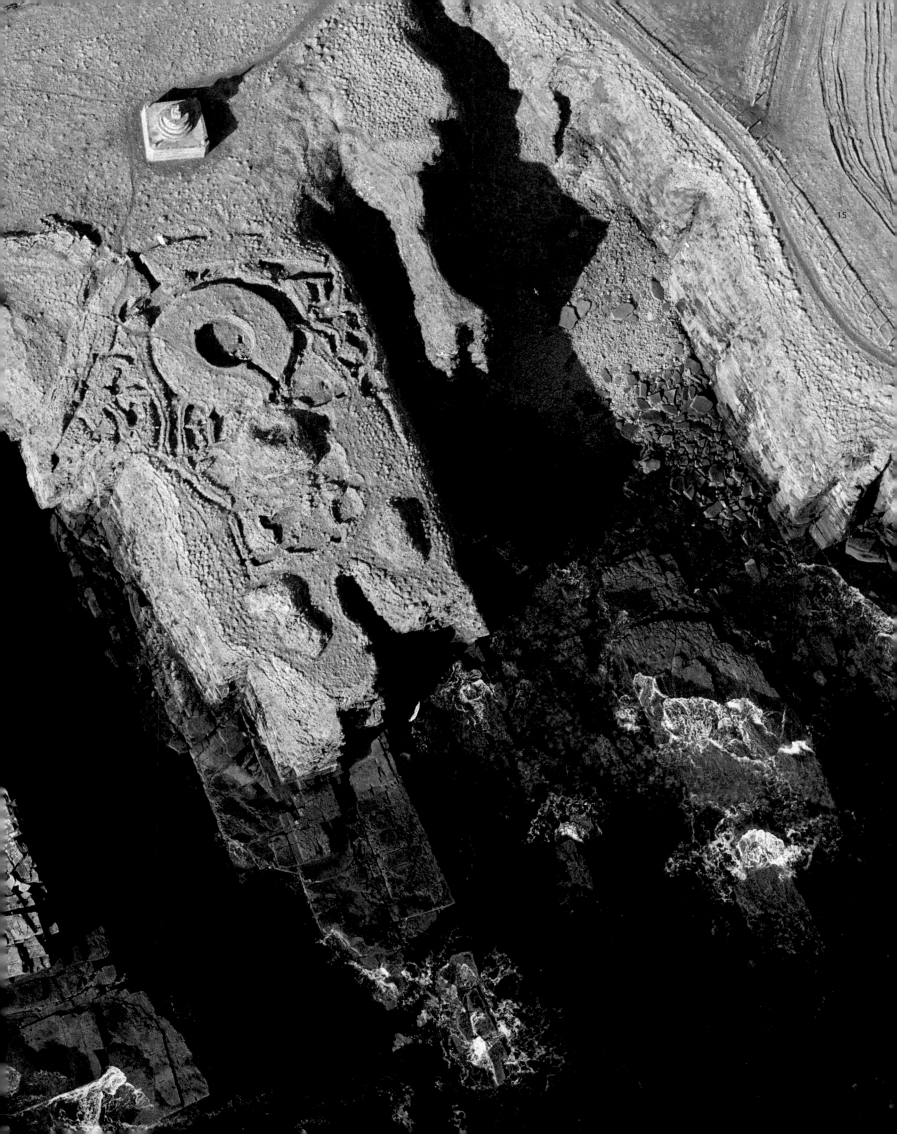

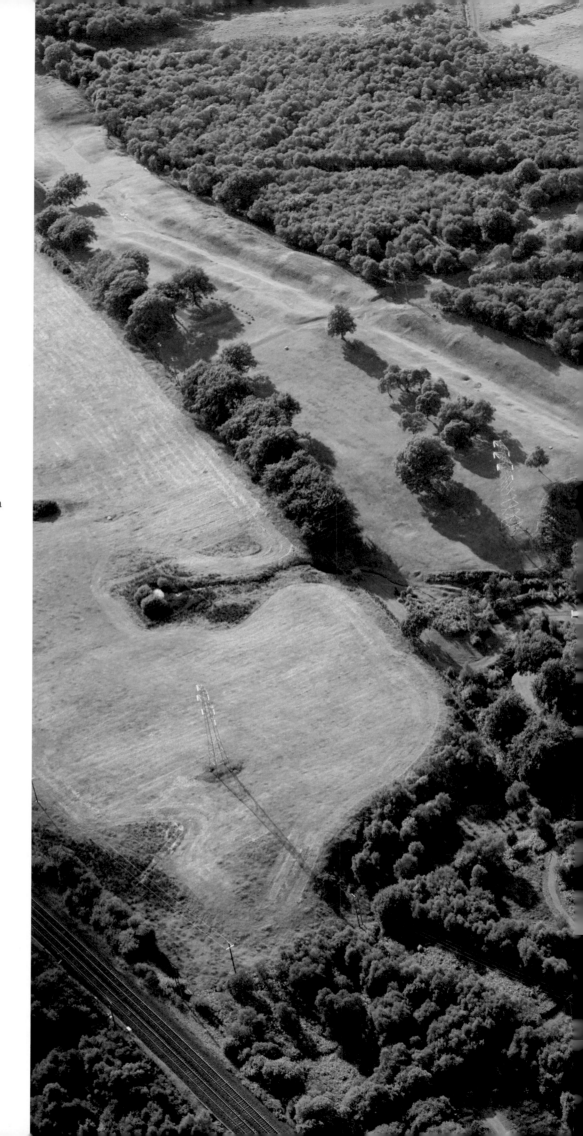

16 Between AD 142 and AD 158 central
Scotland marked the north western
boundary of the Roman Empire. The
Romans built the first known military
fortifications in Scotland, their legions of
disciplined soldiers manning what was
part of the extensive frontier – or '*limes*'
– constructed to consolidate hundreds
of years of campaigning and conquest
throughout Europe. The Antonine Wall
– pictured here just west of Falkirk – was
a turf rampart fronted by a deep ditch
that ran for 60km from Old Kilpatrick on
the River Clyde to Bo'ness on the Firth
of Forth. Dotted with forts, like this one
at Rough Castle, the Wall divided the
Roman Empire from the lands of Caledonia
beyond. DP014298 2006

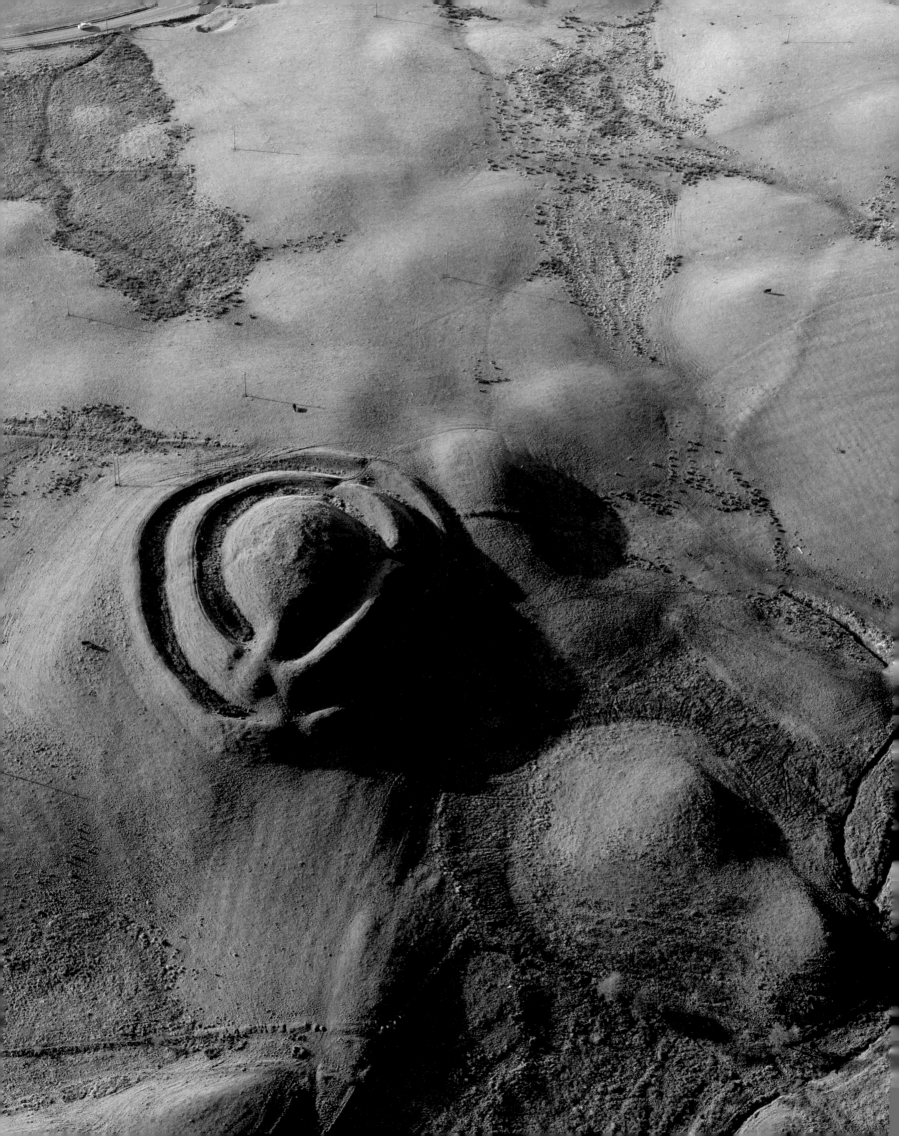

From about AD 1100 timber castles were
built on top of mounds known as mottes.
Dinvin near Pinmacher in southern
Ayrshire is one of the best-preserved
examples in Scotland, its 7m-high
oval mound circled by rings of deep
ditches. DP052214 2008

Surrounded by the regimented fields of
modern farming, the stone castle at Duffus
sits like an ancient, abandoned island in the
Lossiemouth landscape. Dating from about
1350, it was built on a motte that origi-
nally supported a twelfth century timber
castle. SC752247 2000

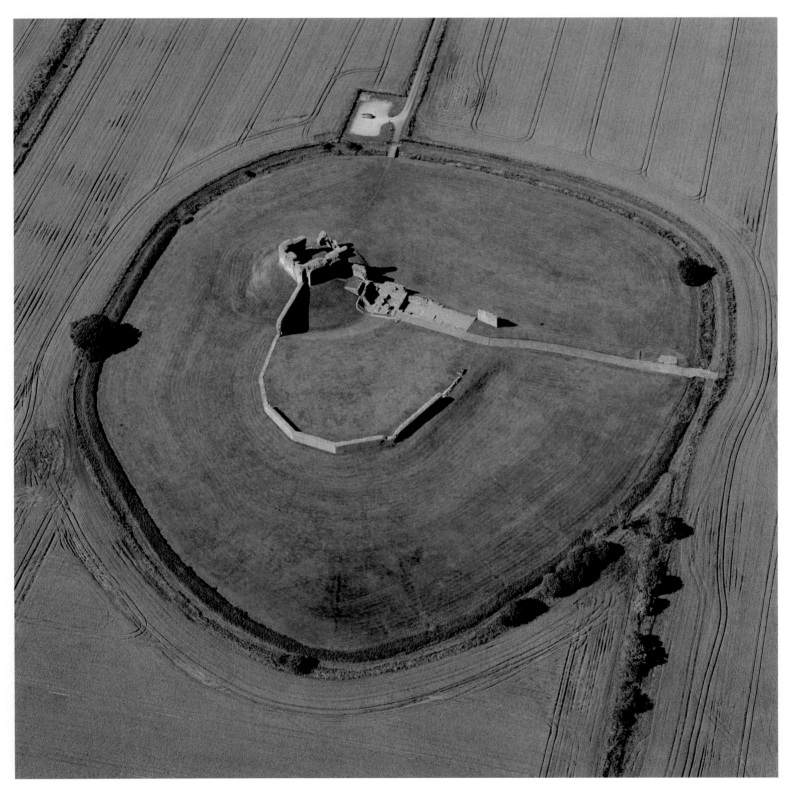

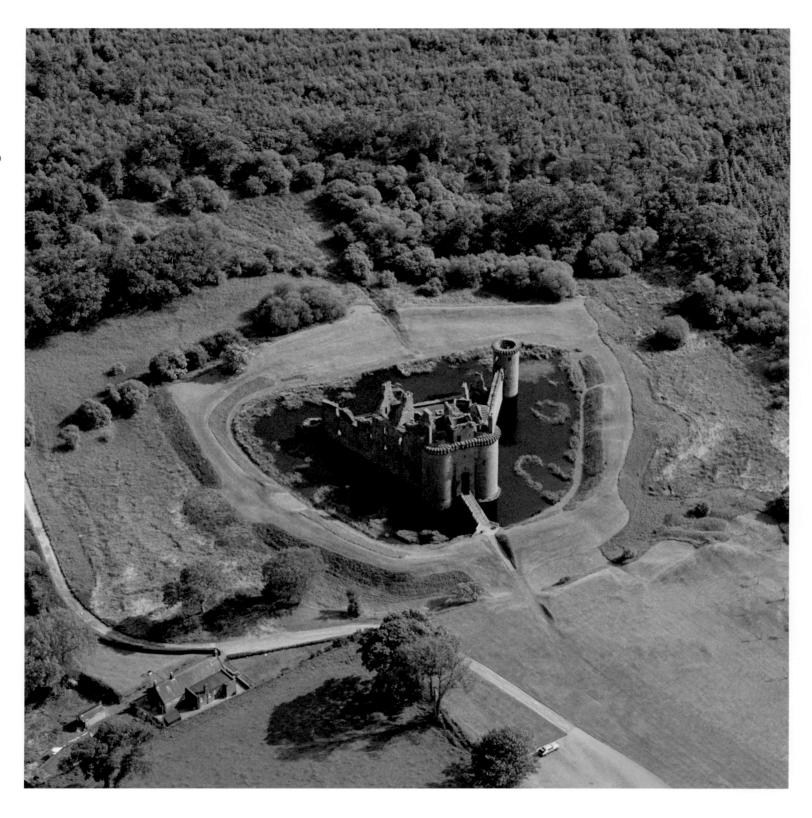

ABOVE

Caerlaverock Castle's triangular shape is unique in Britain, though frustratingly no one knows why it was built in this way. Lying close to the Anglo-Scottish border, Caerlaverock was besieged on a number of occasions, including by Edward I of England in 1300, when the garrison surrendered within two days. A thirteen-week siege in 1640 was the Castle's last, after which it was stripped of its valuables and parts of the walls were demolished. SC798377 1972

OPPOSITE

The last great castle to be built in Scotland, Tantallon in East Lothian was the seat of one of the most powerful baronial families, the Douglas Earls of Angus. The massive curtain wall is crowned by high towers and fronted by a rock-cut ditch, and the steep cliffs and jagged shoreline provided protection from any approach by sea. Built in the 1350s, Tantallon remained a stronghold for 300 years, enduring sieges in 1491 and 1528. Attacked again in 1651 by Oliver Cromwell, the Castle was devastated by gun-powdered artillery and abandoned. SC800165 1994

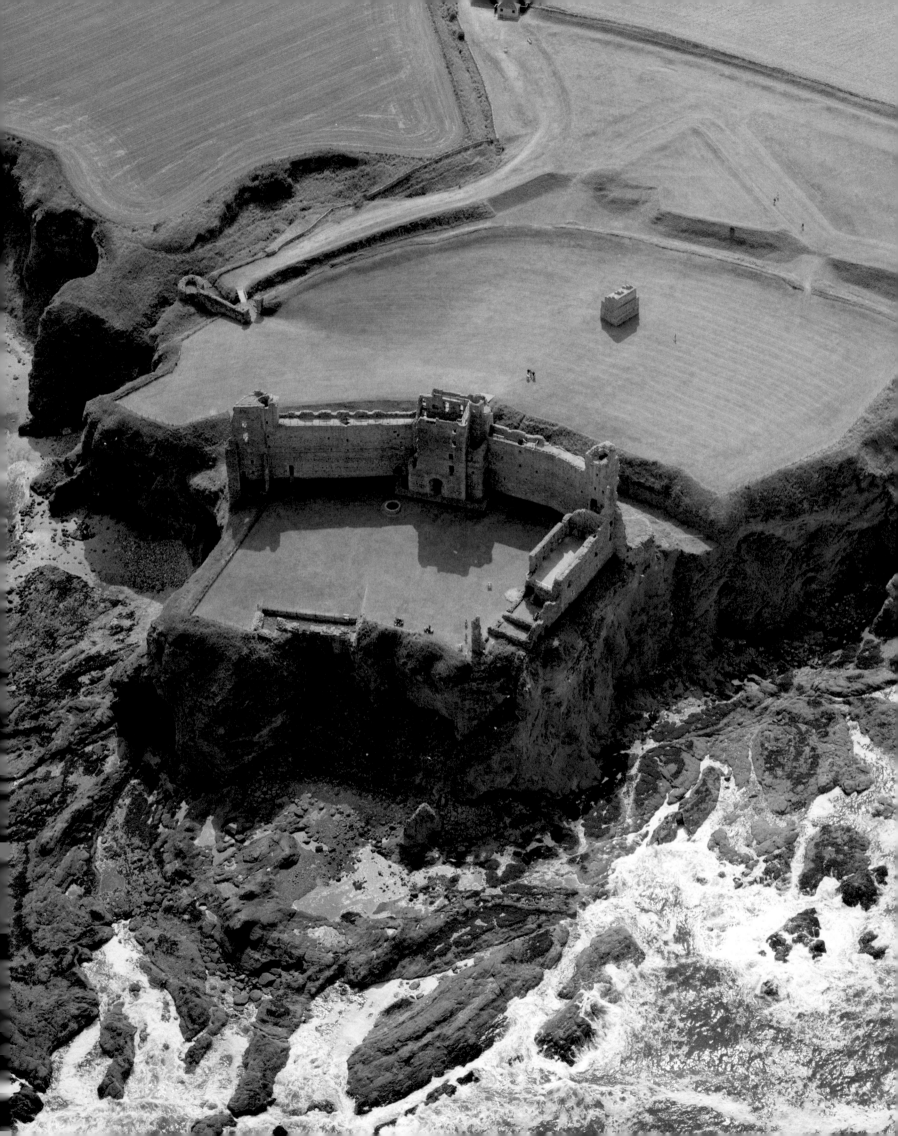

22　　Forbidding and brutal, the massive, sheer stone walls of Hermitage Castle rise up out of the moorland with undisguised menace. An unsubtle barb in the landscape, the Hermitage that remains today was first built in 1360, on the site of a timber castle dating back to 1240. The construction of the original castle in the volatile borderlands of Scotland and England was seen as such a provocative act that it brought the two countries to the brink of war.

DP026924 2007

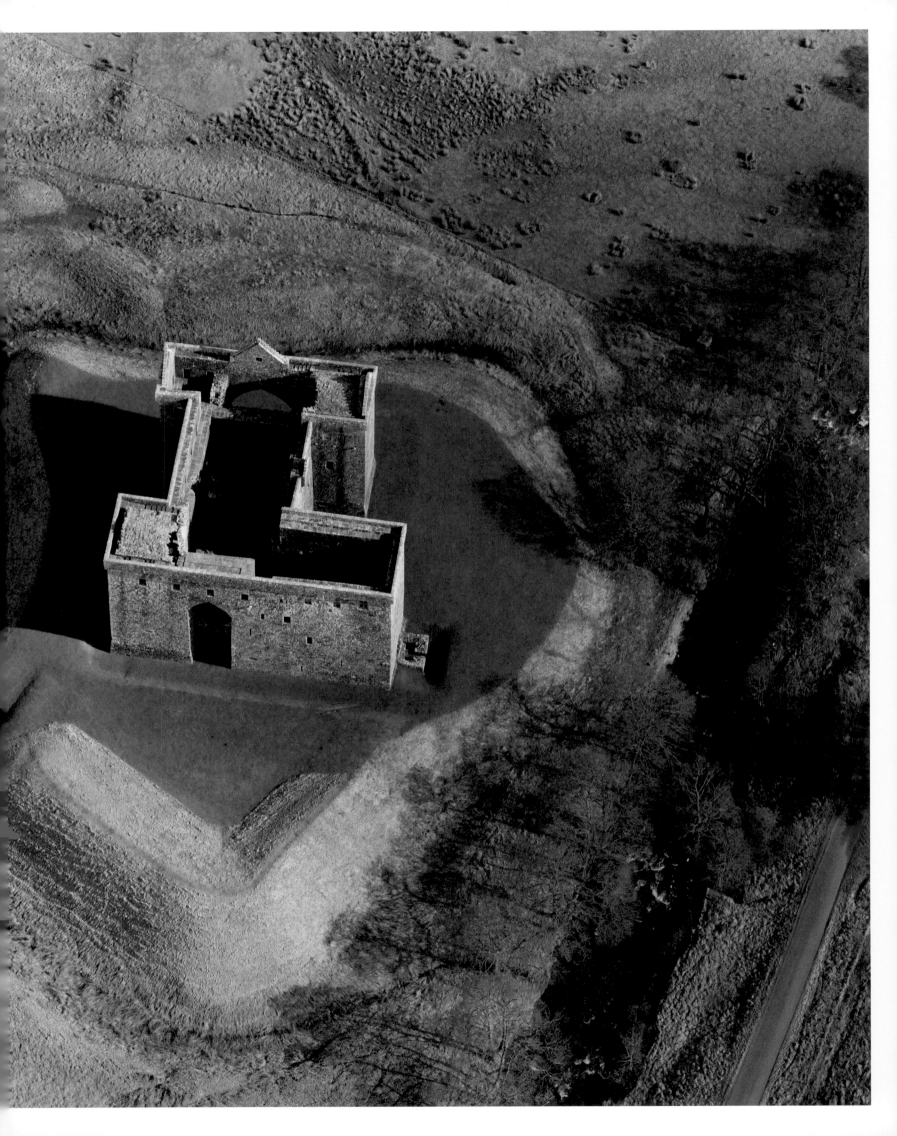

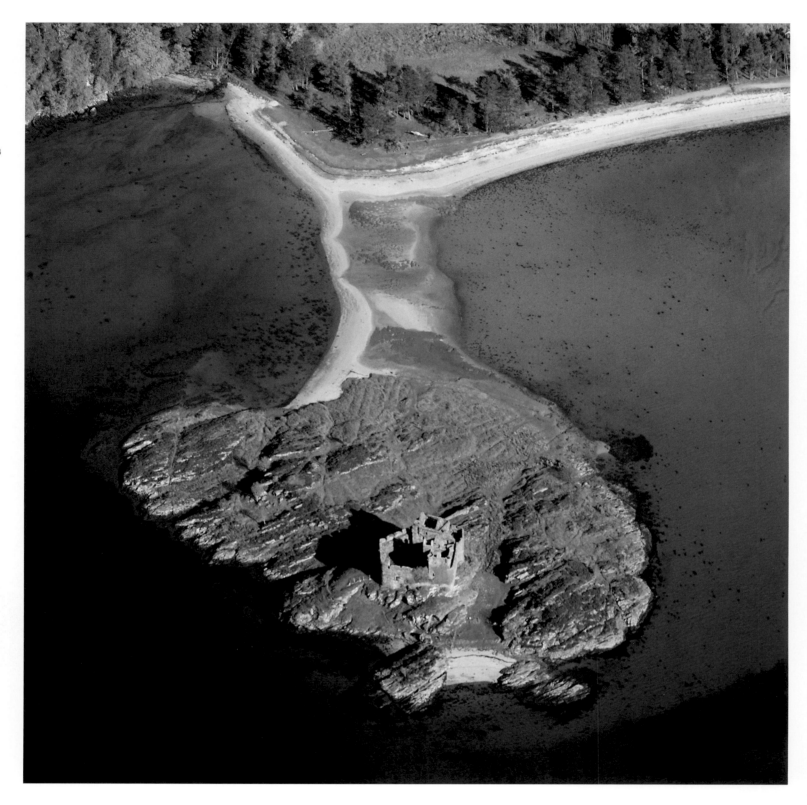

Burned down during the Jacobite rebellion
of 1715, Castle Tioram merges into the
exposed rocks of a small tidal islet near
the mouth of Loch Moidart to the south of
Mallaig. DP031388 2007

Clinging to the dramatic coastline of Caithness,
the walls of Castle Girnigoe have almost
become one with the stacks and cliffs of this
rocky peninsula. Built in the late fifteenth
century by the Sinclair Earls of Caithness and
abandoned 200 years later in the course of a
family feud, it shares the fate of many castles –
its once formidable structure crumbling back into
an implacable landscape. SC873681 1991

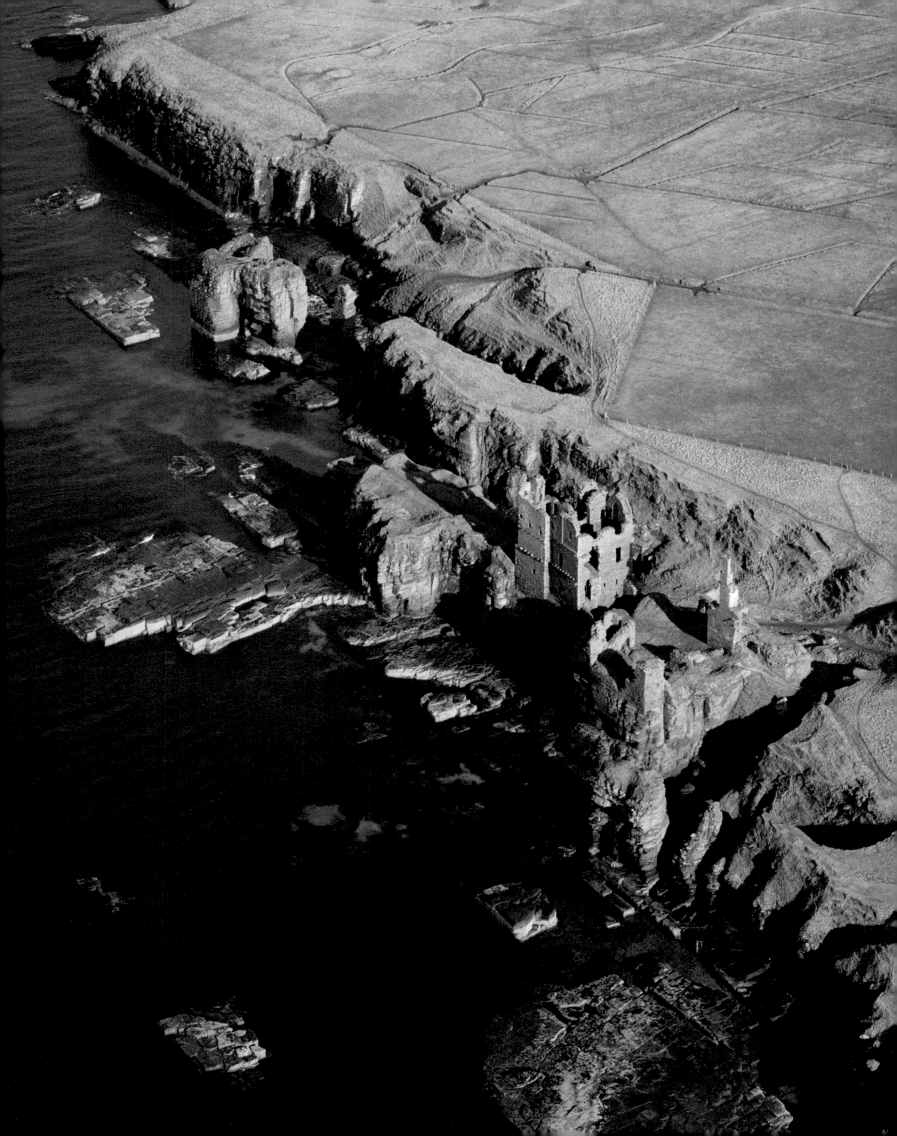

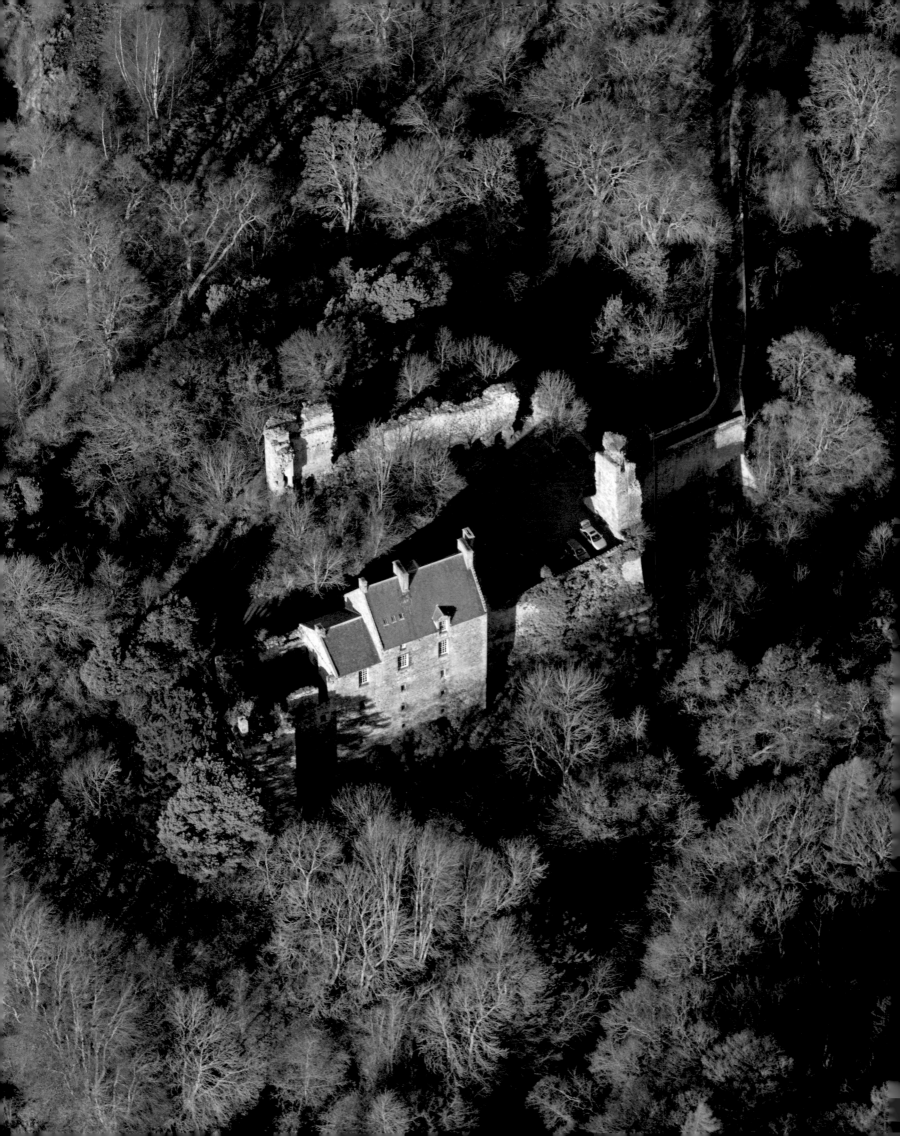

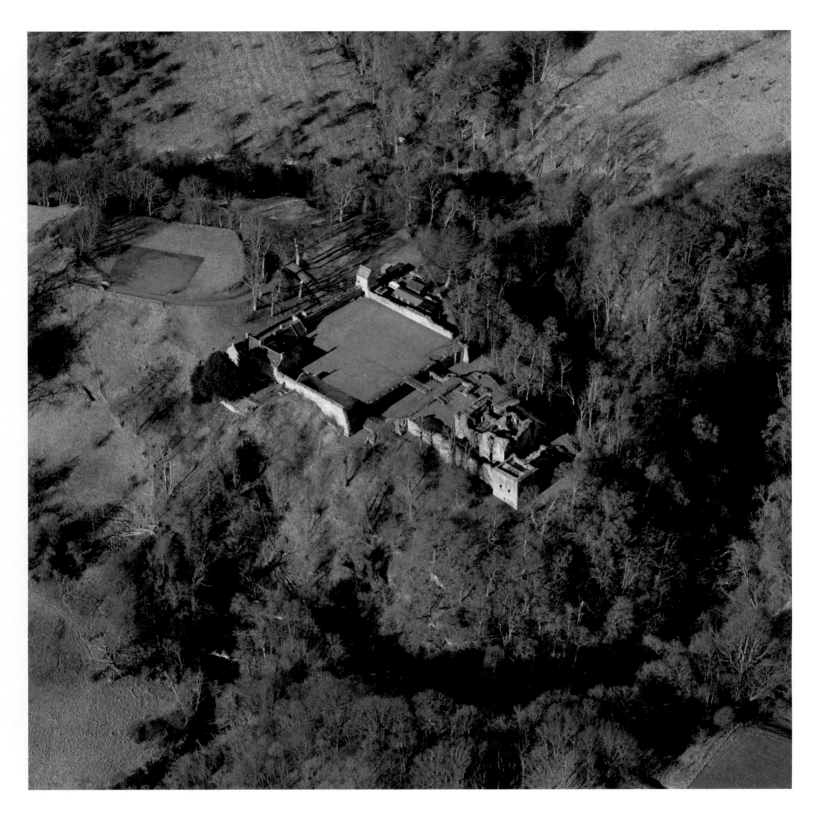

Nestled among woodland and bathed in soft light, the remains of Roslin Castle – once an austere sentry on the River Esk – have been mellowed considerably by time. First built in the 1300s as the seat of the St Clairs, the former Princes and Earls of Orkney, it was destroyed by Oliver Cromwell's deputy General Monk during the Civil War. DP037778 2007

Craignethan Castle in Clydesdale was built about 1530 by Sir James Hamilton of Finnart, head of the second most powerful family in Scotland after the royal Stewarts. For a time a close friend of James V, Hamilton suffered an abrupt fall from grace and was executed in 1540. Like its creator, Craignethan was to be equally short-lived. Less than 50 years after its construction, the castle was almost completely razed during the political and military crises of the Reformation. SC1114945 1996

28 An elegant pleasure palace conveniently
sited between Edinburgh and Stirling,
Linlithgow was a royal retreat enjoyed
for its peace and fresh air. The first royal
dwelling was built in the 1100s by David
I, and in 1302 Edward I of England built
a formidable defensive circuit around the
palace, the only time Linlithgow could
claim to be a fortification. The roofless ruin
that survives today was begun by James I
in 1424 and was later a nursery for Mary
Queen of Scots. With the removal of the
royal court to London after 1603 the palace
deteriorated and was eventually gutted by
fire in 1745. DP013242 2006

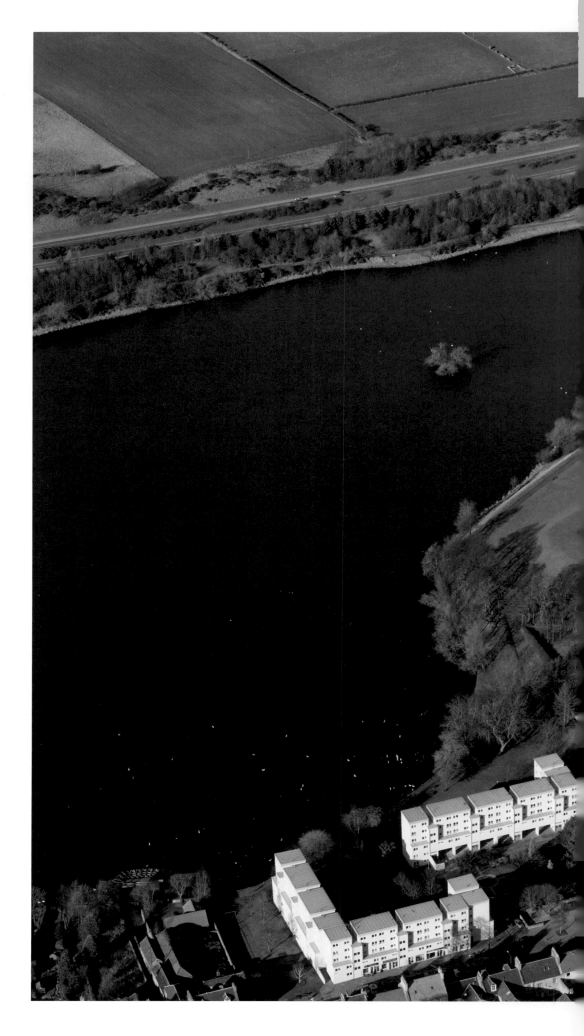

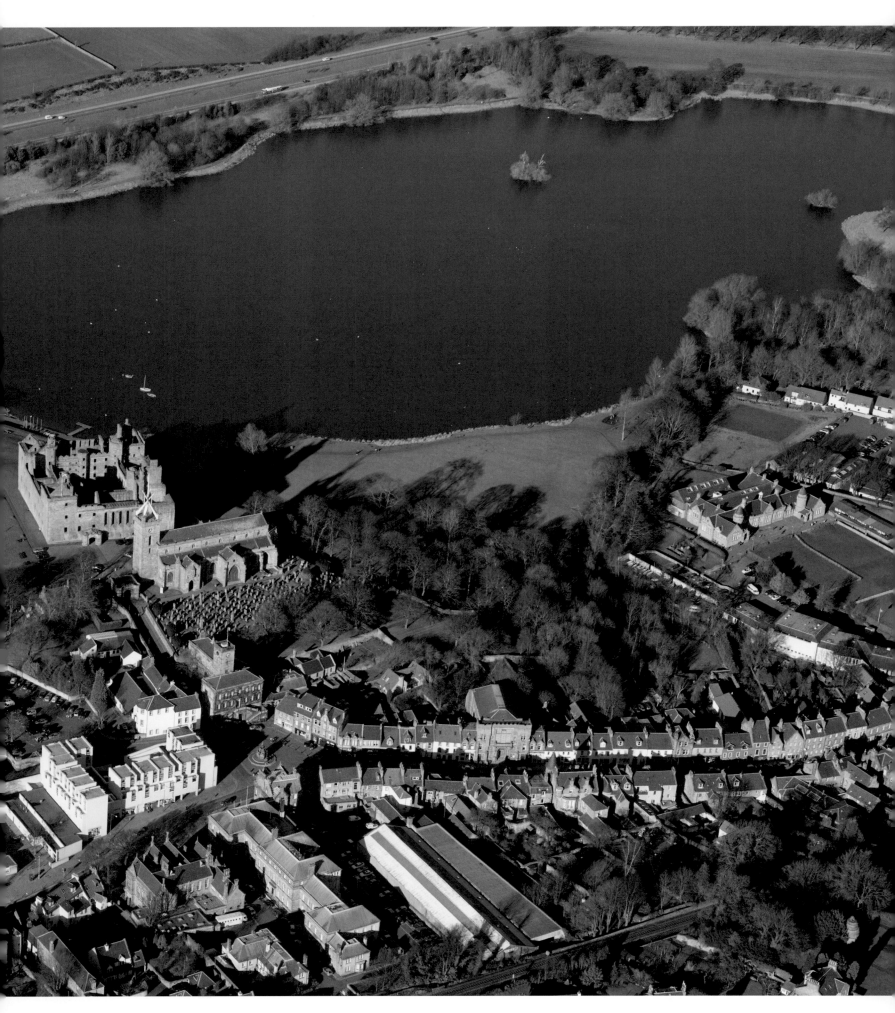

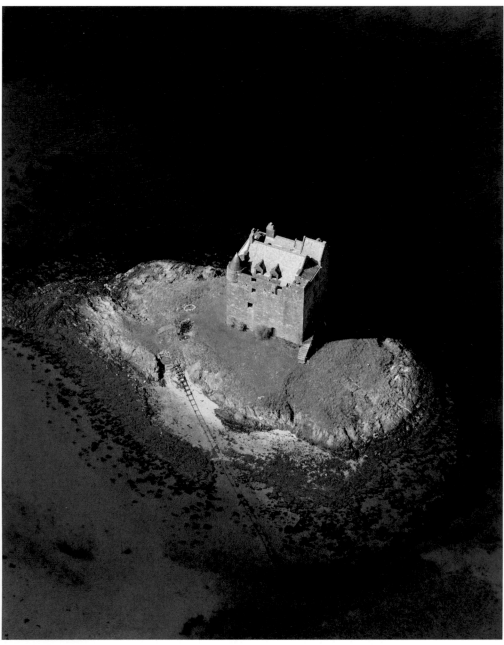

30

Set against spectacular Highland scenery, Castle Stalker still retains much of its original character as a tough and brooding sentry guarding the mouth of Loch Laich near Connel on the Appin coast. Built about 1540, its location underlines the importance of controlling the western seaways in medieval Scotland.

ABOVE **DP026789** 2007

RIGHT **DP017741** 2006

DEFENDING THE LAND

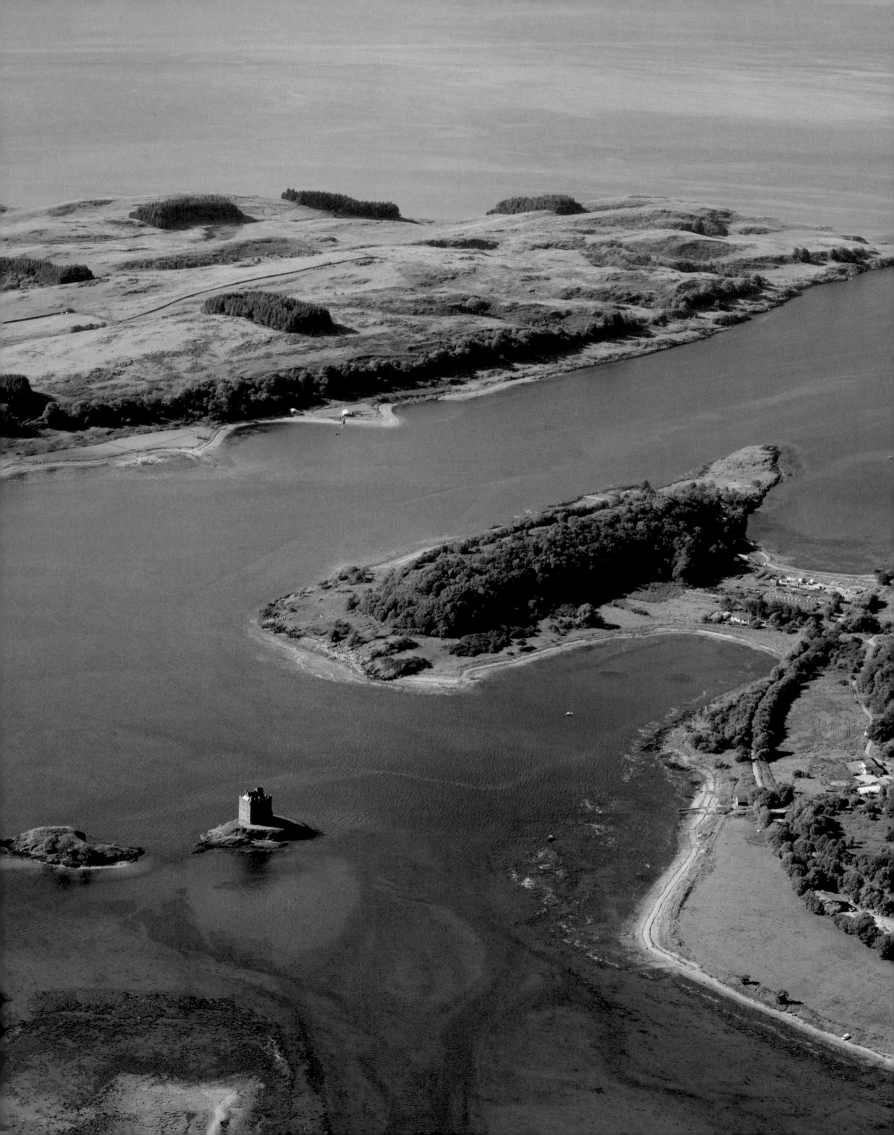

Rumoured to be Bram Stoker's inspiration for the gothic lair of Count Dracula, the labyrinthine ruins and lingering shadows of Slains Castle near Cruden Bay are an evocative presence on the Aberdeenshire coastline. Although some of the remains date back to the 1700s, Slains was virtually rebuilt in 1846, and only became derelict in the first half of the twentieth century. DP018240 2006

FOLLOWING PAGES

The City of Edinburgh is dominated by its volcanic past, and nowhere more strikingly than with its castle. A fortification for nearly 3,000 years, it rises high above the city on an imposing surge of dark basalt rock. In many ways, the history of Edinburgh Castle is the history of Scotland. It began as an Iron Age fort, became an early medieval fortress and seat of royal power, acted as a prisoner of war camp during the Napoleonic Wars and, today, as a garrison, tourist attraction and home to the Stone of Destiny, it is an icon for the nation. DP057132 c1920

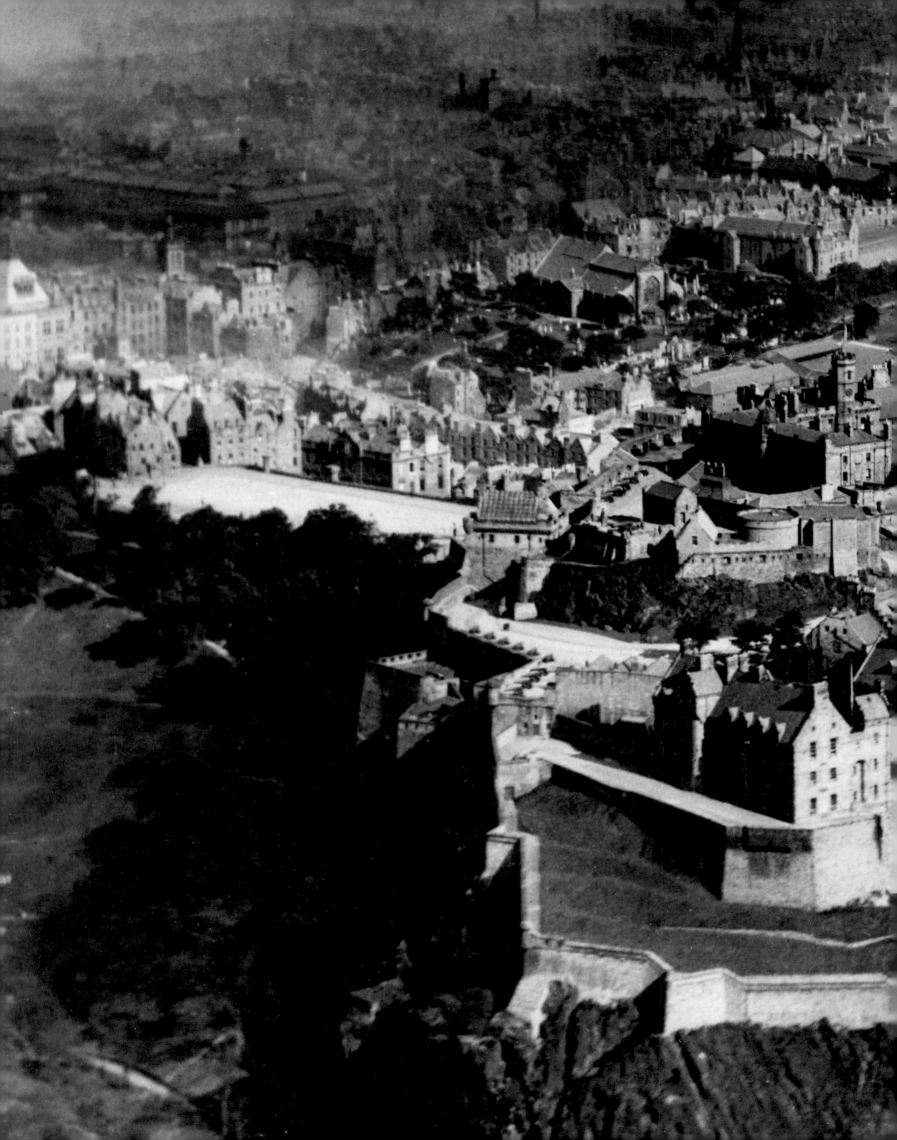

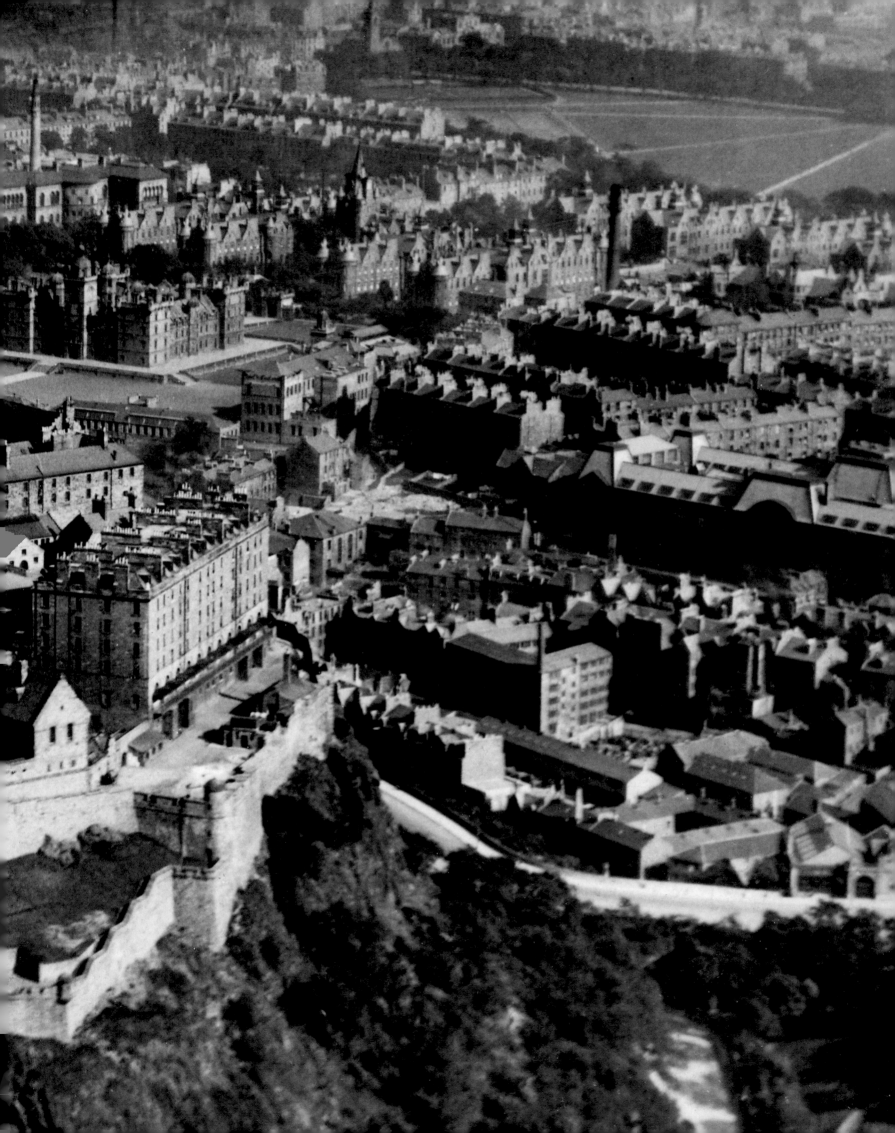

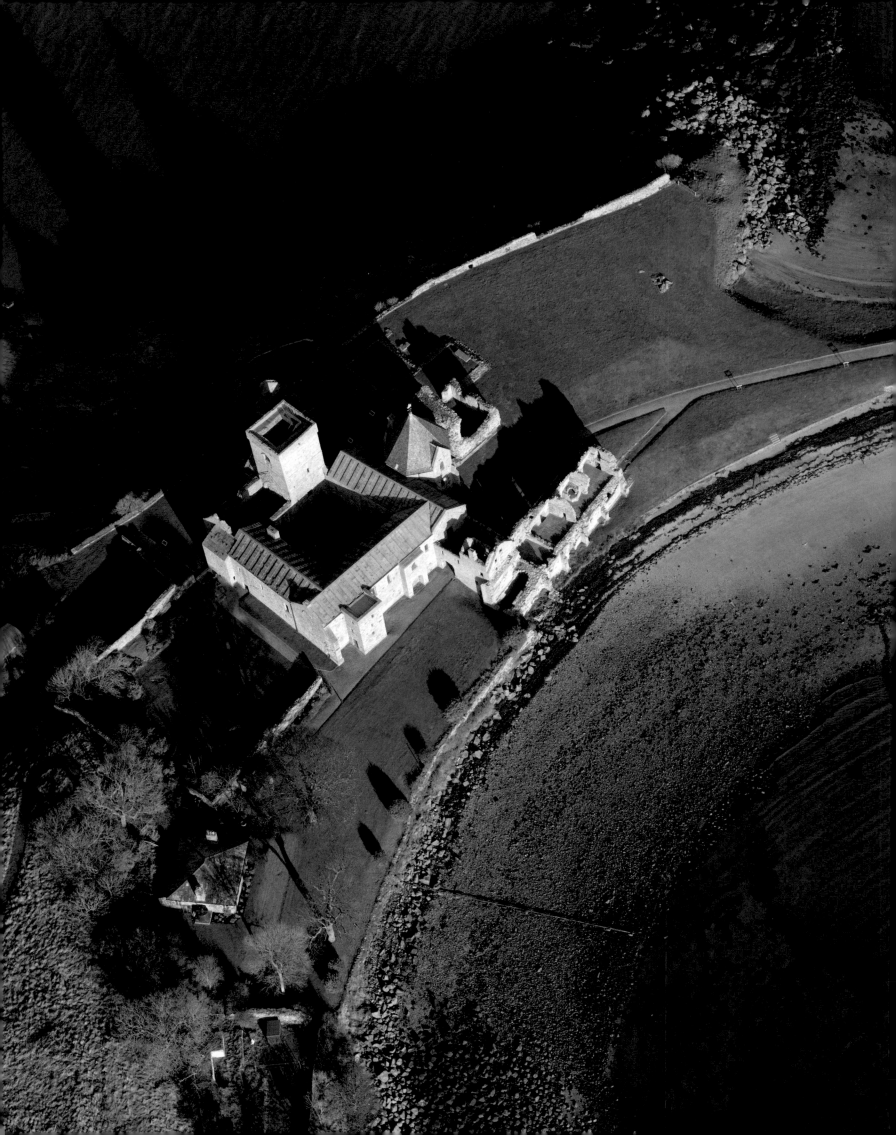

Ritual and Religion

In 1440, in an Augustinian abbey on the tiny island of Inchcolm in the Firth of Forth, an abbot called Walter Bower began writing a history of Scotland. Seven years and sixteen books later, the *Scotichronicon*, the first uninterrupted narrative of the nation, was complete. 'He is not a Scot who is not pleased with this book', proclaimed Bower of his *magnum opus*, which told the story of the Scots from their mythological beginnings to the death of James I. But, had it not been for Alexander I, who promised 300 years earlier to found an abbey on Inchcolm after finding shelter there when his ship was caught in a fierce storm, Bower might never have been afforded the seclusion to write what is regarded as the most important medieval account of Scottish history.

Inchcolm Abbey was established in 1235 and is one of the best-preserved monastic buildings in Scotland. Although subject to raids by English ships in the fifteenth century, the island setting was ideal for a religious order, providing quiet seclusion for prayer and worship, as well as protection from the temptations of secular society. Throughout medieval Europe, monasteries and

1 Inchcolm
2 Calanais
3 Ring of Brodgar
4 Eckford
5 Aikey Brae
6 Iona
7 Sweetheart Abbey
8 Restenneth Priory
9 Arbroath Abbey
10 St Andrews Cathedral
11 Dunfermline Abbey
12 Canna
13 Edinburgh
14 Paisley Abbey
15 Glasgow Cathedral

abbeys were the intellectual powerhouses of their day, accumulating vast libraries and supporting generations of scholars like Bower. But the Abbey was not the first religious imprint on Inchcolm, and in earlier centuries when Christianity was still a fledgling presence in Scotland, the island was a retreat for hermits and monks, who lived in bare stone cells as they sought solitude to commune with God.

The history of Inchcolm is repeated across the nation. Scotland has been a Christian country for well over a thousand years, with ancient tombstones, ruined abbeys, parish churches, crowded cemeteries and majestic cathedrals providing a physical timeline for one of the world's leading religions. Yet sites like the prehistoric stones of Calanais on the Isle of Lewis, which date back about 5,000 years, are enigmatic reminders of the lost ritual practices of our pre-Christian ancestors. The meaning and purpose of Scotland's many standing stones, burial chambers and stone circles may remain a matter for inspired speculation, but the effort invested in creating these monuments demonstrates the central role they played for past peoples trying to make sense of their world.

For millennia, the call to worship, to create holy sites and structures in celebration of the divine, has left an indelible mark on the nation's landscape. Linked through time by the enduring power of religious belief, they remain some of Scotland's most awe-inspiring monuments.

PREVIOUS PAGES

Casting long shadows over the waters of the Firth of Forth, the abbey buildings on Inchcolm are a lasting marker of the island's place as one of the cradles of Christianity in Scotland. DP037739 2007

OPPOSITE

The stones of Calanais on the Isle of Lewis radiate out in four lines from a central ring. Set up around 3,000 BC, Calanais is one of the oldest monuments of its kind in Scotland, and, although its purpose remains unknown, the site has long been associated with astronomical events. Remarkably, within 2,000 years of being built, the stones were enveloped by peat. It was not until 1857, when Sir James Matheson – then owner of Lewis – ordered workers to remove the bog, that their full extent was revealed once more. SC958513 2004

FOLLOWING PAGES

Five worn paths thread like veins towards the heart of the Ring of Brodgar, one of Orkney's iconic ancient monuments. Dating from between 3,000 BC and 2,000 BC, Brodgar was a cathedral of the Neolithic era, its circle of massive stones once bringing communities together in ritual and worship. Now, thousands of years later, it remains an attraction for many visitors and tourists. DP058594 2009

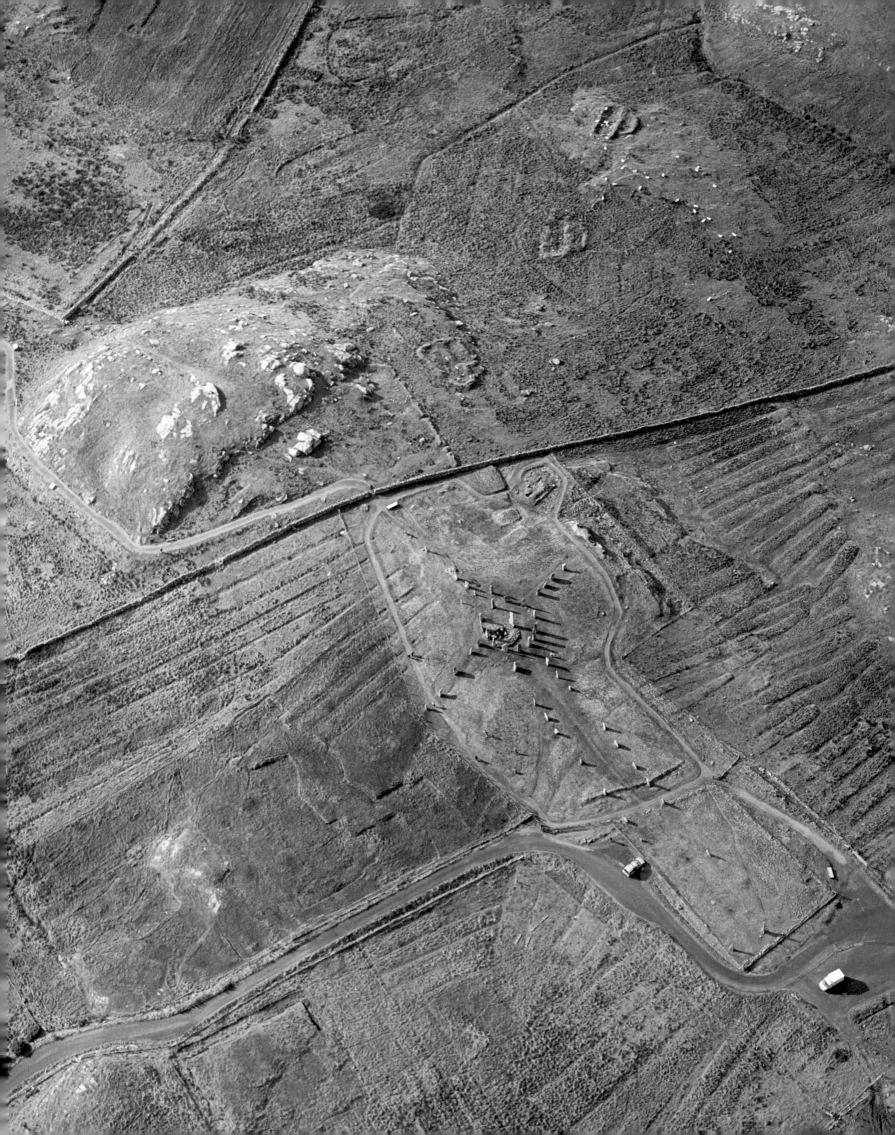

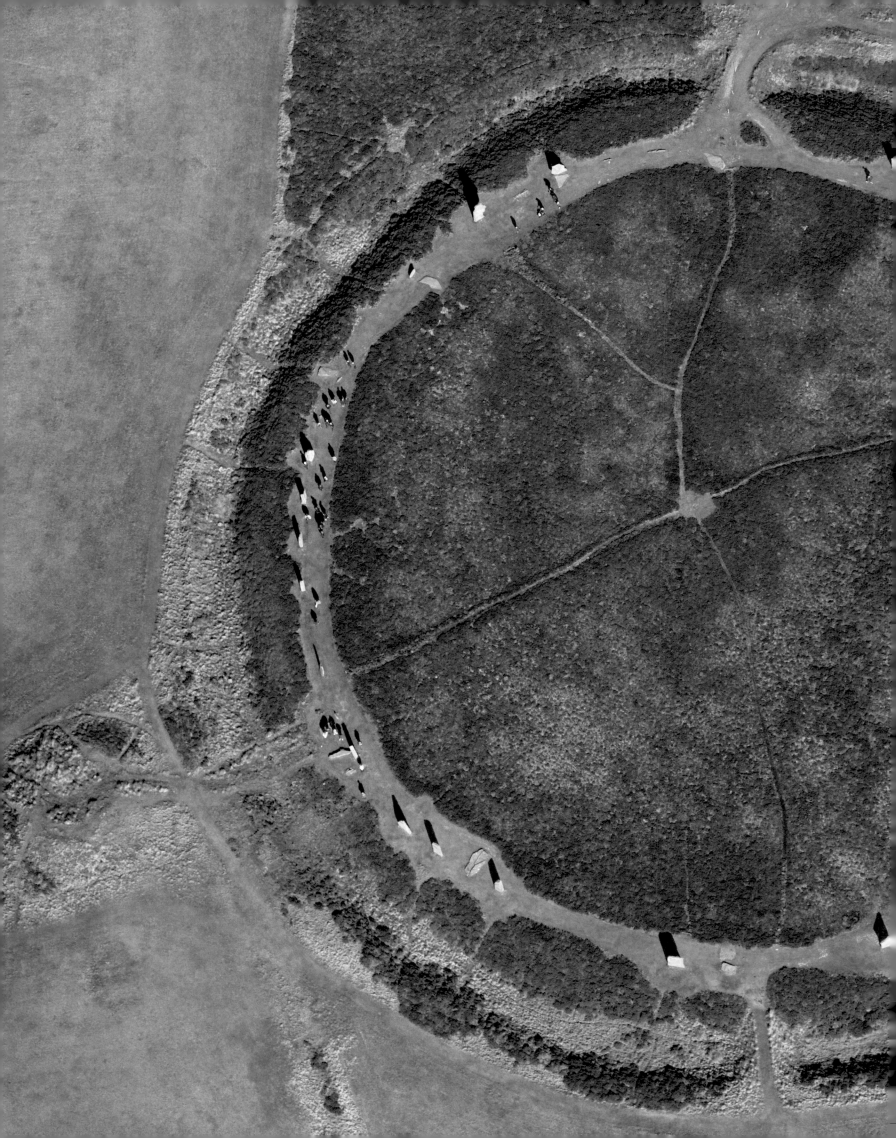

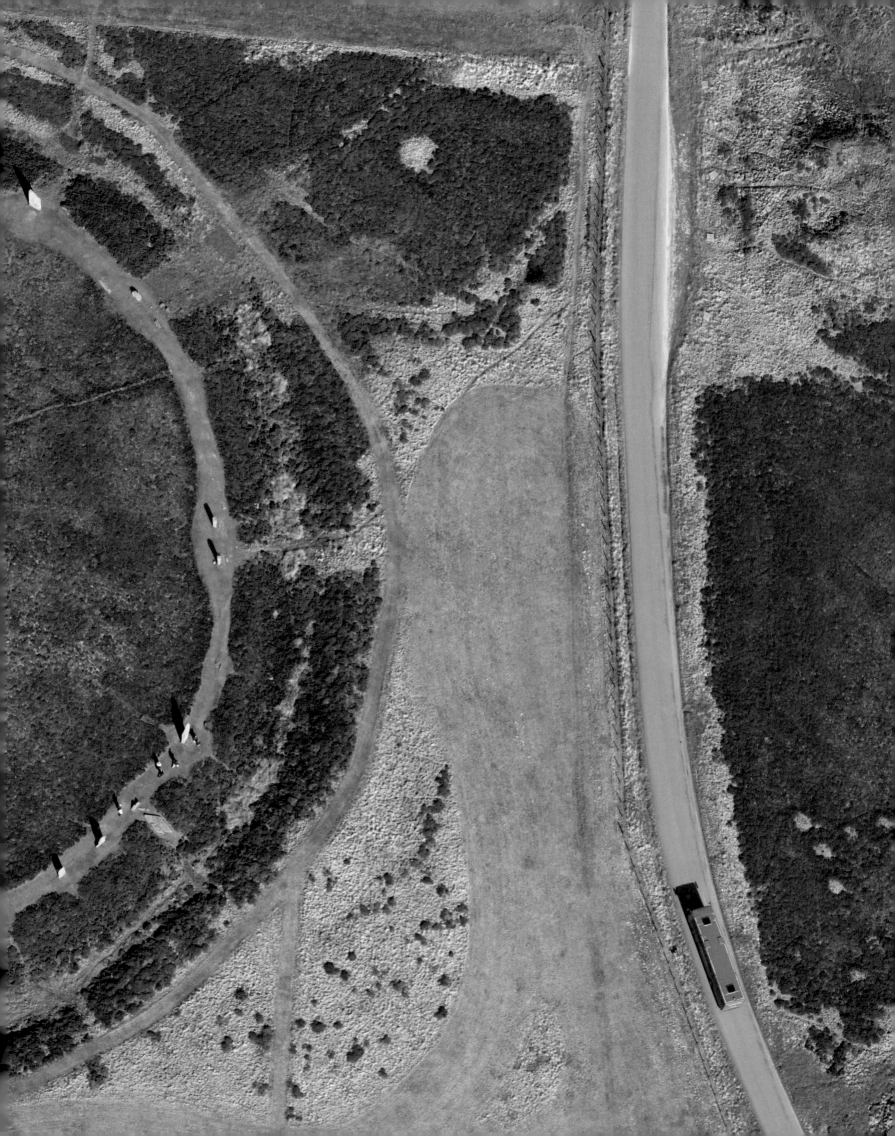

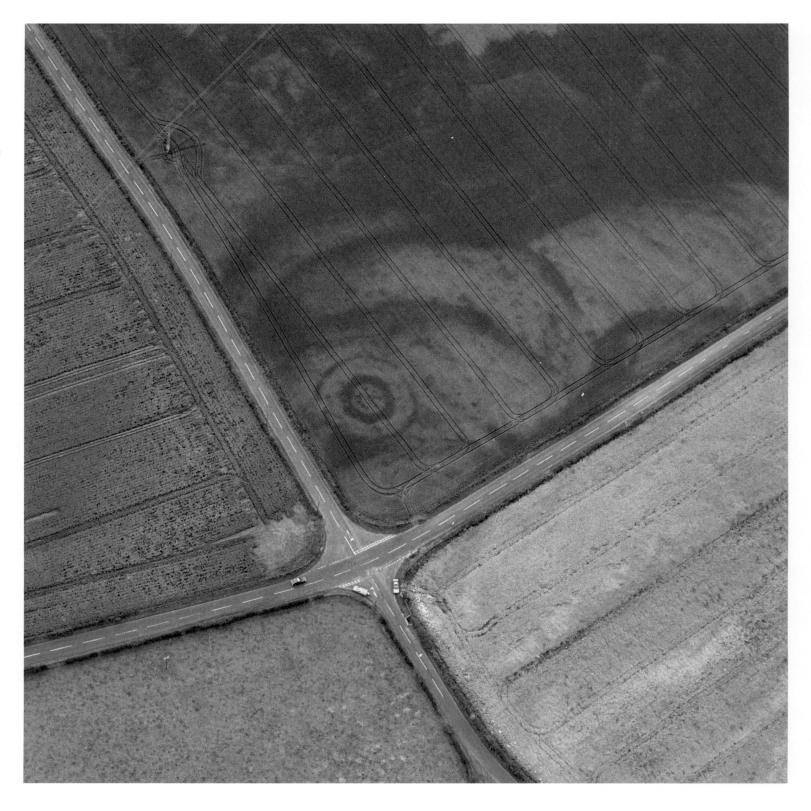

ABOVE

In a patchwork farming landscape near Eckford
in the Borders, the growth of ripening crops
reveals a remarkable secret hiding beneath the
soil. Created between 2,000 BC and 1,000 BC,
this faint circle – which is just weeks away from
being erased by the blades of a combine harvester
– is all that remains of a once complex religious
monument formed by a ring of timber posts set
in deep pits. SC1004902 1996

OPPOSITE

A jigsaw of nineteenth century fields frames
the stone circle of Aikey Brae on the summit of
Parkhouse Hill in northern Aberdeenshire. Visitors
to the circle are drawn to confront a massive
horizontal slab placed between two pillars. This
'recumbent' slab – in popular folklore an altar stone
for rituals – was, for the people who farmed this
ancient landscape some 4,000 years ago, the blocked
doorway to another world. SC958377 2004

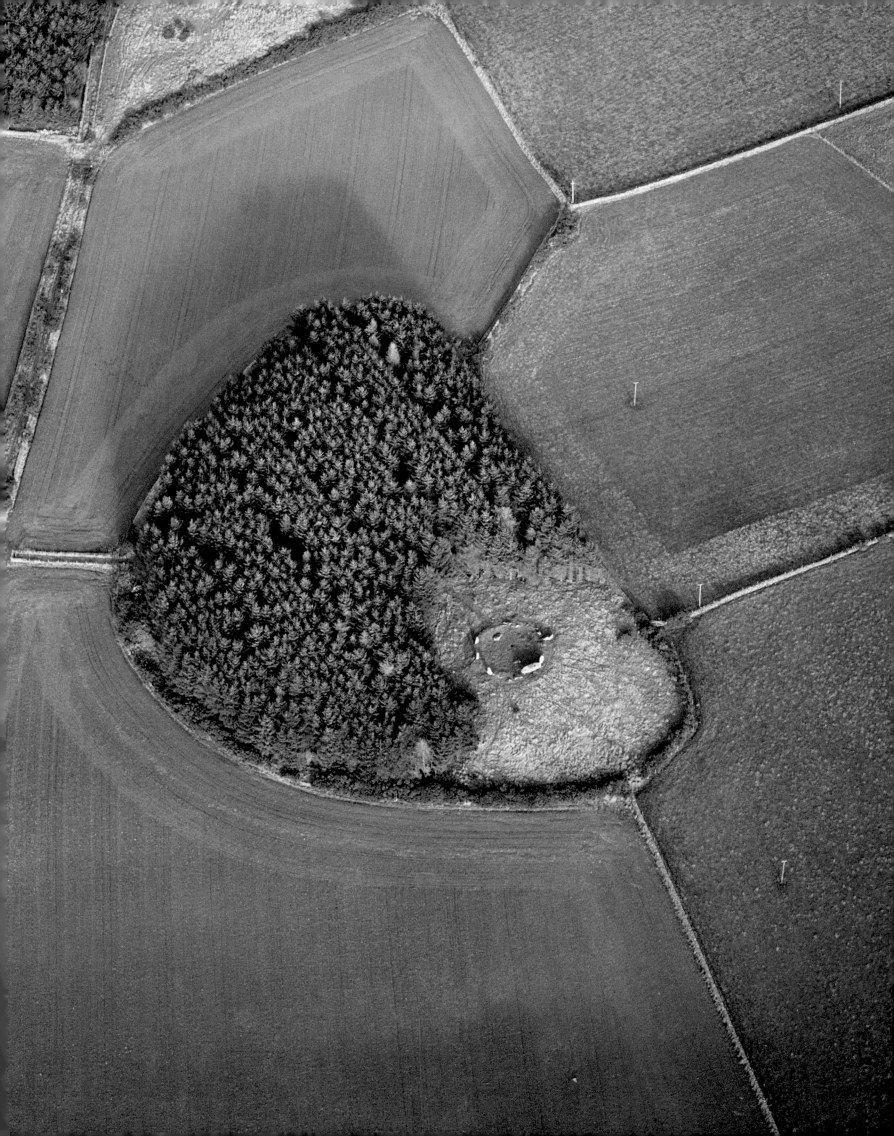

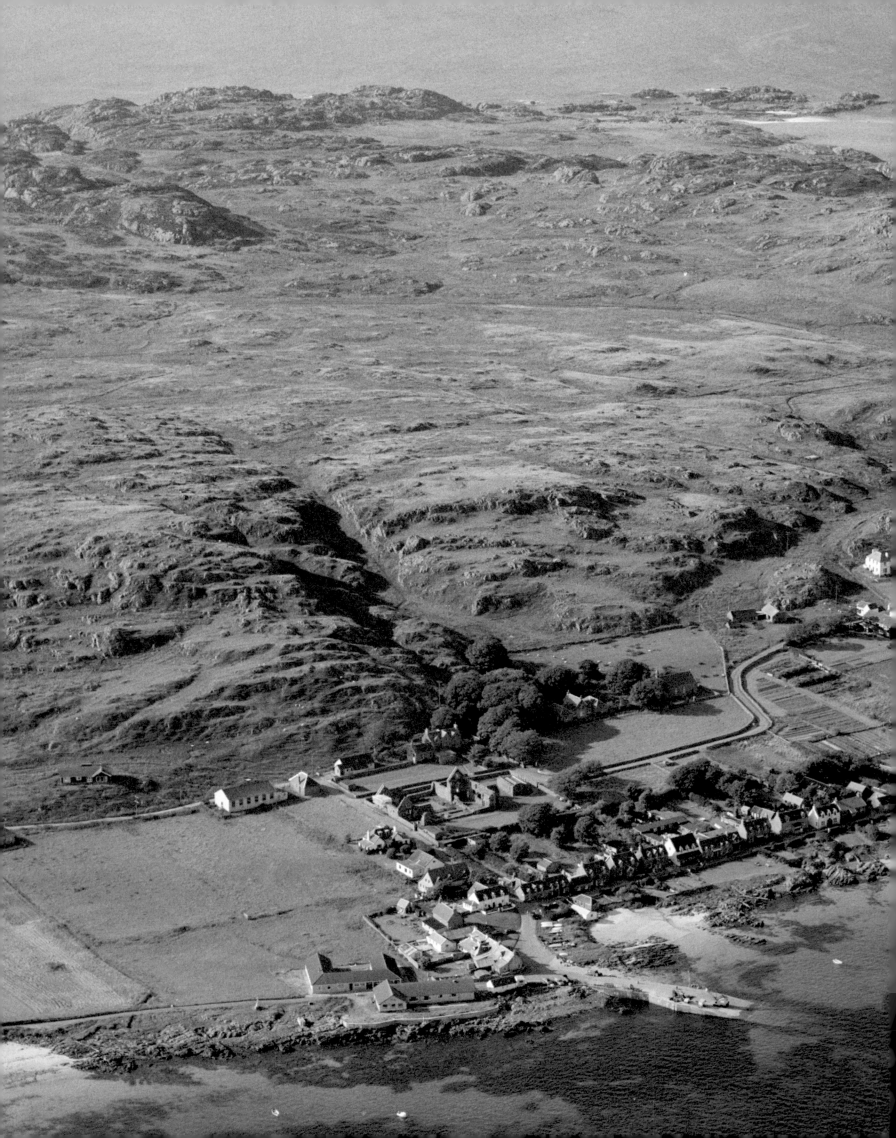

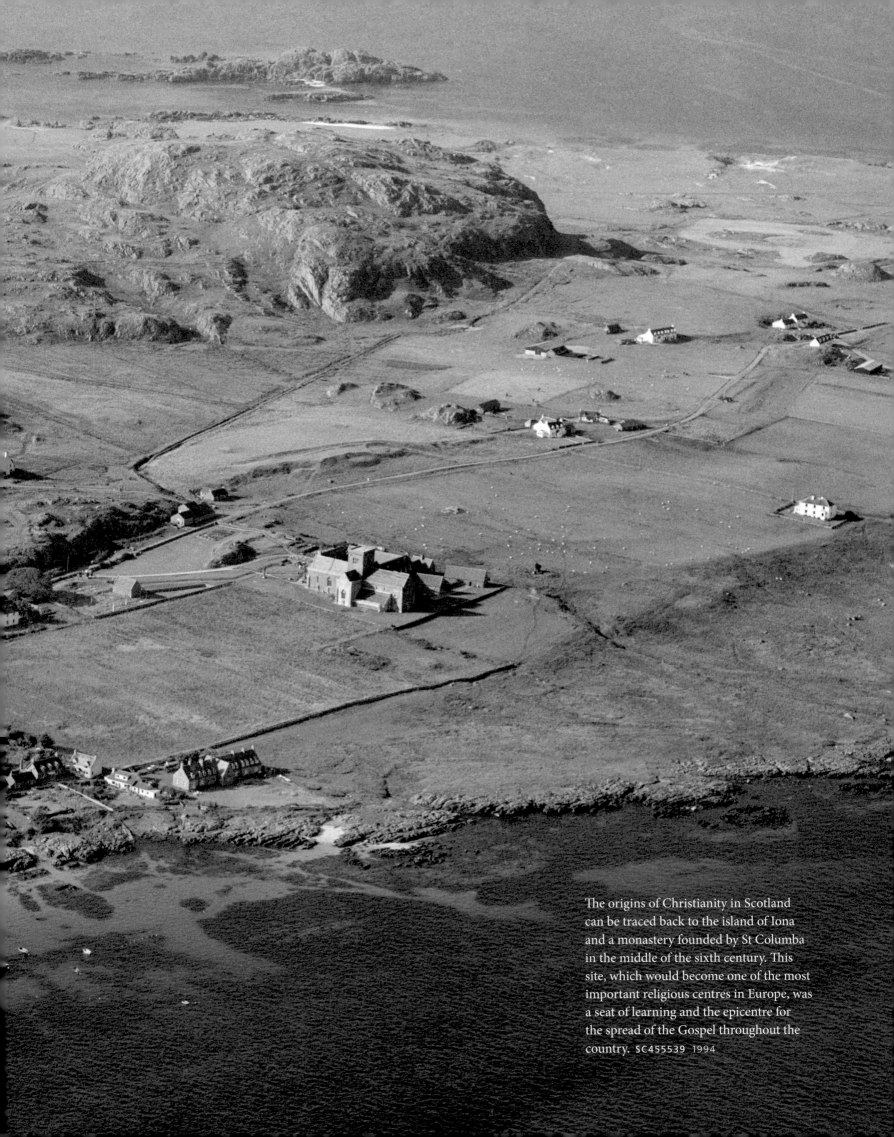

The origins of Christianity in Scotland can be traced back to the island of Iona and a monastery founded by St Columba in the middle of the sixth century. This site, which would become one of the most important religious centres in Europe, was a seat of learning and the epicentre for the spread of the Gospel throughout the country. SC455539 1994

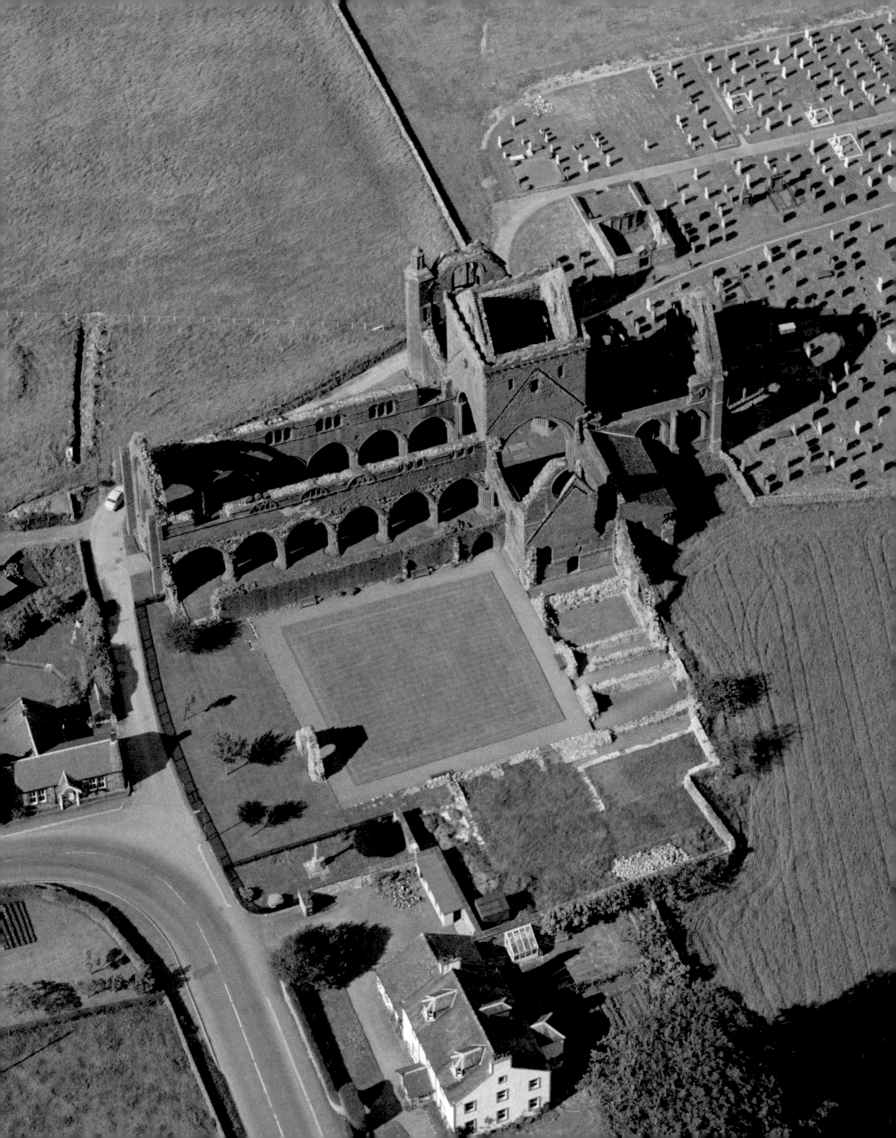

The red sandstone walls of the ruins of Sweetheart Abbey near Dumfries glow in the summer sun. A monument to divine and human love, the Abbey was founded in 1273 by Lady Devorgilla of Galloway in memory of her husband John Balliol. SC800175 1972

A peaceful ruin surrounded by golden fields, Restenneth Priory near Forfar was favoured by early Scottish kings, including David I and Malcolm IV. The Priory grew wealthy on its extensive land holdings and privileges, but gradually faded into obscurity after being damaged and burned during the Wars of Independence with England. SC773014 1970

'It is in truth not for glory, nor riches, nor honours that we are fighting, but for freedom.' Drafted in the scriptorium of Arbroath Abbey, the Declaration of Arbroath, the most famous document in Scotland's history, saw the nation's nobles swear their independence from England. The Abbey remains a powerful icon for Scottish nationalism. In 1951, in a highly symbolic act, the Stone of Destiny – which was taken as spoils of war by Edward I of England in 1296 – was removed from Westminster Abbey and later found within the remains of Arbroath. SC798201 1970

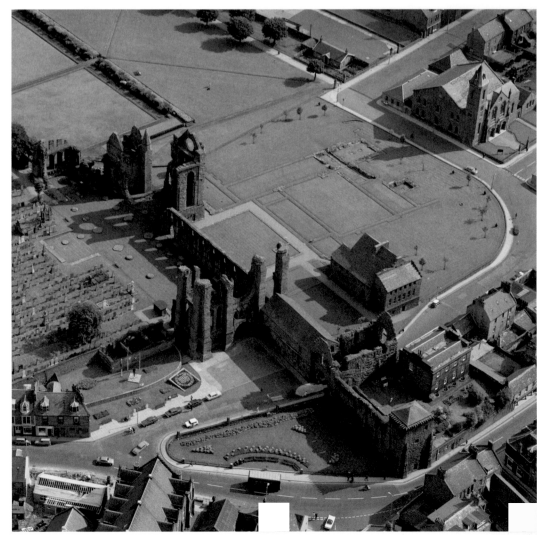

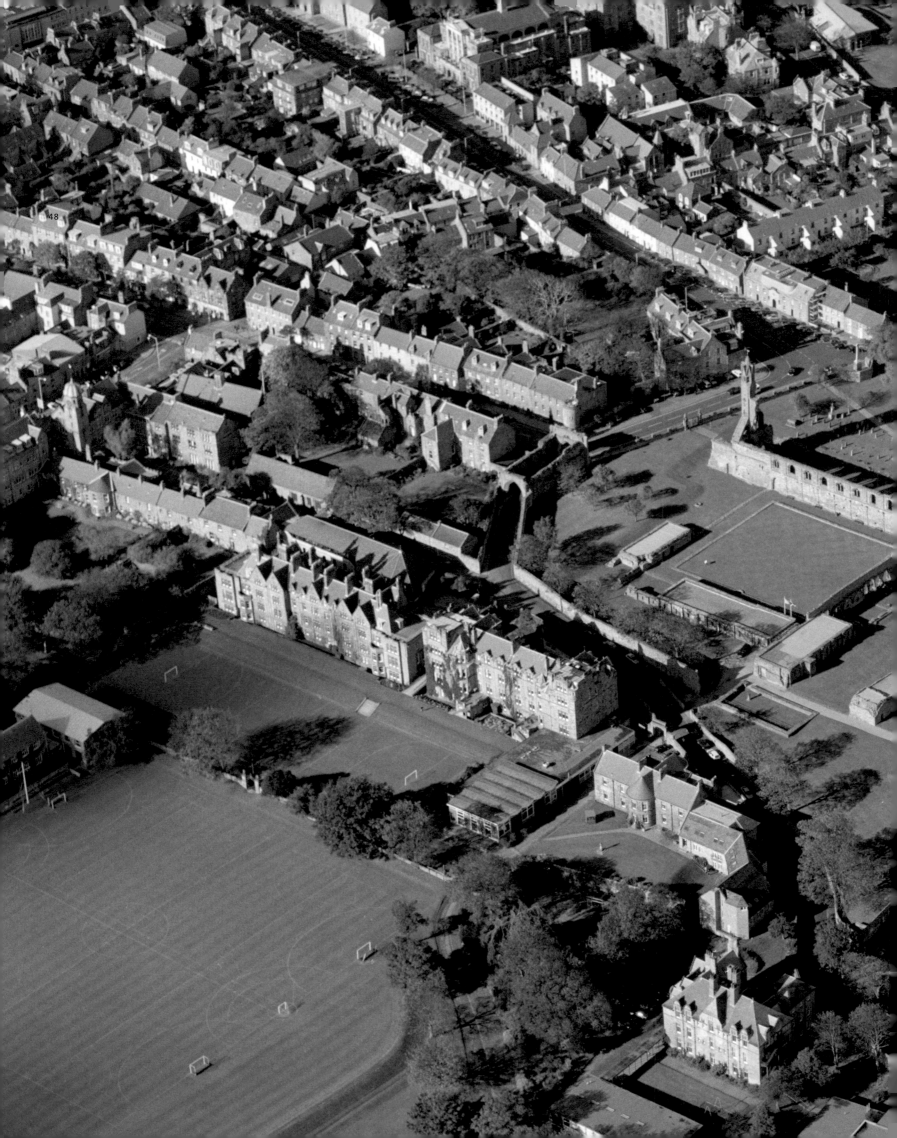

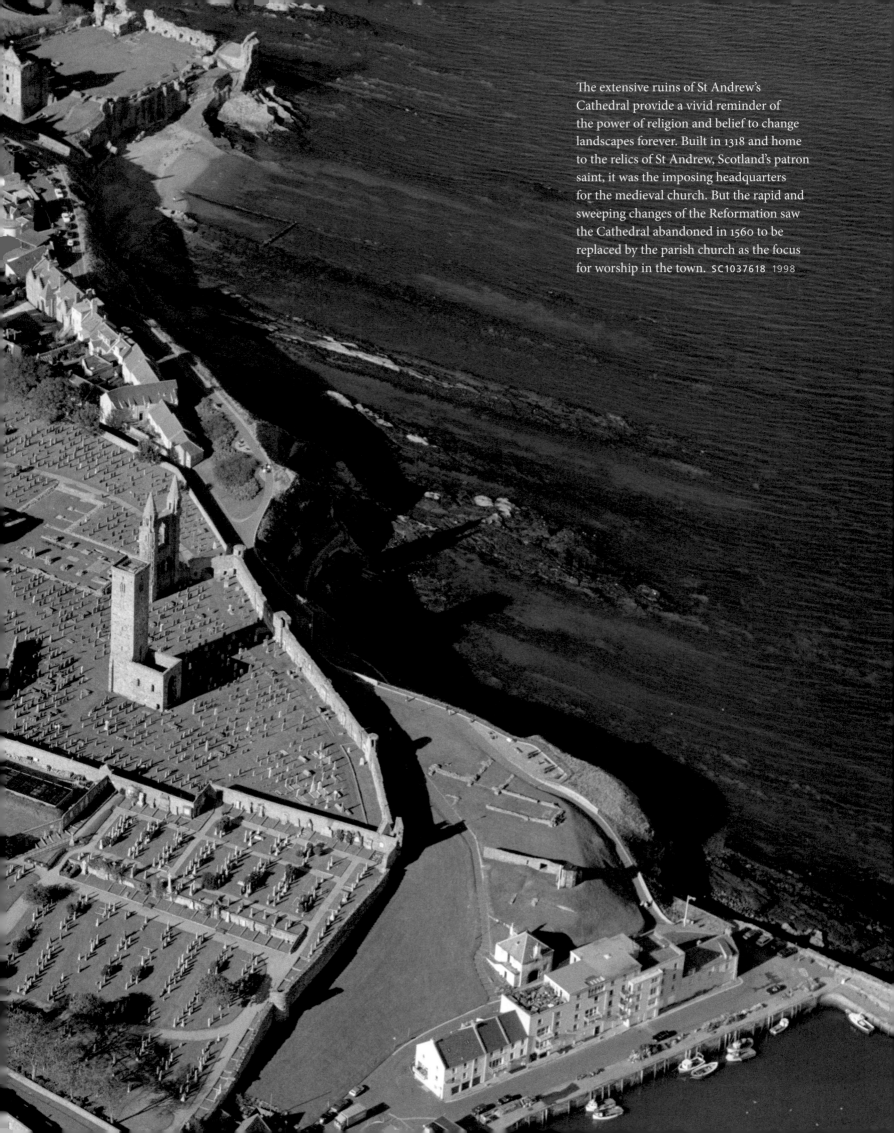

The extensive ruins of St Andrew's Cathedral provide a vivid reminder of the power of religion and belief to change landscapes forever. Built in 1318 and home to the relics of St Andrew, Scotland's patron saint, it was the imposing headquarters for the medieval church. But the rapid and sweeping changes of the Reformation saw the Cathedral abandoned in 1560 to be replaced by the parish church as the focus for worship in the town. SC1037618 1998

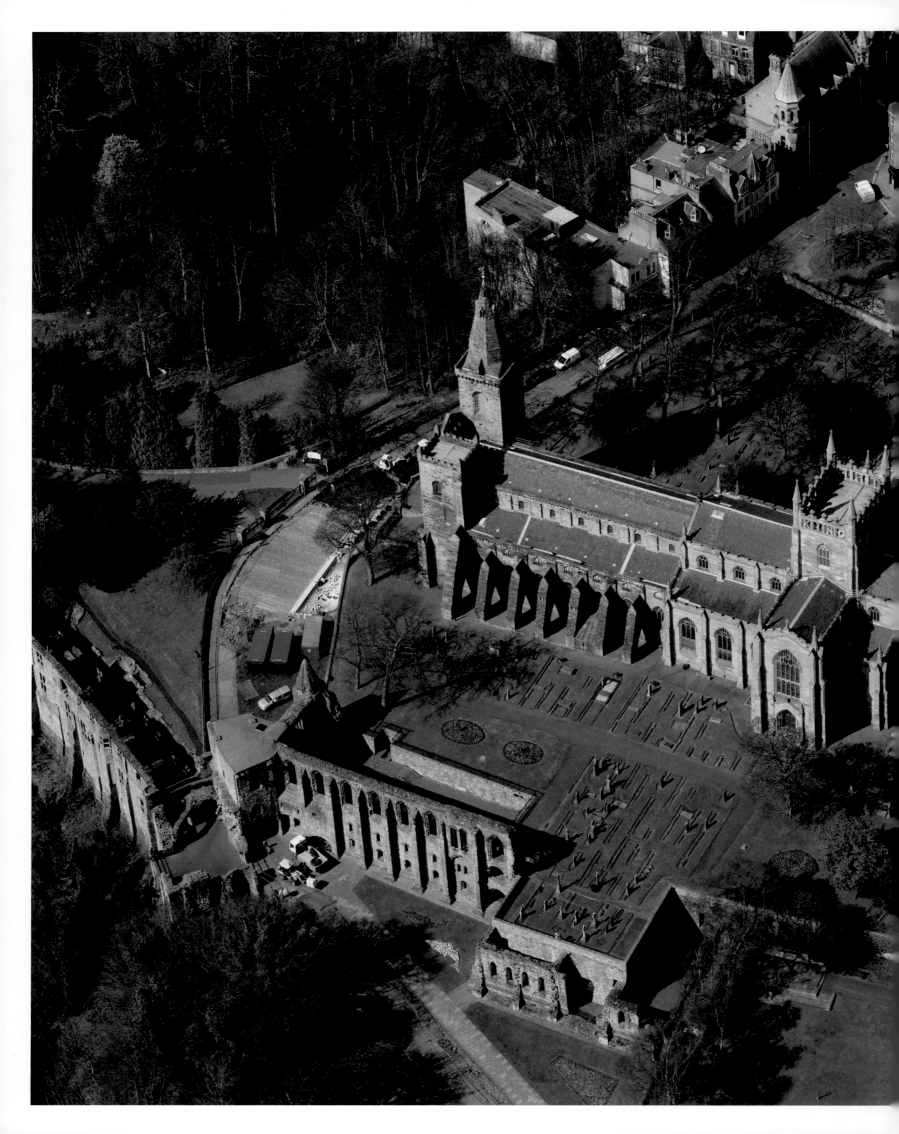

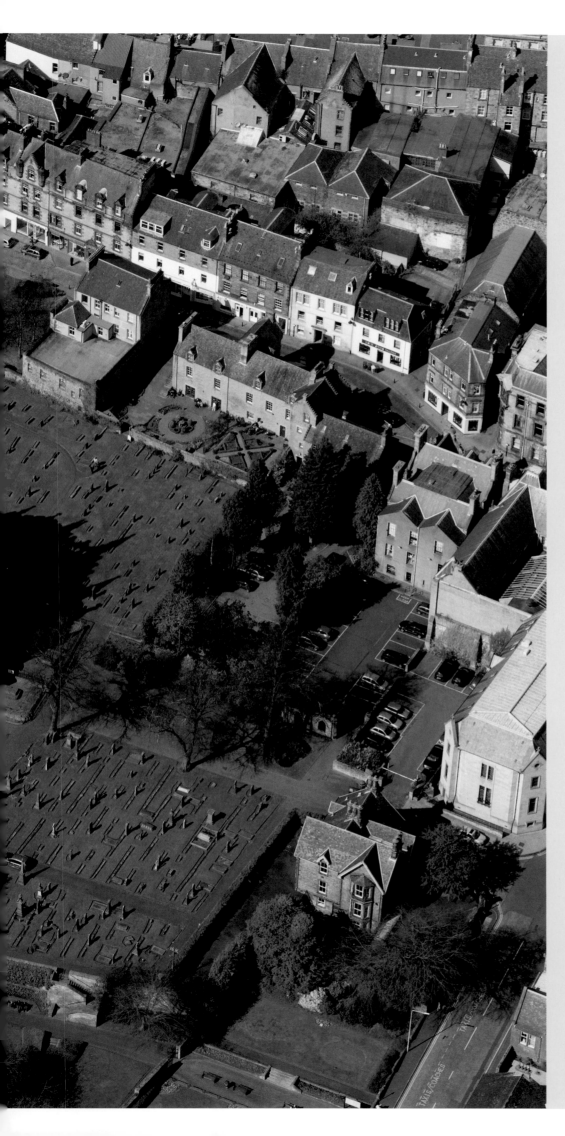

A tightly pressed bank of houses looks out at the grand structure of Dunfermline Abbey set within its spacious grounds. After the collapse of the Abbey's main tower in 1818, the remains of Robert the Bruce were found beneath the building, creating huge national interest. The former King was reburied, and a new tower was built in commemoration. DP043347 2008

FOLLOWING PAGES
The disused Roman Catholic Church of St Edward the Confessor on Canna, one of the Small Isles, is still an imposing landmark in the bay. Built between 1886 and 1890 to a design by the architect William Frame, it was closed in 1963, no longer required by a declining population. SC794156 1994

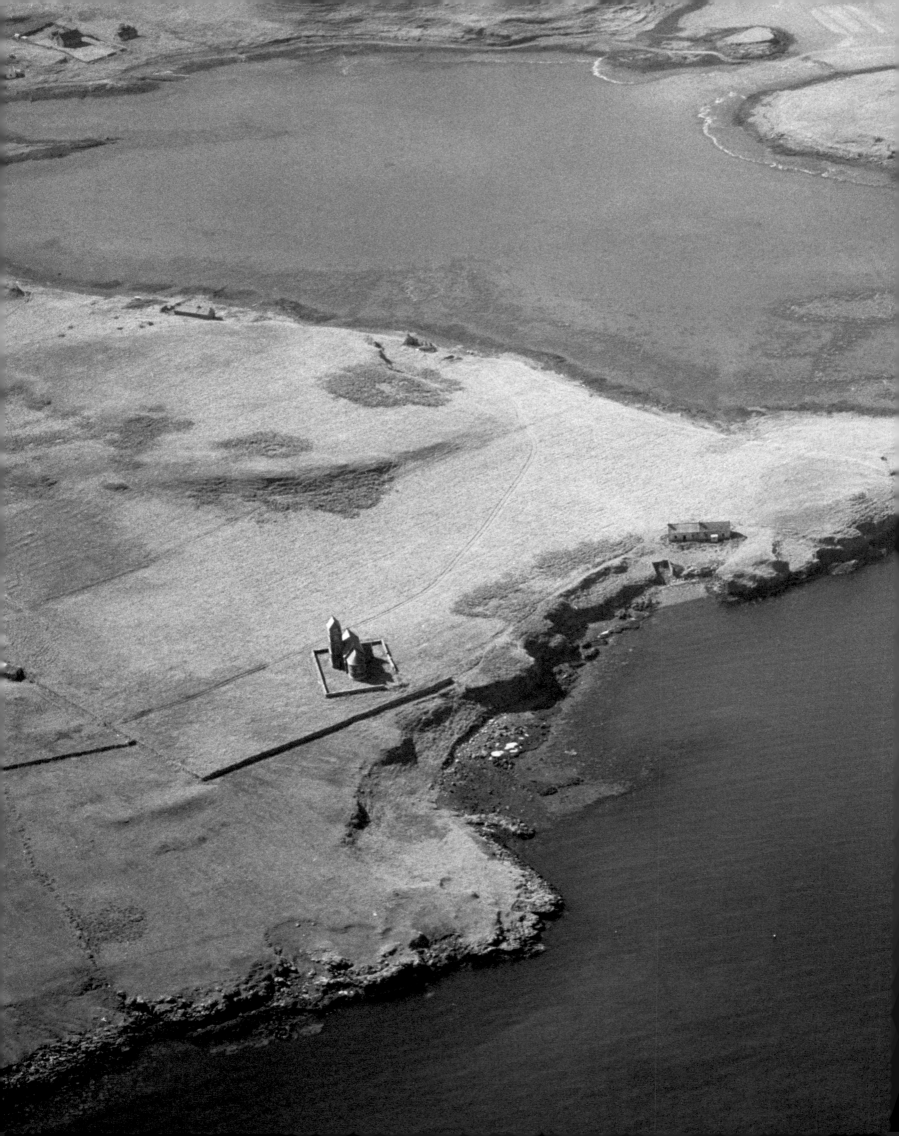

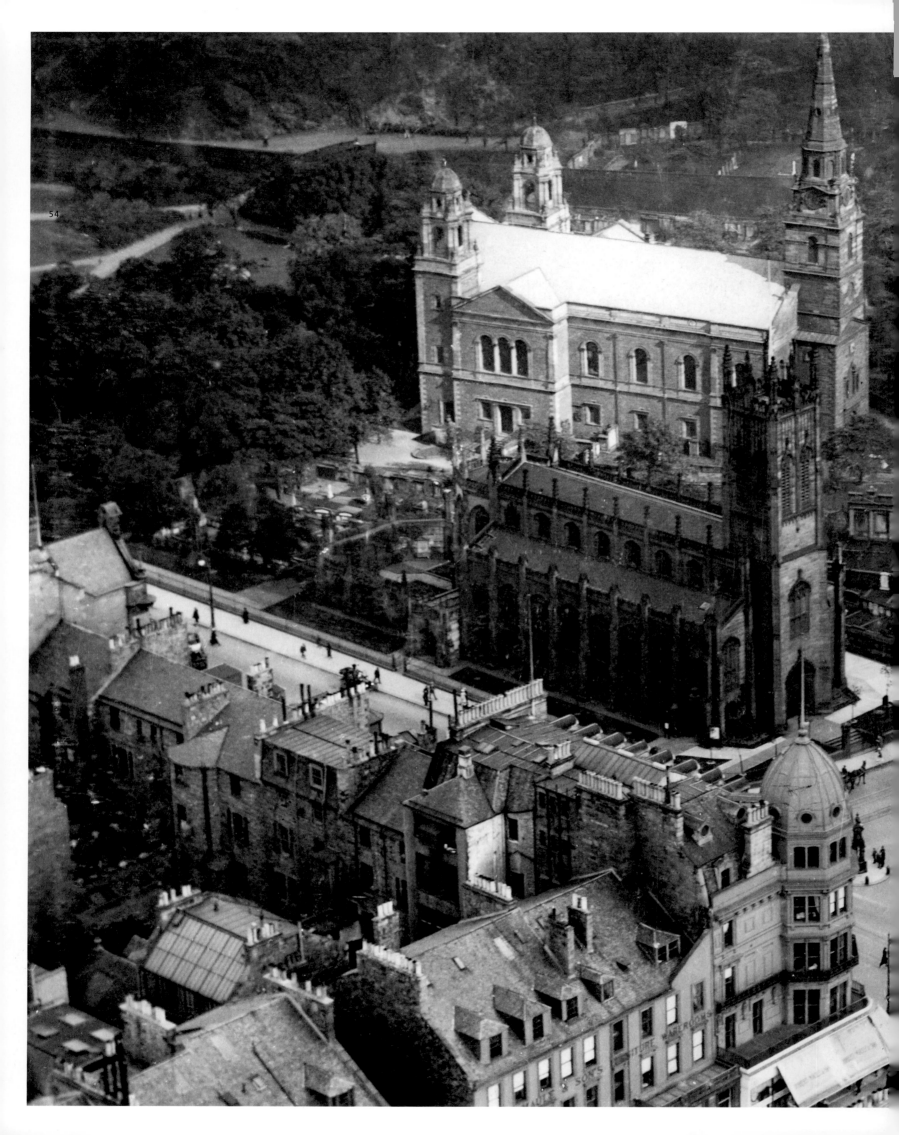

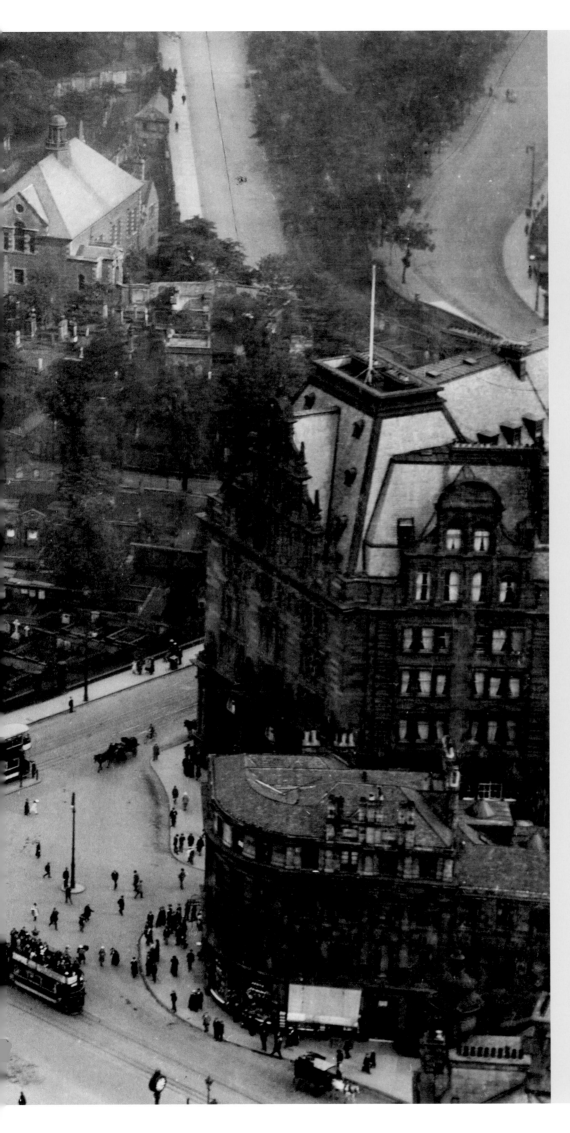

Taken from a low-flying aircraft skimming the rooftops of Edinburgh, St John's Episcopal Church and St Cuthbert's Church dominate the busy confluence at the west end of Princes Street. The positioning of churches at road junctions and in town centres is commonplace – providing architectural markers of the crucial role Christianity has played in Scotland's history for well over a thousand years.

DP057131 c1920

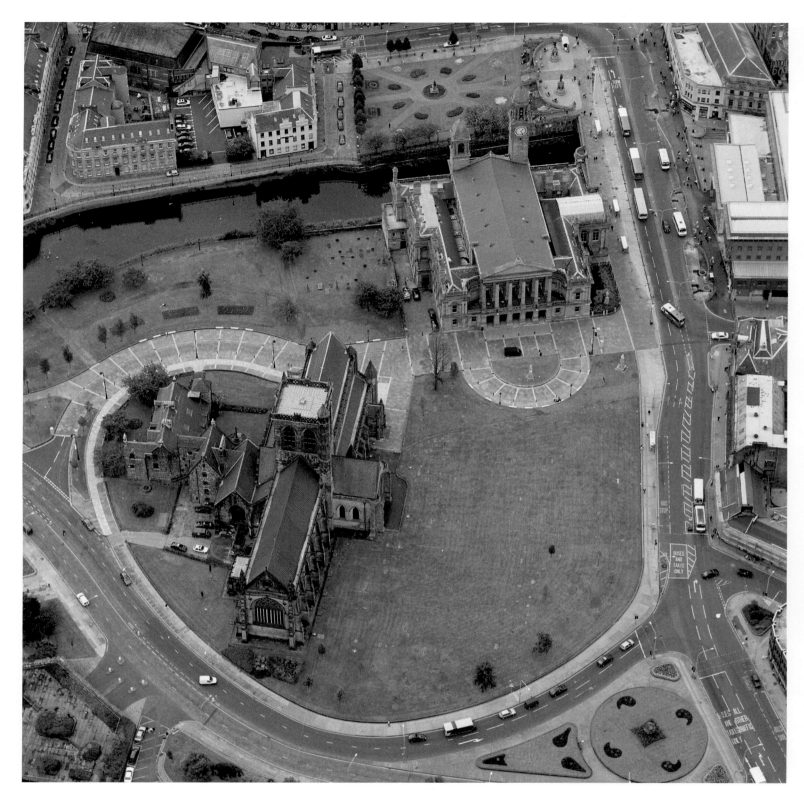

56

Hemmed in by the tarmac and concrete
of a modern city, Paisley Abbey still holds
its own 900 years after its foundation. The
Town Hall beside it was built between 1879
and 1892 in a mixed classical style, a state-
ment of Paisley's aspirations and self-belief
as one of the industrial powerhouses of
Scotland. SC1111734 1999

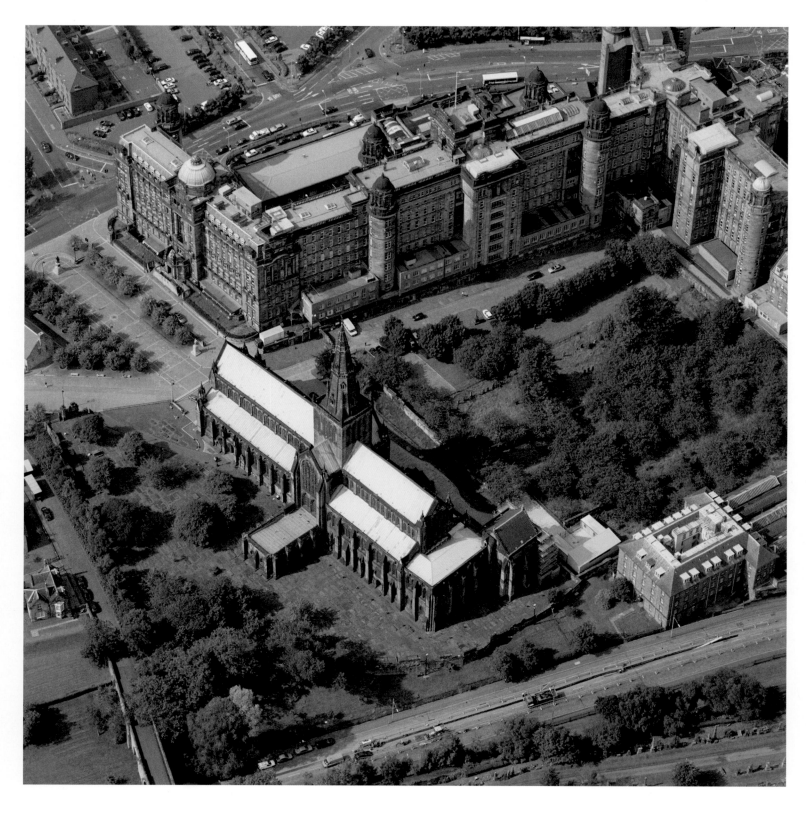

A precious monument from the past,
St Mungo's in Glasgow is the only medieval
cathedral to have survived the Reformation
largely intact. Most of the structure
dates from the 1200s, and, although the
Reformation saw the removal of many
decorative features, it remains as a grand
medieval building lying at the heart of
Scotland's largest city. SC1023497 1998

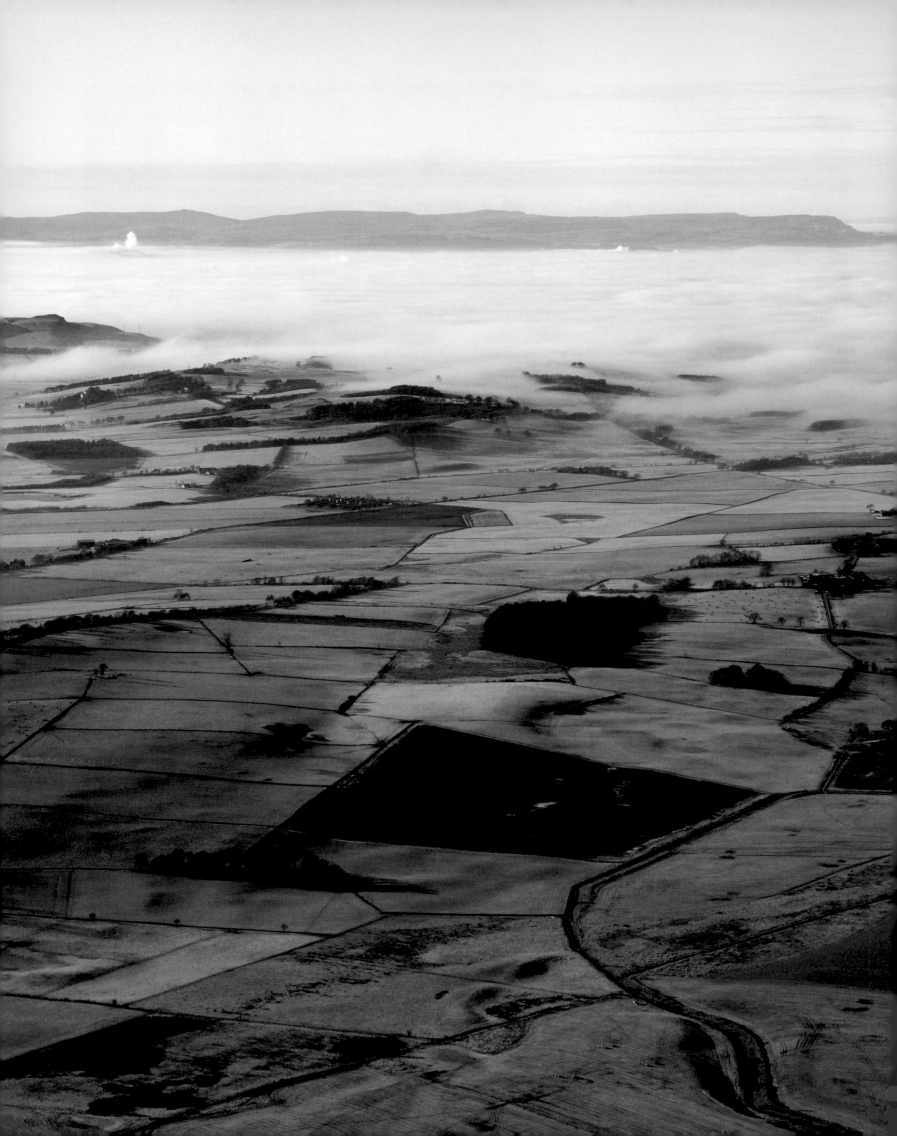

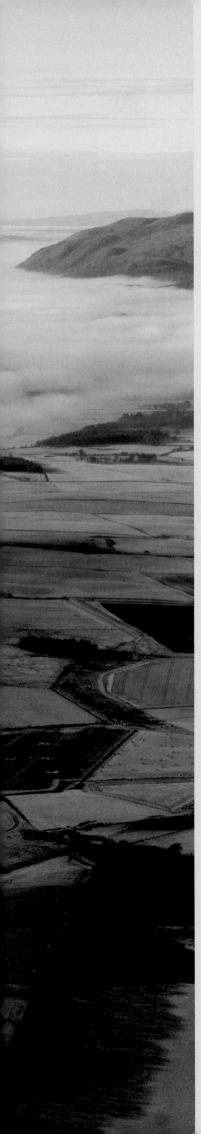

Taming the Earth

As the glaciers of the last ice age released their grip on Britain, a vast forest grew across much of the country. The dense carpet of pine, birch, rowan, aspen and juniper that covered the Scottish Highlands became the great Caledonian Forest. Over 6,000 years ago, the inhabitants of Scotland began to carve small clearings out of this wild and imposing landscape, turning the soil to cultivate crops. As some of the nation's first farmers, they could have had little idea of how their labours in the shadows of the ancient pinewoods would alter the country forever.

For the coming millennia, the majority of Scotland's people lived out their lives to the rhythms of a farming calendar. Hundreds of generations followed in those original footsteps, clearing the forests that blanketed the country, working the land and nurturing crops to feed their families and communities. Yet although buildings and methods evolved gradually over time, it is only in the last 300 years that this basic farming life has changed much at all. A typical rural scene, with its patterns of small-holdings spread across the countryside, farmhouses

1 Firth of Tay
2 Stanhope
3 Black Isle
4 Glencoe
5 Dunsyre Hill
6 Fethaland
7 Easter Bleaton
8 Scarp
9 Sangobeg
10 Northton
11 Dun Ban
12 Cunndal
13 St Kilda
14 Loch Lomond
15 Loch Tulla
16 Whitelee

marked by slow drifts of smoke from the hearth, rows of wind-blown crops and small groups of cattle tended by lone herdsmen, would have looked as familiar to a prehistoric farmer as it would thousands of years later to his seventeenth century descendant.

Farming, above all other human activities, tamed and shaped the wilds of Scotland. It has left layer after layer of remains, giving remarkable insights into the lives of our ancestors. The broken-down walls of long-abandoned buildings show where they lived, grassed-over banks let us trace the outlines of their fields, and the faint impressions of disused roads and tracks allow us to follow in their footsteps.

Now only fragments of the once great Caledonian Forest remain. When looking down on the colourful and familiar patchwork of large fields dominating much of today's lowland countryside, we see how completely Scotland's early wilderness has been changed. At the other extreme, across highland valleys and moors, abandoned farms and fields have merged back into the texture of the land, reverting to type – once again fierce, rugged and unruly. These haunting and beautiful landscapes should not fool us into forgetting one remarkable fact. Almost no part of Scotland has been left untouched and unaltered by its people.

PREVIOUS PAGES
The fog rolls in across the Firth of Tay at the end of a clear winter's day. Resting beneath are the ordered fields of a landscape created and modified by the people of Scotland over many thousands of years. DP008007 2004

OPPOSITE
Glowing in the evening sun, the jumbled, chaotic remains of a succession of prehistoric and medieval communities are sliced through by the solid lines and strict order of a row of improved fields at Stanhope in the upper Tweed valley. SC993215 2001

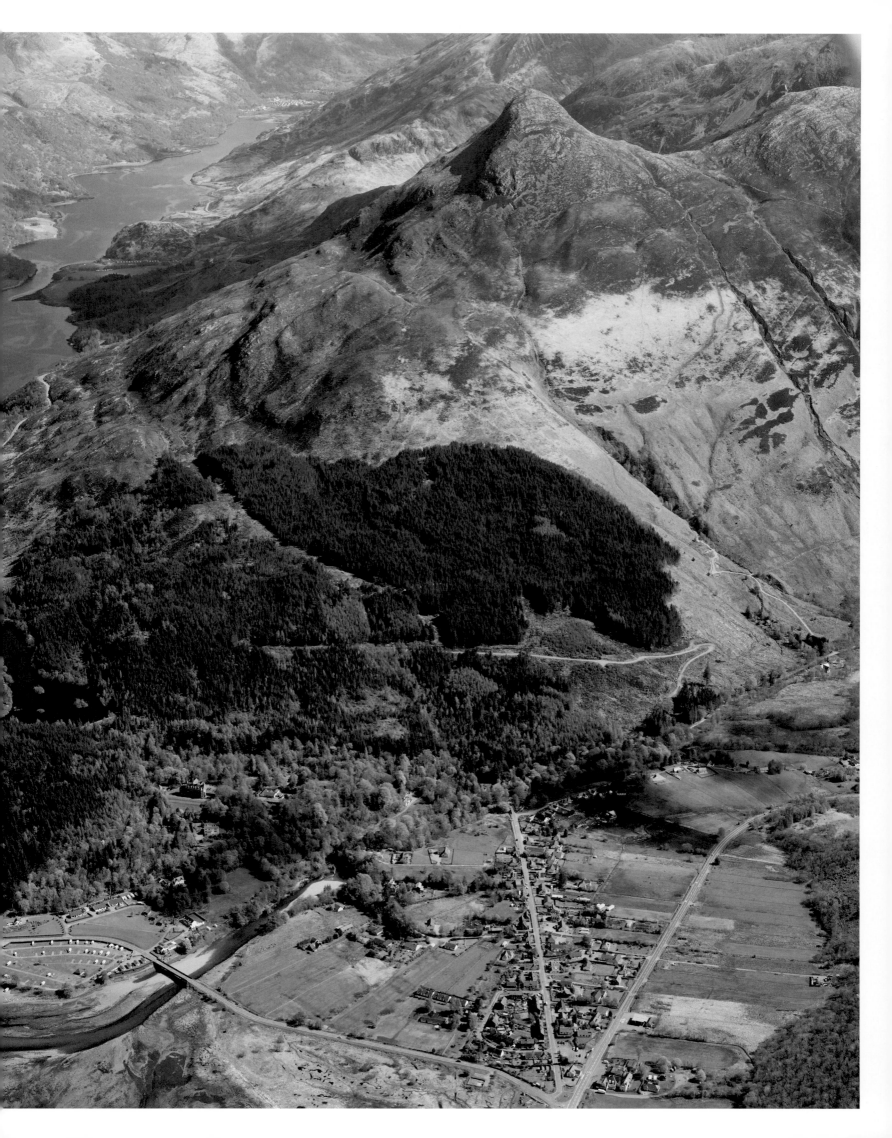

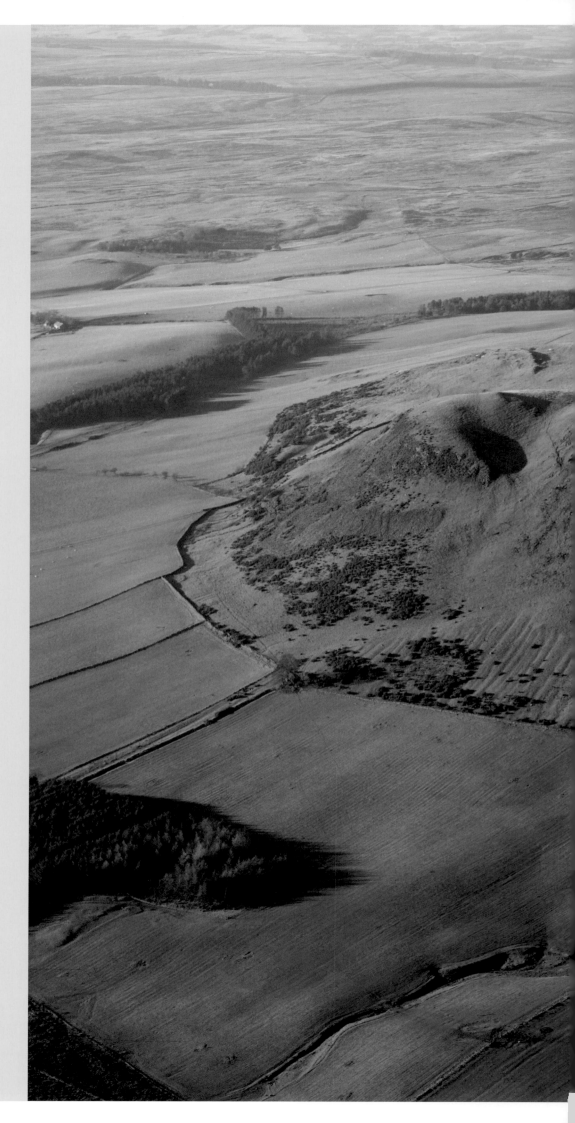

64 A defiant boss of rocky, unimproved ground surrounded by modern fields, the lower slopes of Dunsyre Hill near Carnwath preserve a distinctive striped pattern of medieval run-rig farming. DP012158 2005

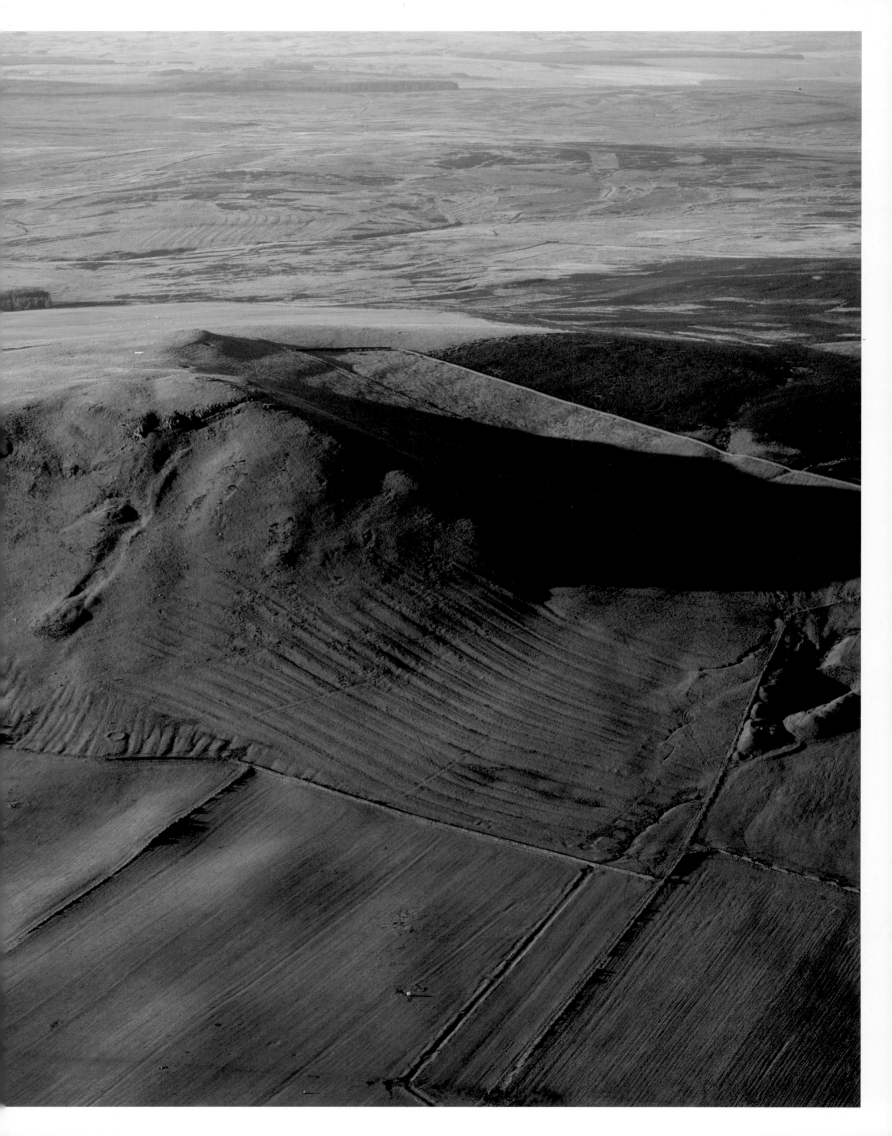

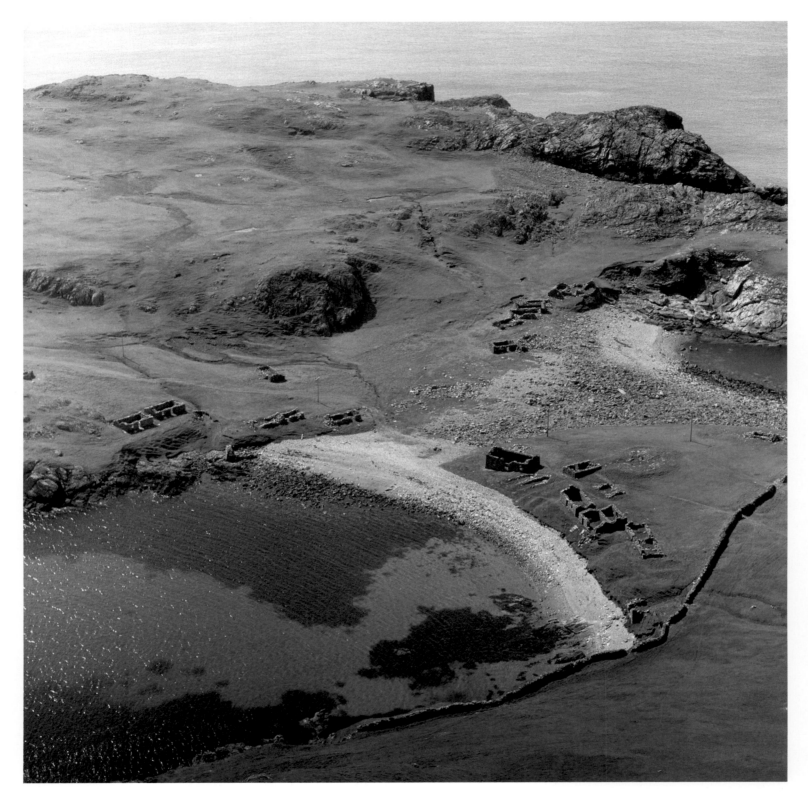

ABOVE
The abandoned shells of these nineteenth century buildings at Fethaland, North Roe, on Shetland, gaze unblinkingly out over a tranquil azure bay. Once a fishing settlement, economic and social forces conspired against this community's survival. SC860587 2003

OPPOSITE
Squeezed between modern ploughed fields and a mountainside, the buildings of this township at Easter Bleaton, near Blairgowrie, have been reduced to stony footings after they were abandoned about 200 years ago. SC376664 1987

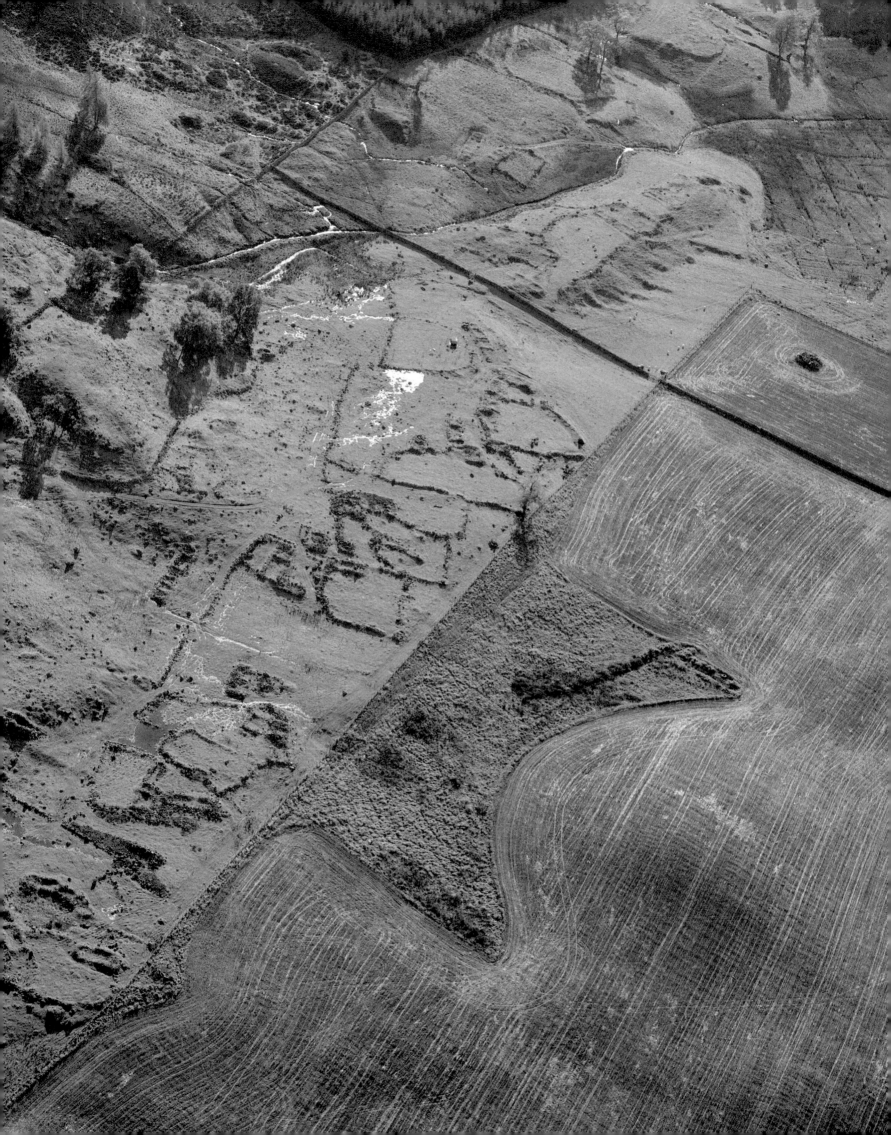

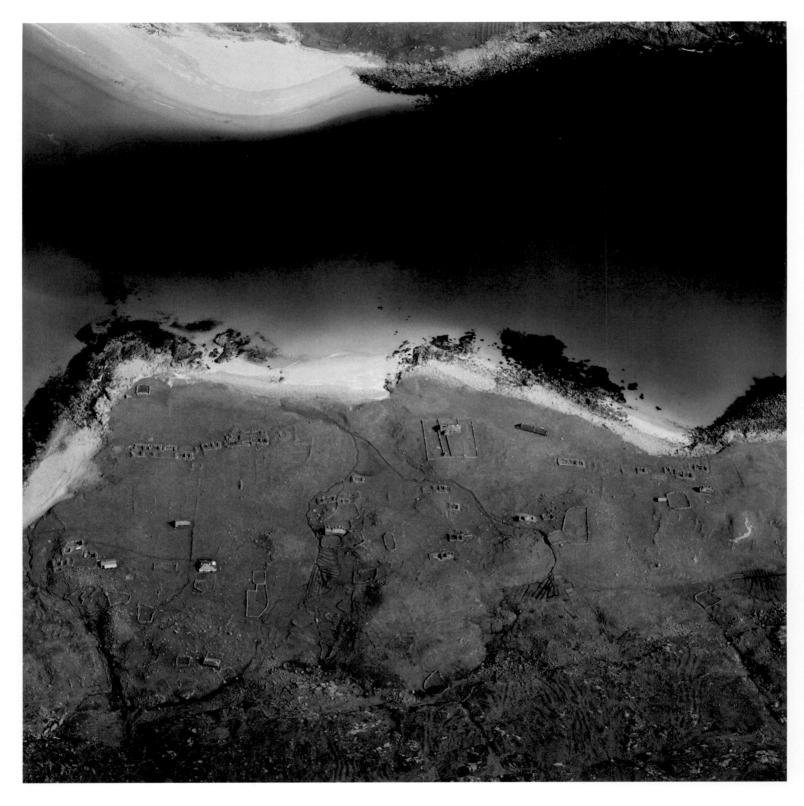

ABOVE
Two golden beaches face each other
across a thin stretch of aquamarine sea
in the Western Isles. A favoured location
for settlement for thousands of years, the
coastal fringe of Scarp off the west coast of
Harris was finally abandoned in the middle
of the twentieth century. SC1007626 2005

OPPOSITE
Across parts of highland Scotland a barren
interior has concentrated settlement onto
the coast. Here at Sangobeg, near Durness,
thin crofting strips overlie the remains of
earlier farms. SC1138548 2004

FOLLOWING PAGES
The narrow spine of a crofting community
clings to the hard, ancient landscape of
Northton at the southern end of Harris in
the Western Isles. DP011860 2005

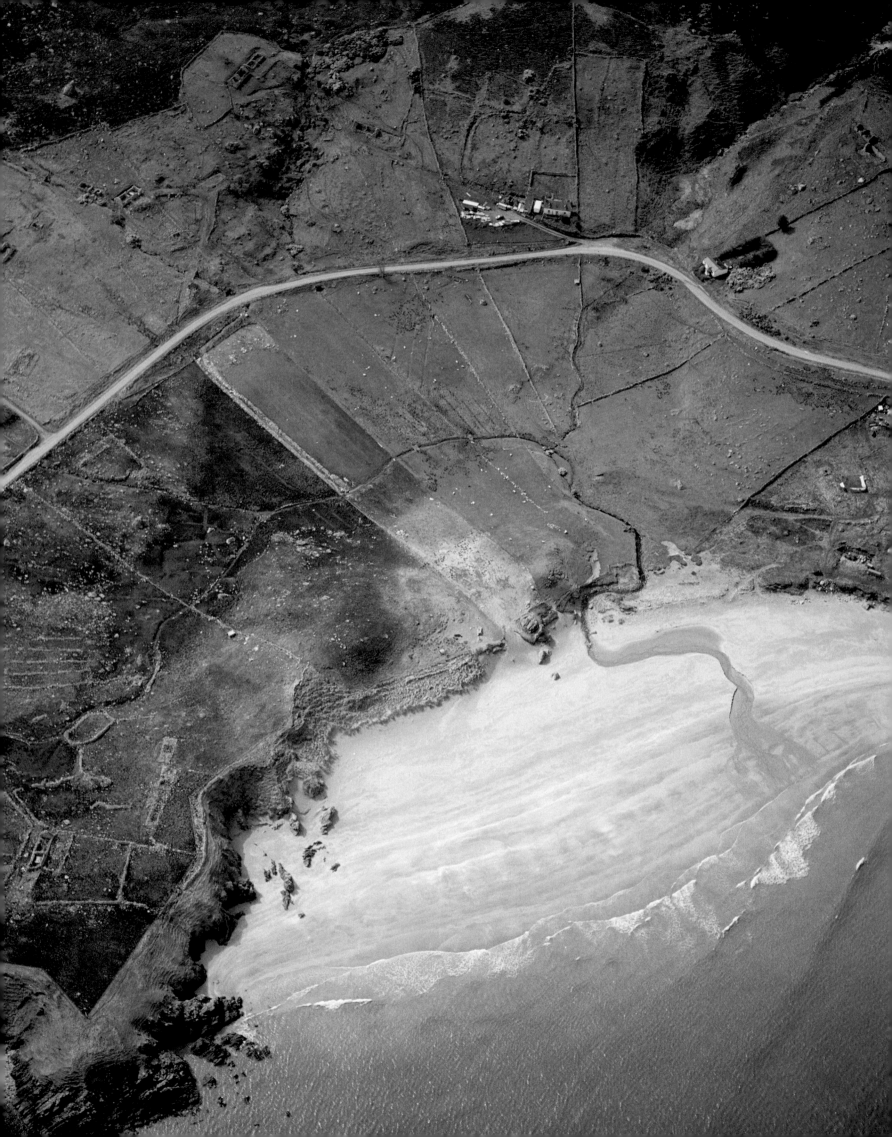

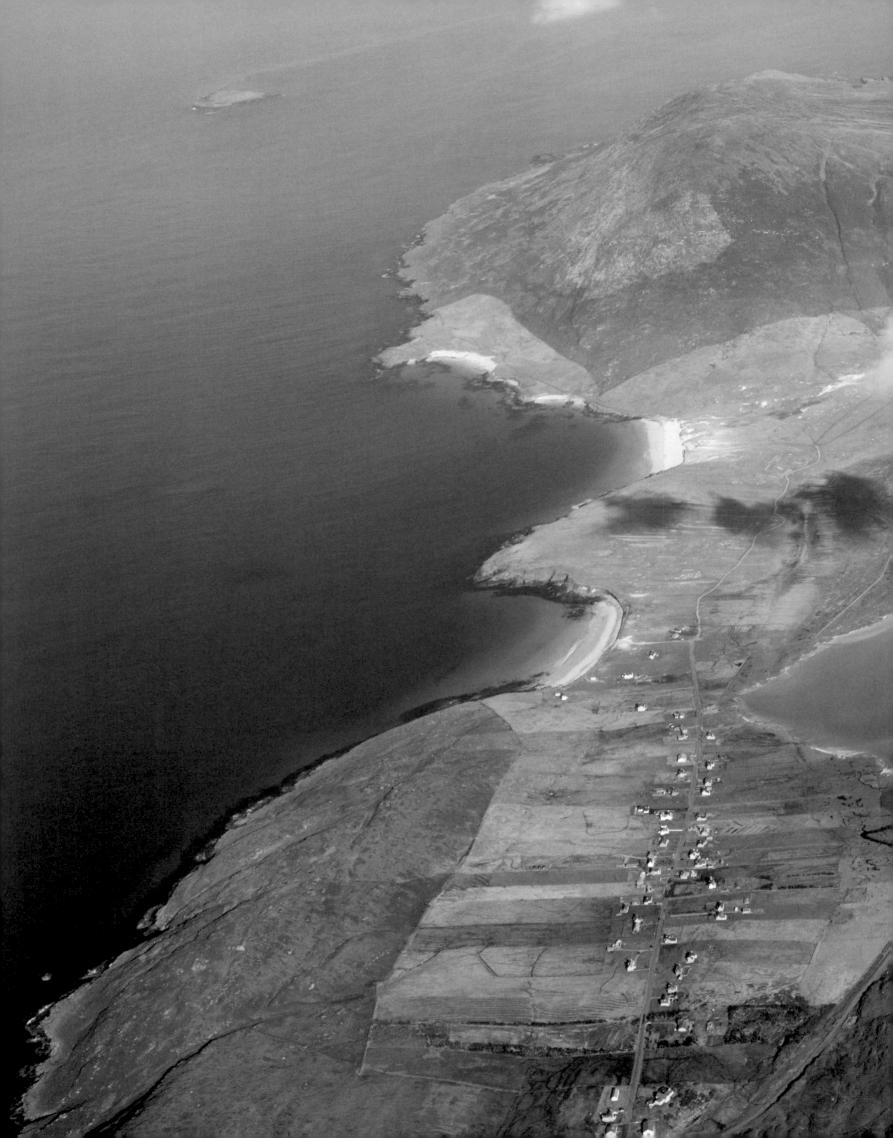

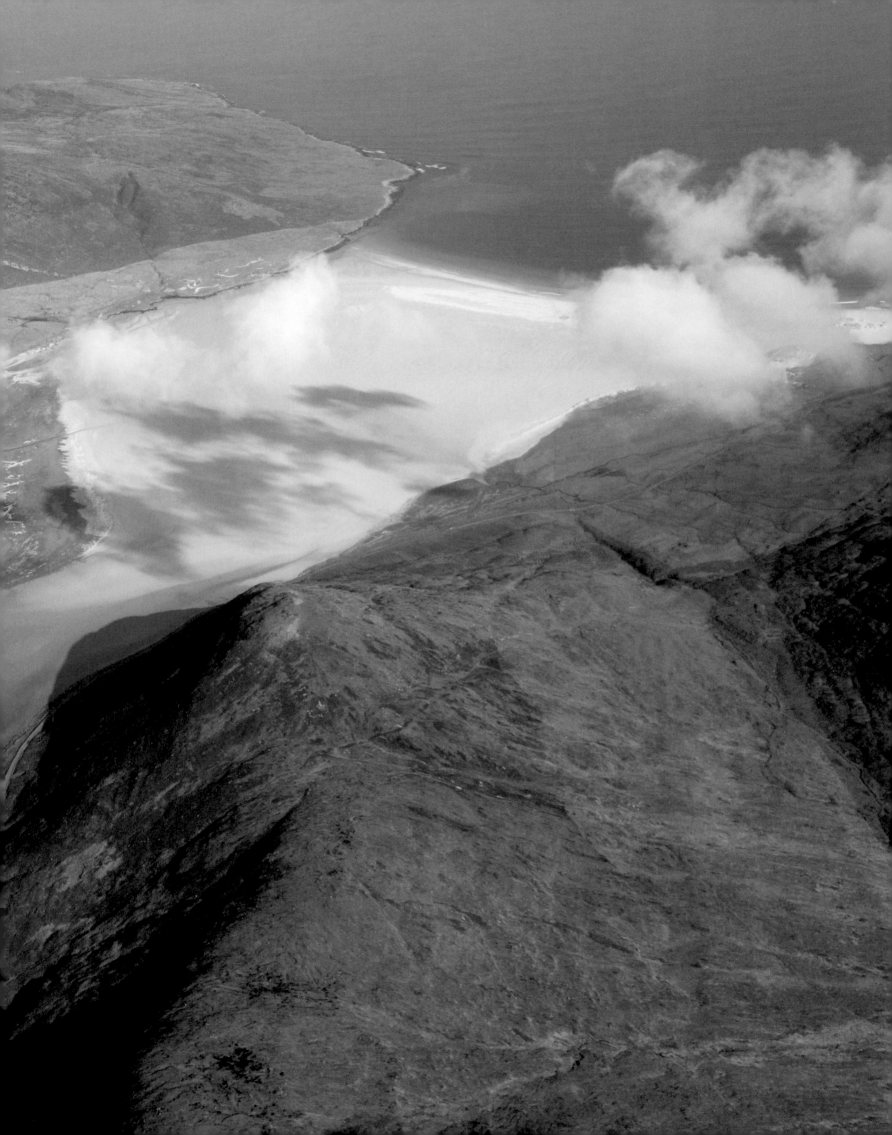

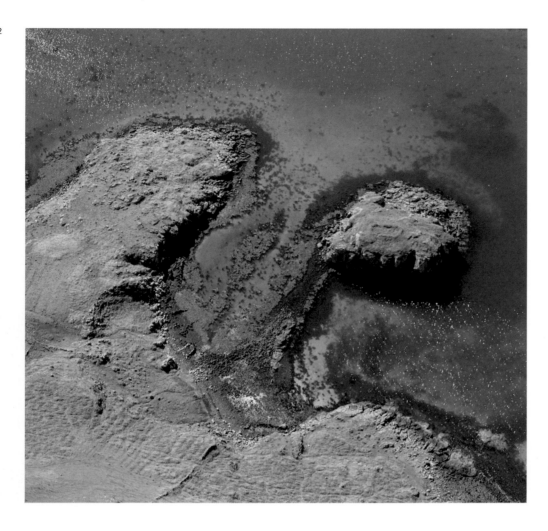

ABOVE
Living life between land and sea, this rocky tidal islet at Dun Ban, Ulva, off the Isle of Mull, supports the faint outlines of a once substantial building. DP027308 2007

RIGHT
On a dramatic coastline gouged and battered by Atlantic storms, the heavily eroded land leading to the cliffs of Cunndal on the Isle of Lewis has been heavily worked over many hundreds of years. A wriggling mass of spade-dug ridges – or 'lazy beds' – cover almost every bit of ground, surrounding the remains of a cluster of buildings on a jagged promontory. SC924863 2004

FOLLOWING PAGES
Over 60km to the west of the Outer Hebrides, the isolated islands of St Kilda break the ocean surface in the often ferocious Atlantic. Visited and perhaps colonised thousands of years ago, generations struggled to scrape a living from the unforgiving land, farming around the main settlement of Village Bay, and scaling the sheer cliffs to hunt sea birds. Gradually losing its population and self-sufficiency, the end of permanent occupation came on 29 August 1930, as the last families – 36 people in total – forever left behind their island home. SC722682 1995

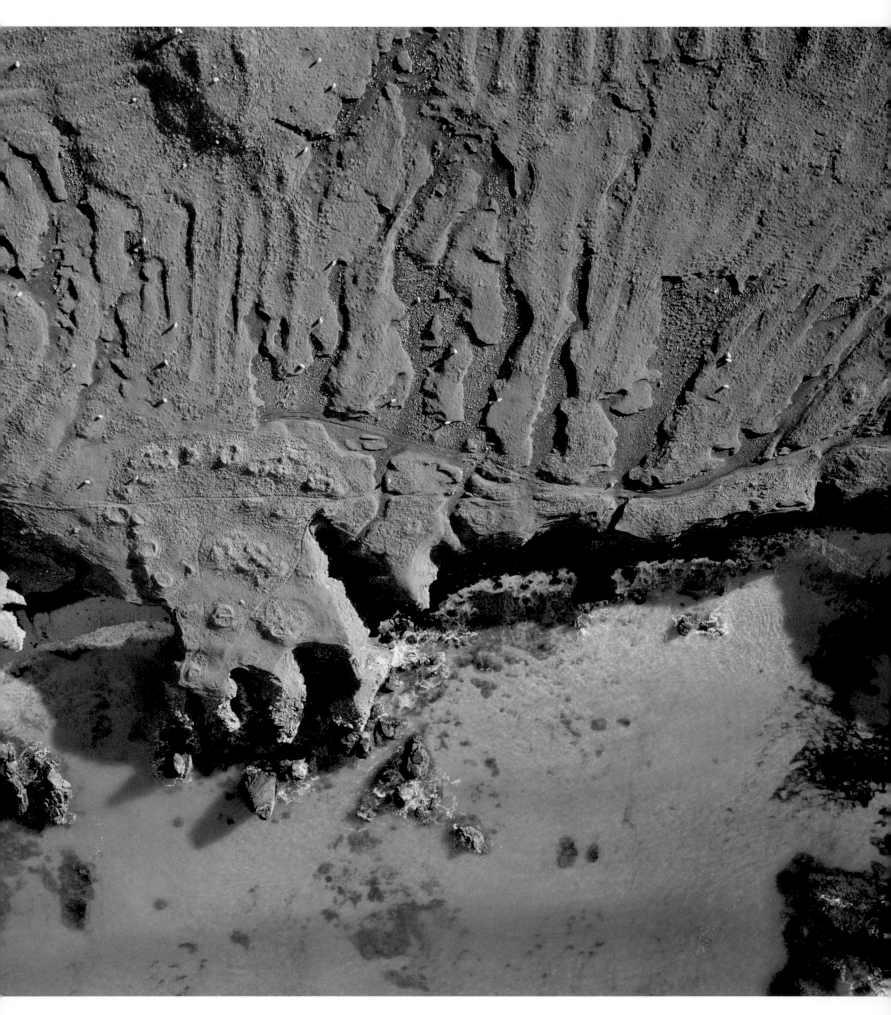

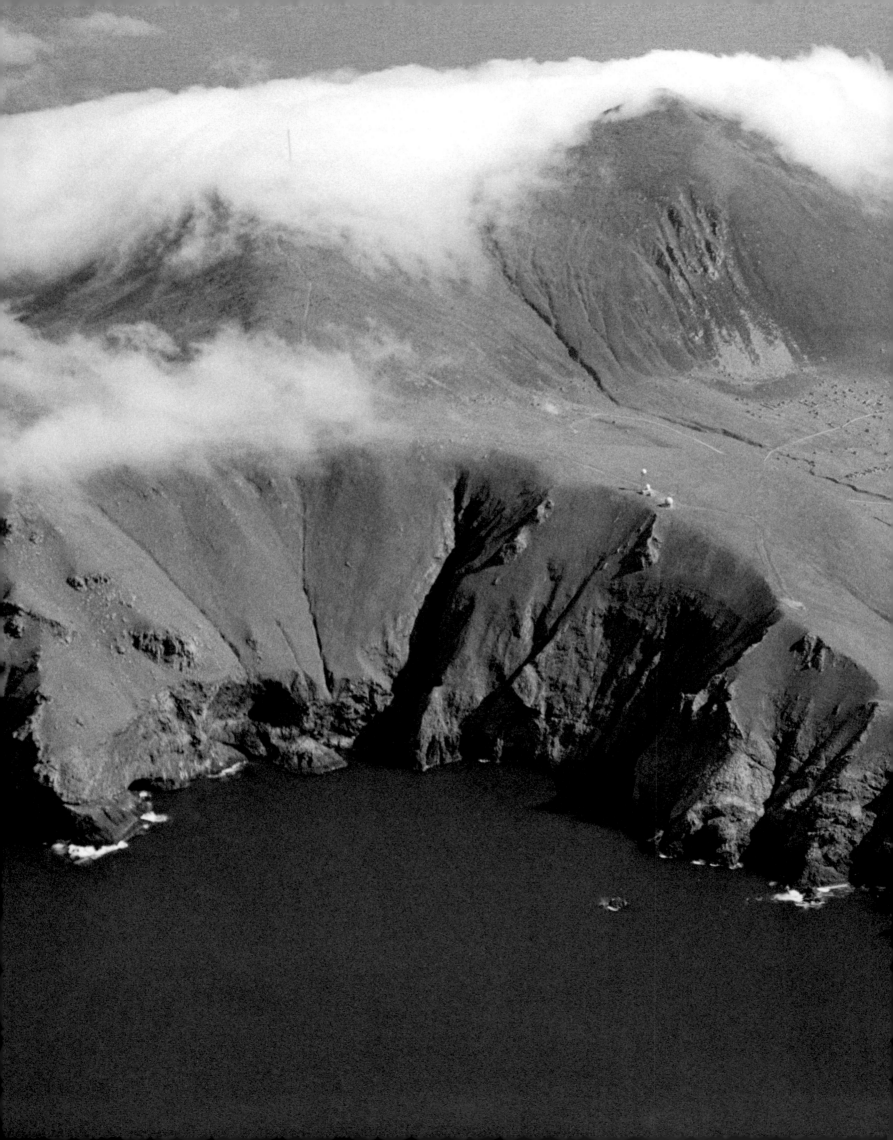

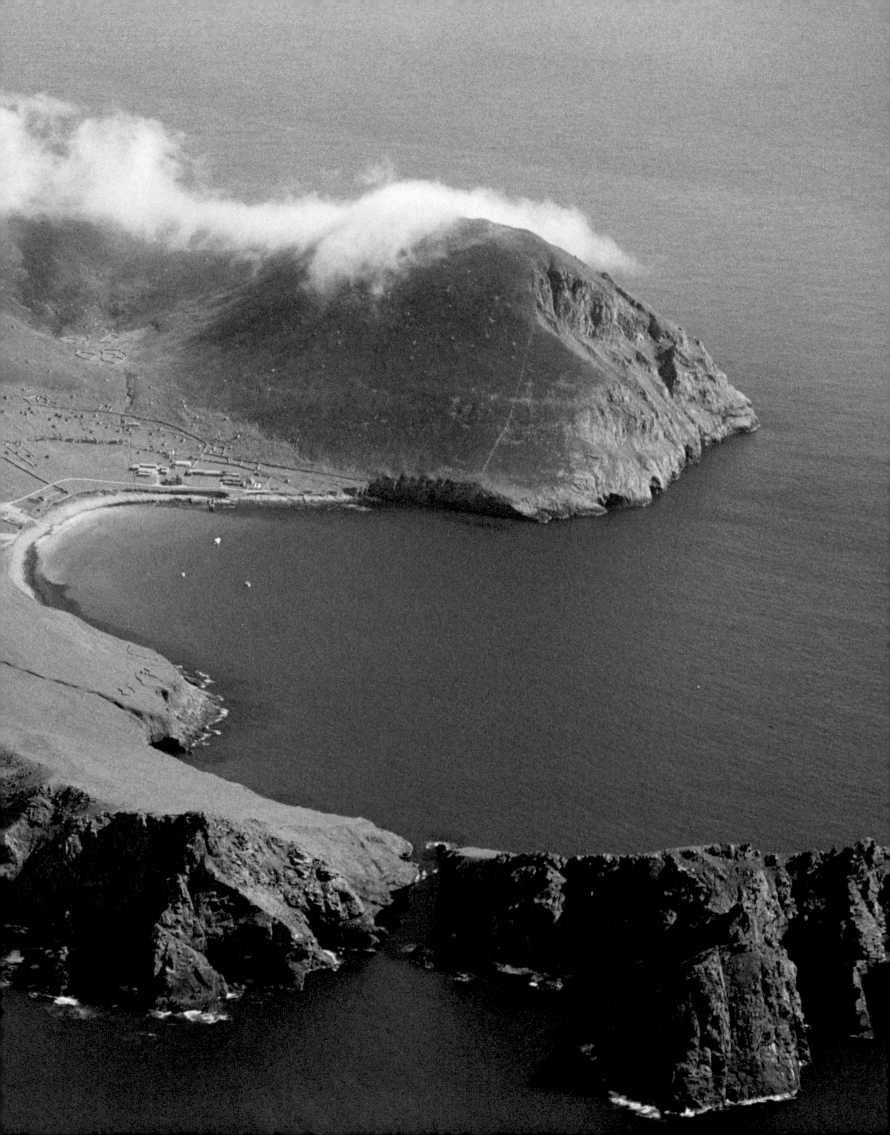

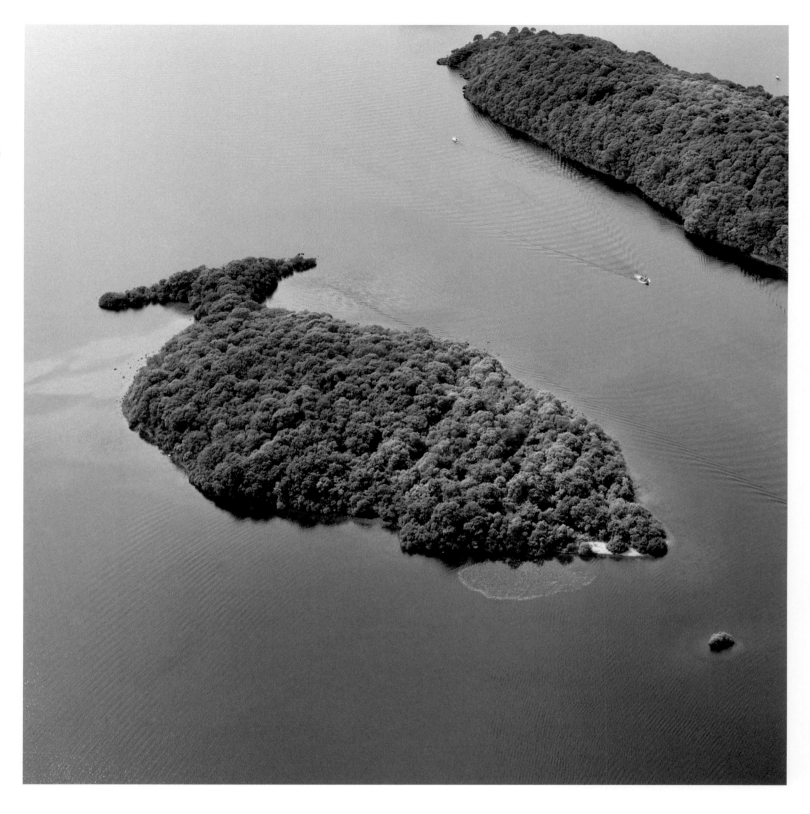

Looking like a giant fish, the curious shape of the tree-covered island of Clairinsh on Loch Lomond is an accident of nature. Surprisingly though, the tiny islet found off its northern tip is man-made, created about 2,000 years ago to support a settlement known as a crannog. Surrounded by breaking waves, the inhabitants of crannogs adapted themselves to a life on the water. Scattered along sea shores and in freshwater lochs, the remains of these unusual homes are visible today as rocky islets shrouded by scrubby trees, like that on Loch Tulla, lying between Bridge of Orchy and Glencoe.

ABOVE LOCH LOMOND SC506612 1999
OPPOSITE LOCH TULLA DP026724 2007

FOLLOWING PAGES
With a target set by the Scottish Government to generate fifty percent of the nation's electricity from renewable energy sources by 2020, wind farms have become a familiar sight on the skyline. At Whitelee in Renfrewshire – Europe's largest onshore wind farm – giant turbines stand 110m above the trees of an extensive commercial coniferous plantation. DP043918 2008

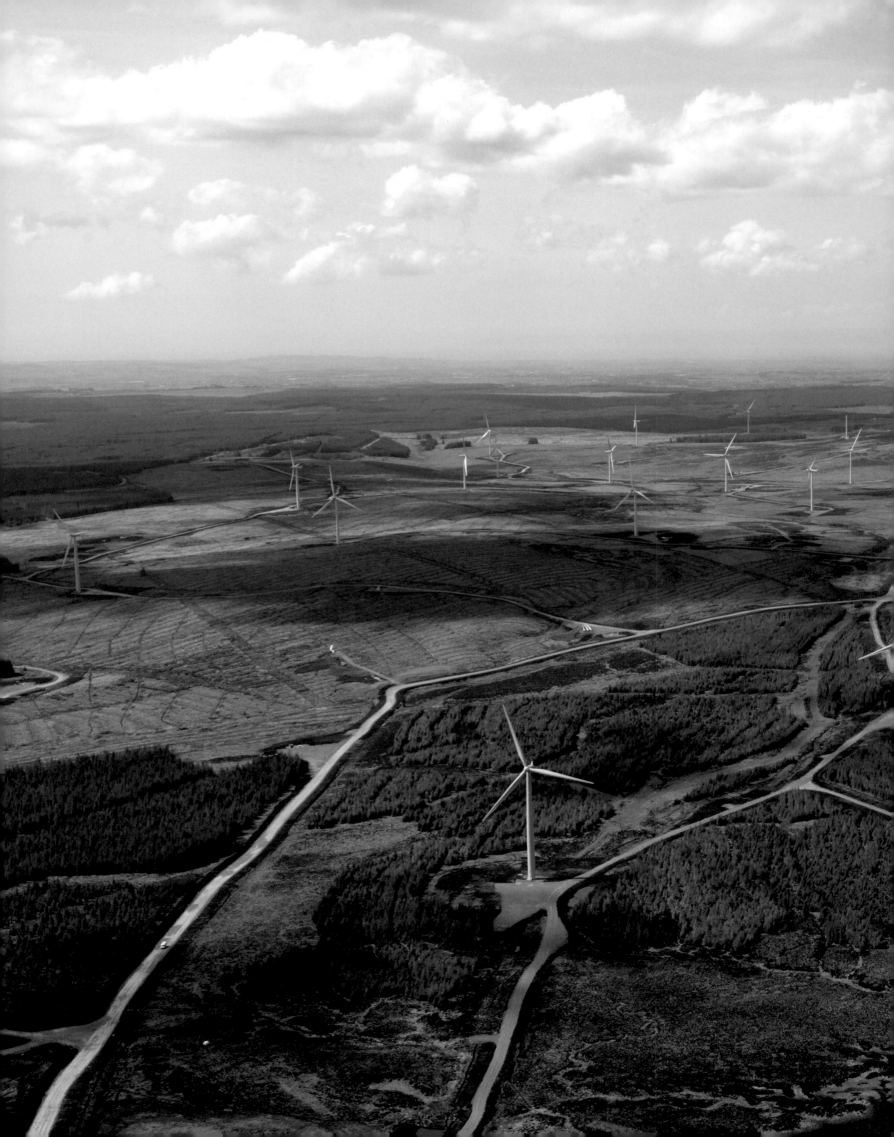

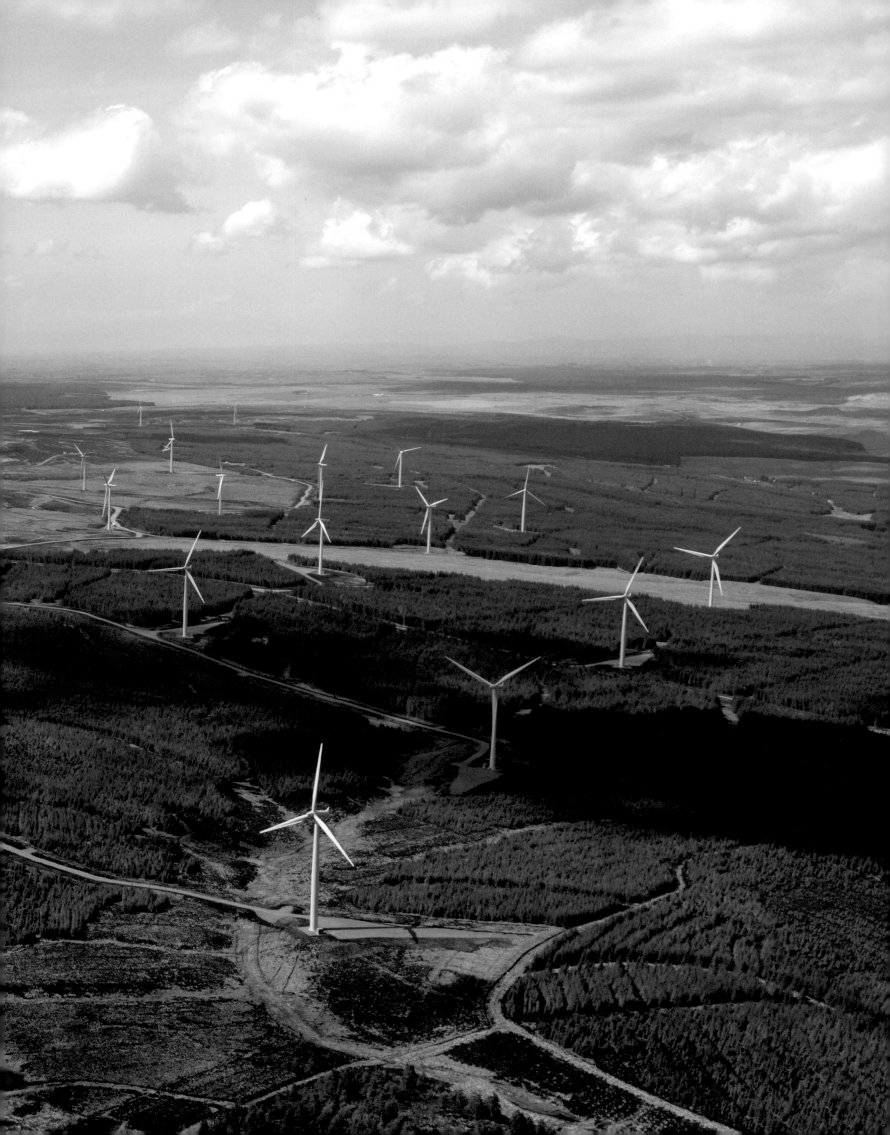

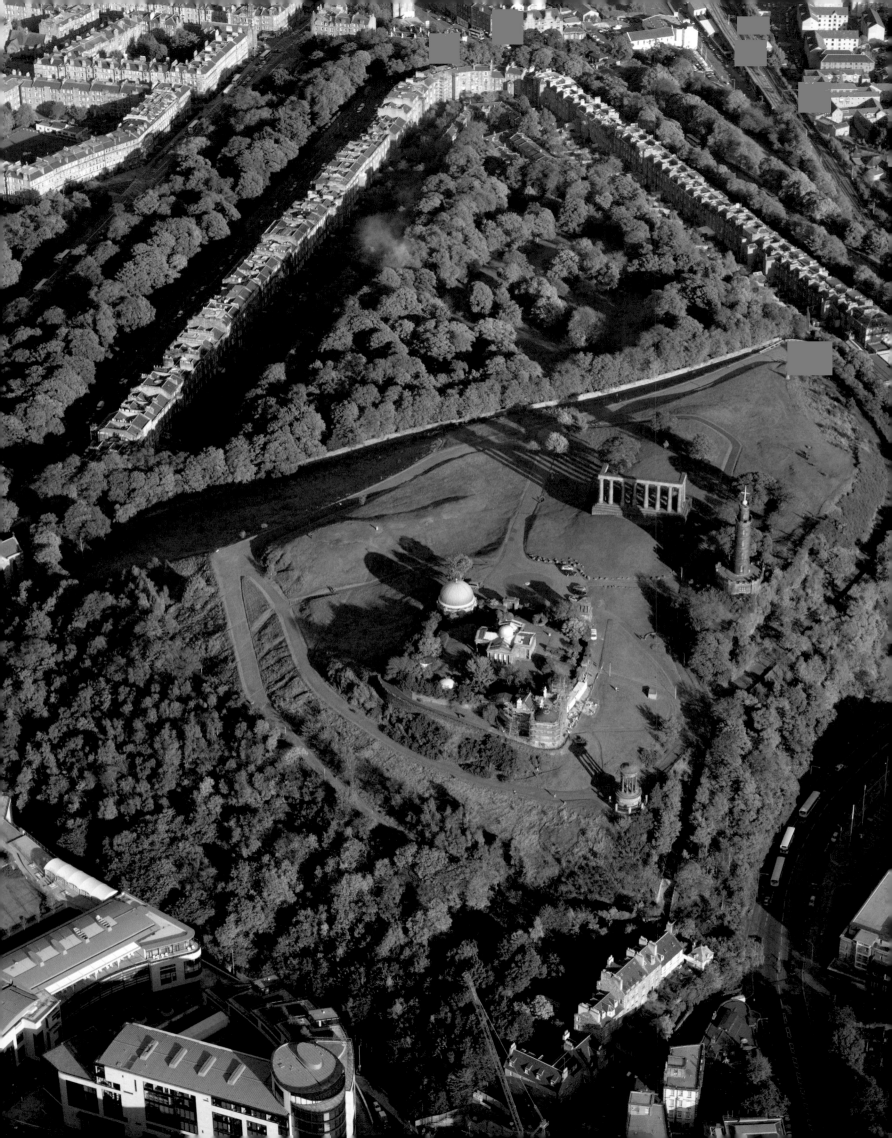

Enlightenment

On 22 May 1754, in the drafty chamber of the Advocates Library in Edinburgh's Parliament House, a remarkable group of people came together. The fifteen founders of the 'Select Society' included some of the greatest thinkers in the western world. Among them were Adam Smith, father of present-day capitalism, David Hume, one of the most influential philosophers of the last 250 years, and Lord Kames, who created the basis for the study of modern history. They gathered to discuss, exchange ideas and venture opinions and arguments on everything from philosophy and literature to economics and agriculture. And they were not alone. Eighteenth century Edinburgh echoed with intense debate as intellectuals, aristocrats, merchants, clerics and professionals mixed together across the city. A cultural revolution, soon dubbed the 'Scottish Enlightenment', had begun.

Over the coming century, driven by the ideas and personalities of what English novelist Tobias Smollett called Edinburgh's 'hot-bed of genius', Scotland was transformed from a poor rural country into a modern capitalist economy. Underpinned by the

1 Edinburgh
2 Binning Wood
3 Drummond Castle
4 Culzean Castle
5 Gosford House
6 Paxton House
7 Hume Castle
8 Marchmont House
9 Melrose
10 Dunbeath Castle
11 Balcarres House
12 Inveraray
13 Eaglesham
14 Ullapool

belief that reason and ingenuity could solve any problem, this philosophy of the Enlightenment was applied to every aspect of life in Scotland, from the development of the social sciences and practical geology, to the questioning of orthodox religious beliefs and the promotion of literacy for all.

These dramatic intellectual developments ultimately had a profound effect on the appearance of the Scottish landscape. A desire for order and productivity saw the countryside recast as the physical embodiment of the 'Improvement' ideal. Regular patterns of enclosed fields and woodland laid a vast geometric grid over the land. Lavish country houses were set amongst sculpted gardens and parkland. Sober, refined and classical, these houses reflected the character of the thinkers that had inspired their construction, their tall windows gazing out with satisfaction over a landscape governed by rules and formality. The change in the countryside was remarkable and, in many cases, complete, sweeping away wholesale the traditional layouts of fields, farms and villages that had developed organically over millennia.

Improvement surged through towns and cities as many medieval street plans were altered, adapted and developed. In Edinburgh, at the epicentre of the Enlightenment, architects like James Craig, Robert Adam and William Playfair looked to the splendour of Ancient Greece and Imperial Rome as they created the formal layout of the New Town and iconic architectural tributes to order and intellect like Register House and the National Gallery.

Throughout the nation, powerful ideas took on physical form. Strong lines and strict regularity characterised the design ethos of the Enlightenment. Viewed from above, the impact of a cultural revolution that began 250 years ago remains stunningly clear. The blueprint for the modern age was drawn with firm, confident strokes, and from the air the Scotland of today unfolds as a landscape shaped by the minds of some of the eighteenth century's greatest thinkers.

PREVIOUS PAGES
Overlooking William Playfair's elegant terraces and topped by the twelve massive columns of the National Monument, Calton Hill cuts an iconic dash on the Edinburgh skyline. This landmark and its cluster of symbolic buildings are a permanent reminder of the city's intellectual and architectural aspirations as the 'Athens of the North'. DP051314 2008

OPPOSITE
The bold lines and geometric shapes of Binning Wood, near Tyninghame in East Lothian, were laid out in the early 1700s by Thomas, sixth Earl of Haddington. Although replanted several times in the last 200 years, the Wood still retains its original, striking framework. DP033427 2007

FOLLOWING PAGES
The grounds of Drummond Castle near Crieff showcase the best example of a formal terraced garden in Scotland. Begun in 1630, this spectacular piece of decorative landscaping was a forerunner of Enlightenment ideas and remains the focal point for the wide expanse of surrounding parkland. SC949575 1996

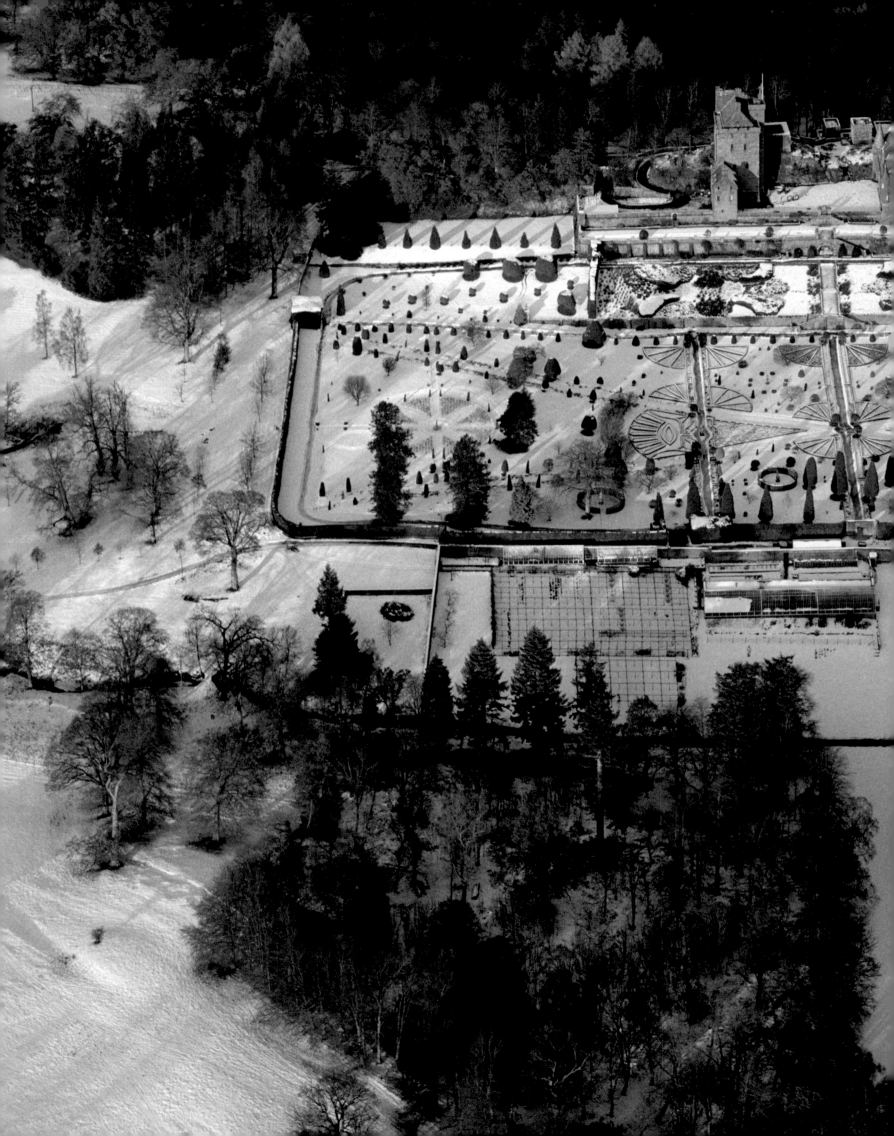

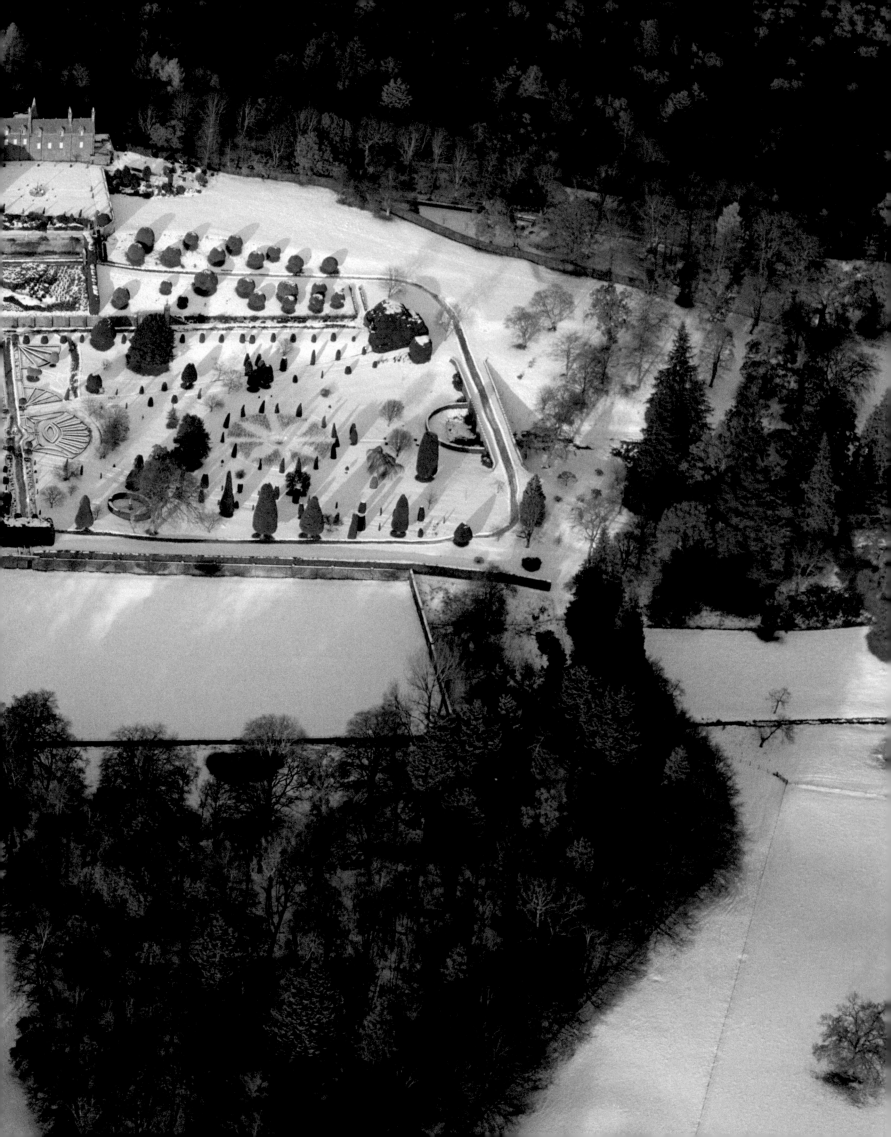

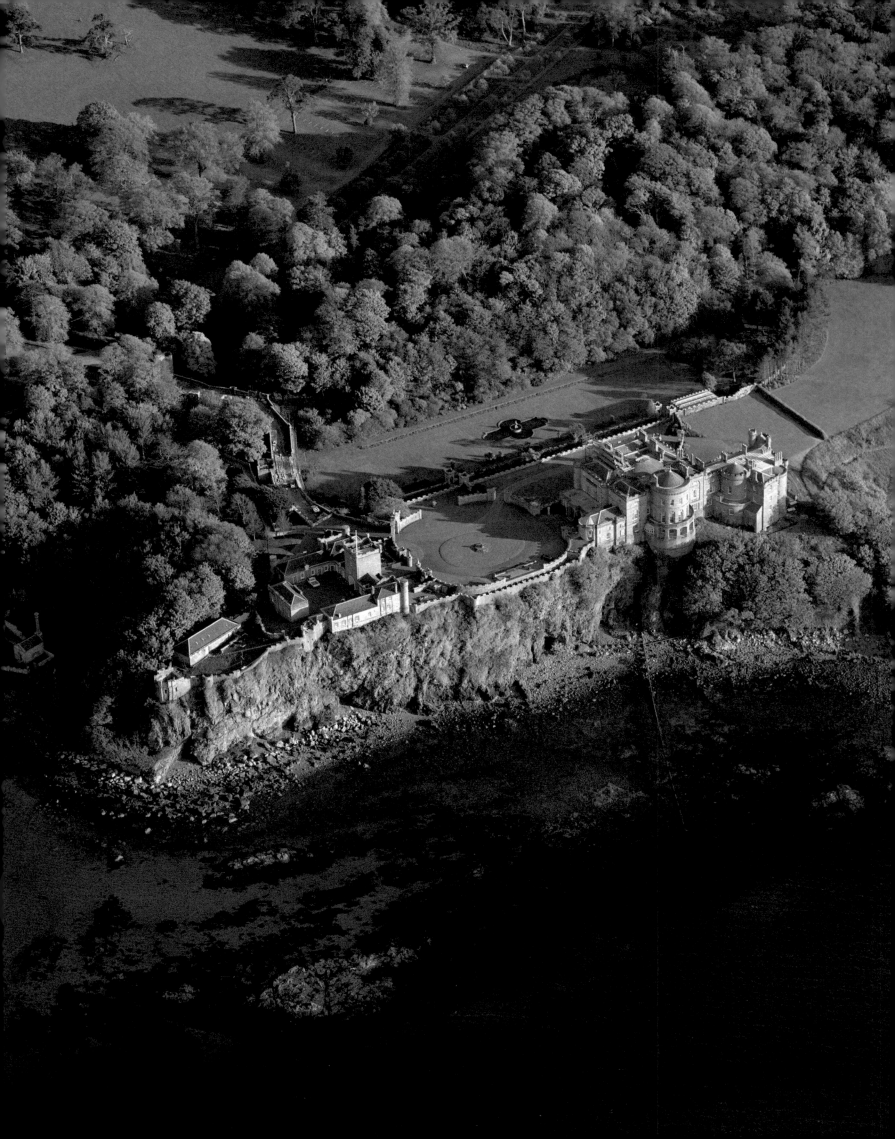

The symmetry, strong lines and imposing entrances of these elaborate mansions were the architectural hallmarks of a new age of refinement – essential features of any Enlightenment trophy house, advertising the wealth and tastes of their cultured owners. The architect Robert Adam, one of the leading figures of the eighteenth century's intellectual revolution, imprinted his philosophy on a variety of buildings, adding to the medieval tower house of Culzean Castle, near Ayr, and, in 1790, designing the wonderfully grand central block of Gosford House near Longniddry. Paxton House, by Berwick-upon-Tweed, was designed and built in 1758 by John Adam – brother of the more famous Robert. Drawing on Palladian ideals inspired by the Rennaissance, Adam created a suitably majestic country house.

OPPOSITE **CULZEAN CASTLE** SC763887 1994
TOP RIGHT **GOSFORD HOUSE** DP054842 2009
BOTTOM RIGHT **PAXTON HOUSE**
DP036124 2007

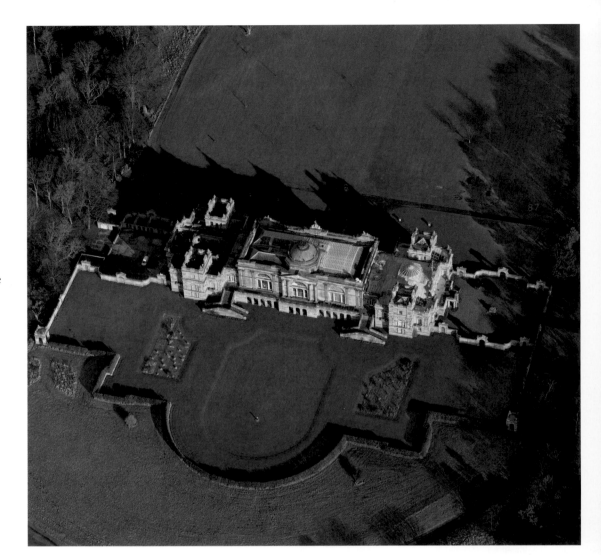

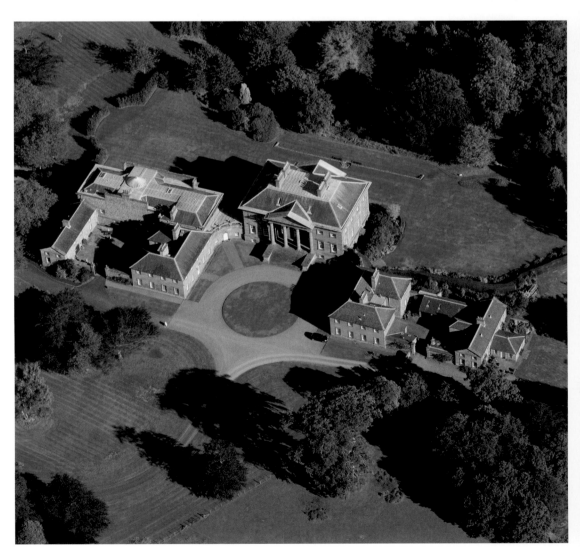

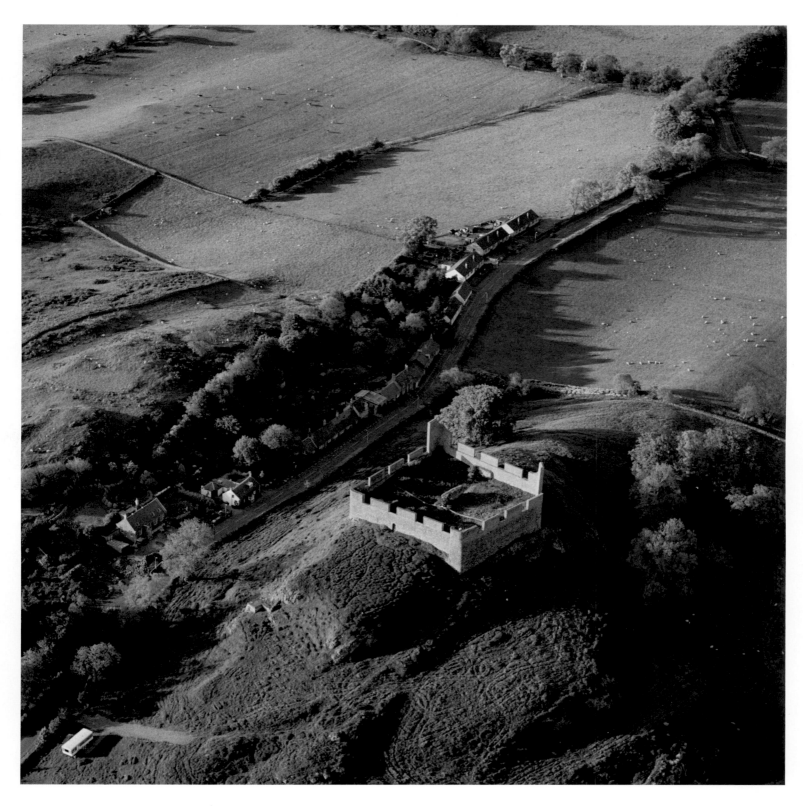

88

ABOVE

The medieval fortification of Hume Castle dominated the surrounding Berwickshire countryside. Ironically, most of what remains today is make-believe and was built in the eighteenth century as a folly – an Enlightenment eye catcher that referenced the past and was deliberately designed to enhance the skyline.
SC602884 1988

OPPOSITE

Like a landscape bowing before its master, the 2km long avenue leading to Marchmont House near Duns in Berwickshire focuses all attention on the facade of this magnificent eighteenth century mansion. Arriving at the house – passing parkland laid out with vistas, follies and drives – was designed to be an impressive and memorable experience. DP013327 2006

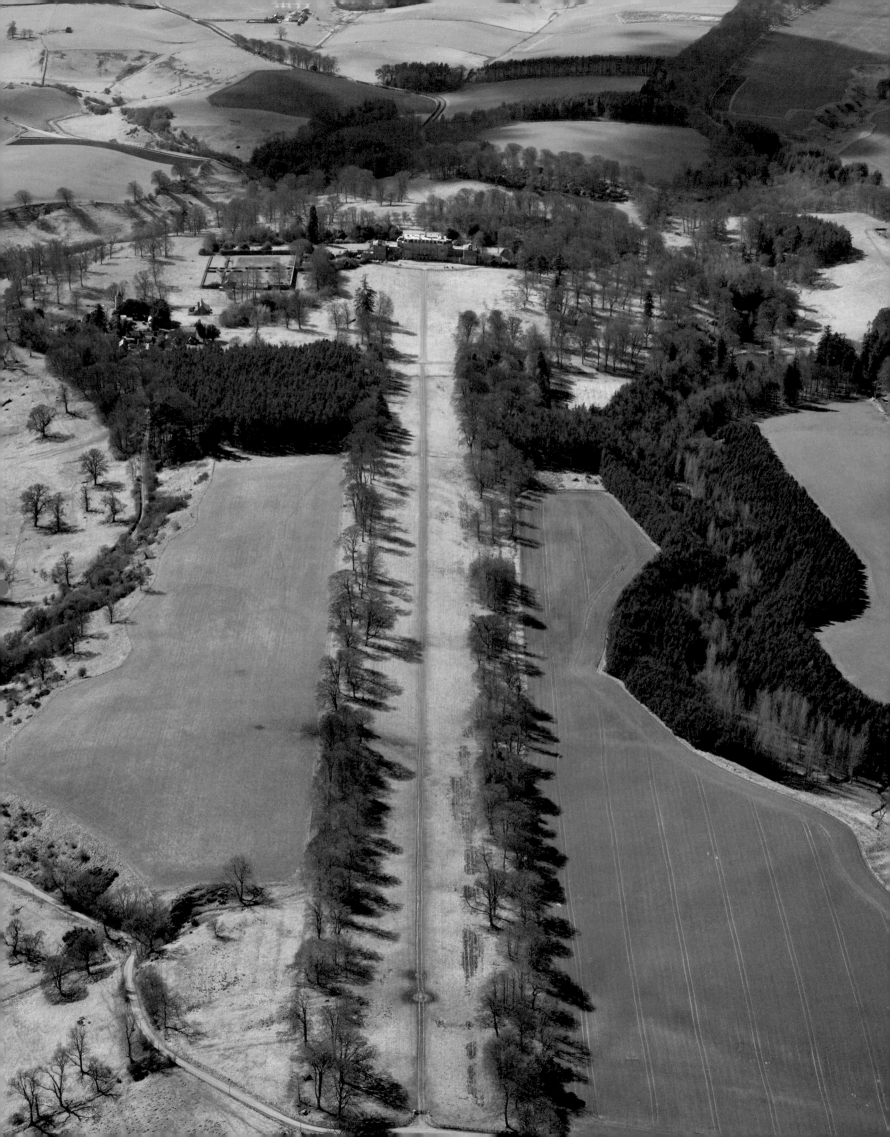

90 Beginning in the mid eighteenth century, the creation of a vast network of fields, roads and woodland has completely remodelled the landscape of the Tweed valley at Melrose. DP011382 2006

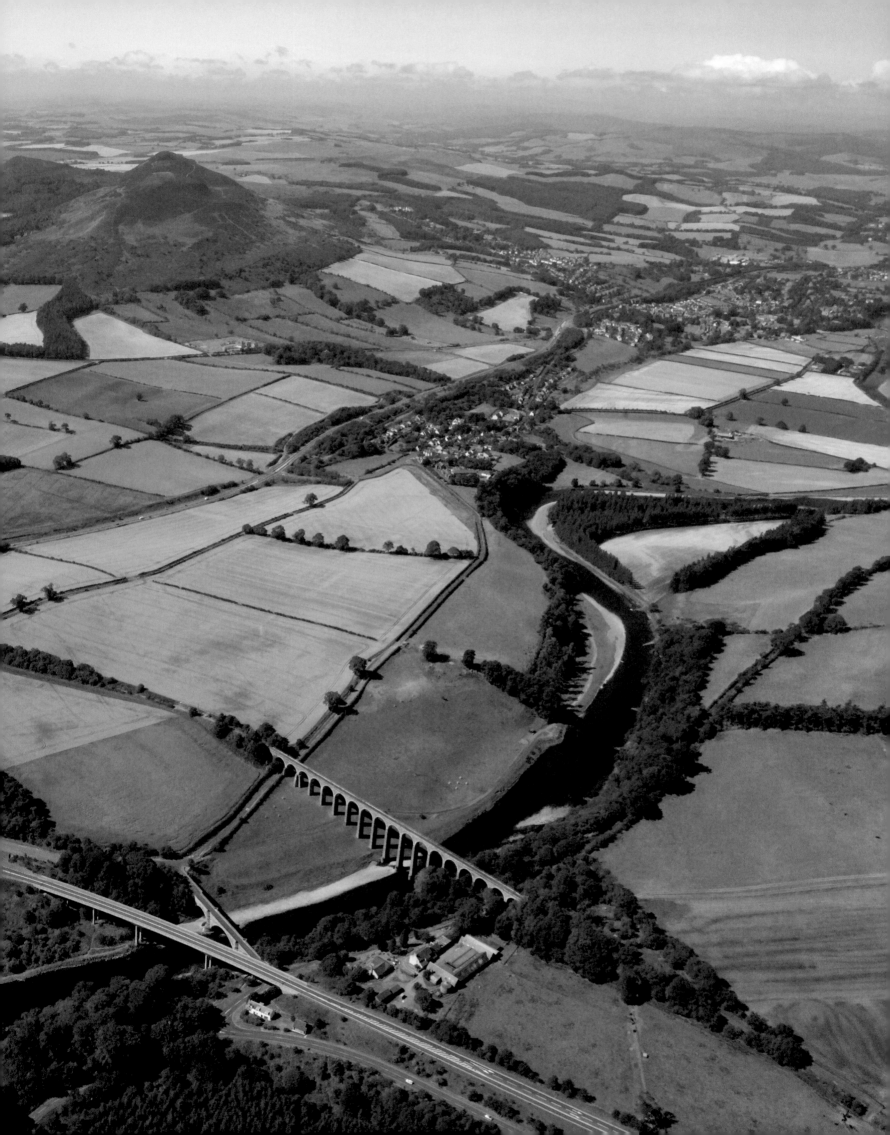

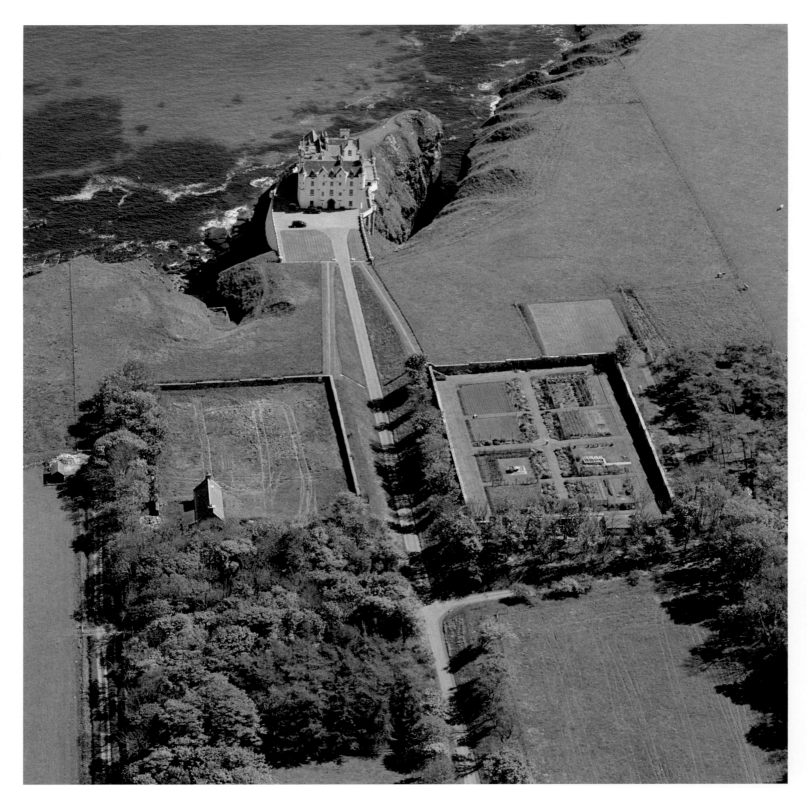

Perched on the rocky Caithness coast south west of Wick, Dunbeath Castle's spectacular natural setting becomes the stage for a carefully contrived piece of landscaped theatre. Modelled by D. & J. Bryce in the mid nineteenth century, the long drive presents a glimpse – as through a keyhole – of the Castle about 1km distant. Its full, cliff-side splendour is revealed only gradually as the visitor approaches along the narrow, tree-lined avenue. ABOVE SC973873 1997 OPPOSITE SC973870 2004

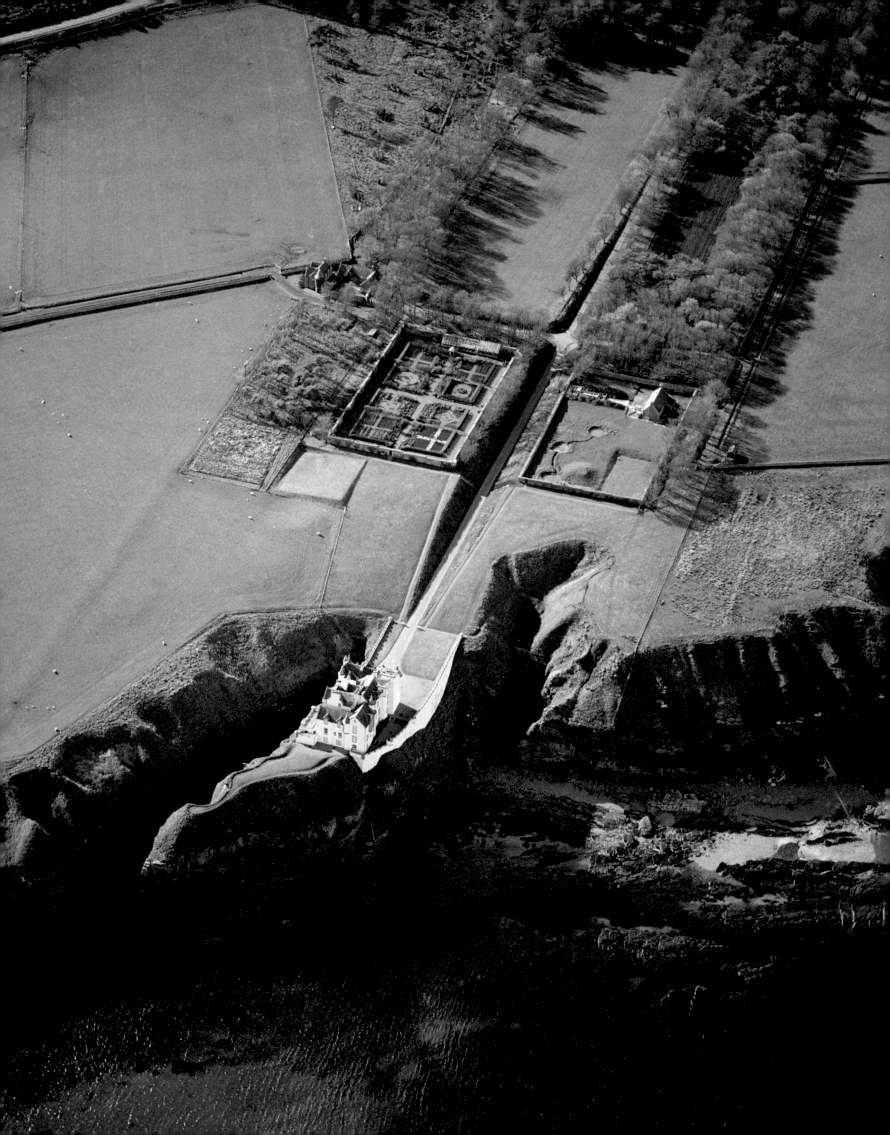

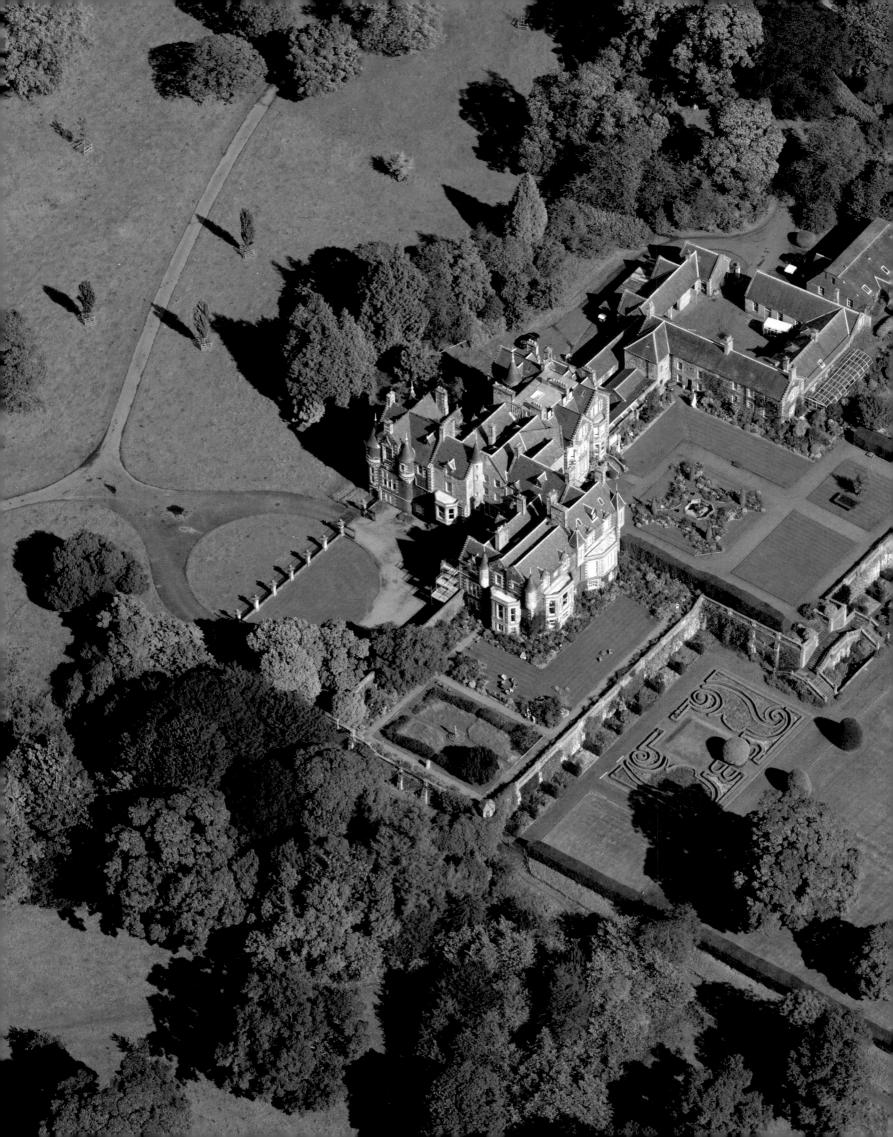

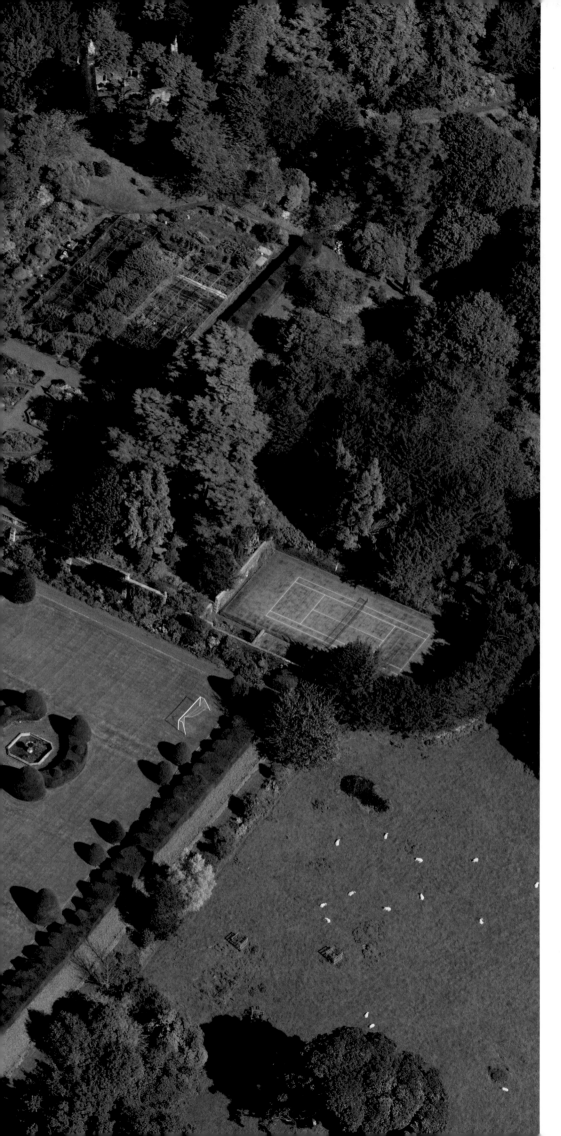

The terraced gardens at Balcarres House, 95
near Elie in Fife, are a lesson in ordered
and manicured perfection. Originally
built in 1595, the House has been altered
considerably over the years to reflect
changing architectural fashions, from
William Burn adding major extensions in
the Scots Jacobean style in 1838, to further
reworking by David Bryce towards the end
of the nineteenth century. DP050886 2008

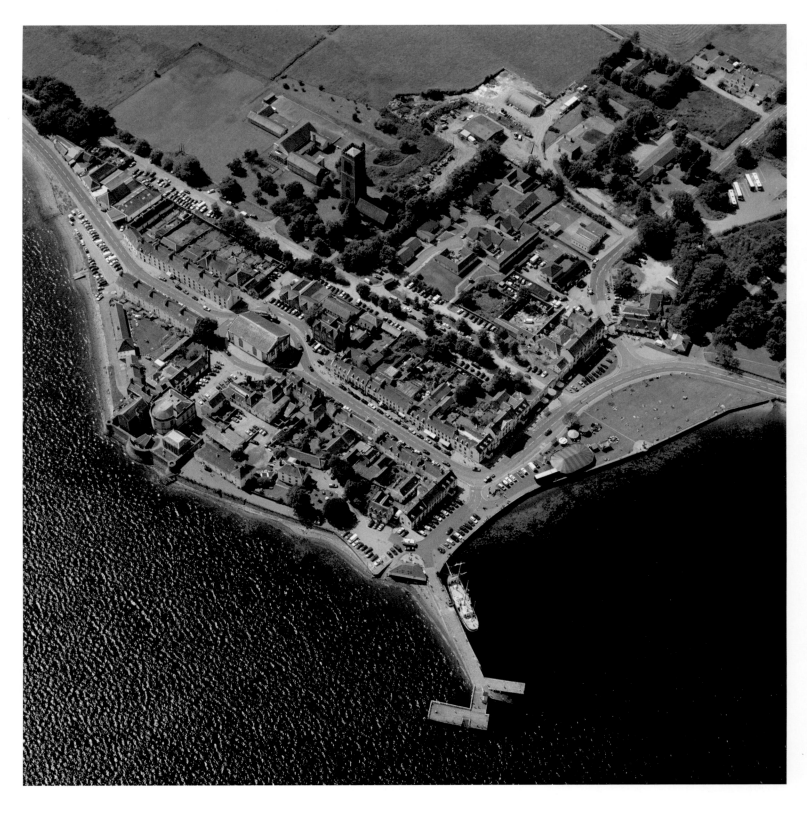

ABOVE
Striving for an ideal of carefully planned urban symmetry, the old town of Inveraray on the shore of Loch Fyne was redesigned in 1743 for Archibald, 3rd Duke of Argyll. SC972843 1999

OPPOSITE
Once an ancient settlement, Eaglesham in Renfrewshire was entirely recast in 1769

by Alexander Montgomerie, 10th Earl of Eglinton, as a model village, deliberately laid out as a letter A. DP040153 2008

FOLLOWING PAGES
Perhaps the most evocative and enduring symbol of the Scottish Enlightenment, the wide streets and graceful crescents of Edinburgh's New Town are a masterpiece of city planning. Built in stages between 1767

and the mid nineteenth century, its neo-classical architecture deliberately references the roots of European civilisation, creating a vast, ordered monument to a nation's cultural awakening. DP038471 2008

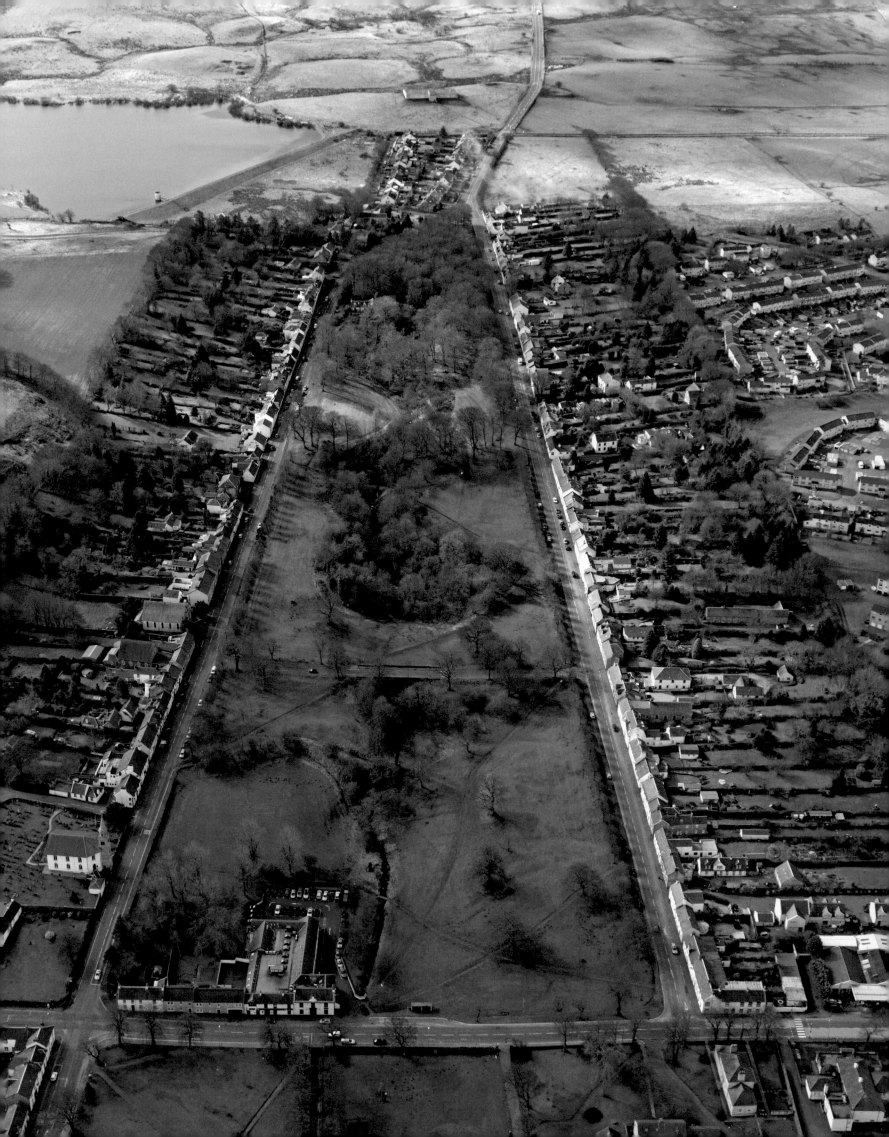

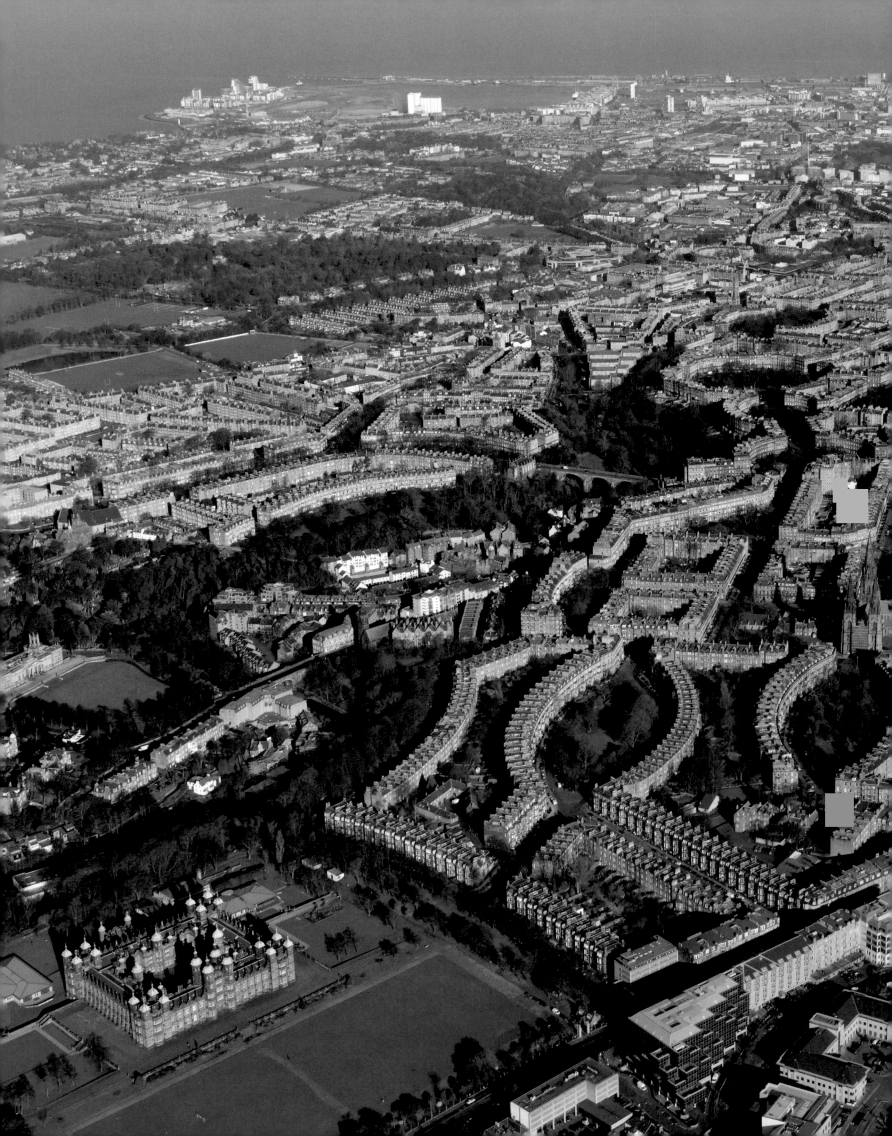

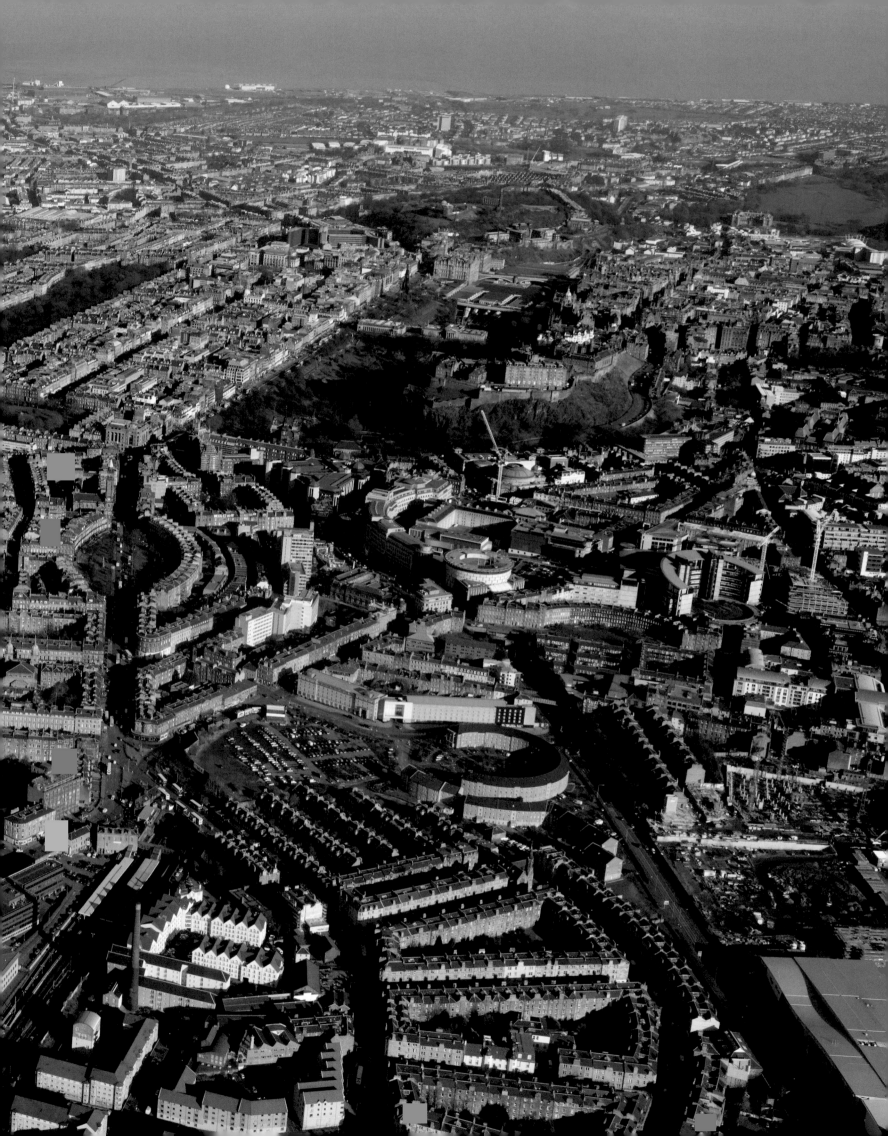

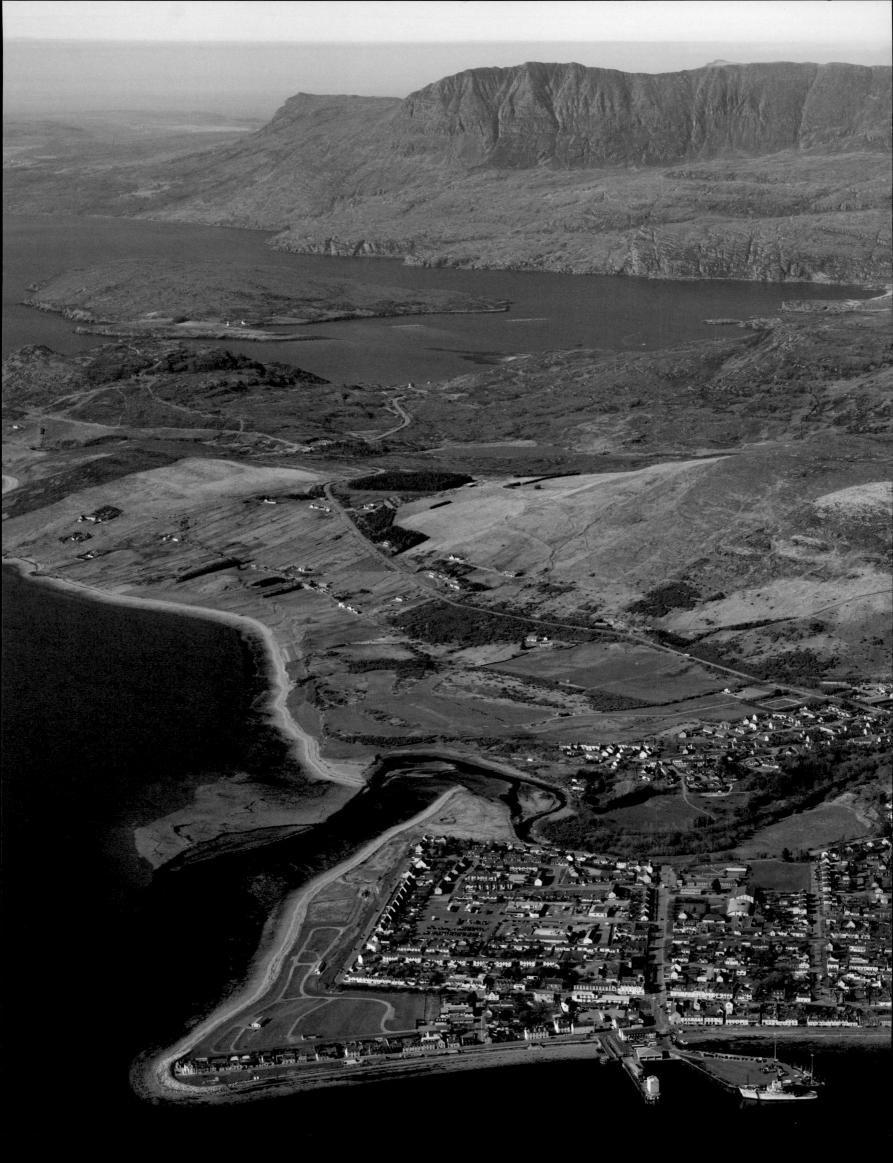

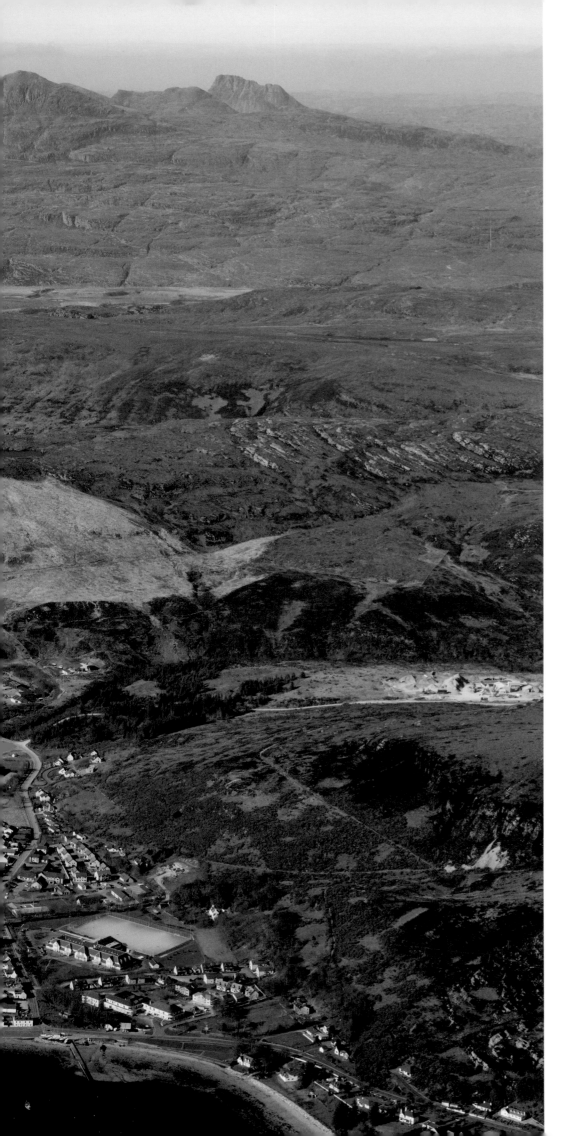

Built for the British Fisheries Society 101
in the late eighteenth century, the
regular geometric pattern of Ullapool's
streets stamp a startlingly ordered
grid over Loch Broom's wild highland
landscape. DP024758 2007

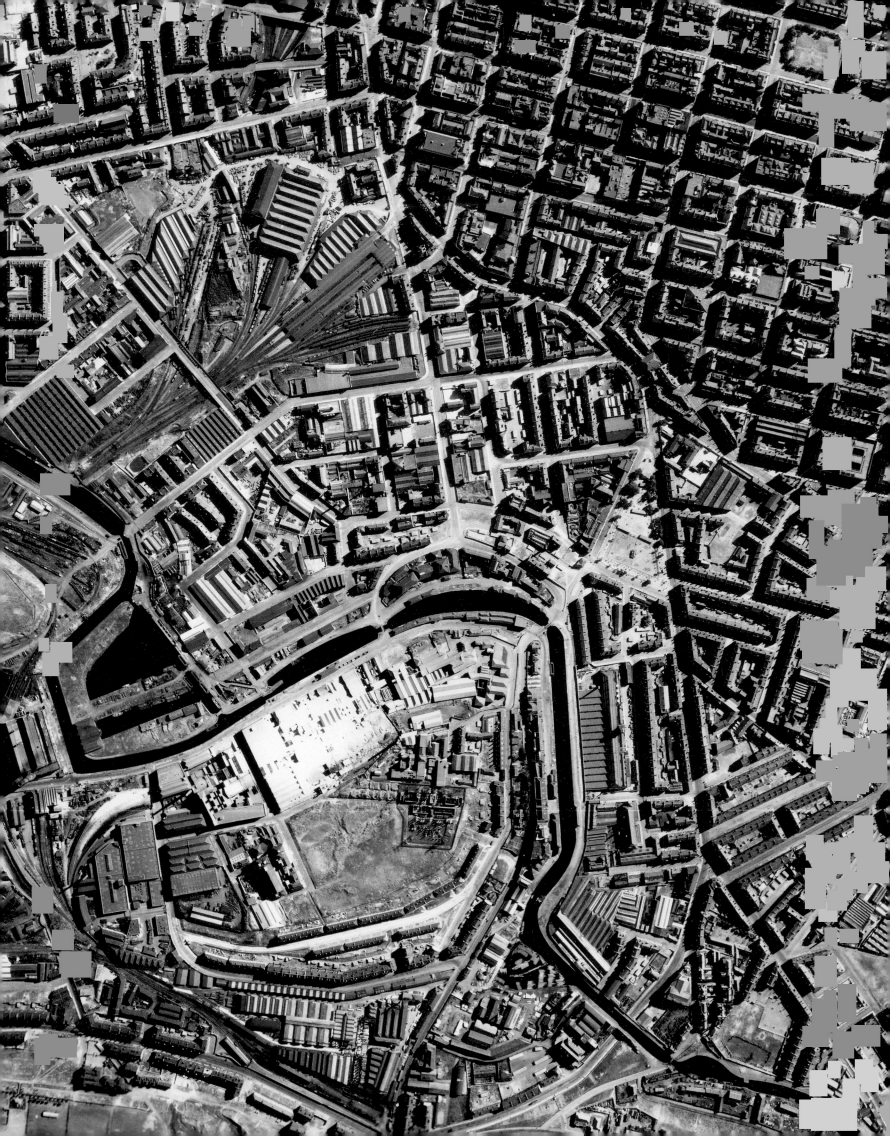

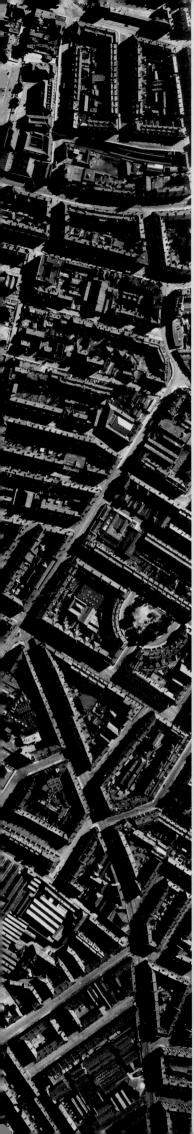

Urban Footprints

Writing in 1723, Daniel Defoe, the English author most famous for the novels *Robinson Crusoe* and *Moll Flanders*, described Glasgow as, 'a very fine city; the four principal streets are the fairest for breadth, and the finest built that I have ever seen in one city together ... It is the cleanest, most beautiful, and best built city in Britain, London excepted.'

Within 30 years, the Glasgow described by Defoe had grown even finer, its airy streets of detached mansions built by Tobacco Lords grown rich on imports from the American colonies. When American Independence ended the tobacco boom, cotton took its place and Glasgow prospered and continued to grow, a glittering monument to commerce and trade. The Merchant City was built, its large blocks of shops, warehouses and residential accommodation forming streets designed to frame views of celebrated buildings, from the grand facade of the Royal Exchange to the baroque splendour of St Andrew's Church. But this expansion, although steady and sustained, would soon be propelled to an incredible rate by the furious pistons of heavy industry.

1 Glasgow

2 St Andrews

3 Jedburgh

4 Edinburgh

5 Aberdeen

6 Livingston

7 Kirkcaldy

The industrial and agricultural revolutions had a huge impact on Glasgow. The once small ecclesiastical town centred on St Mungo's Cathedral – the original 'dear green place' – had experienced only modest growth up to the beginning of the eighteenth century. Over the next 150 years, Glasgow exploded into the Second City of the Empire, a sprawling industrial engine, powering away under a near permanent canopy of black smoke and fire. Wealthier residents moved west out of the overcrowded old town, creating early suburbs like Blythswood Hill, with its open-ended network of street grids. Industries consumed much of the city and vast tracts of tenements and slums grew up to house the legions of workers.

Glasgow approached the industrial age with incredible vigour, and was the most radically transformed of Scotland's urban environments. But the expansion continued throughout the country, feeding towns and cities from Aberdeen to Edinburgh. Such rapid growth had inevitable consequences as bulging urban centres were cloaked in soot and grime, and by the latter half of the twentieth century, government directives enforced a clear-out, demolishing tenements and relocating populations to high-density housing on the outskirts of cities. 'New Towns' like East Kilbride and Livingston were built as pioneers of a utopian form of living, their planned layouts of green spaces and activity zones carefully designed as a vision of how people should live and work.

The massive population surge that began in the eighteenth century overran urban Scotland and demanded instant answers to problems of inadequate housing and overcrowding. The solutions presented, from tower blocks to satellite cities, have left distinctive imprints on the land, sometimes tearing communities apart, sometimes creating new ones, but always adding more layers to the diverse cityscapes we recognise today.

PREVIOUS PAGES
Pictured here in 1947, a jumbled wave of buildings, roads and warehouses meets the solid shore of Glasgow's regimented Georgian street grid. Just over 20 years after this photograph was taken, the wide concrete and tarmac of the M8 motorway would be laid directly through this inner-city landscape. SC802946 1947

OPPOSITE
The grandeur of Glasgow's City Chambers looks out over George Square at an expanse of ordered grid-iron canyons. The late nineteenth century saw substantial remodelling of the central streets, as technology allowed structures to grow higher and higher, and customised building blocks of red-hued sandstone arrived from the Dumfriesshire quarries. DP015629 2006

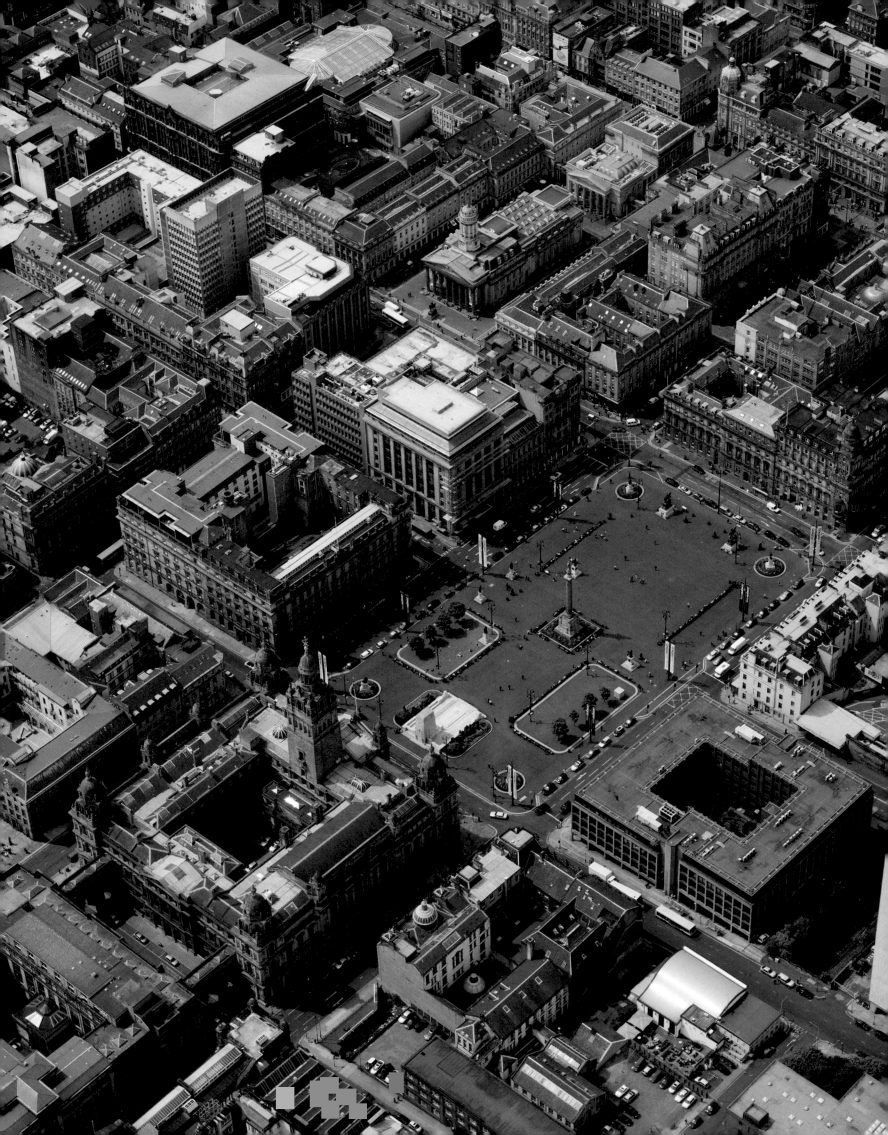

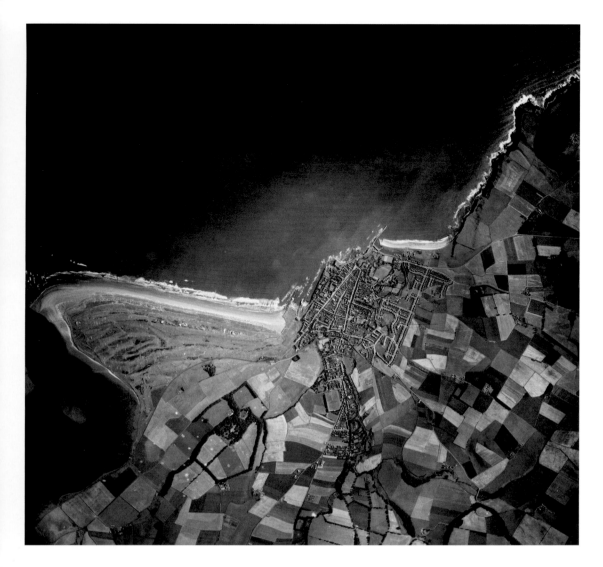

With its thin streets and strings of terraced houses, the typical medieval plan of St Andrews in Fife brought townspeople together in a crowded cluster of humanity. The creation of towns and cities in Scotland began about 1,000 years ago, and, ever since, there has been a relentless march away from our rural past and towards increasingly urbanised living.

Narrow properties stretching back from street frontages – taking the shape of a herringbone when seen from above – are the hallmarks of a medieval town, as seen here at Jedburgh in the Borders. SC1138558 1978

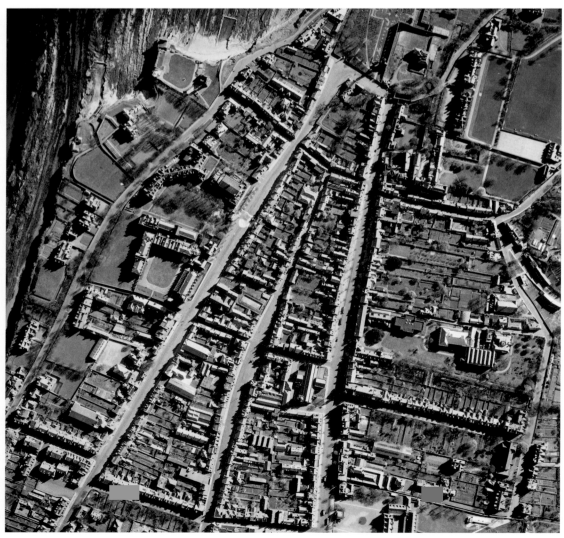

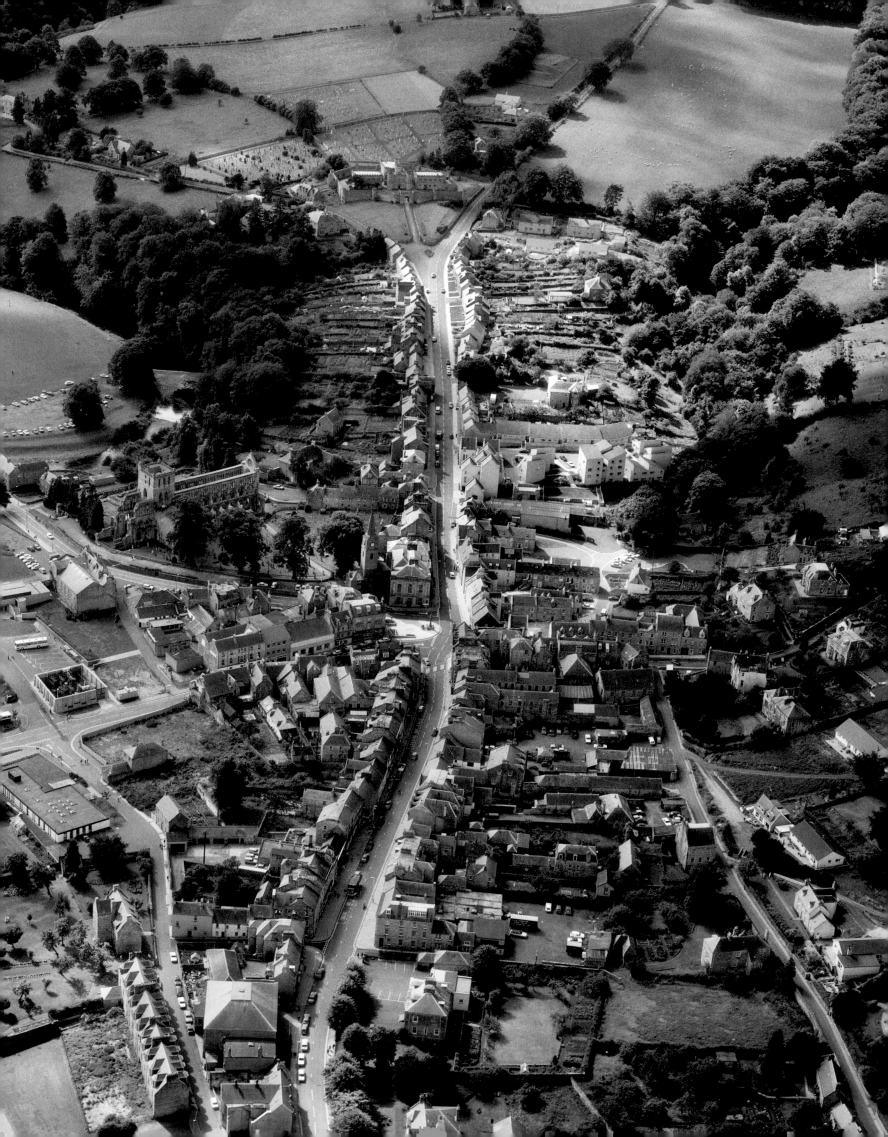

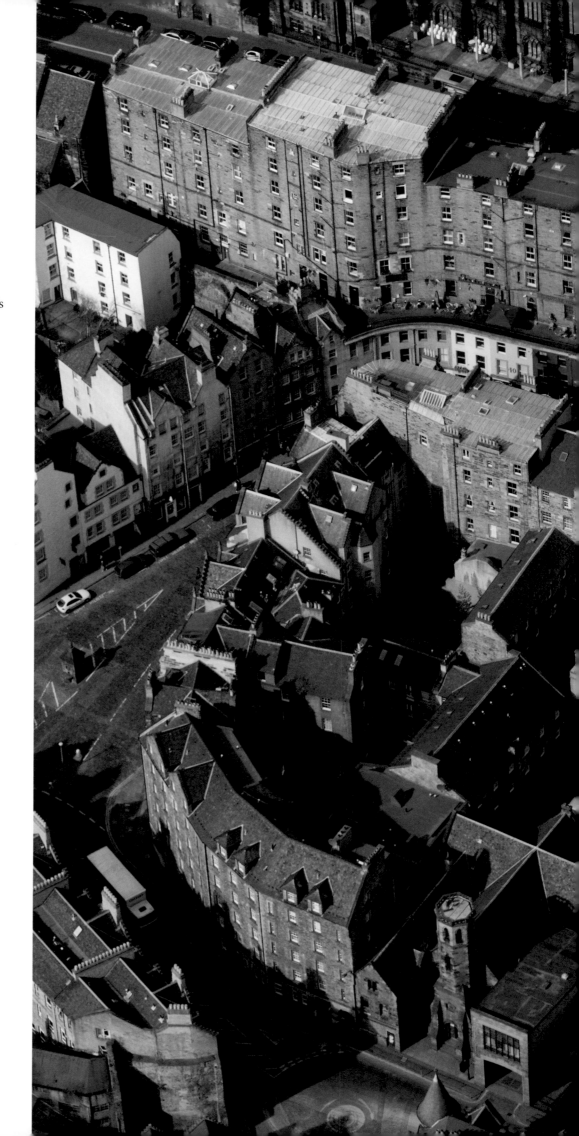

108 Winding beneath the cliff-like tenements
of Edinburgh's Old Town, when first built
in the mid nineteenth century Victoria
Street was a passageway between two
different worlds. From the Grassmarket
and the Cowgate – once seen as the capital's
dark and impoverished underbelly – it
rises up to George IV Bridge to meet
the grand establishment buildings of the
National Library and the High Court of
Justiciary. DP026263 2007

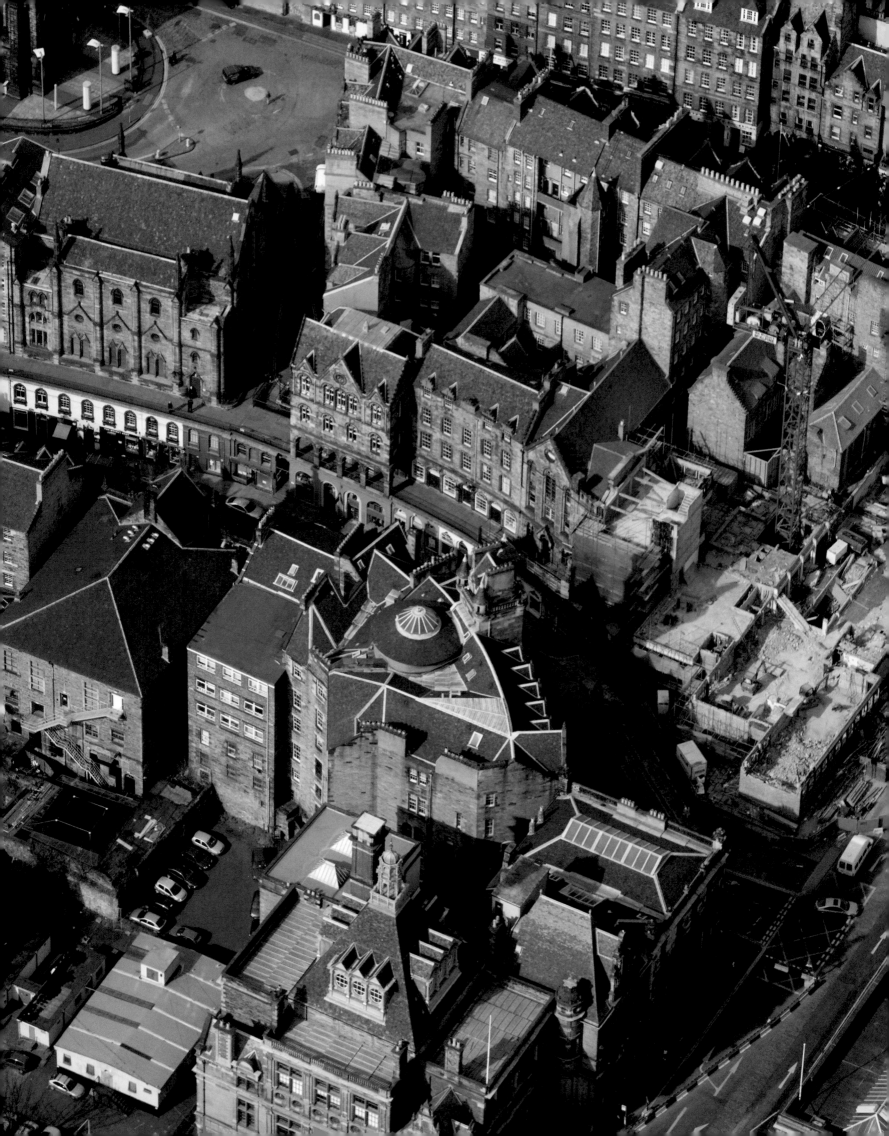

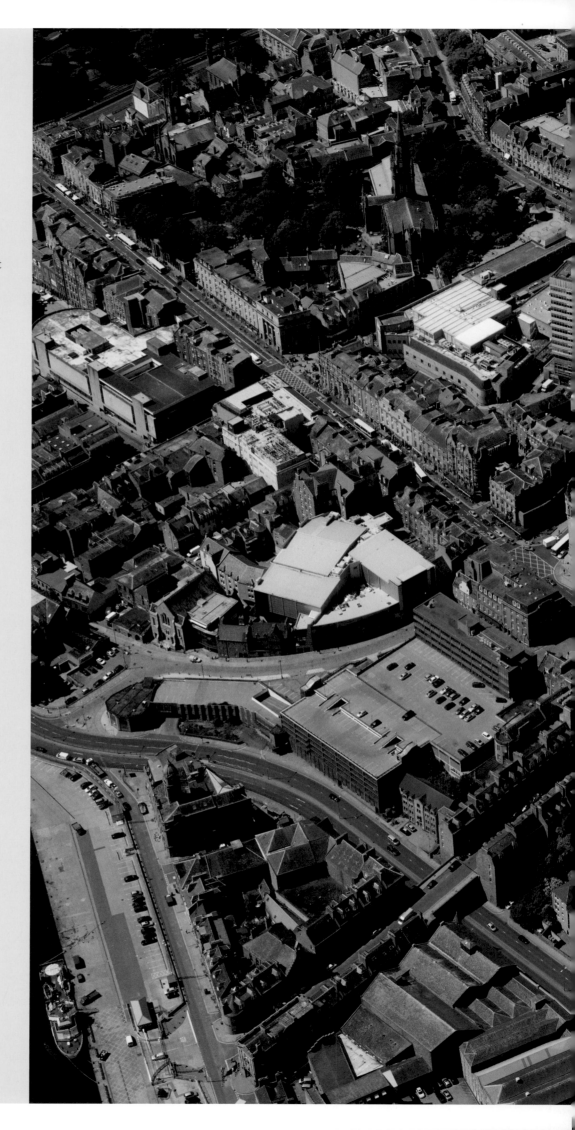

110 The grey facades that earned Aberdeen the nickname of the 'Granite City' are made up of many fine nineteenth century buildings, including Marischal College to the top right – one of the largest granite buildings in the world. Over the last hundred years, new road networks and civic developments have carved up the street layouts of previous centuries. DP018191 2006

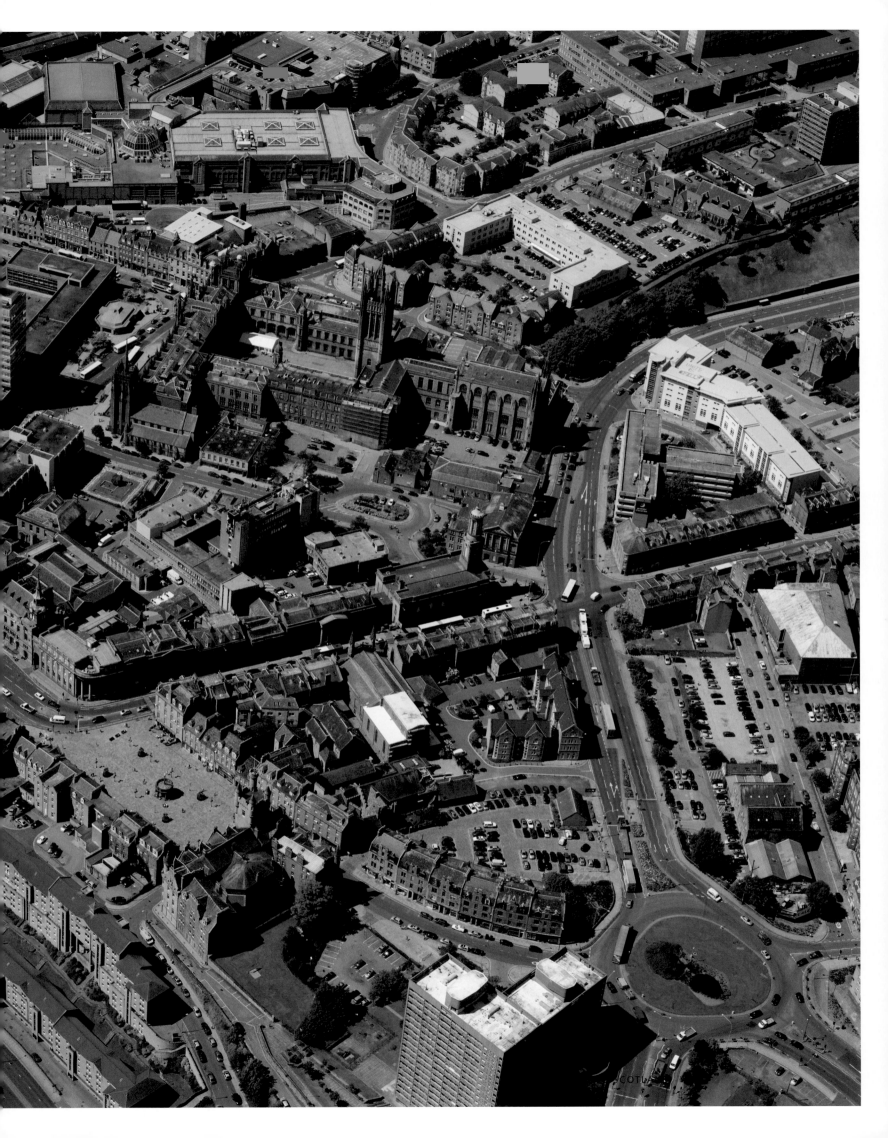

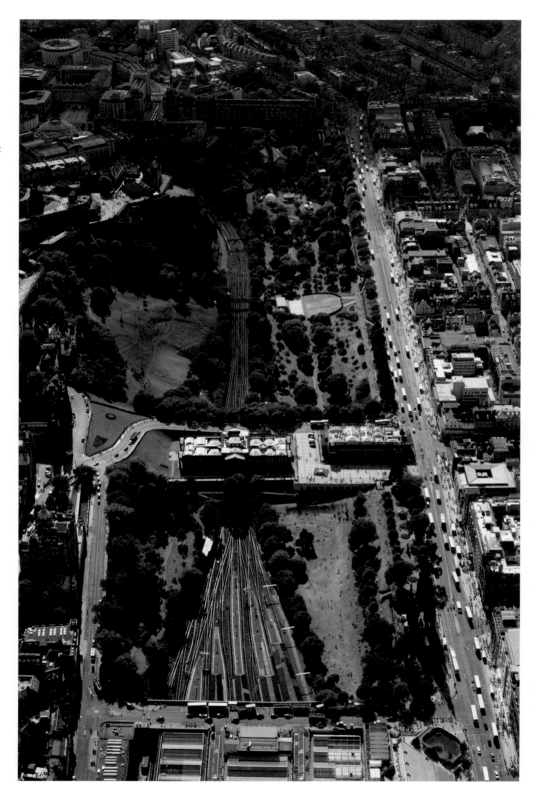

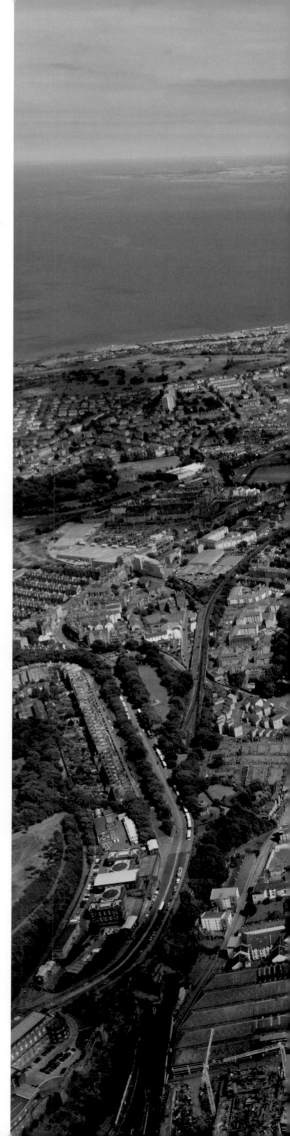

ABOVE

Like a fault line between the Old and New Towns, the railtracks of Waverley Station burst through an ancient glacial hollow – and former site of the Nor' Loch, the receptacle of medieval Edinburgh's many sewers – to cross the sculpted parkland of Princes Street Gardens and run beneath the nineteenth century sandstone edifice of William Playfair's National Gallery. DP014129 2006

RIGHT

Hundreds of years after first spilling out from the Royal Mile's medieval core, the city of Edinburgh and its suburbs have completely surrounded the volcanic bulk of Arthur's Seat and continue to spread along the East Lothian coastline. DP010713 2005

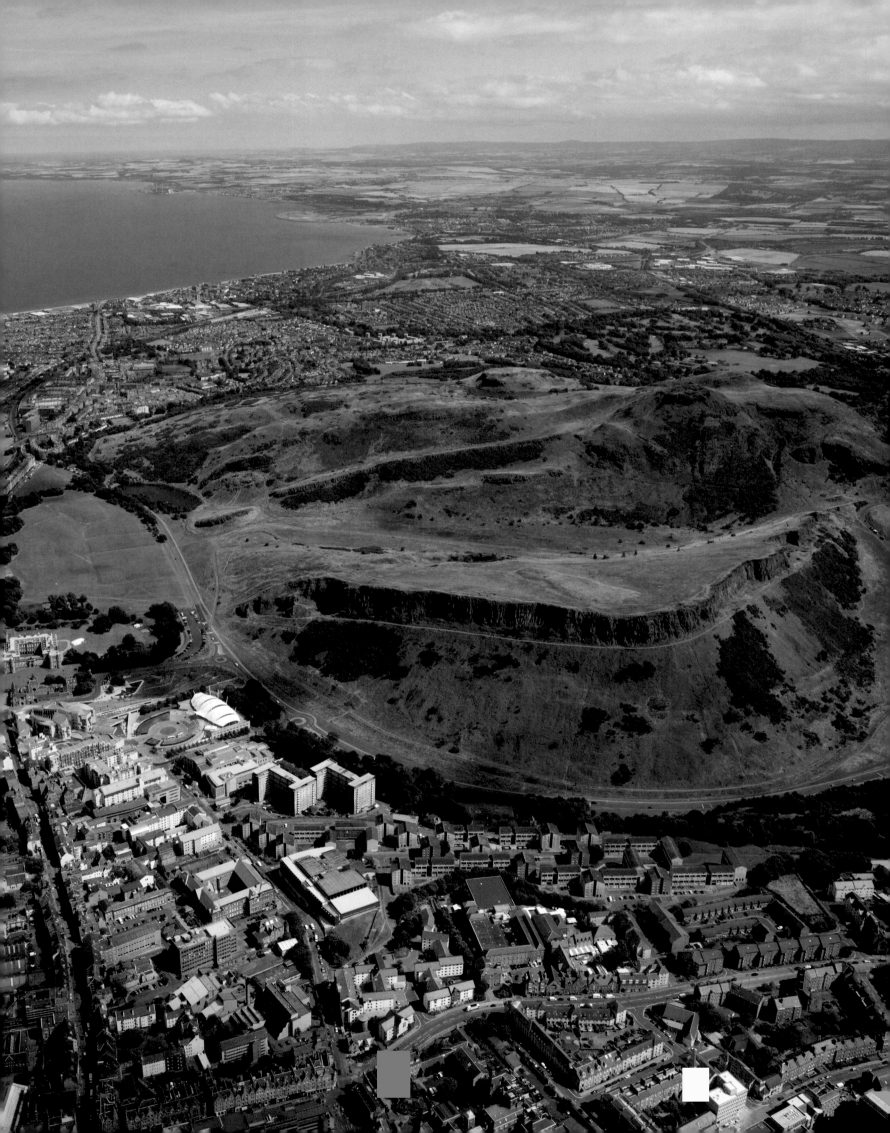

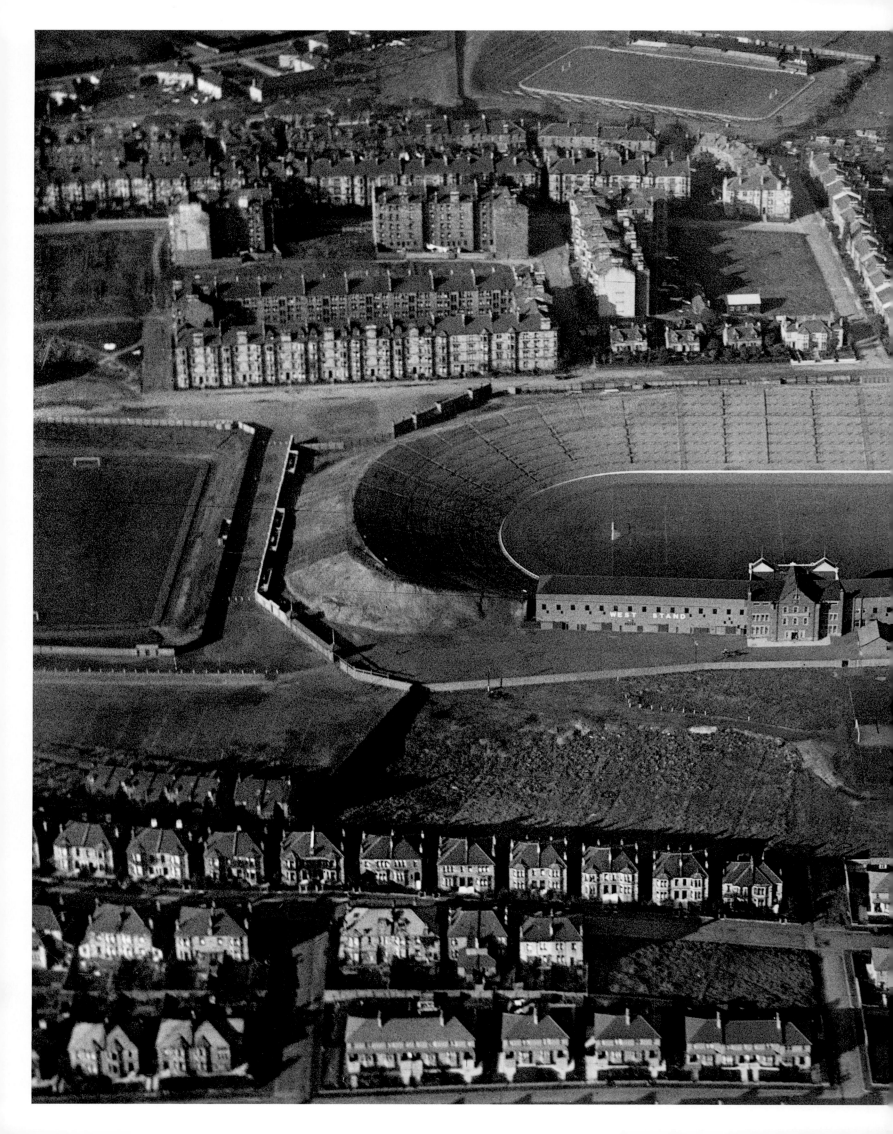

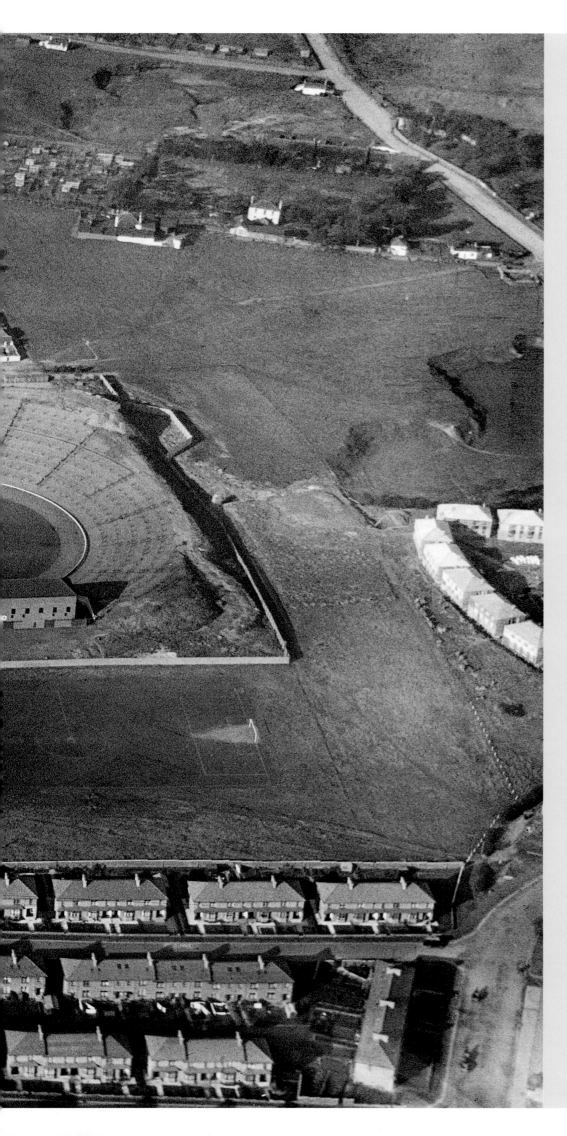

An ever-growing urban population fuelled
the popularity of spectator sports. Sitting
proudly among the tenements and terraced
housing of Mount Florida in Glasgow,
at the time of this photograph Scotland's
national football stadium of Hampden
Park was the largest in the world. Although
overtaken for size in 1950 by the Maracana
in Rio de Janeiro, Brazil, it still retains the
European record for the highest attendance
at a single game – a 149,415 turnout for
Scotland against England in the 1937 British
Home Championship. The wide, extensive
terraces that allowed for such huge
numbers have now disappeared completely.
Safety requirements resulted in the
reconstruction of Hampden, and, in 1999,
it was reborn as a 52,000-capacity, all-seater
stadium. DP048143 1927

FOLLOWING PAGES
A packed mixture of housing, factories and
parks spreads outwards from nineteenth
century Edinburgh through the Gorgie
area of the city. In the centre left of the
photograph are Tynecastle and Murrayfield
stadiums. SC943153 1941

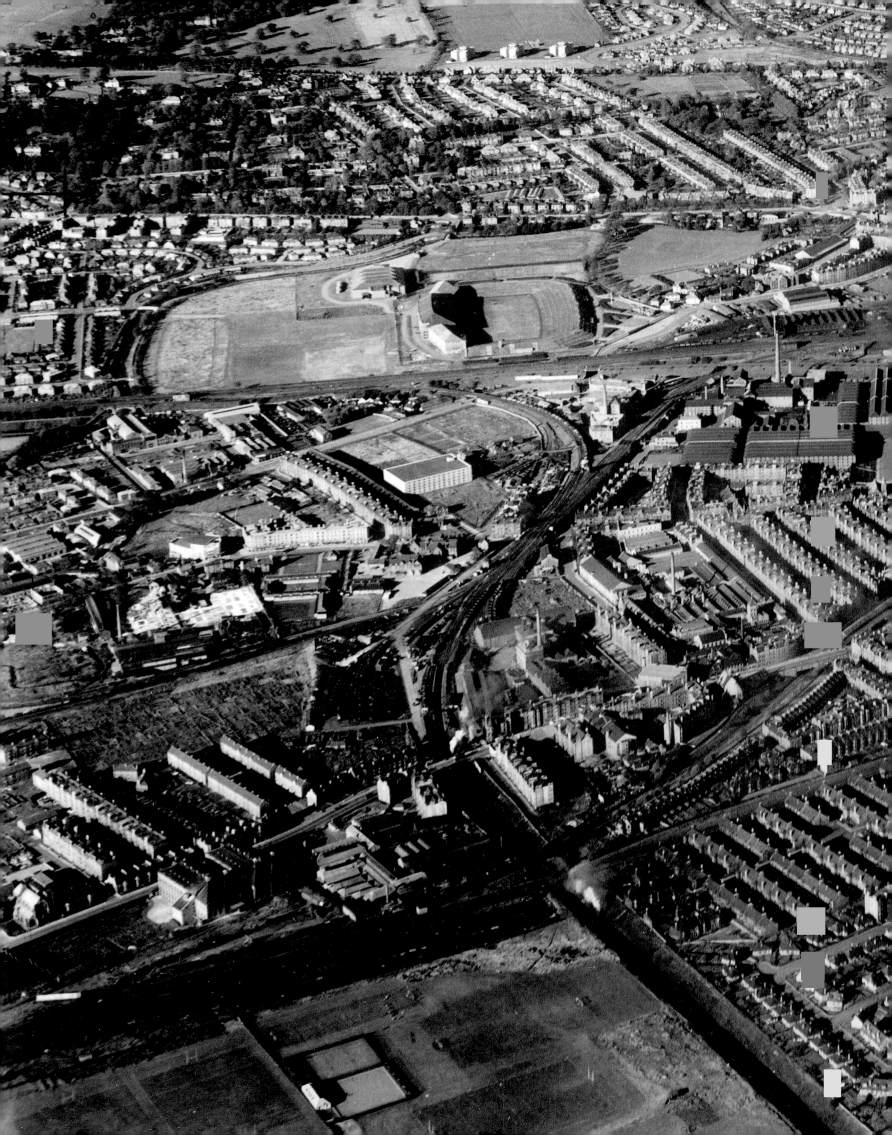

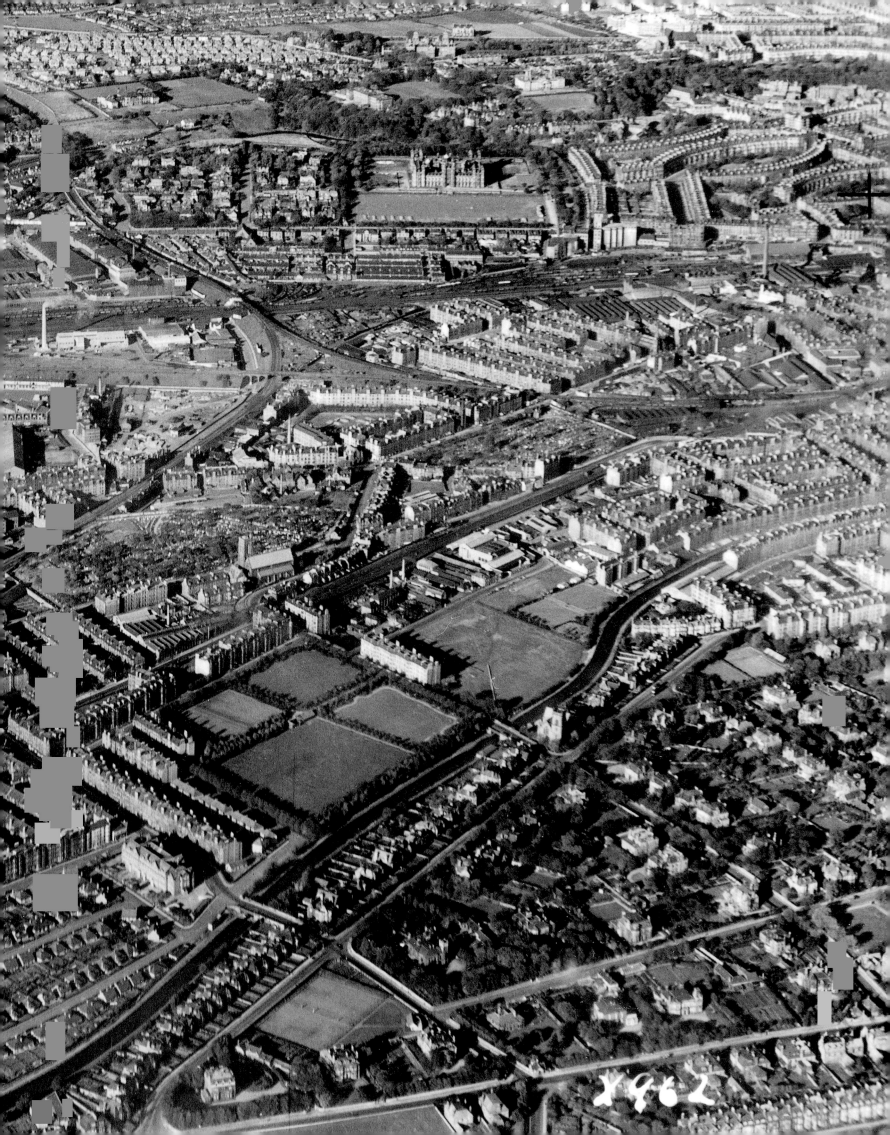

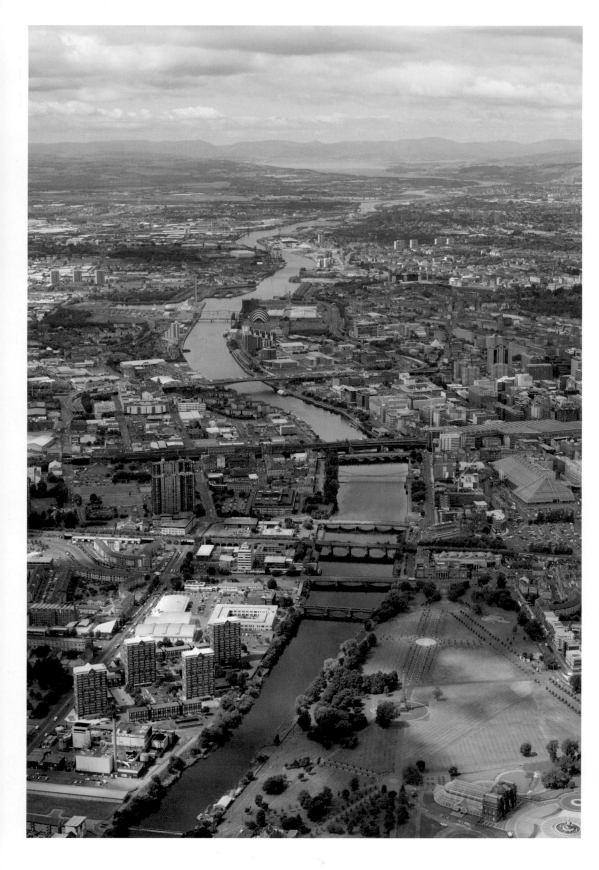

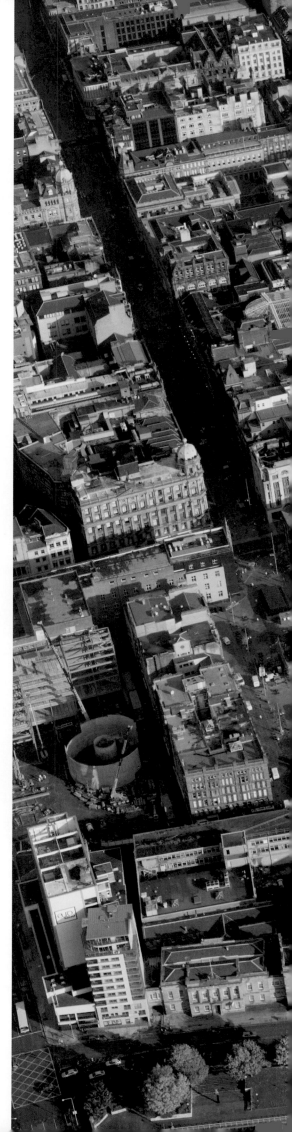

Faint pockets of sunlight trace the course of
the River Clyde through Scotland's largest
city, lighting up Glasgow Green and flicker-
ing through the urban landscape towards
the distant hills of Cowal. DP009519 2005

A distinctive pyramid of glass and
steel, St Enoch's shopping centre in
Glasgow dwarfs the packed rows
of surrounding nineteenth century
buildings. DP009900 2005

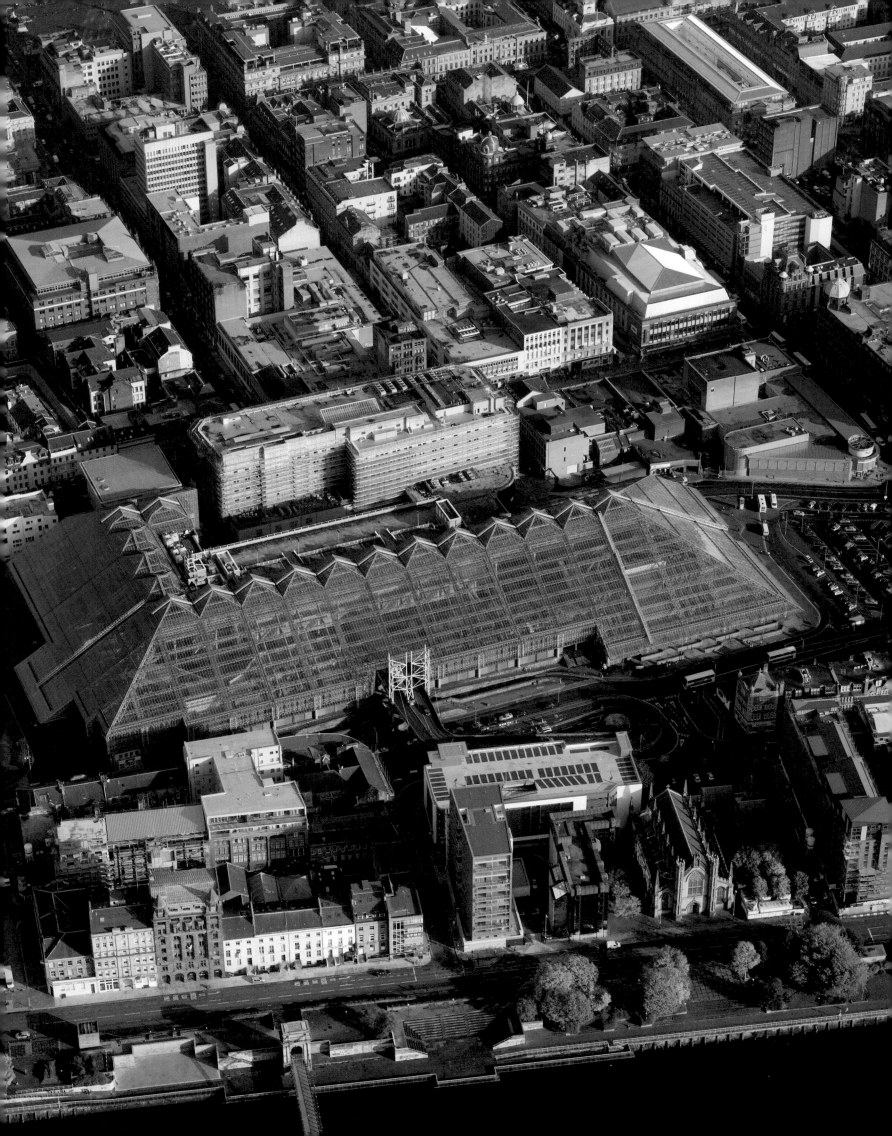

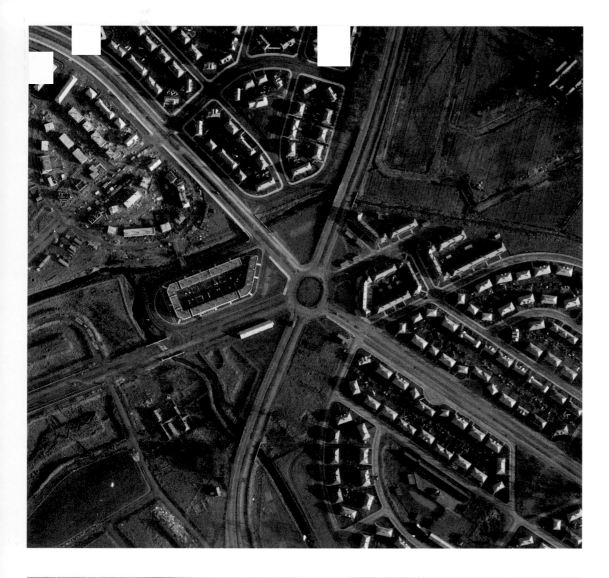

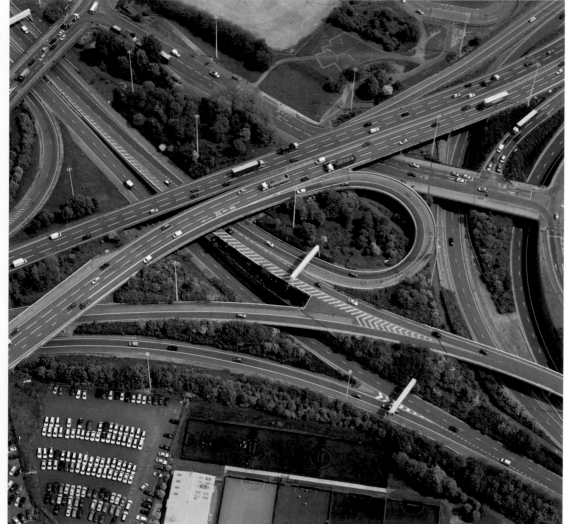

TOP LEFT
Expanding across farmland to the south west of Glasgow, the need to house an ever growing population saw the creation of suburbs like Pollock. Based on the principles of 'garden city' design, its carefully planned layout of private gardens set within curving crescents was introduced as a direct response to the smoky, overcrowded inner-cities. SC1138693 1945

BOTTOM LEFT
Increased car ownership and the importance of developing a sophisticated transport infrastructure saw motorways slice through Glasgow during the 1960s and 1970s. This dizzying knot at the Townhead interchange on the M8 opened in 1968. DP015611 2006

OPPOSITE
In the latter half of the twentieth century, government directives led to planned relocations outwith crowded city centres, pioneering the development of high-density, often high-rise housing. Schemes like Prospecthill Circus on the south east side of Glasgow – developed between 1953 and 1968 – were heralded as the future of modern city living. Just 40 years later, many of these lofty experiments in population management have now been demolished. DP011583 2005

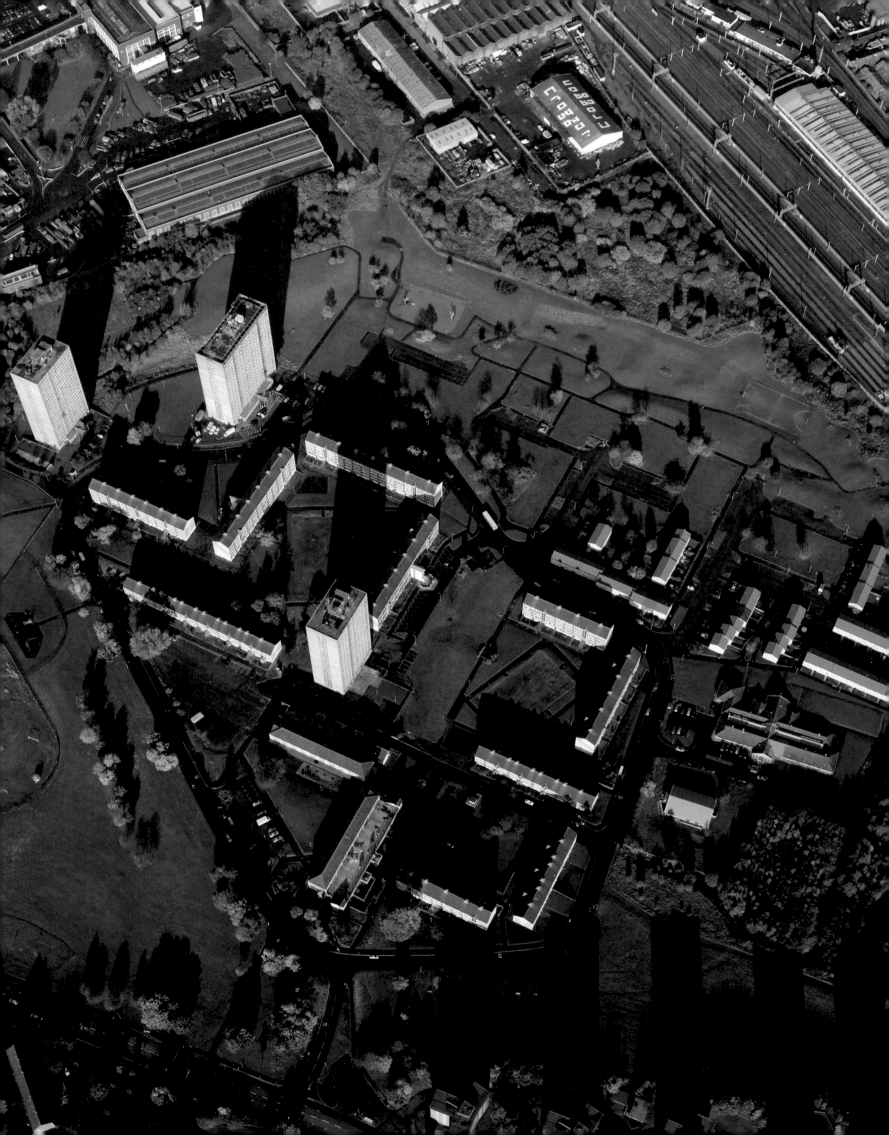

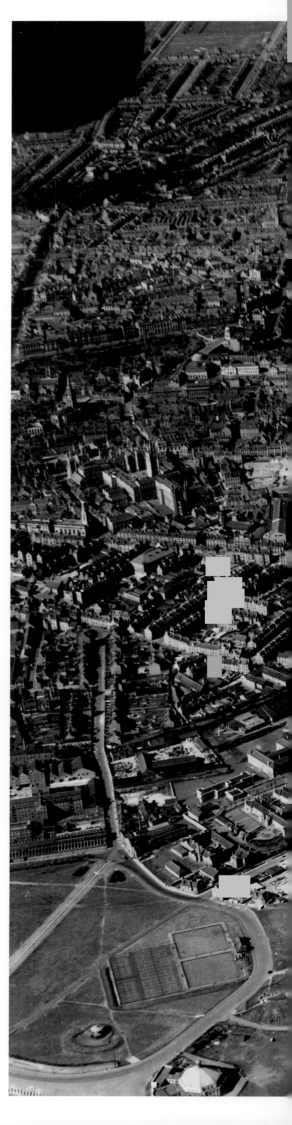

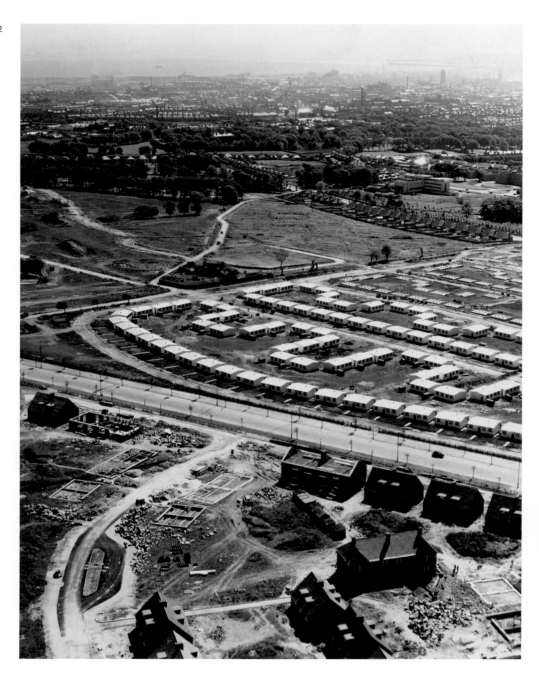

ABOVE

Along with many other Scottish towns and
cities, Aberdeen grew enormously after the
Second World War. Seen here in 1947, a
drive to build is underway. Separated by the
wide new avenue of North Anderson Drive,
permanent houses under construction on
what is now Stocket Parade in the fore-
ground are watched over by an estate of

boxy prefabs, the standard form of wartime
and immediate post-war emergency
housing. SC682700 1947

RIGHT

By contrast, in 1942, military accommoda-
tion blocks below Pittodrie football stadium
fill up the open spaces on the fringes of the
densely packed old city. SC910903 1942

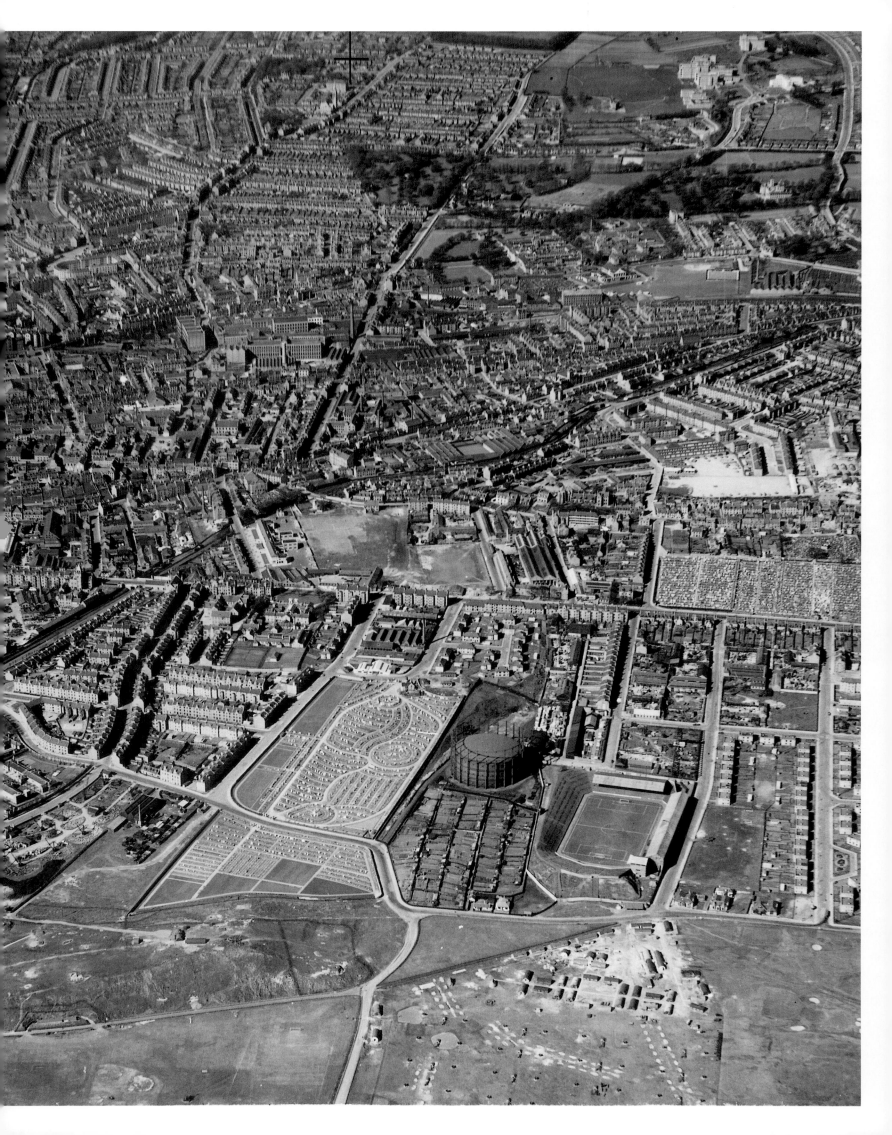

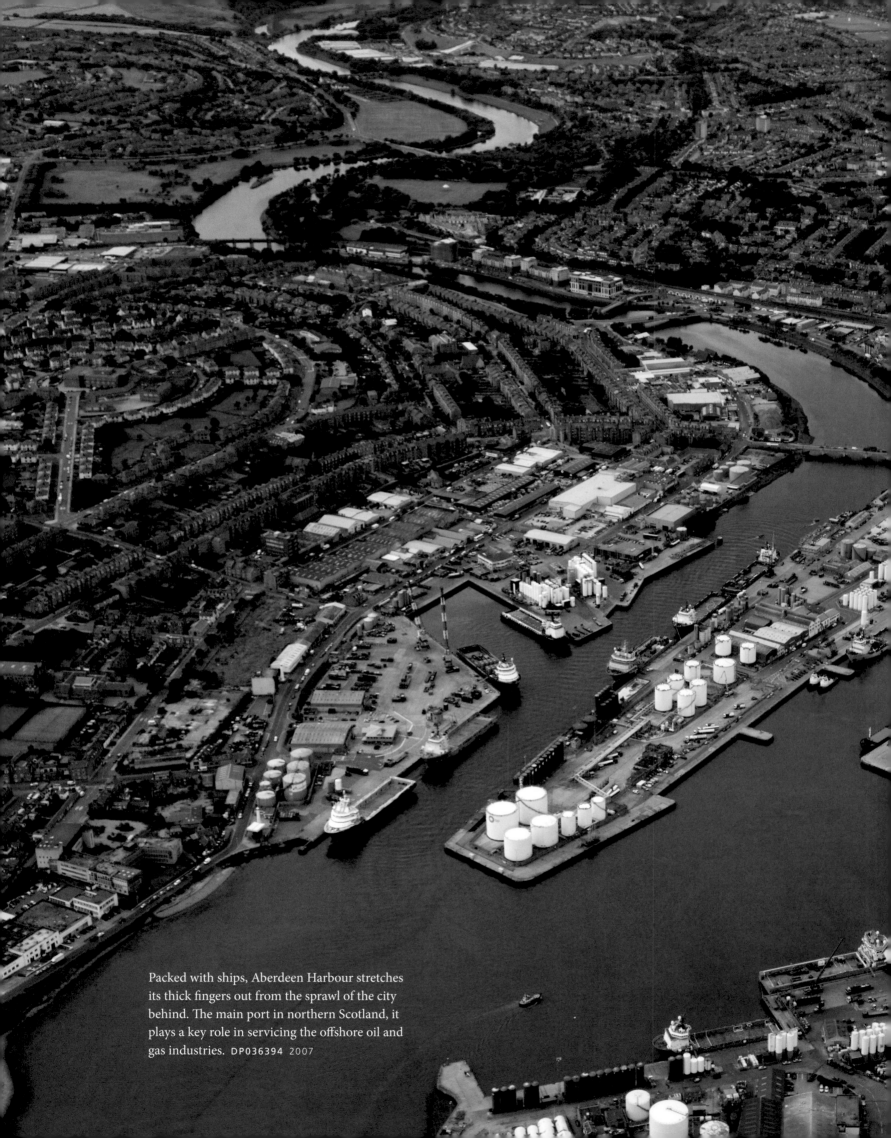

Packed with ships, Aberdeen Harbour stretches its thick fingers out from the sprawl of the city behind. The main port in northern Scotland, it plays a key role in servicing the offshore oil and gas industries. DP036394 2007

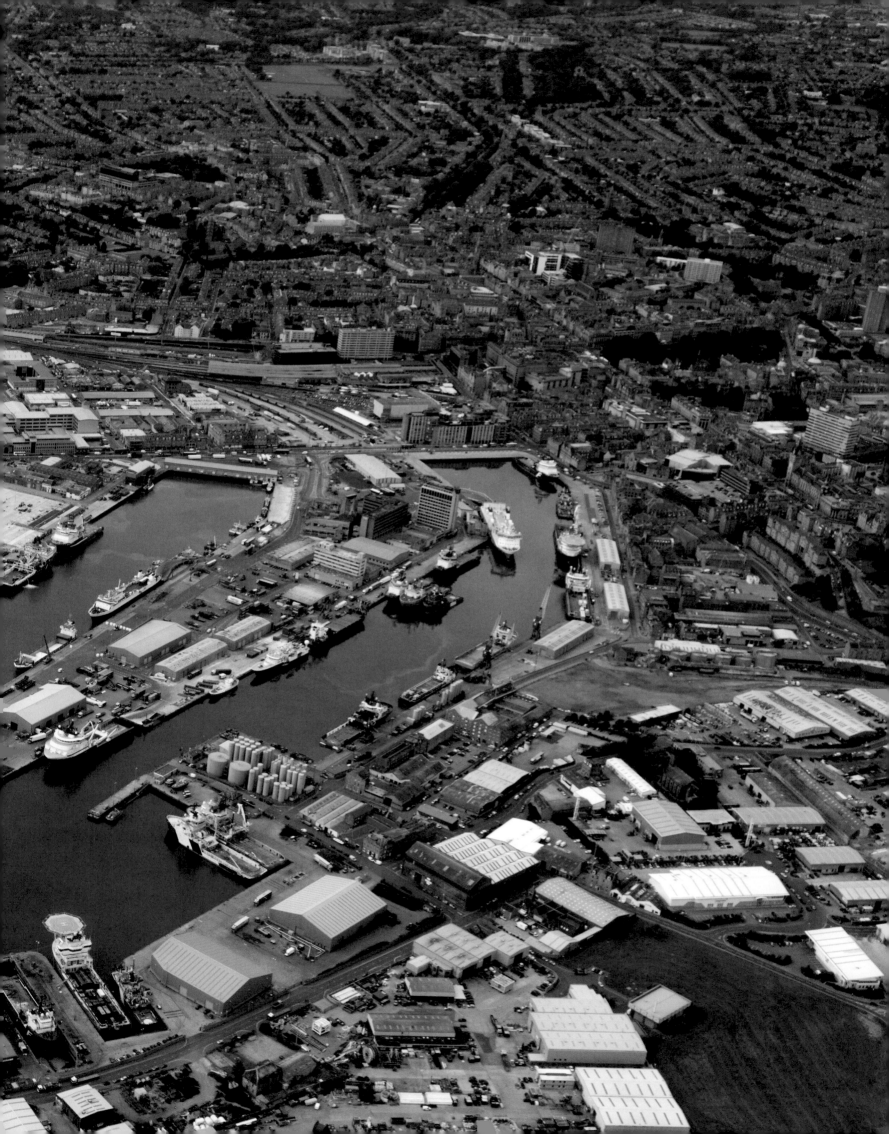

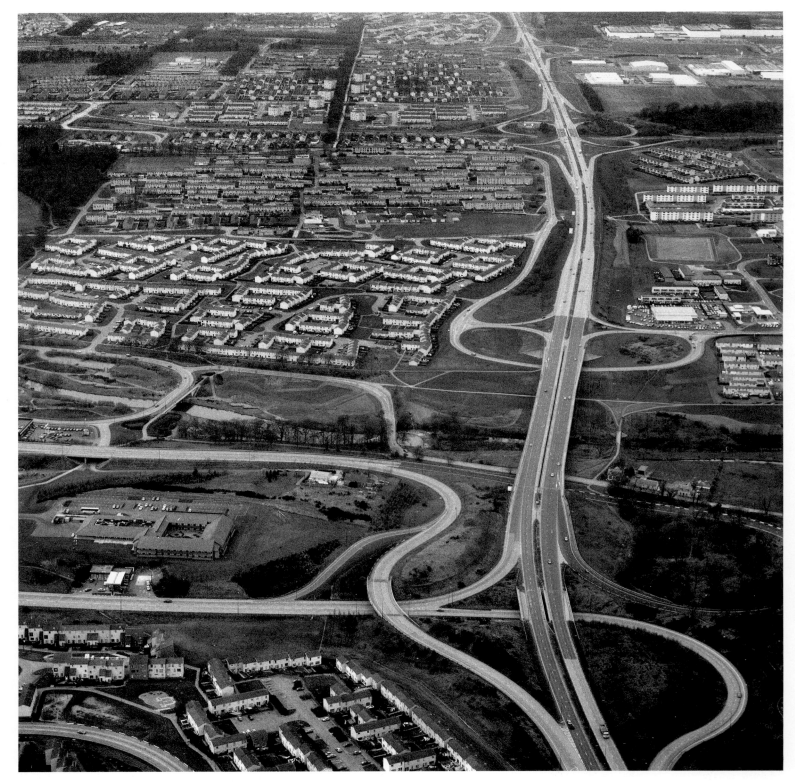

'A design for life' – symmetry, pattern and structure underpinned the creation of Scotland's 'New Towns'. Built between 1947 and 1966 to relocate people from the overcrowded inner-cities, the towns were imprinted with very specific ideals, creating discrete zones for housing, commerce, recreation and infrastructure, and separating pedestrians from traffic with mazes of concrete walkways and overpasses. The product of collaborations between architects, planners and landscape architects, their unique design ideology left distinctive patterns on the Scottish land-scape, as seen here at the two Livingston estates of Howden and Craigshill.

ABOVE **HOWDEN SC1075693** 1989
OPPOSITE **CRAIGSHILL SC1075686** 1989

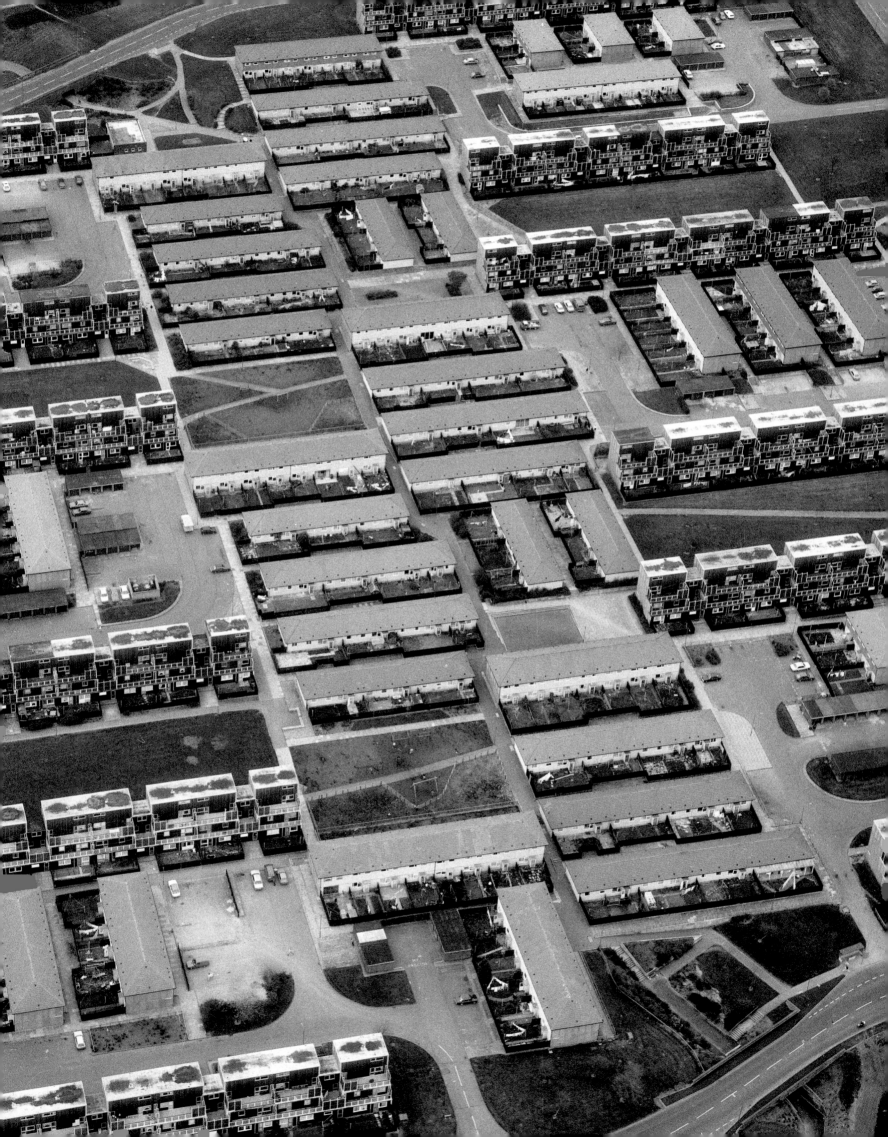

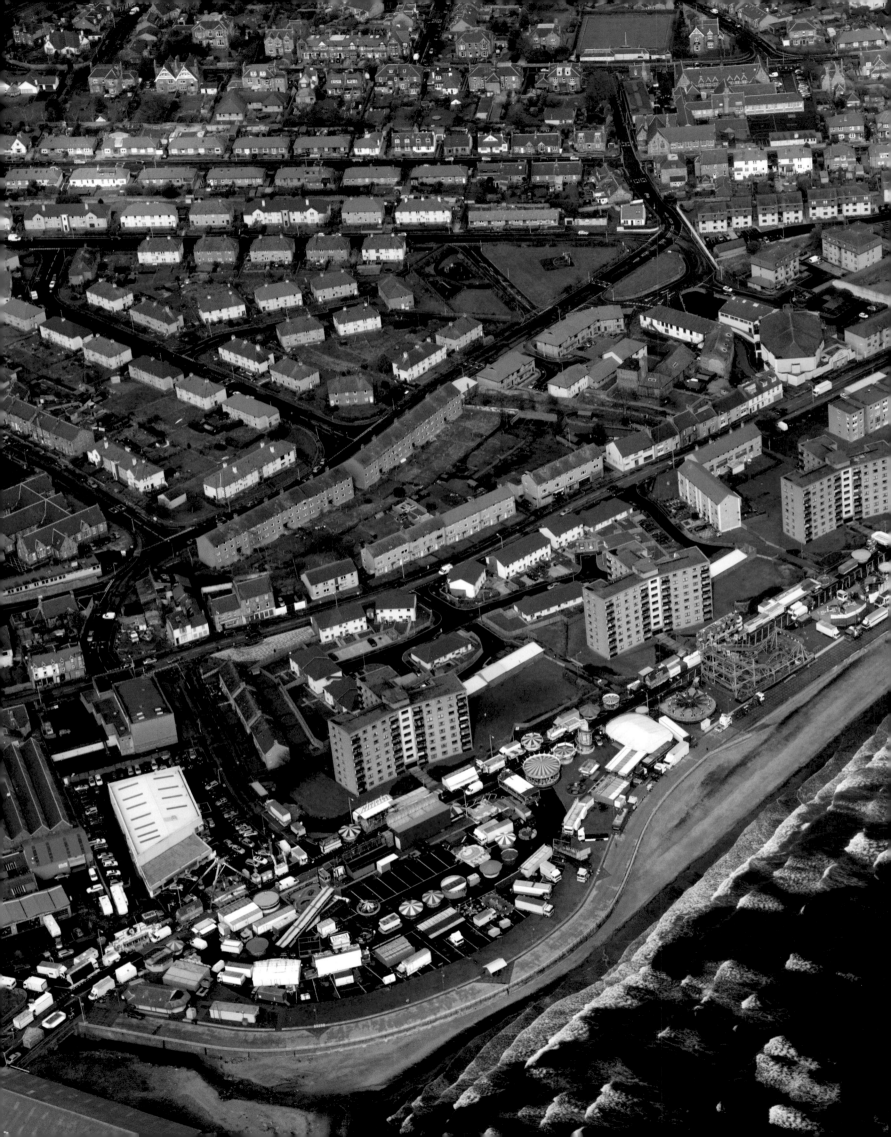

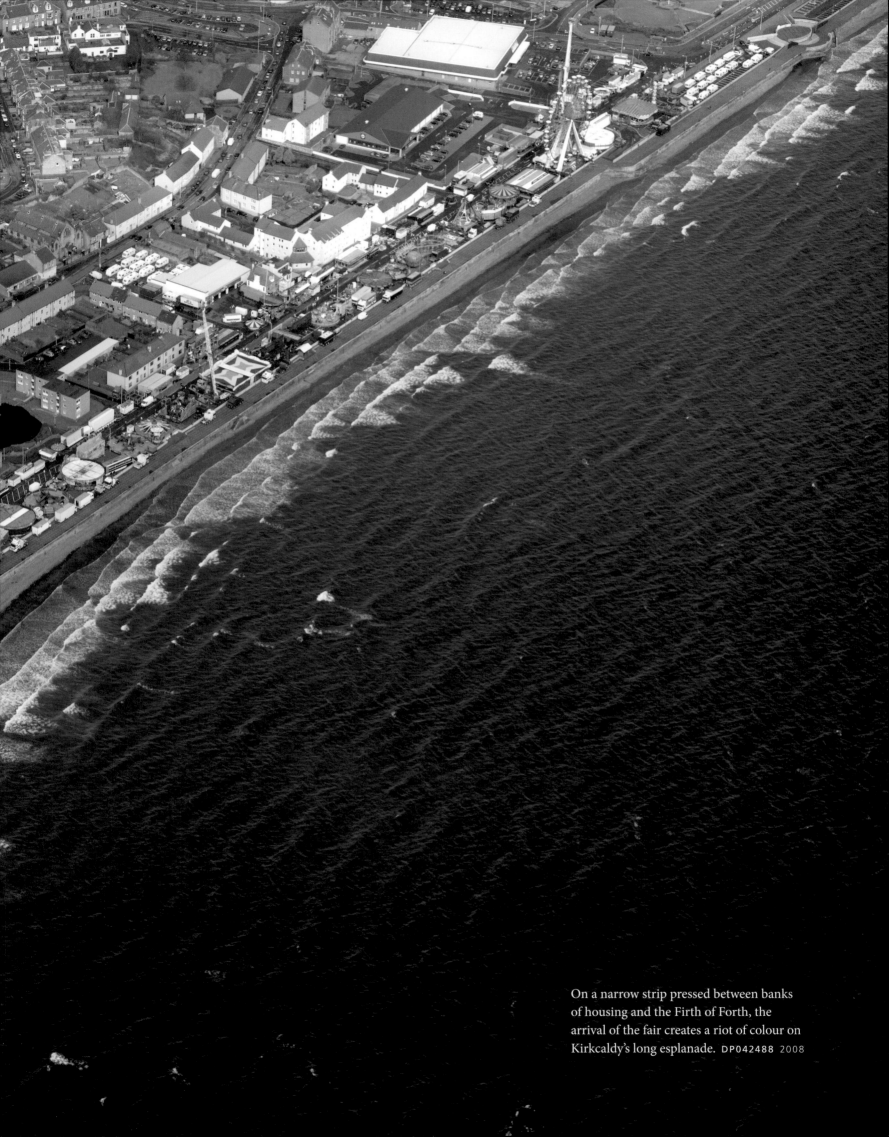

On a narrow strip pressed between banks of housing and the Firth of Forth, the arrival of the fair creates a riot of colour on Kirkcaldy's long esplanade. DP042488 2008

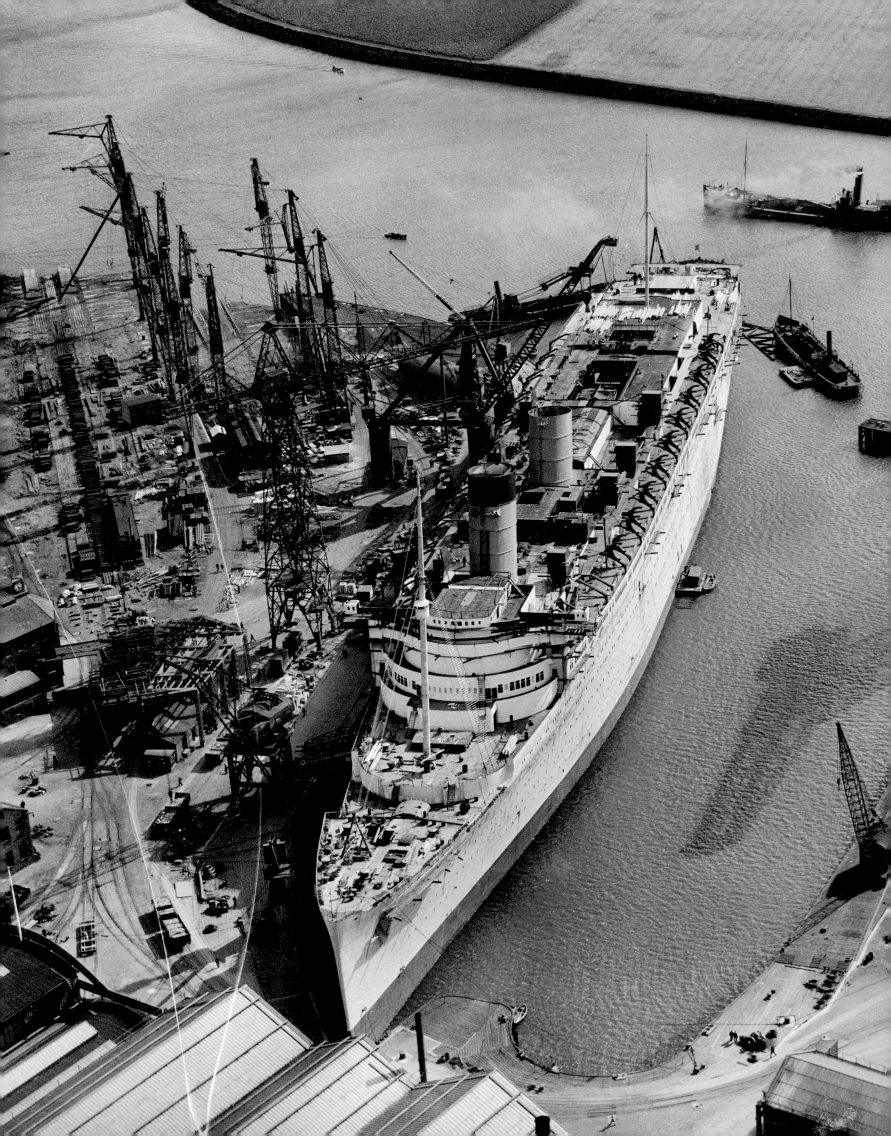

The Engine Room

Towering 45m above the River Clyde, one structure has dominated the Clydebank skyline for over 100 years – the Titan Cantilever Crane. The first of its kind in the world, the giant Titan Crane was the iconic strongman of Scotland's shipbuilding industry, its huge steel arm able to lift weights of up to 200 tonnes. Today, its legendary brawn, which once helped build some of the largest and most famous ships in the world, is no longer called upon for heavy work. Instead, tourists climb the superstructure to look down on the quiet riverside and try to picture it as it once was – with row after row of skeleton hulls lit by arcs of welded metal, and thousands of skilled ship workers labouring to a crashing symphony of steel on steel.

Erected in 1907 in John Brown's Shipyard, the Titan Crane witnessed the dramatic rise and fall of heavy industry over the course of a century. For a time, Scotland was the engine room of the British Empire, its raw materials fuelling a massive expansion in manufacturing. Coal from Lanarkshire and Ayrshire drove the steam engines of the mills and railways, and iron works

1 Glasgow
2 Coatbridge
3 Motherwell
4 Barony Colliery
5 Bo'ness
6 Denbeath
7 Powharnal Colliery
8 Tarbrax
9 Balbackie
10 Kelty
11 Traprain Law
12 Belnahua
13 Cromarty Firth
14 Grangemouth
15 Clachnaharry
16 New Lanark
17 Dundee
18 Stonehaven
19 Mallaig
20 Anstruther Easter
21 Crail

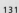

provided the building blocks for incredible feats of marine and mechanical engineering. The industrial revolution started in the eighteenth century and reached an extraordinary peak as the Victorian era ended and the twentieth century began. And, as the world lurched towards a first, terrible, global conflict, the exploitation of resources and the pace of manufacturing grew ever more frantic. Britain, along with many other nations, flexed its industrial muscles in a deliberate display of power.

Whole communities grew up utterly dependent on specific resources like coal and iron. Central Scotland, its skies darkened by belching furnaces, marched to the beat of the industrial machine, the working day marked out by the piercing calls of the factory hooters. Such dependency had its dangers. In the Great Depression of the 1920s and 1930s, with dwindling markets and increased competition, the first signs of a decline – and its devastating consequences – emerged. A brief respite, as the Second World War created an artificial surge of activity, only delayed the inevitable.

As Scotland moved through the second half of the twentieth century, the engines of heavy industry were broken up, leaving their debris scattered across the nation. Many industrial communities died, the intensive extraction of coal, iron and shale leaving behind strange, alien landscapes. The once proud tradition of shipbuilding disappeared almost without trace and many docks have been redeveloped as leisure complexes and housing. The Titan Crane, one of only five remaining in the world, is now a museum piece, a silent monument to Scotland's industrial heritage. But those tourists high up on its arm, who take in a panorama across the Central Belt, see a landscape that once led the industrialisation of the world.

PREVIOUS PAGES
Watched over by the Titan Cantilever Crane, Cunard's ocean liner RMS *Queen Mary* nears completion in John Brown's shipyard, Clydebank. DP046173 1935

OPPOSITE
A bare skeleton of steel struts, Hull 552 in John Brown's shipyard would become RMS *Queen Elizabeth*, a luxury ocean liner and, when launched in 1938, the largest passenger vessel in the world. Like her sister ship, the *Queen Mary*, she was converted into a troop carrier during the Second World War, and later the two maintained a weekly transatlantic service from Southampton to New York via Cherbourg. DP046175 1937

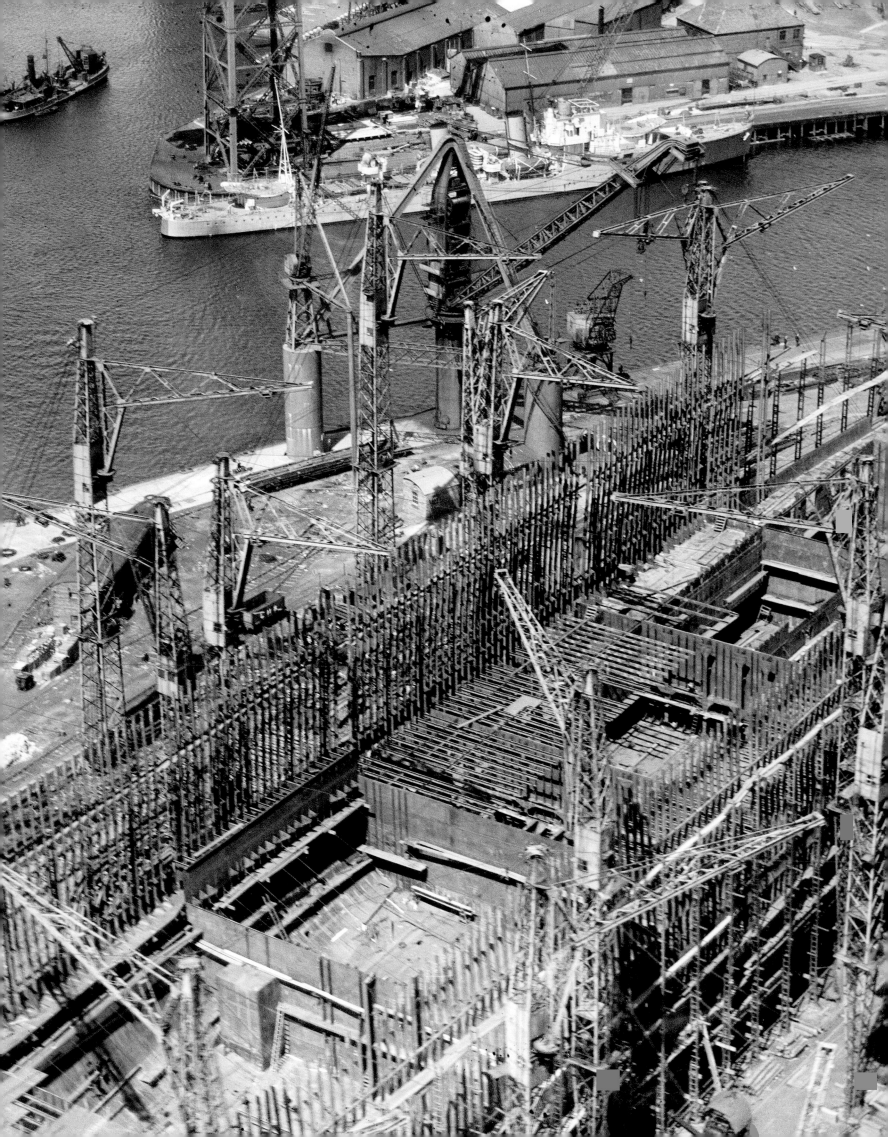

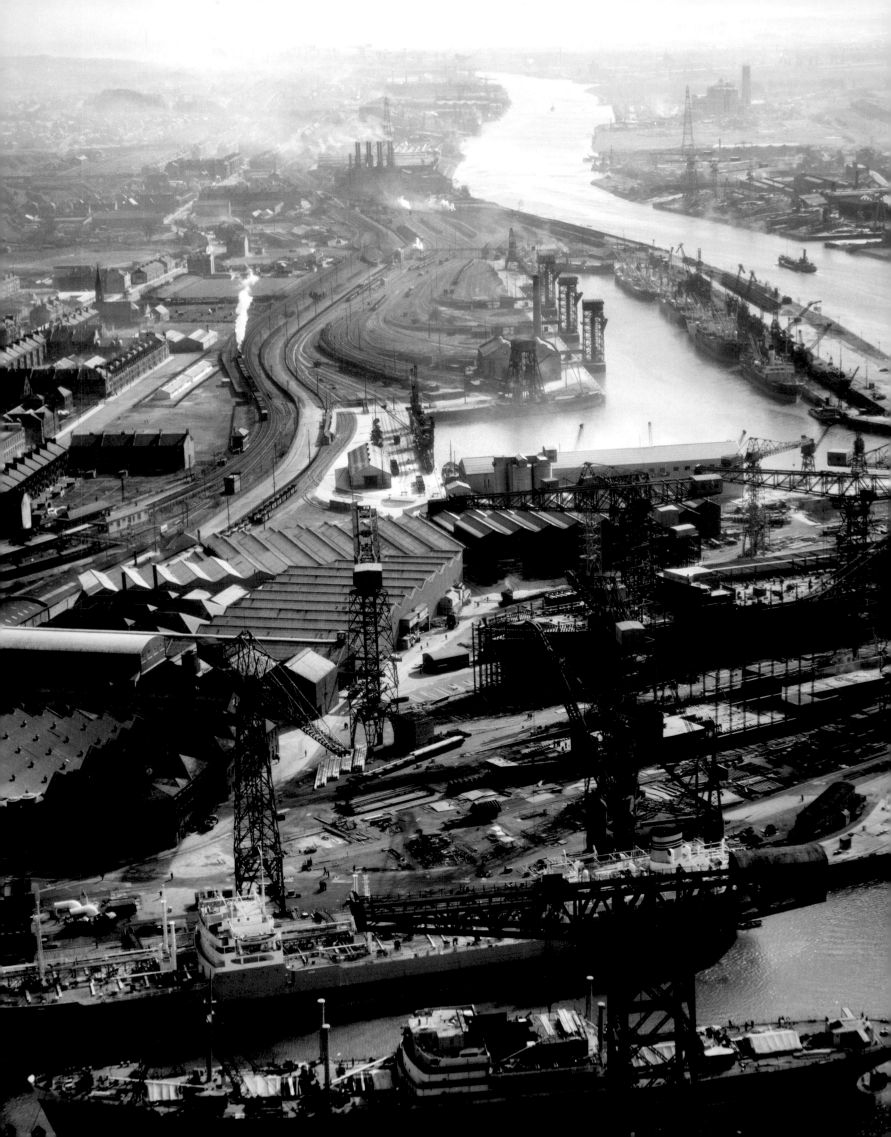

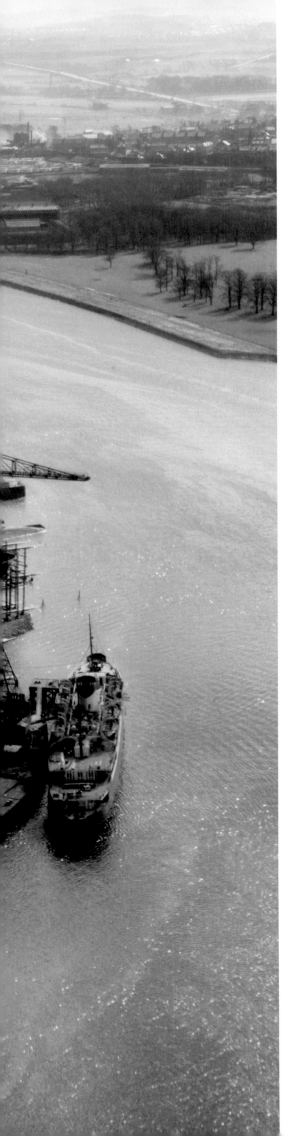

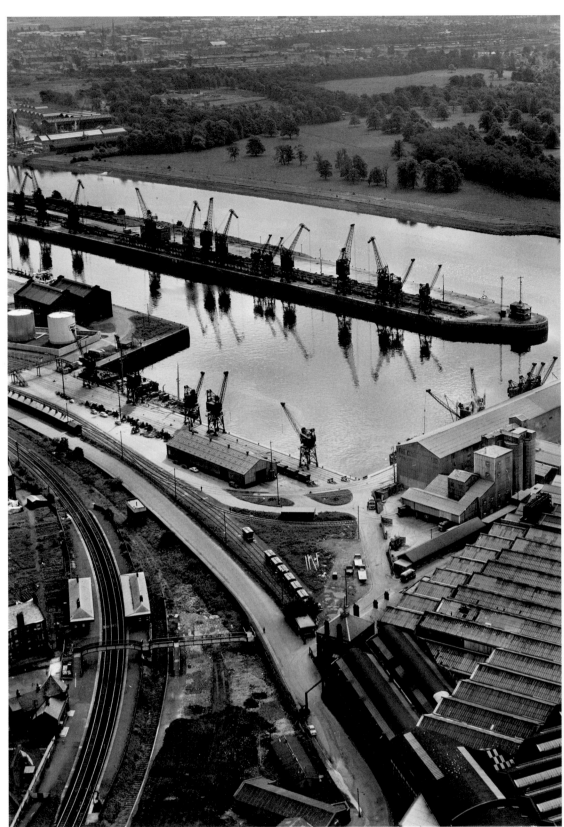

Driven to new extremes of manufacturing by the artificial market of war, it was only a matter of time before an inevitable decline afflicted Scotland's shipbuilding industry. Where once the busy frames of vessels under construction filled the quays and warehouses of John Brown's shipyard, by the 1960s rows of cranes hung listlessly over still waters.

LEFT **SC1024489** 1950

ABOVE **DP048411** 1963

ABOVE SCOTLAND

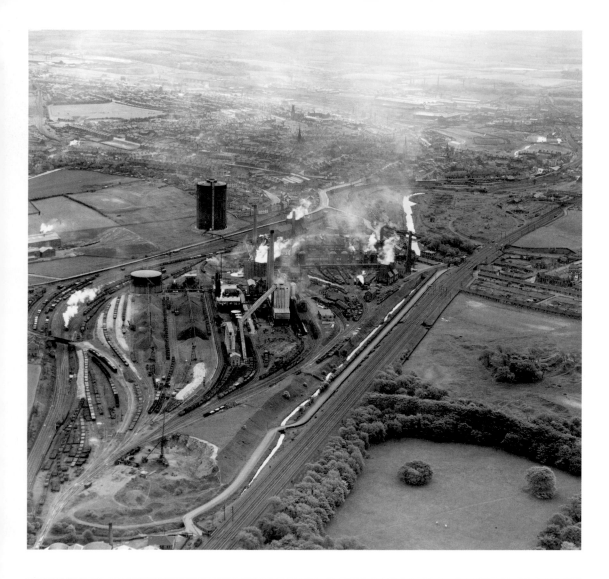

The modern world was built by iron and steel – great buildings, ships, bridges and industries forged in the molten heat of the blast furnace. Blurred by gouts of smoke and steam, the Iron Works at Gartsherrie in Coatbridge were founded in the early nineteenth century, while the Craigneuk Steel Works in Motherwell, pictured in 1949, were redeveloped in the 1950s to form Ravenscraig Steel Works. After generations sustaining the prosperity of central Scotland, the industry's many past glories are now a fading memory.

TOP LEFT **GARTSHERRIE SC682543** 1948
BOTTOM LEFT **CRAIGNEUK SC682719** 1949
OPPOSITE **RAVENSCRAIG DP048376** 1978

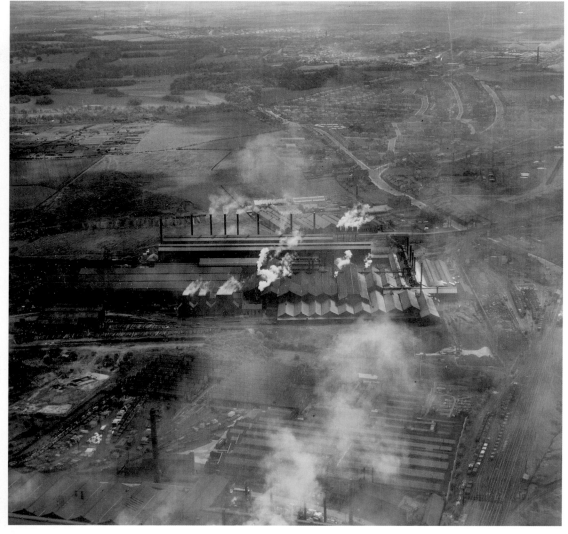

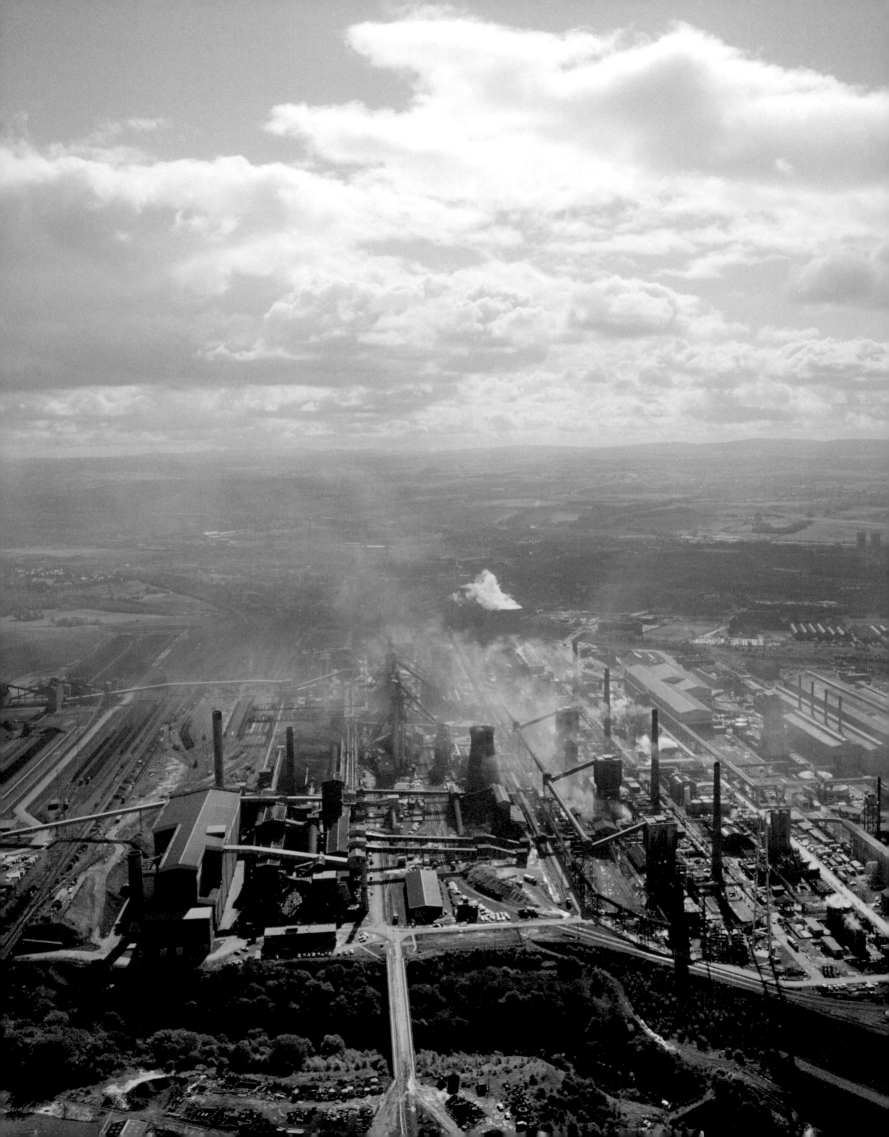

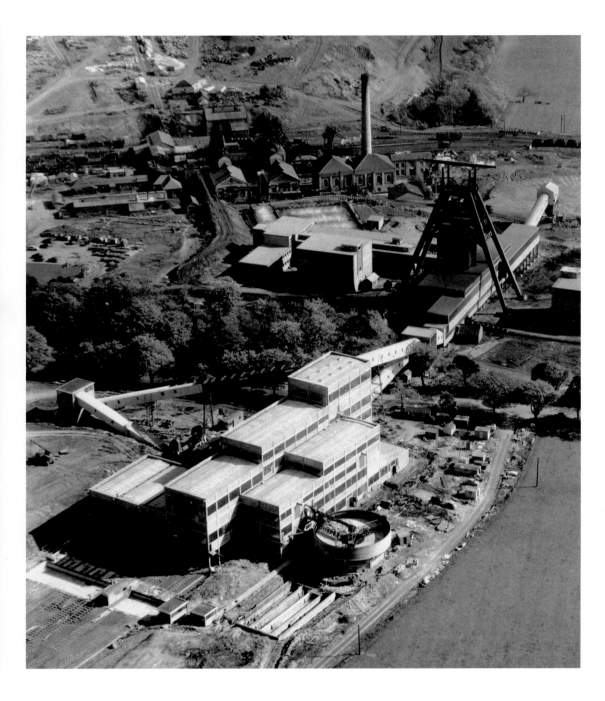

ABOVE

ABOVE

A giant steel 'A' frame – constructed by the prolific Sir William Arrol & Co – towers above a complex of support buildings at Barony Colliery near Auchinleck. Today the lonely 'A' frame is all that remains on the abandoned site, a monument to a once massive industry. SC706234 1950

RIGHT

Rising from the mudflats of Bo'ness, the huge 'bing' – or spoil heap – of the Kinneil Colliery becomes the dominant landmark on this stretch of the Firth of Forth. Half a century ago, both above and below ground, Scotland's Central Belt was gripped by heavy industry in a way that is difficult to imagine today. SC682615 1948

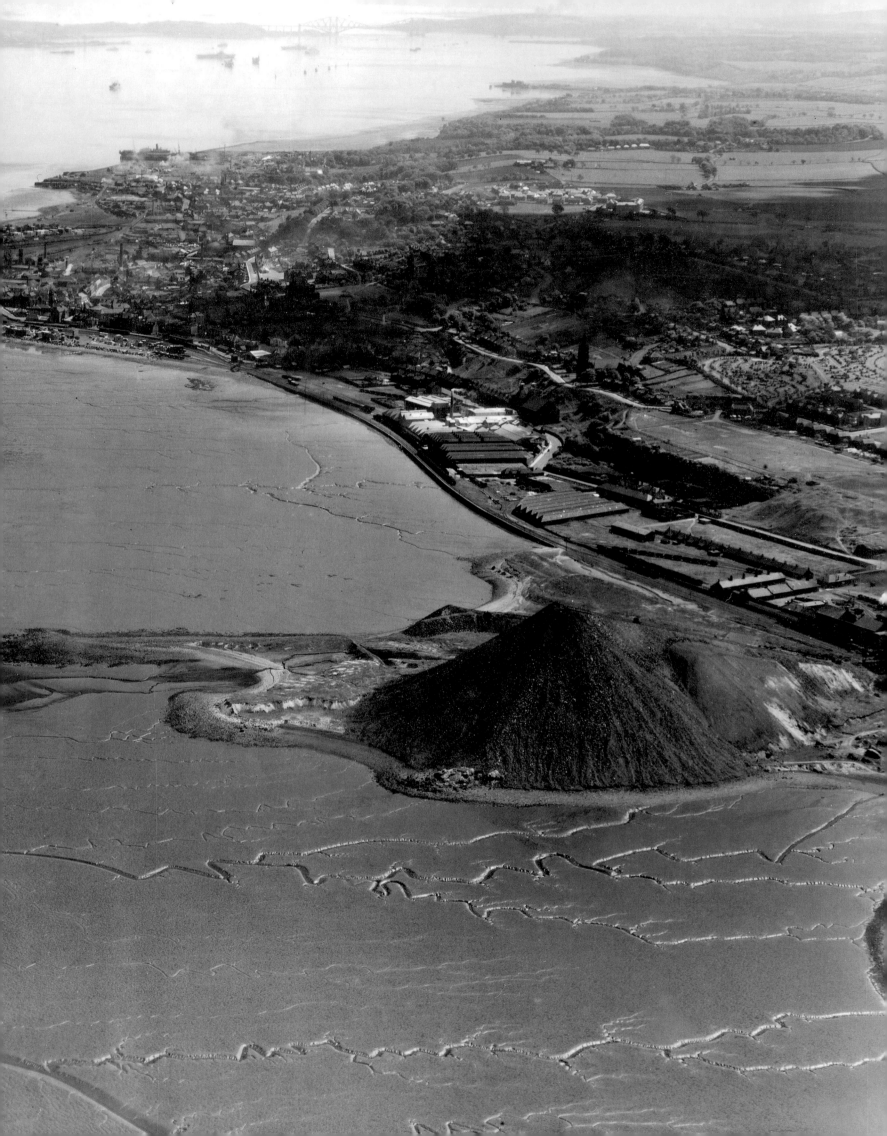

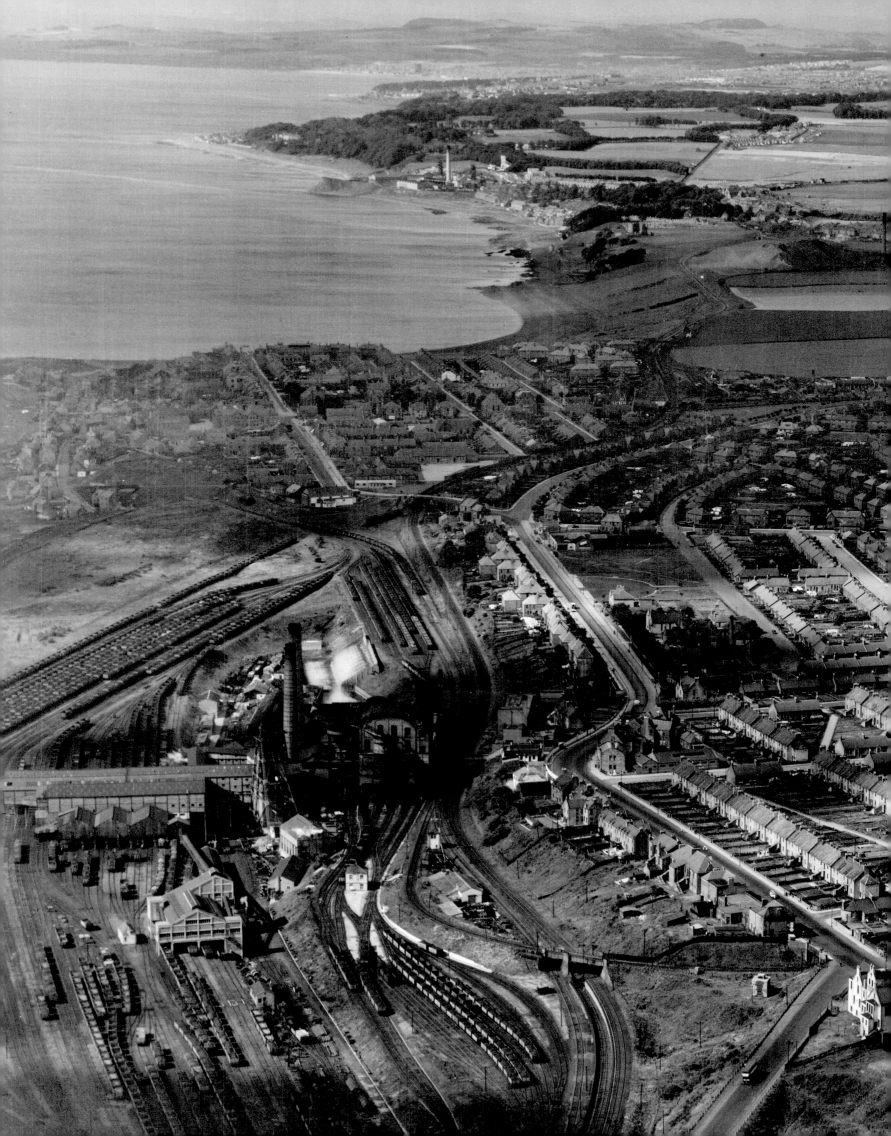

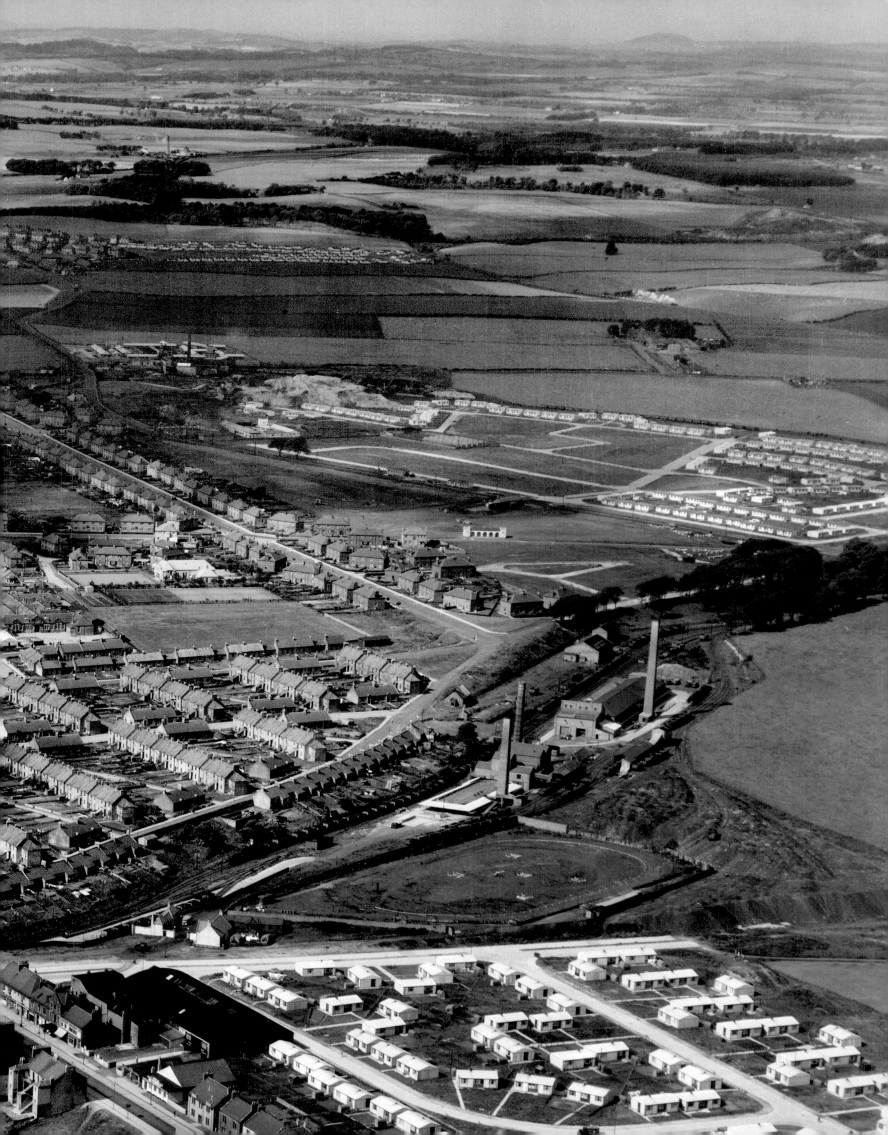

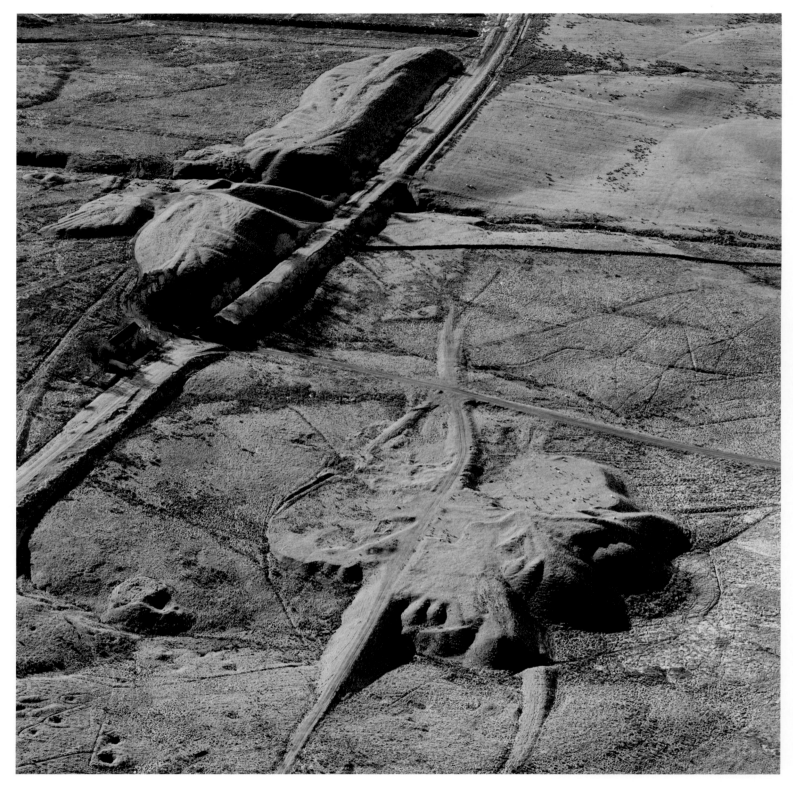

PREVIOUS PAGES
A community built on coal, the village
of Denbeath served the now long gone
Wellesley Colliery, near Buckhaven in
Fife. Tight rows of workers' houses face
the louring bulk of the Colliery on the
centre left of the photograph, with the
many tracks of the mining company's
private railway system sweeping around
and through the village. SC682501 1948

ABOVE
Great dods of spoil and disused railways
create a hillside of abstract shapes near
Auchinleck. Once at the coal-face of the
industrial revolution, these are all that
remain of the mid nineteenth century
Powharnal Colliery. DP013215 2006

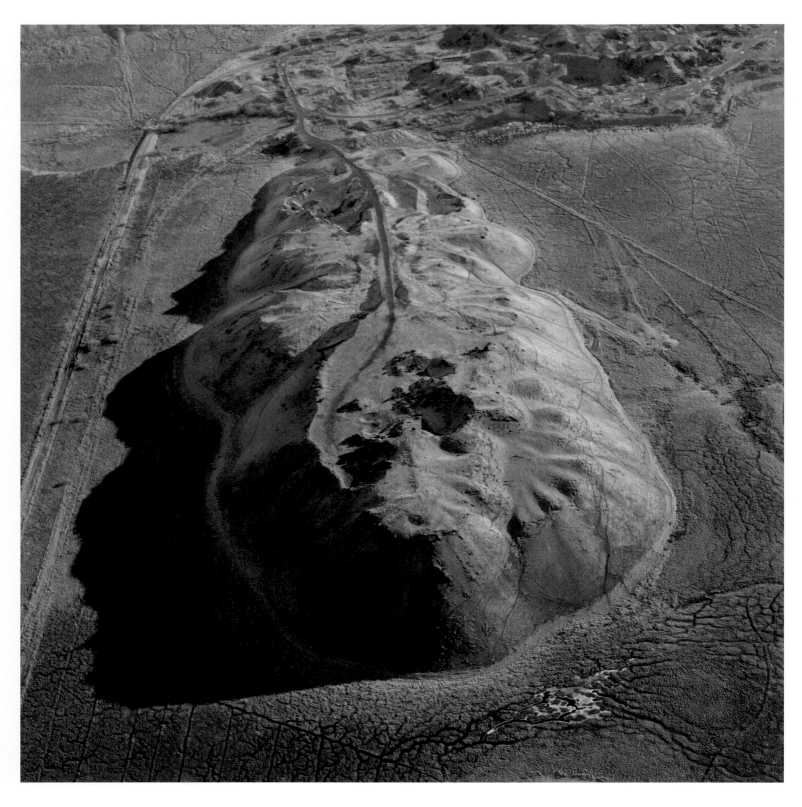

ABOVE
Pressing down on a wide plain of boggy
ground, the vast oil-shale bing at Tarbrax
in West Lothian dwarfs all around it.
This mountain of waste comes from rock
containing hydrocarbons, its characteristic
pinkish hue the result of heating the
shale to release kerosene, lamp oil and
paraffin. DP012067 2005

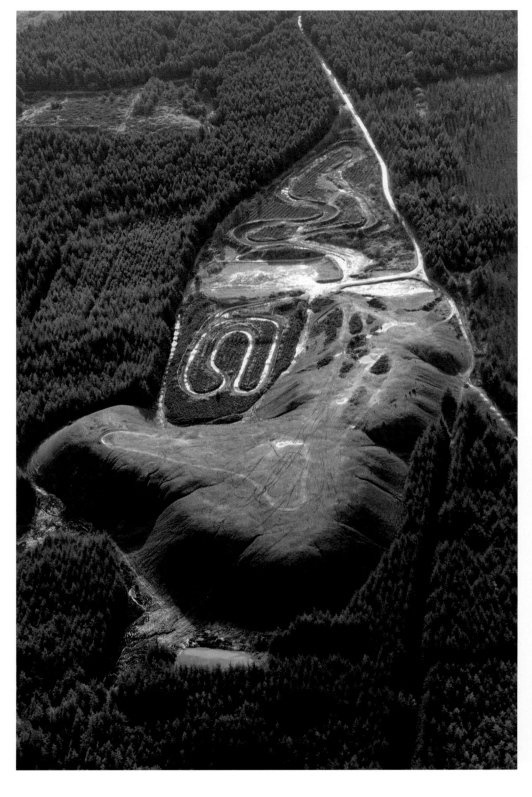

ABOVE

A giant blister erupting from the forest, this bing at Balbackie, near Shotts, marks the site of a nineteenth century coal mine. DP051589 2008

RIGHT

Cheaper than deep mining and capable of extracting thin measures of coal, open cast schemes excite strong emotions. When seen from above against the wider landscape, the sheer size of the excavations at Kelty in Fife become strikingly clear. DP040698 2008

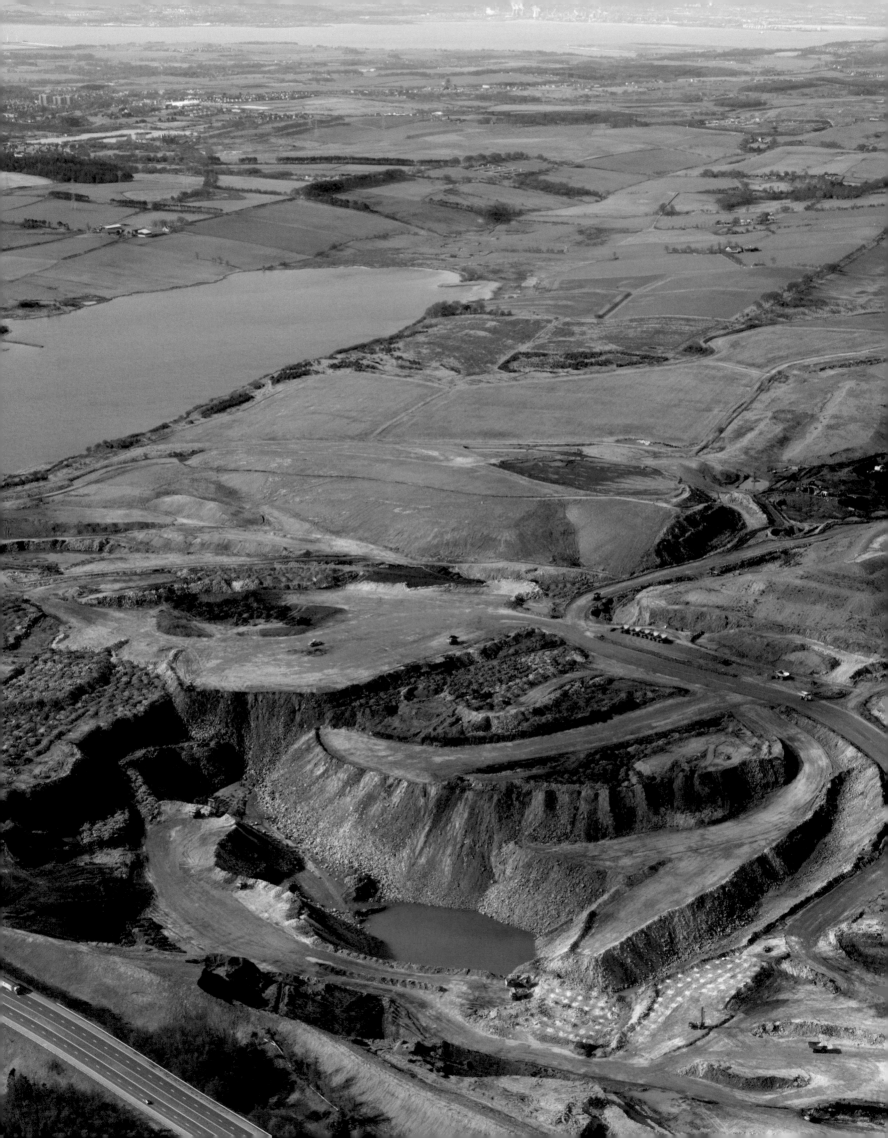

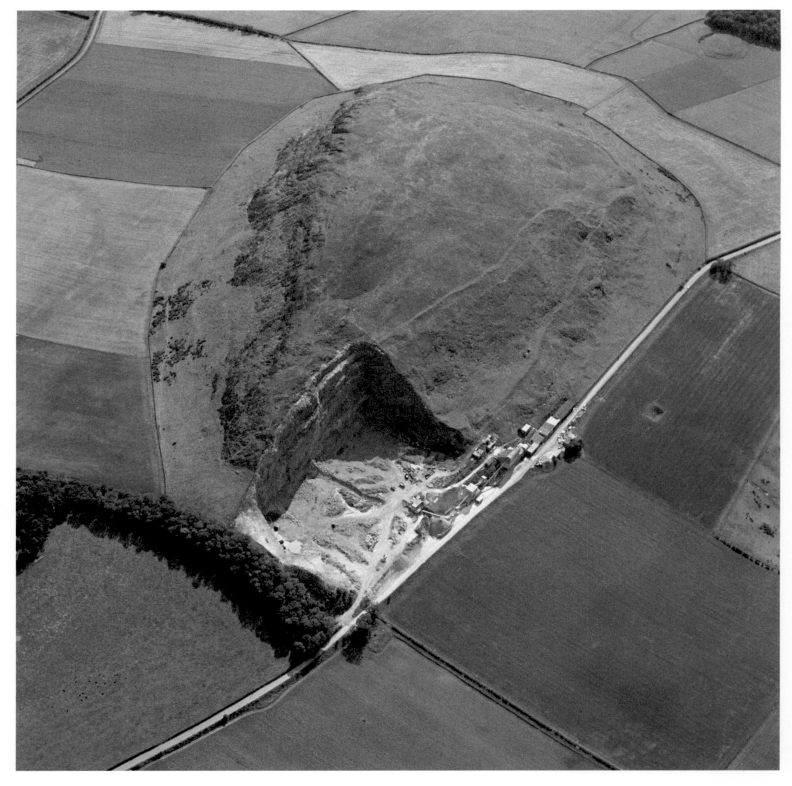

Despoiling a landmark to feed a drive for
road building, this now disused quarry
has taken a giant bite out of Traprain Law.
Rising dramatically above the fields of East
Linton, such crude quarrying is a legacy of
the past. SC370940 1972

Belnahua, a 'slate island' in the Firth of
Lorn, has been almost completely hollowed
out – the result of a massive demand for
roofing materials in the period leading up
to the First World War. DP017994 2006

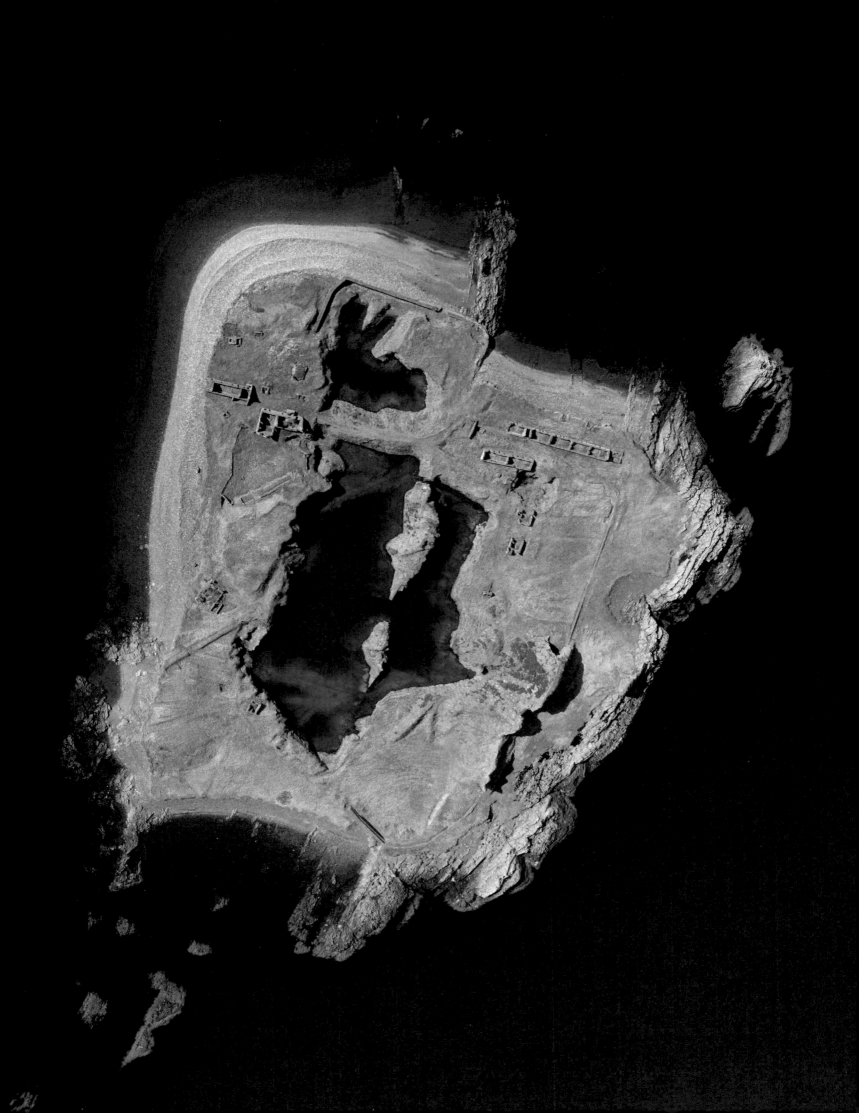

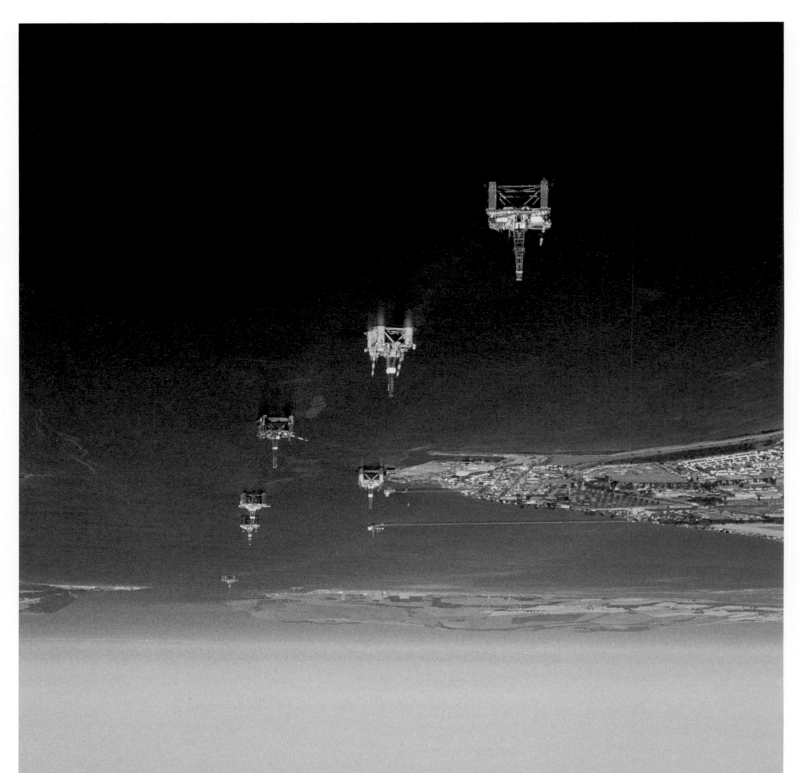

ABOVE

As the old industries of the industrial revolution headed into decline, new ones arrived to take their place. Threading a line through the Cromarty Firth, these drilling platforms sitting off Invergordon point the way to the 'black gold' of the North Sea oil fields. SC921050 2000

OPPOSITE

Built in 1924 by Scottish Oils, the oil refinery and petrochemical works at Grangemouth on the Firth of Forth is one of the oldest in Europe. SC974973 1988

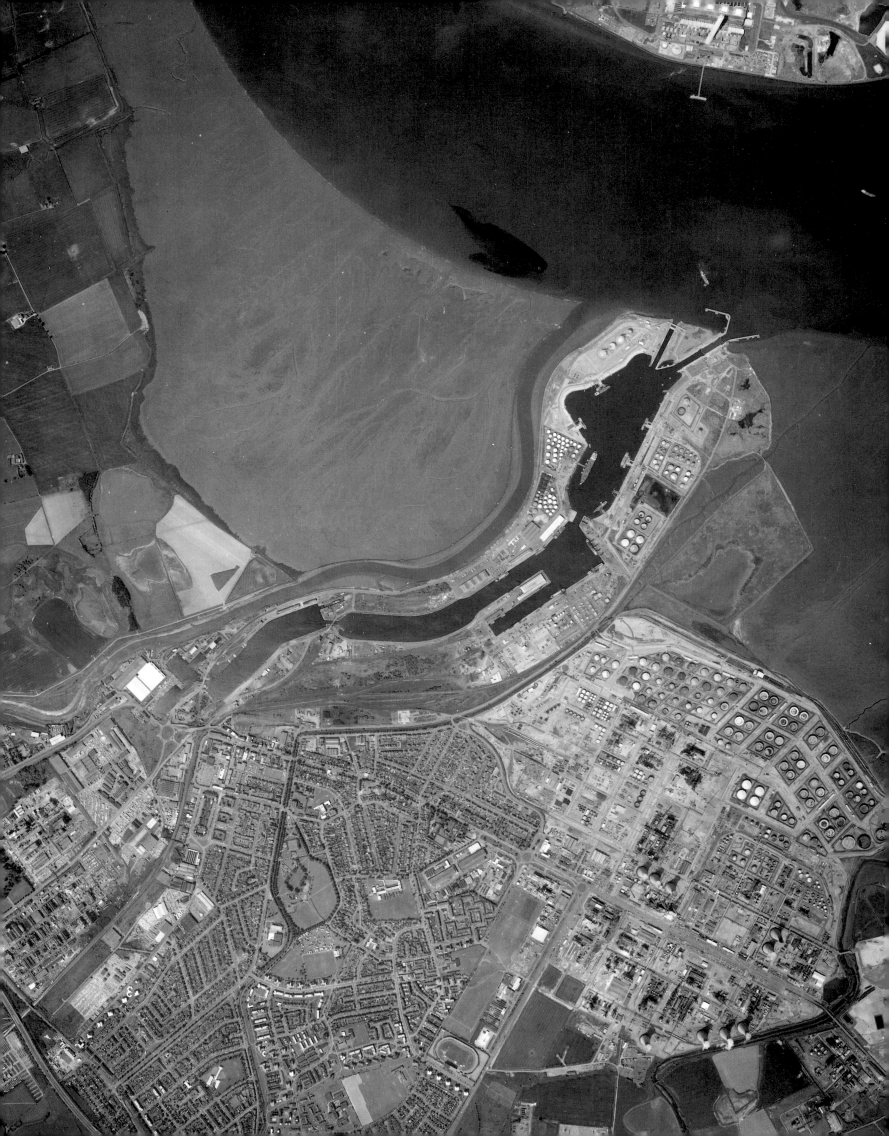

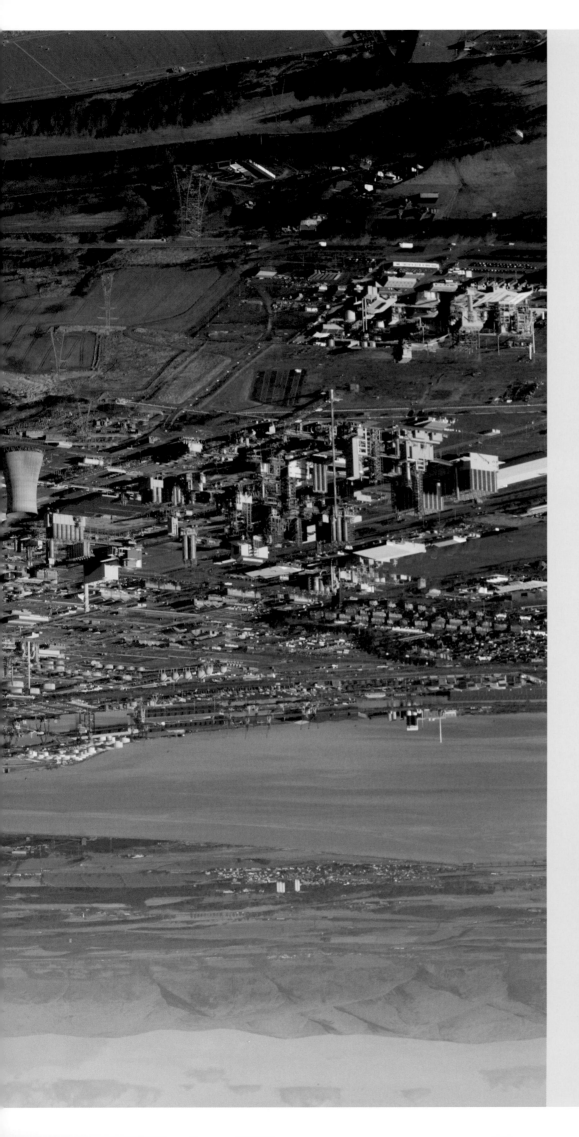

150 Sprawling like an industrial city over 690 hectares on the south shores of the Forth, Grangemouth is capable of processing 210,000 barrels of oil a day, and 10 million tonnes of oil each year. DP013239 2006

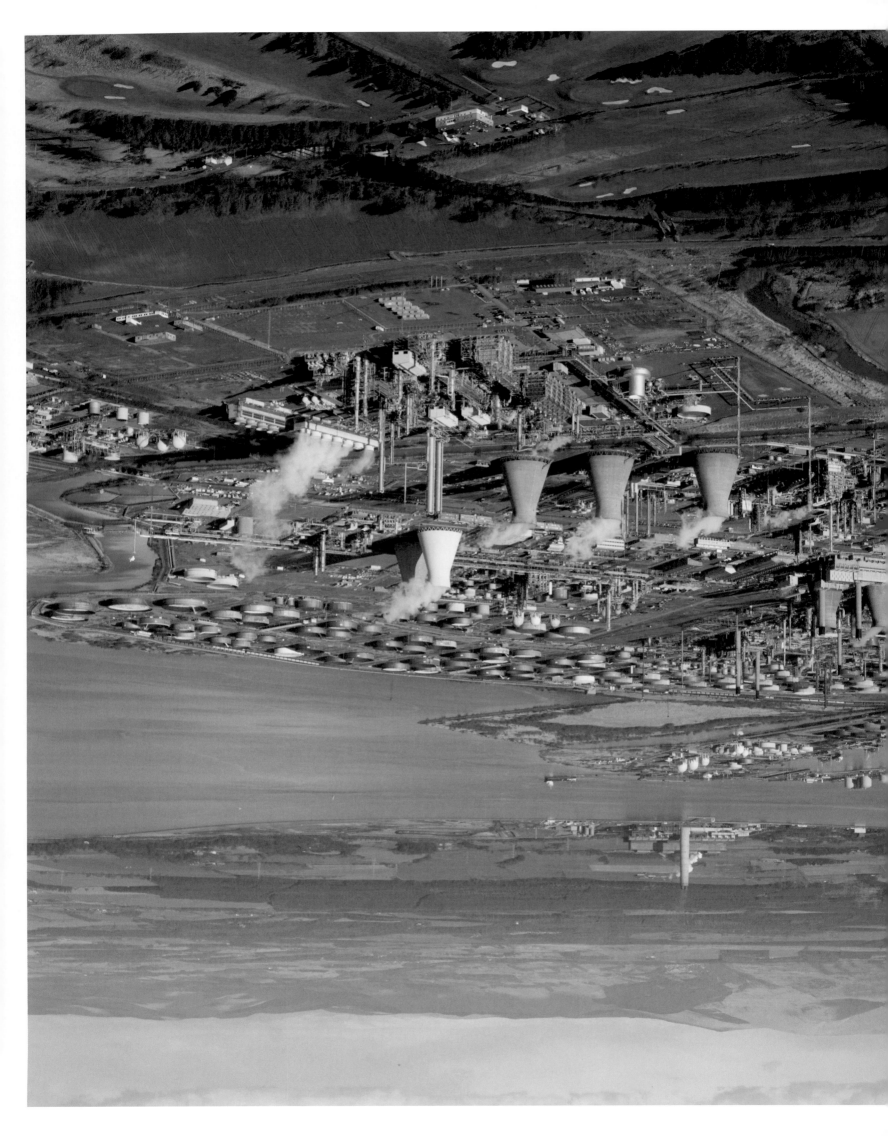

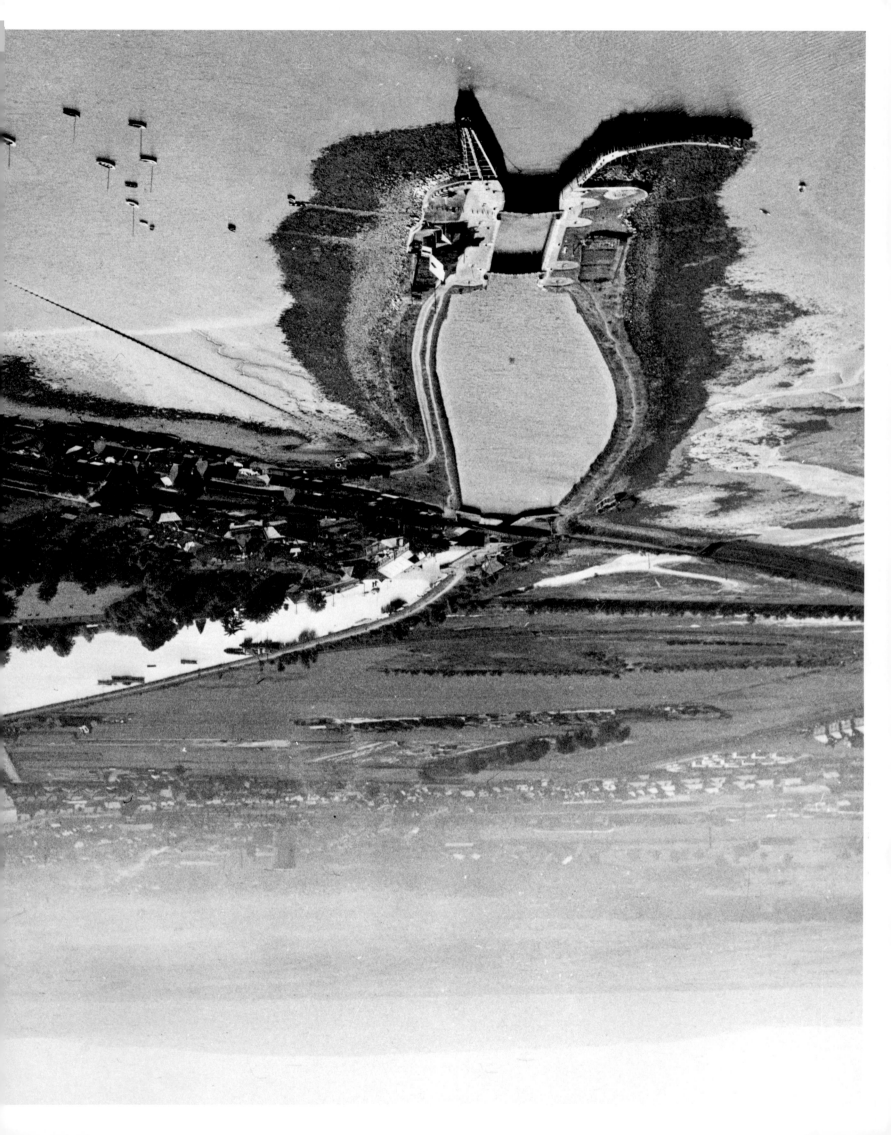

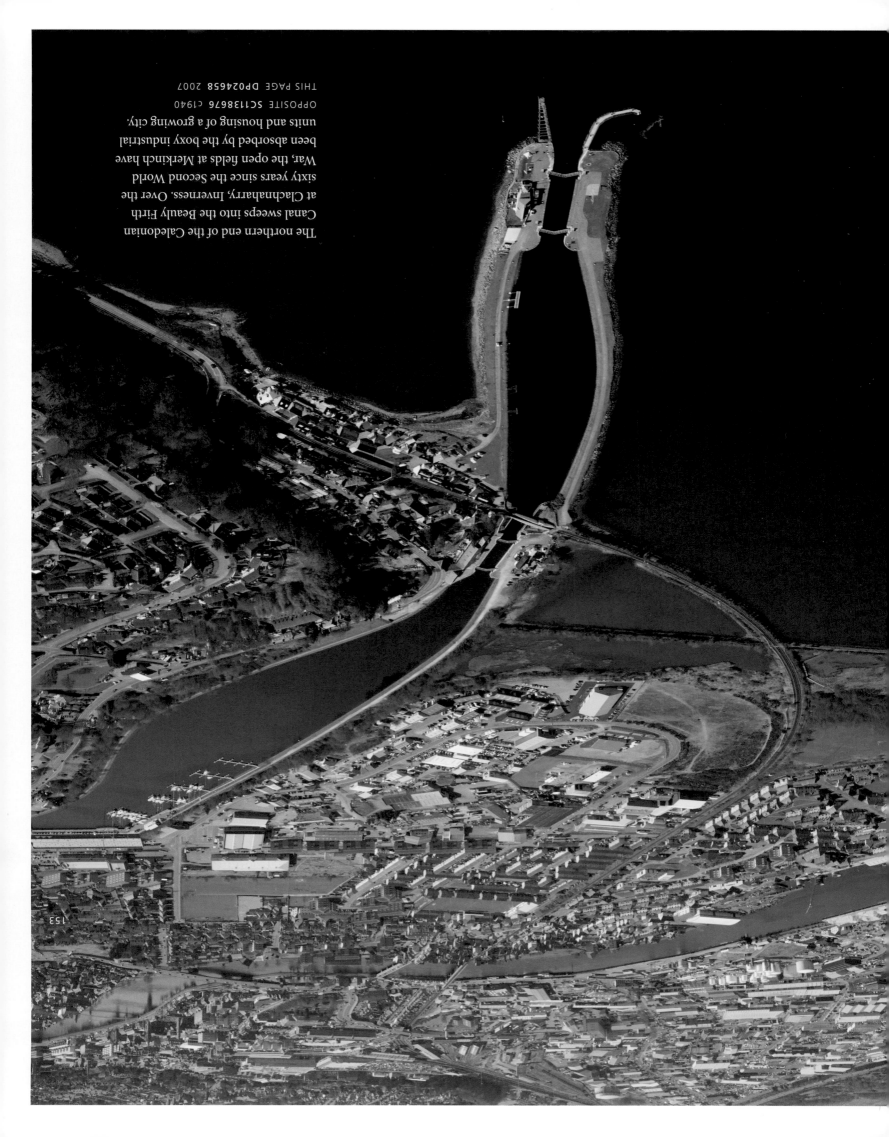

The northern end of the Caledonian Canal sweeps into the Beauly Firth at Clachnaharry, Inverness. Over the sixty years since the Second World War, the open fields at Merkinch have been absorbed by the boxy industrial units and housing of a growing city.

OPPOSITE SC1138676 c1940
THIS PAGE DP024658 2007

153

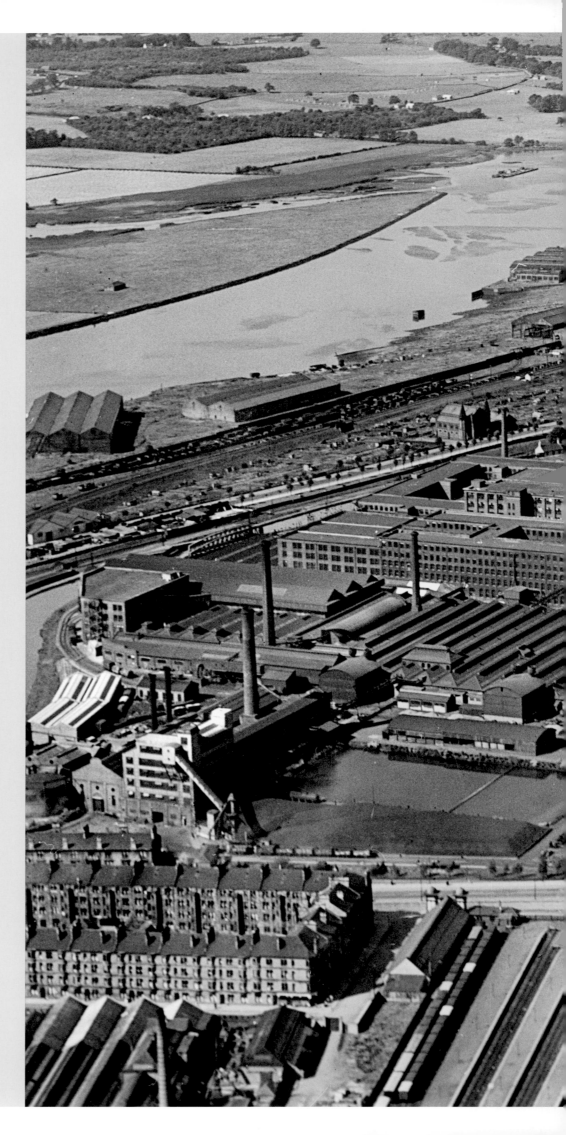

PREVIOUS PAGES

Standing tall on the steep banks of the
River Clyde, the purpose-built textile mill
village of New Lanark was founded in
1785. Early in the nineteenth century, the
Utopian idealist Robert Owen inspired
a model industrial community here,
pioneering a progressive social philosophy
which advocated education, factory reform
and humane working practices. In recogni-
tion of the profound influence that the
New Lanark model had on social develop-
ments throughout the nineteenth century
and beyond, it is now a World Heritage
Site. DP055178 2009

RIGHT

Marking out the hours for its many
workers, the clock tower of the Singer
Sewing Machine Factory at Kilbowie,
Glasgow, was once the second highest time-
keeper of its kind in the world. Established
beside John Brown's shipyard on the Clyde,
at its peak the Singer factory employed
12,000 people and was the world's largest
sewing machine manufacturer. This
huge complex of buildings has entirely
disappeared, today referenced only in the
name of Clydebank, Singer Station on the
Glasgow train network, seen here on the far
right of the photograph. DP048412 c1930

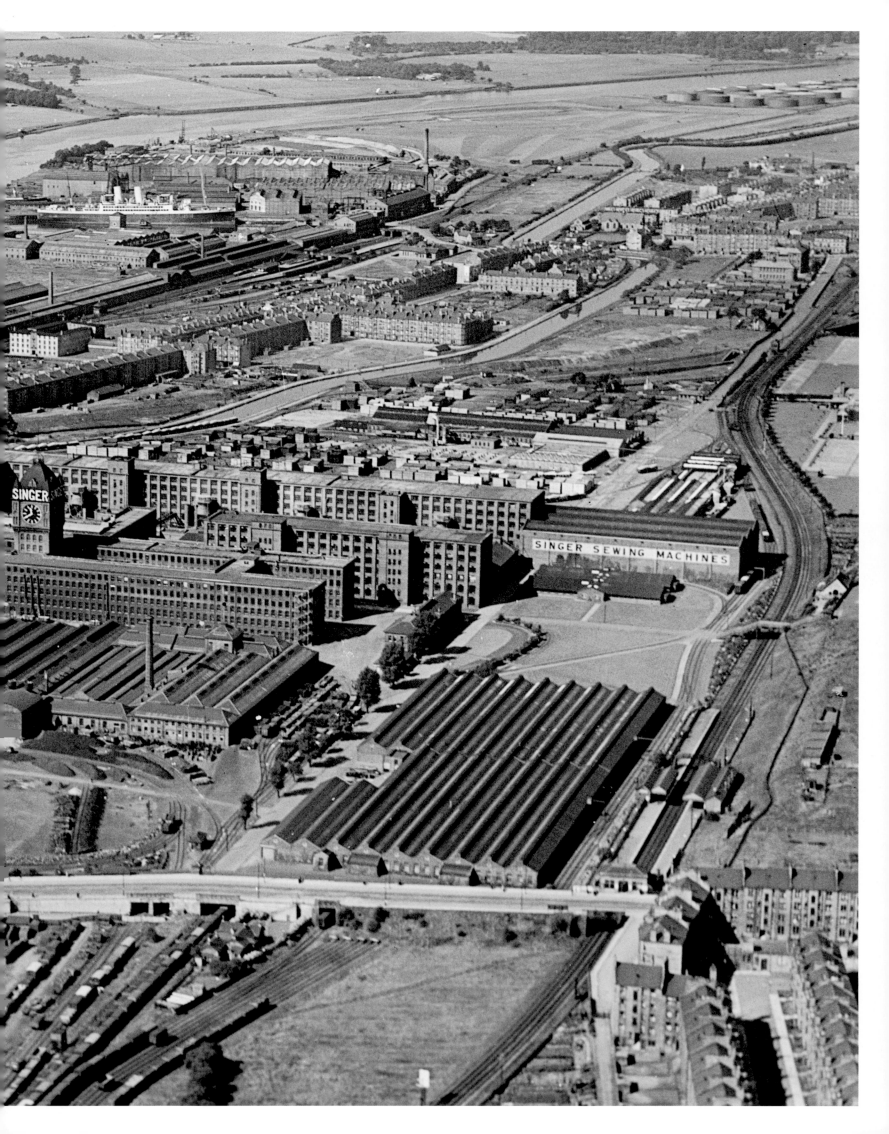

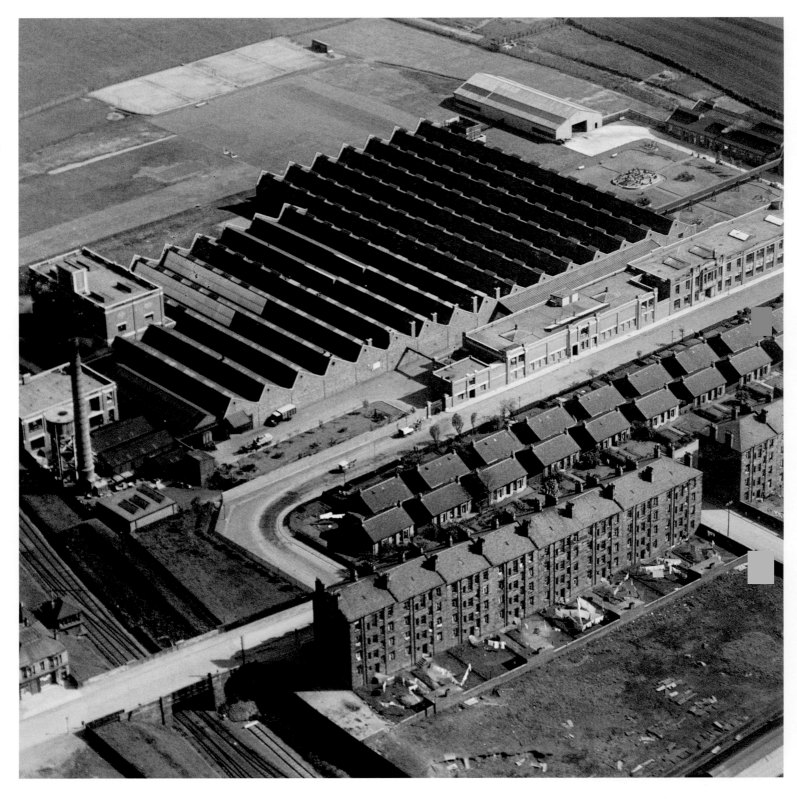

ABOVE

'Butter Bar Biscuits are really delightful – TRY THEM!' An unsubtle advertising slogan by today's standards, but no doubt a success for the Macfarlane Lang & Co Biscuit Factory in Glasgow, which went on to become part of United Biscuits, now one of Britain's leading food suppliers.

DP048145 1929

OPPOSITE

The smoking chimneys of the jute industry still dominated the Dundee skyline well into the first half of the twentieth century. Of the eleven jute mills visible here, all are now gone after the collapse of the industry in the post-war period. SC682696 1947

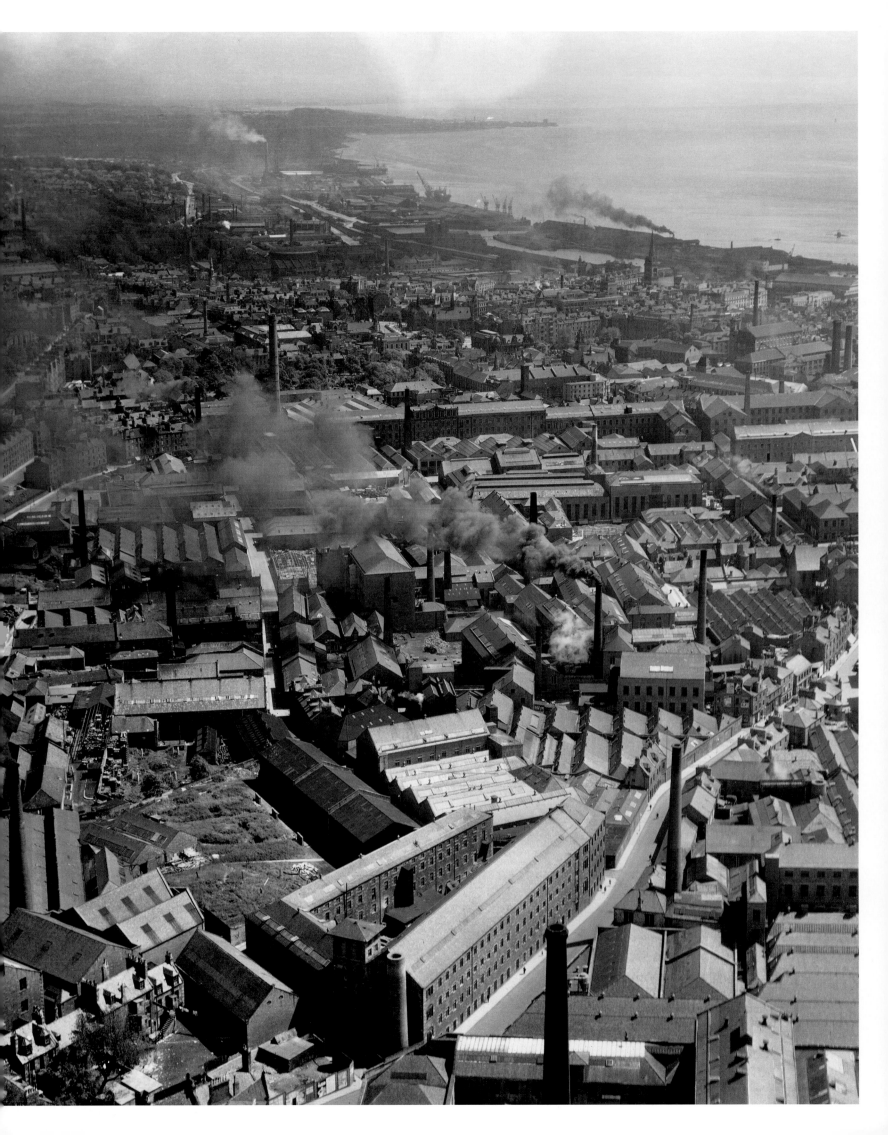

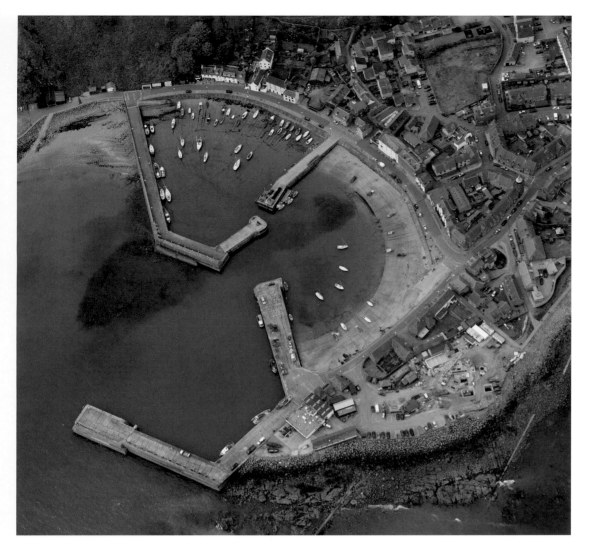

On Scotland's long, indented coastline, the strong, hard-standing lines of harbours, piers and jetties create new boundaries between water and land. From Stonehaven in Aberdeenshire to Mallaig in the West Highlands, the fishing industry has been a crucial part of the economy for many hundreds of years. Considerable development and investment – particularly in the nineteenth century – brought structure to the industry and further spliced many communities to the fortunes of the sea. Stonehaven harbour, pictured here, was redesigned in 1825 by Robert Stevenson, and became one of the most important herring fishing ports in Scotland.
DP048604 2008

As the 'Road to the Isles' and the West Highland Railway come together at their final stops, the harbour walls of the thriving fishing port of Mallaig carry on into the waters of the Sound of Sleet. DP031354 2007

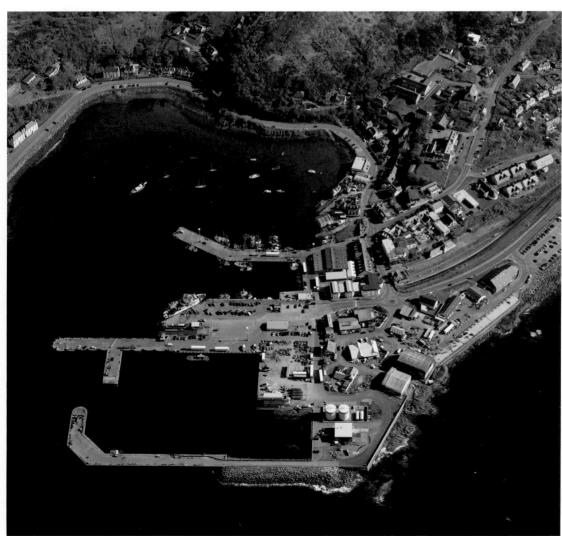

The importance of Anstruther in Fife as a fishing centre dates back to at least the fourteenth century. At that time, the land of Anstruther Easter harbour was owned by Balmerino Abbey and the monks received salted herring from the fishermen in return for allowing them space to dry their nets. In the nineteenth and early twentieth century, Anstruther was the capital of the Fife fishing industry. DP016603 2006

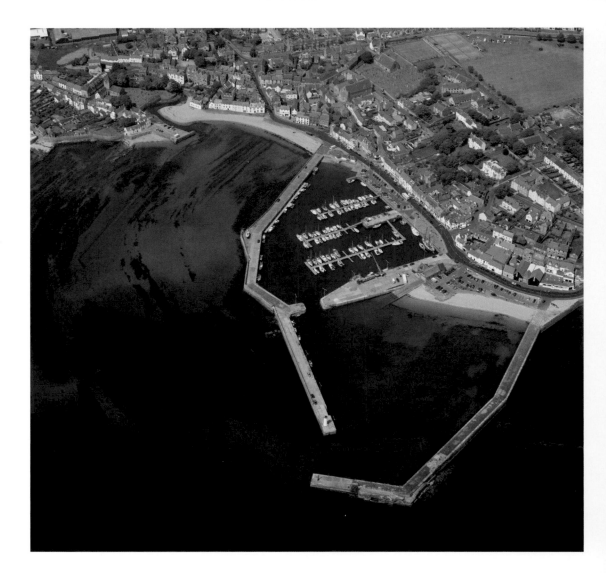

The village of Crail was famously known for its sun-dried haddocks – 'Crail capons'. The west pier of this tiny harbour in Fife's East Neuk was built by Robert Stevenson & Sons in 1828, providing the village with a secure anchorage that remains in use to this day. DP032890 2007

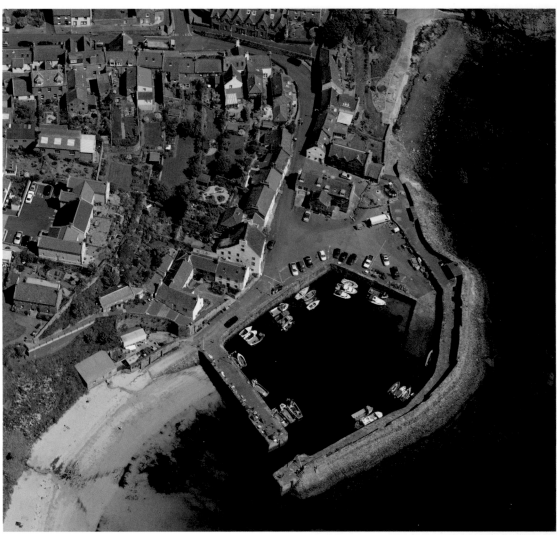

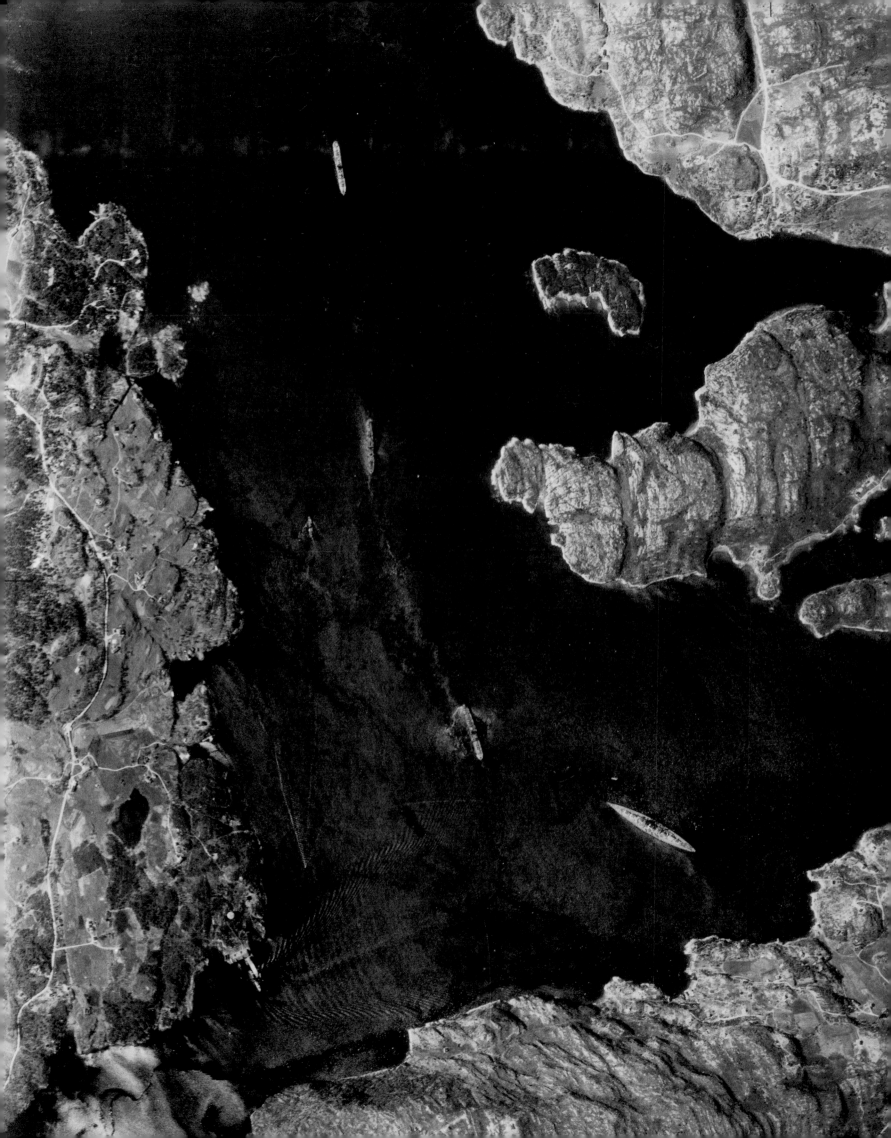

Scotland at War

On the morning of 21 May 1941, a Spitfire roared along a camouflaged runway near Wick in the far north of Scotland, taking off on a reconnaissance flight to look for the largest and most feared battleship in the German Navy – the *Bismarck*. At 1:15pm, 25,000ft above a fjord on the south coastline of Norway, Pilot Officer Michael 'Babe' Suckling photographed a large warship. He was convinced that he had found the *Bismarck*. Returning to Wick, Suckling and the station's photographic interpreter viewed the prints still wet from the darkroom. They informed Coastal Command of their discovery and the order came for the photographs to be flown to London for immediate analysis. Suckling took to the air once again. Low on fuel after his earlier sortie, he was forced to land at Nottingham and drive through the blackout night, arriving in the early hours. His sighting was confirmed and, just seven days later, after an arduous chase, Germany's flagship vessel was caught and destroyed by the Royal Navy.

By the onset of the Second World War, the nature of global conflict had reached such a terrifying state that entire continents

1 Loch of Strathbeg
2 Leuchars
3 Firth of Forth
4 Mathernock Farm
5 Scapa Flow
6 Gullane Links
7 Cromarty Firth
8 Inveraray
9 Happendon Wood
10 Hillington
11 Kinloss
12 Throsk
13 Dalbeattie

were recast as battlefields. Britain, separated from the rest of Europe by sea, became an island fortress, a country mobilised for war by a vast military infrastructure that left no part of the country and its population untouched. The airfield at Wick, the staging post for crucial aerial reconnaissance missions like Suckling's, as well as regular bombing raids, was one of many built on land requisitioned by the War Office. Country houses were transformed into makeshift hospitals and barracks, and the countryside was dotted with villages of Nissen huts and even prisoner-of-war camps. The threat of invasion saw coastal batteries in strategically important locations from Scapa Flow to the Firth of Forth bolstered along much of Scotland's east coast by pillboxes, machine-gun emplacements and long lines of anti-tank blocks, particularly on shallow beaches suitable for enemy landings.

Important industrial and manufacturing sites, from munitions and aero engine factories to the Clyde shipyards, found themselves on the front line as targets for Luftwaffe bombing. Wearing camouflage coats of paint, they were protected by menacing arcs of anti-aircraft emplacements. On hill tops and coastlines, radar, radio and listening bases strained to detect the sounds of enemy activity, their now derelict remains a remarkable testament to the value of intelligence gathering in modern warfare.

Historic aerial photographs are a fascinating record of Scotland in the midst of the greatest conflict the world has ever seen, a country bristling with defences and armaments, its industries straining to support the war effort. Over 60 years later, contemporary images show crumbling coastal batteries and defences, poignant monuments to the sacrifices made by a landscape and its people in the defiance of tyranny.

PREVIOUS PAGES
'The photograph that sank a battleship'. Pilot Officer Michael 'Babe' Suckling's discovery of the *Bismark* sparked one of the largest search and destroy missions in naval history. ACIUN183660 1941

OPPOSITE
An island fortress living in fear of invasion, heavy defences lined the Scottish coast as German forces swept across continental Europe. Here, at the Loch of Strathbeg between Peterhead and Fraserburgh, a sunken ship lies in the shallow waters of a shoreline of barbed-wire entaglements. Very much a working photograph, the 'frisket' – or title strip – along the bottom of the picture records the mission number, date, focal length of the camera and direction of flight. Images like this were often taken by the Royal Air Force to monitor coastal defences. SC1031159 1941

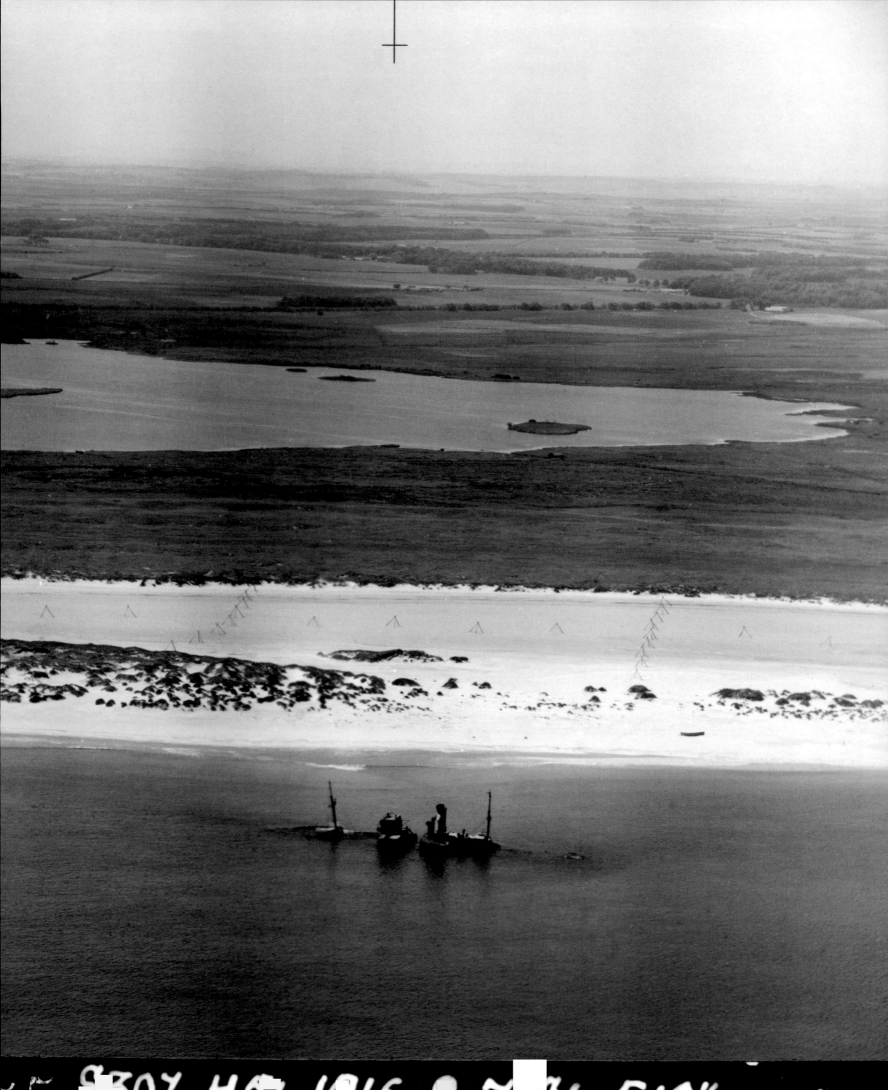

5 S307. H57. 1416. 8. 7. 41. F14" ⟶

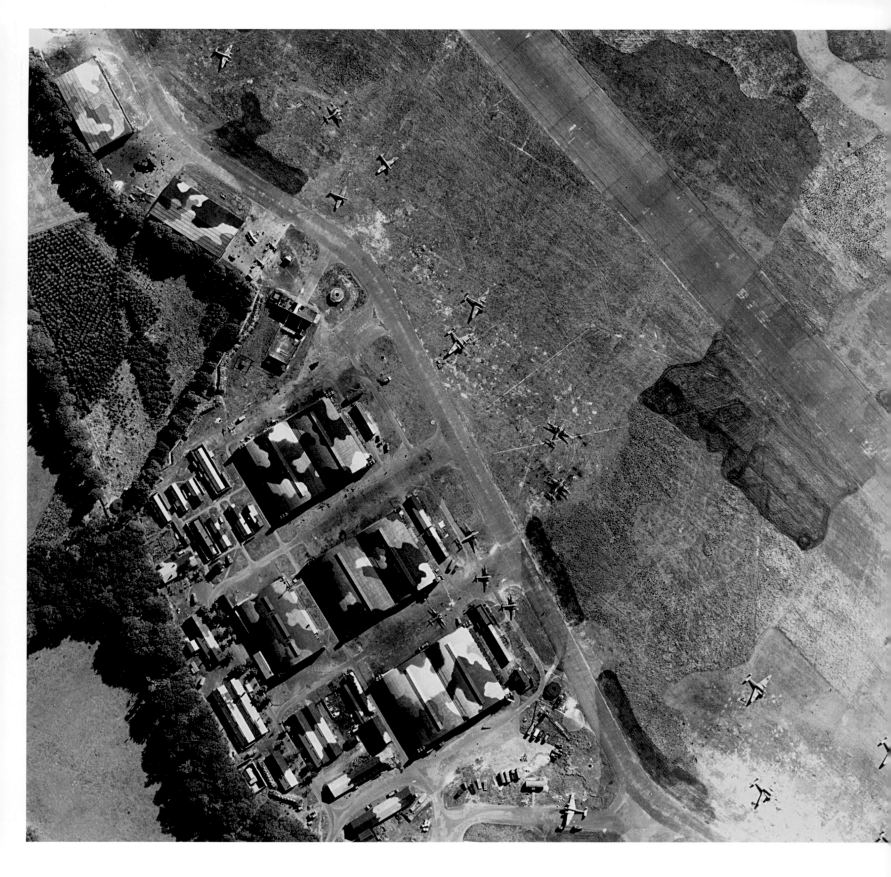

ABOVE
Camouflaged against aerial attack, air-fields like Leuchars in Fife were a vital part of Britain's war machine. Aircraft parked on the grass and tarmac beside the hangars include Spitfires, Hampden bombers and Lockheed Lodestar transports. SC458731 1942

OPPOSITE
Front-line Scotland. The first German air-raid into Scottish skies took place on 16 October 1939 and was planned with the help of extensive Luftwaffe intelligence photography. The annotations on this reconnaissance image of the Forth Railway Bridge identify anti-aircraft and coastal batteries. SC372380 1939

Queensferry (Firth of Forth)
Hilfsstützpunkt Port Edgar

Karte 1:100 000
Blatt
Sch. 27

1:63 360
Blatt
Sch. 68

Kriegsaufnahme:
597 R 54

Länge (westl. Greenw.): 3° 23' 20'' Breite: 56° 0' 0''
Mißweisung -13° 24' (Mitte 1939) Zielhöhe über N.N: 50m

Nachträge:
2.10.39.

Maßstab etwa 1 : 15 000 (1cm → 150 m)

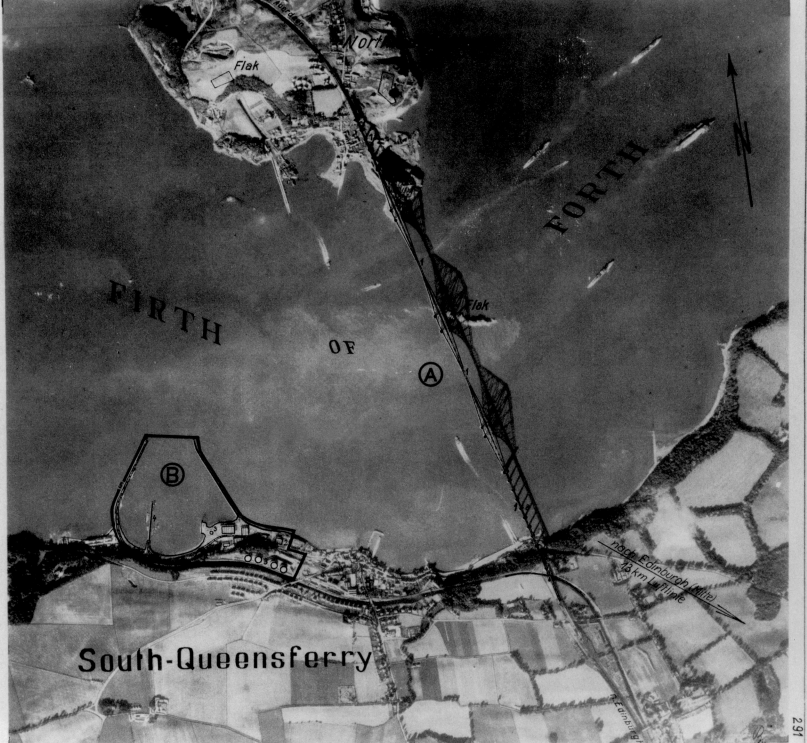

Ⓐ GB 41 6 Eisenbahnbrücke über den Firth of Forth

1) 2 Stahlbrückenbogen auf 3 Hauptpfeilern, in je 4
 massiven Fundamentblöcken verankert
1a) 2 Viadukte mit 17 Steinpfeilern
 Brückengesamtlänge etwa 2 500 m, Breite etwa 8m

Ⓑ GB 12 12 South Queensferry - Port Edgar
 (Hilfsstützpunkt)

2) 5 Depothallen etwa 6 000 qm
3) 6 Tanks: 4 große ⌀ etwa 35m, 2 kleine ⌀ ca 5m
 etwa 4 200 qm
4) Ölpier mit Gleisanschluß
5) Kai mit Entladekränen
6) Verwaltungsgebäude
 bebaute Fläche (Schwerpunkte) etwa 10 200 qm

 Gleisanschluß vorhanden

291

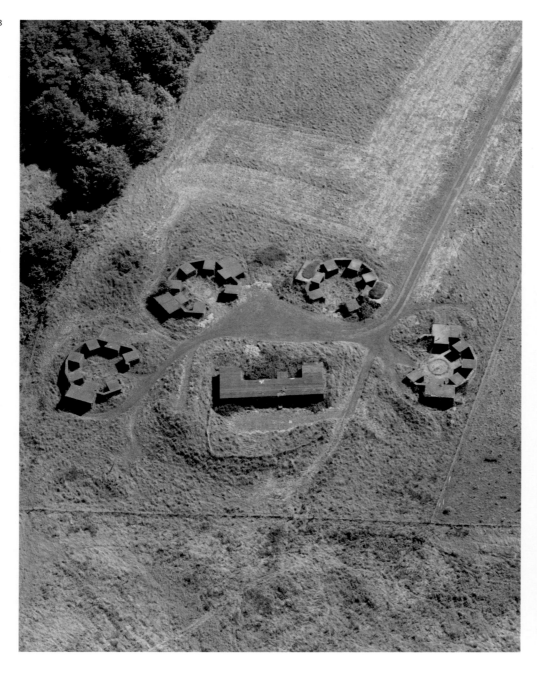

ABOVE

These empty sockets of shuttered concrete once housed four 3.7-inch anti-aircraft guns. Lying on Mathernock Farm above Port Glasgow, they were one of the defences for the Firth of Clyde and Glasgow – vital manufacturing areas for Britain's war effort. DP035812 2007

RIGHT

The remains of two six-pounder guns still stand sentinel at Scad Head on the western shores of Scapa Flow, Orkney – part of an extensive range of coastal batteries built to defend Britain's main northern naval base. DP053367 2008

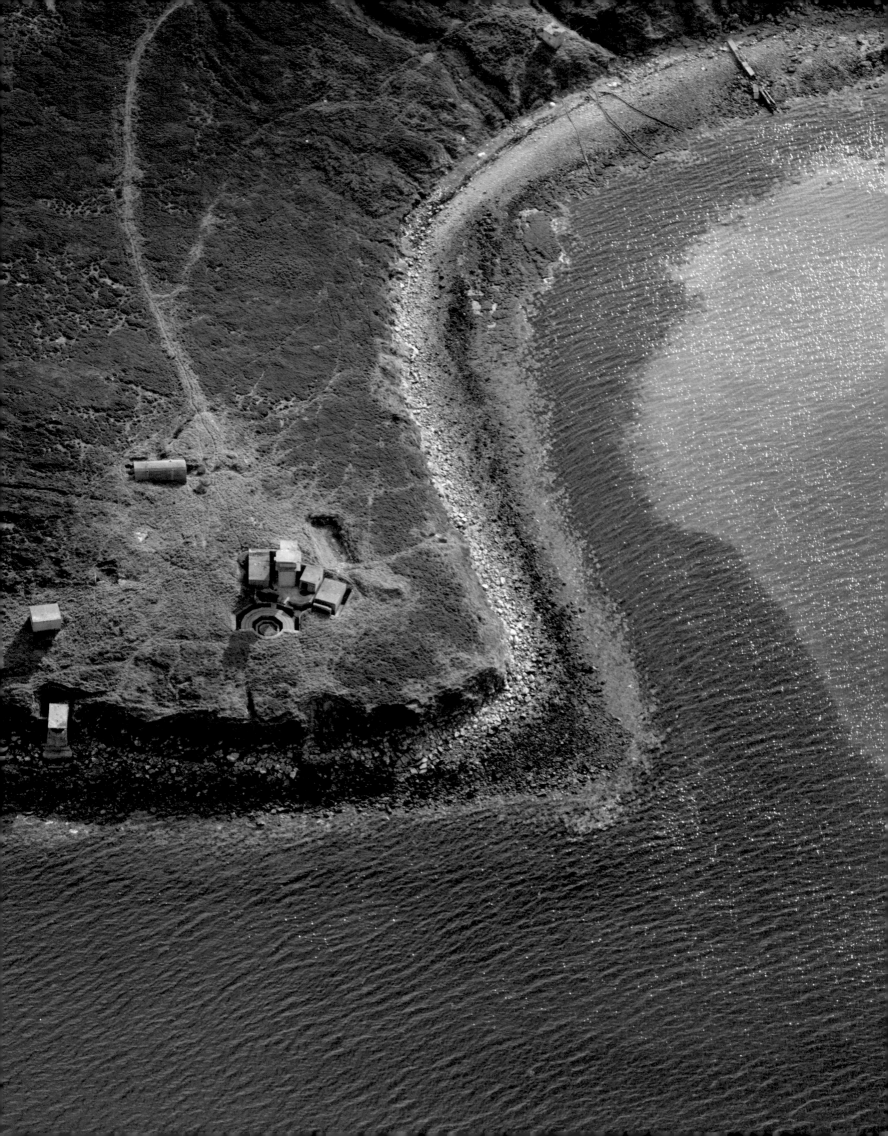

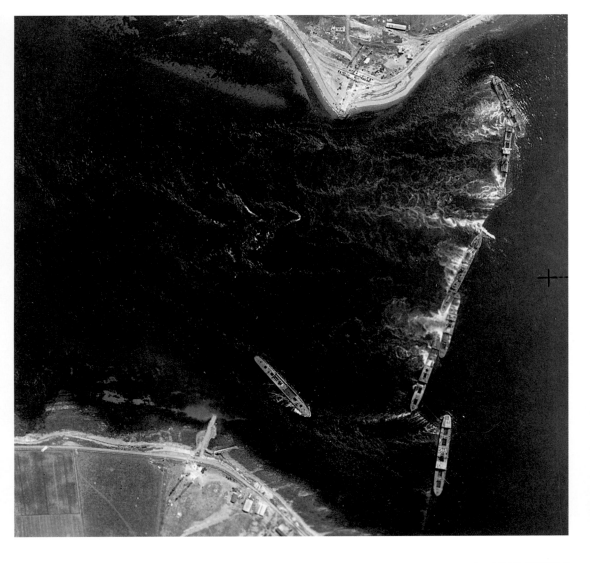

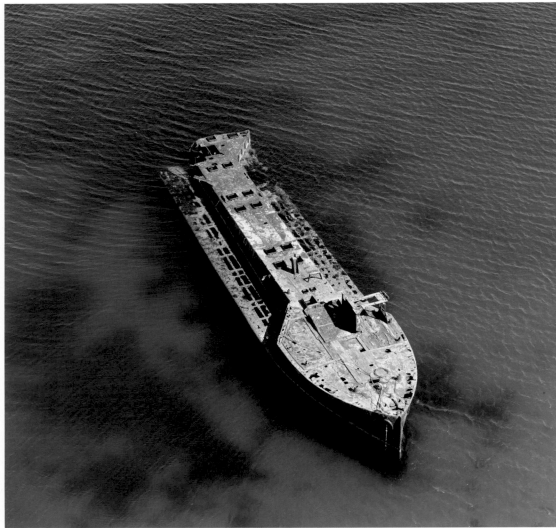

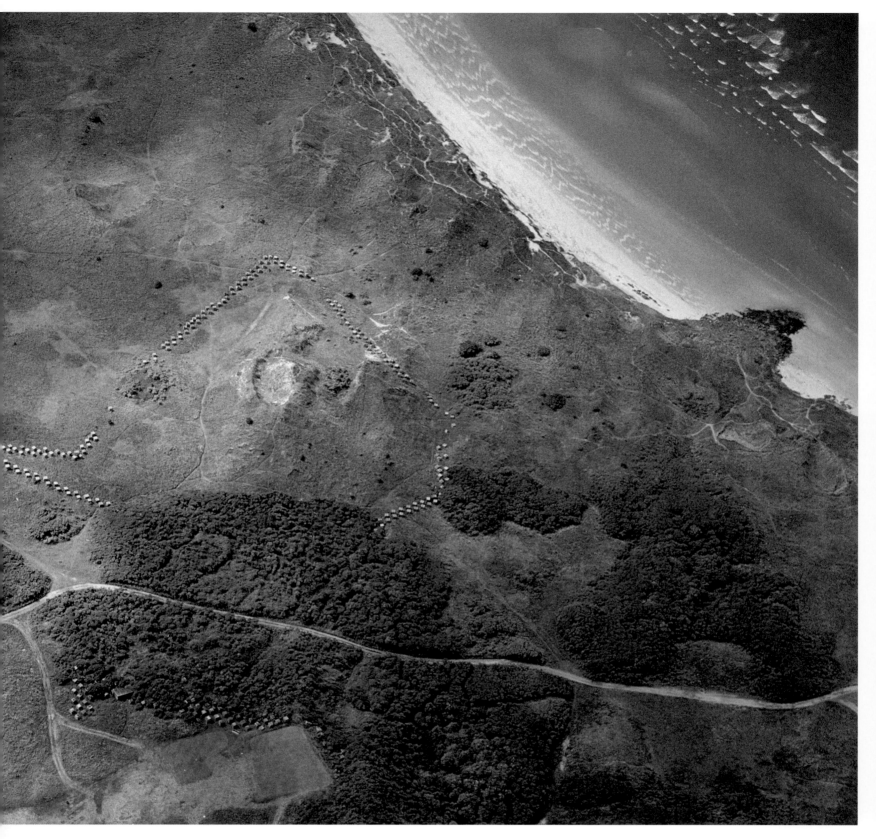

TOP LEFT

On 14 October 1939, little over a month after Britain had entered the Second World War, the German submarine U-47 slipped through the Kirk Sound and past the defences of Scapa Flow to sink the battleship HMS *Royal Oak*. 833 lives were lost in this one attack, tragically exposing the weaknesses of Scapa Flow and leading to the substantial reinforcement of its defences. Seen here in 1942, the narrow channel between Lamb Holm and Orkney Mainland is plugged by a line of 'block ships' – scuttled hulks that were later replaced by the permanent lines of the Churchill Barriers. SC458742 1942

BOTTOM LEFT

A study in decay against an acid green sea, the *Nana* is a former tanker sunk as a 'block ship' in Scapa Flow in March 1939 and later refloated and towed to Inganess Bay near Kirkwall airport. DP058591 2009

ABOVE

Huge square blocks of concrete form a defensive enclosure on the East Lothian shoreline at Gullane Links. These anti-tank blocks litter Scotland's coast, built to repel a German invasion that never materialised. SC857700 1998

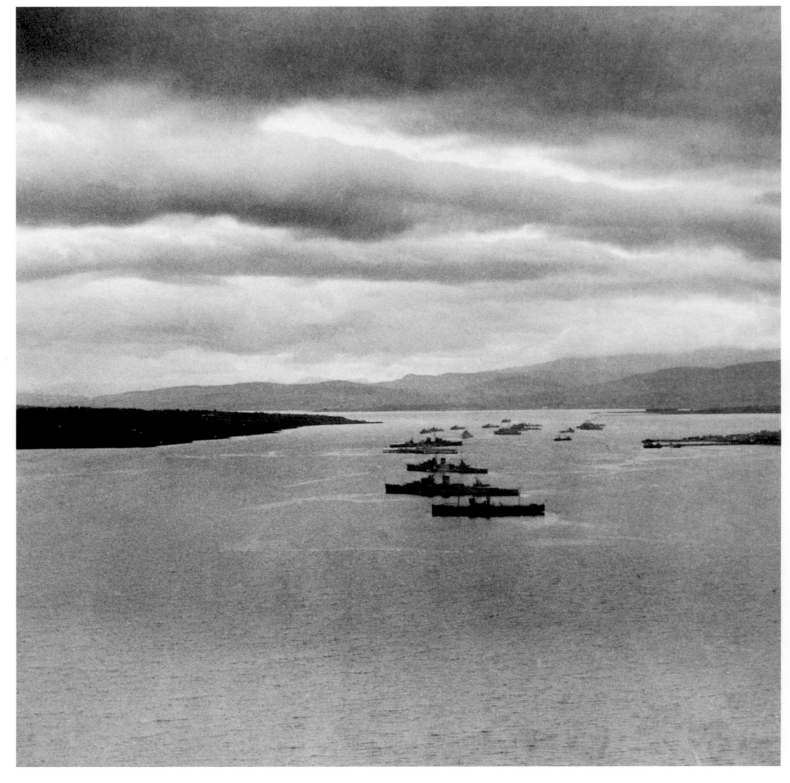

Anchored under a leaden war-time sky in
the Cromarty Firth off Invergordon, these
vessels include ocean-going cargo ships
and at least two Leander class cruisers.
SC1139612 c1940

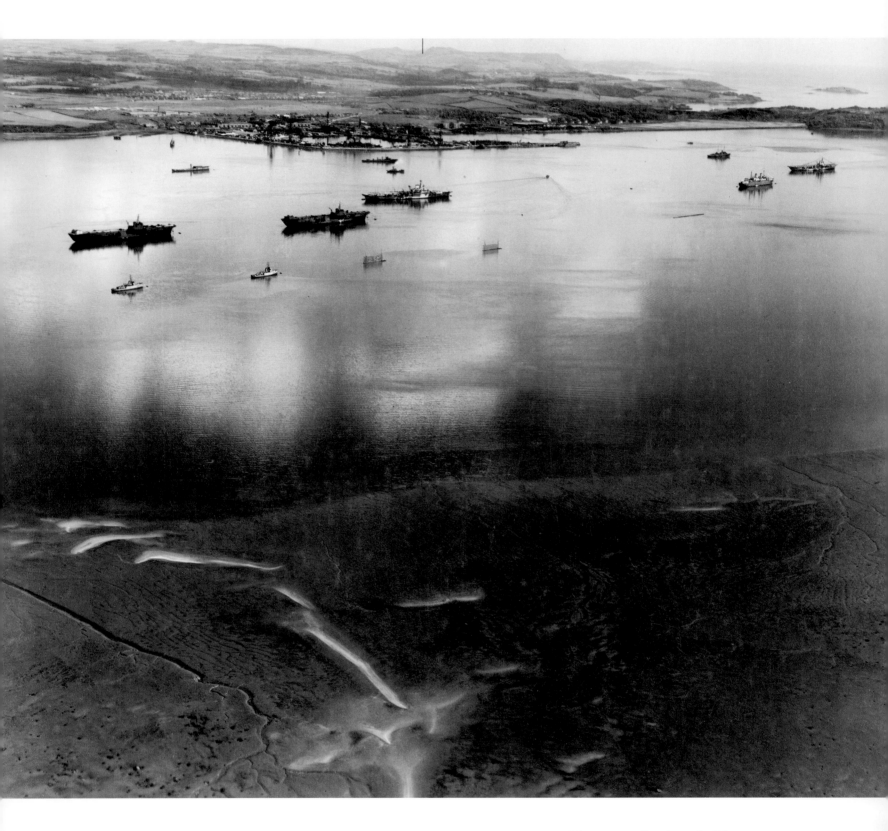

Three years after the end of the war,
the serene waters of the Firth of Forth
at Rosyth Royal Naval Dockyard are
broken by warships on manoeuvres,
as aircraft carriers, mine-sweepers and
ship-towed targets advance through the
estuary. SC682608 1948

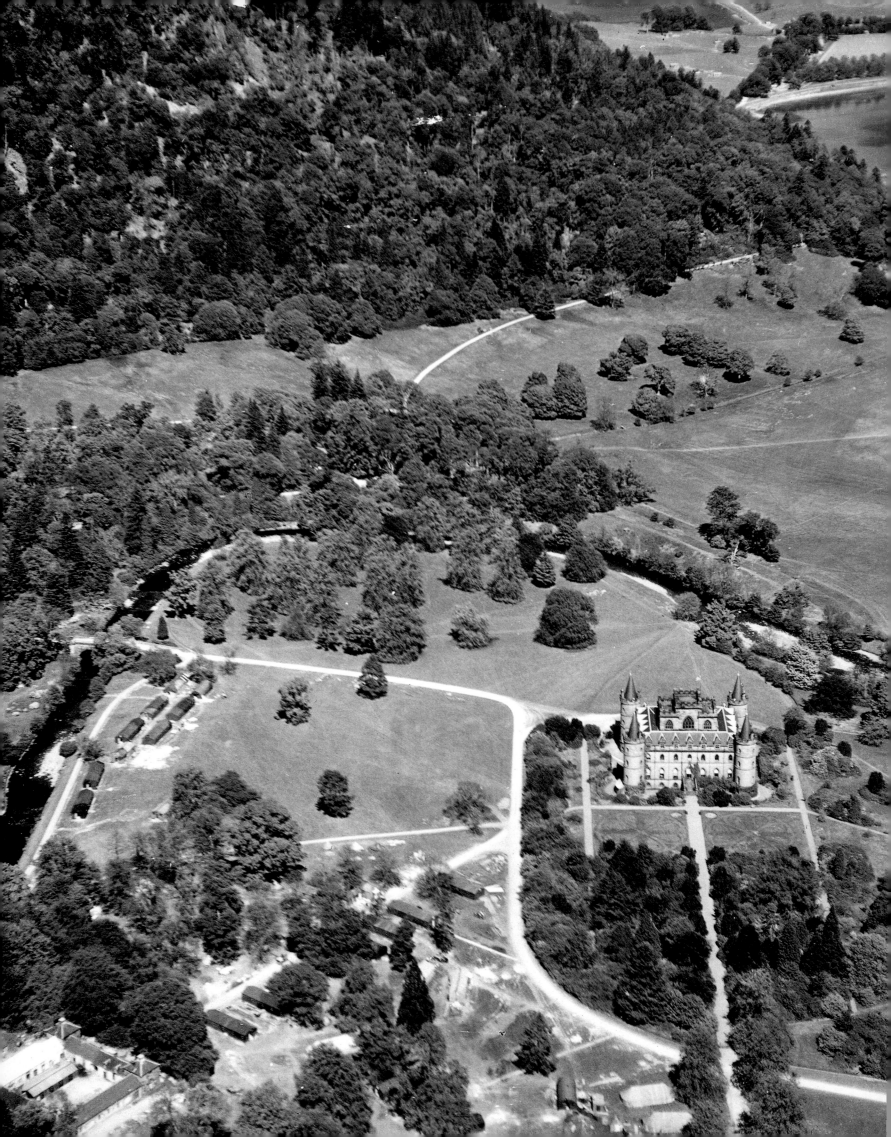

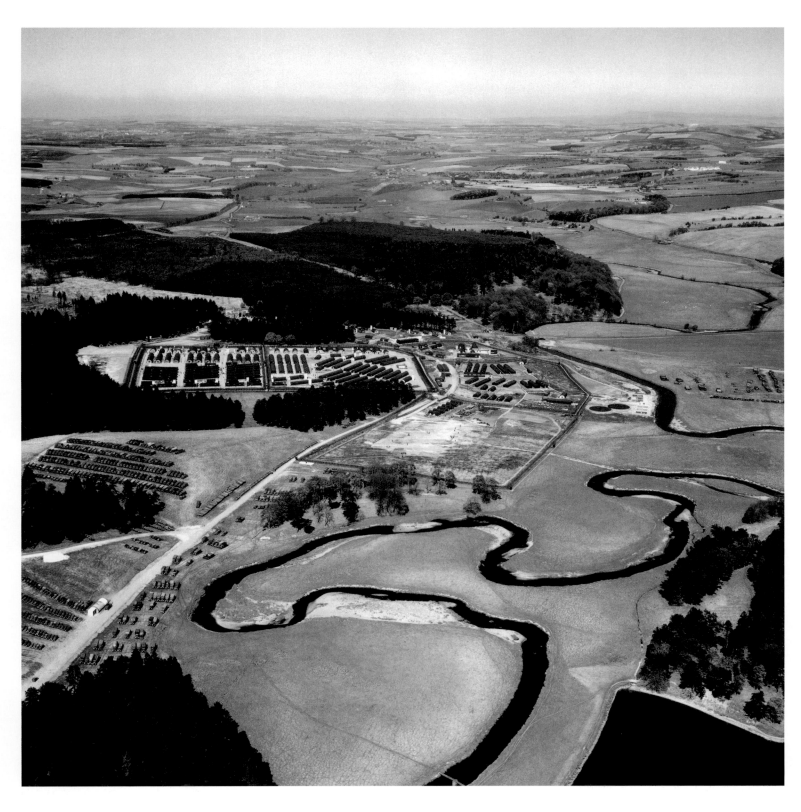

Some 250,000 troops passed through the No.1 Combined Operations Training Centre set up in 1940 at Inveraray. Bringing the Army, Navy and Air Force together as combined assault forces, the troops who trained here took part in the major seaborne invasions of the War.

SC458849 1941

The prisoner-of-war camp tucked away on the edge of Happendon Wood to the south west of Lanark was one of a number scattered across Scotland. At the time of this photograph in 1946, the prisoners appear to have left and the camp is being used as a store for surplus military vehicles destined to be sold or scrapped. SC682811 1946

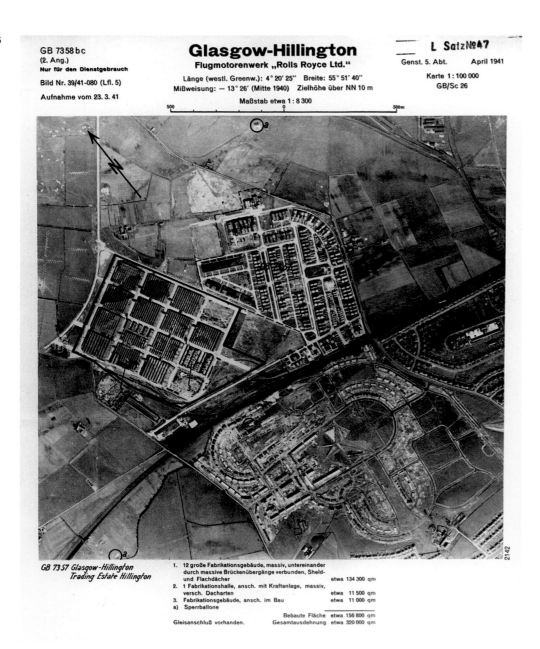

GB 7358 bc
(2. Ang.)
Nur für den Dienstgebrauch

Bild Nr. 39/41-080 (Lfl. 5)

Aufnahme vom 23. 3. 41

Glasgow-Hillington
Flugmotorenwerk „Rolls Royce Ltd."

Länge (westl. Greenw.): 4° 20' 25" Breite: 55° 51' 40"
Mißweisung: – 13° 26' (Mitte 1940) Zielhöhe über NN 10 m

Maßstab etwa 1 : 8 300

L Satz№ 47

Genst. 5. Abt. April 1941

Karte 1 : 100 000
GB/Sc 26

GB 73 57 Glasgow-Hillington
Trading Estate Hillington

1.	12 große Fabrikationsgebäude, massiv, untereinander durch massive Brückenübergänge verbunden, Sheld- und Flachdächer	etwa 134 300 qm
2.	1 Fabrikationshalle, ansch. mit Kraftanlage, massiv, versch. Dacharten	etwa 11 500 qm
3.	Fabrikationsgebäude, ansch. im Bau	etwa 11 000 qm
a)	Sperrballone	
	Bebaute Fläche	etwa 156 800 qm
Gleisanschluß vorhanden.	Gesamtausdehnung	etwa 320 000 qm

Powering the Spitfires of the Royal Air
Force, the aero-engines produced by the
Rolls Royce factory at Hillington, near
Glasgow, were vital to the British war
effort. Not surprisingly it was on the hit-list
for the Luftwaffe and is clearly marked
on the German intelligence photograph
above. In 1942 the Royal Air Force also
photographed the factory, specifically to
assess the effectiveness of its camouflage.

ABOVE **SC445485** 1941

RIGHT **SC458784** 1942

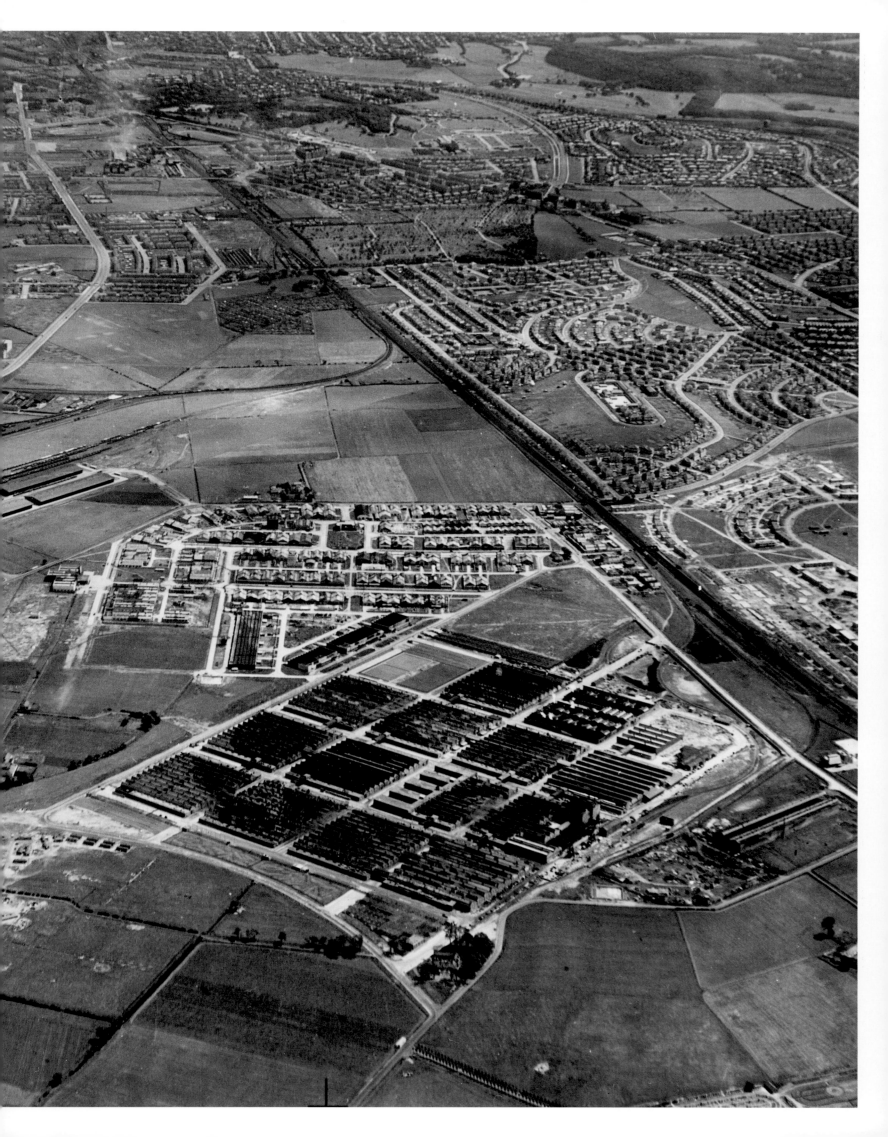

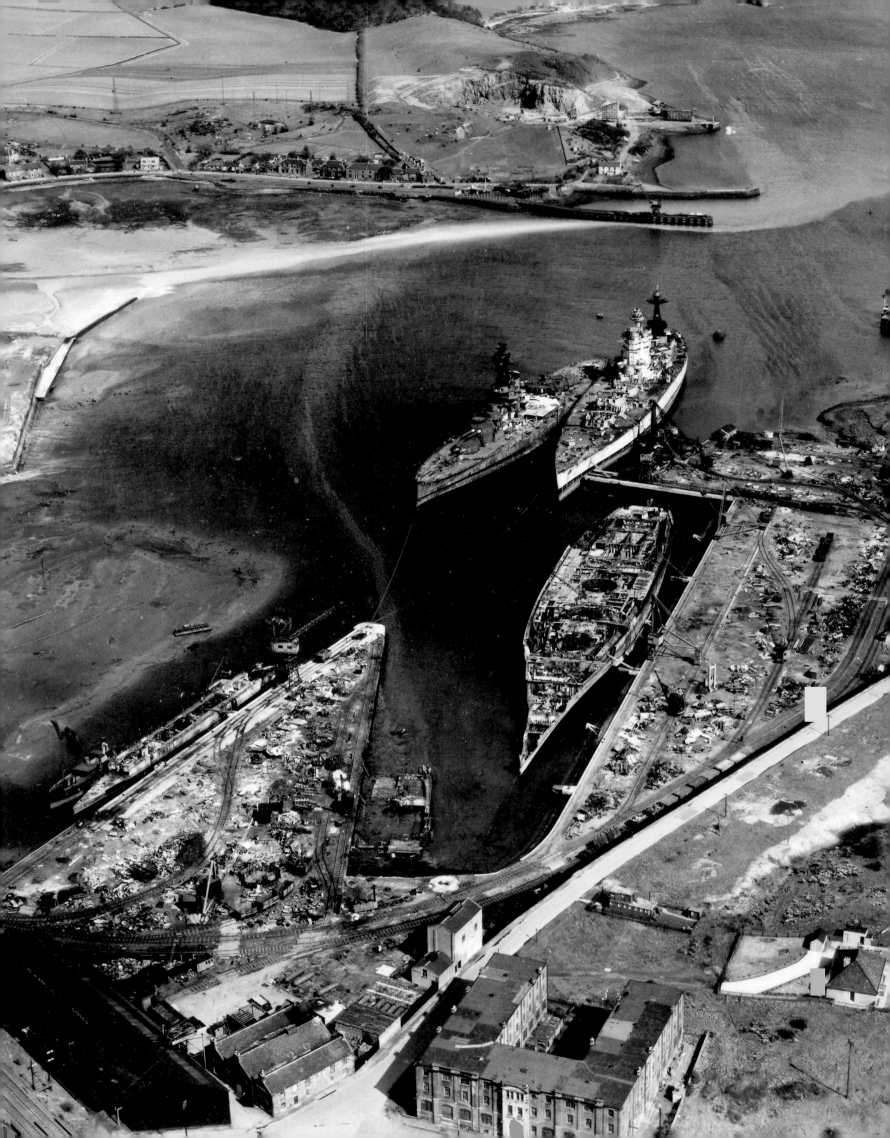

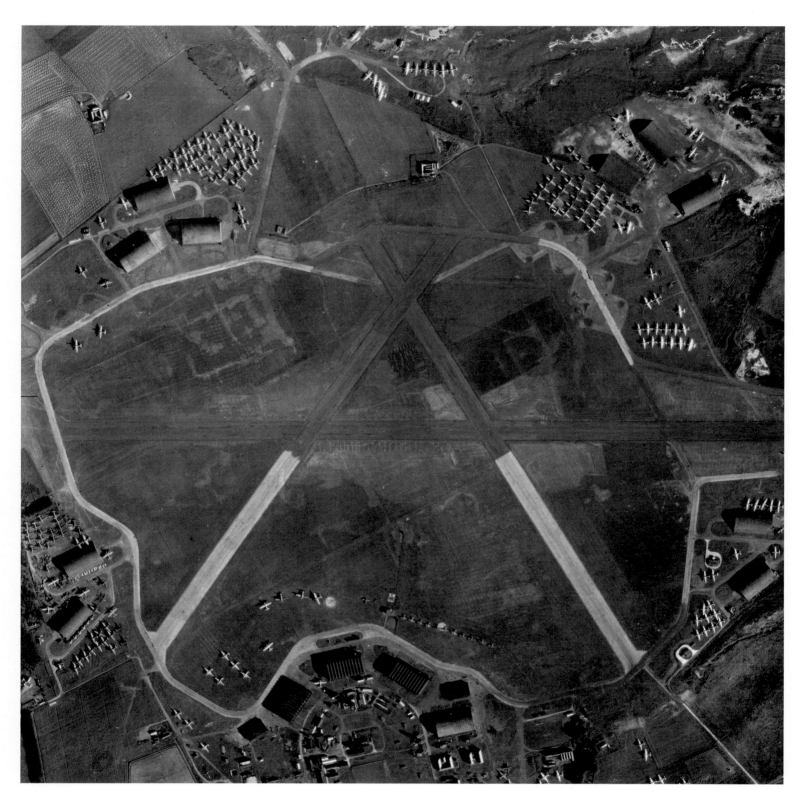

OPPOSITE

At the end of the world's greatest conflict, the dismantling of Britain's vast war machine began. At Thomas Ward & Sons ship breaking yard by Inverkeithing Bay on the Firth of Forth, the scrapping of HMS *Rodney* is well-advanced, while two further battleships, HMS *Nelson* and HMS *Royal Sovereign*, silently wait their turn.

DP048095 1949

ABOVE

Surrounding the criss-cross landing strips of RAF Kinloss, row after row of aircraft prepare for a similar fate, their country and their purpose served.

SC1132607 1946

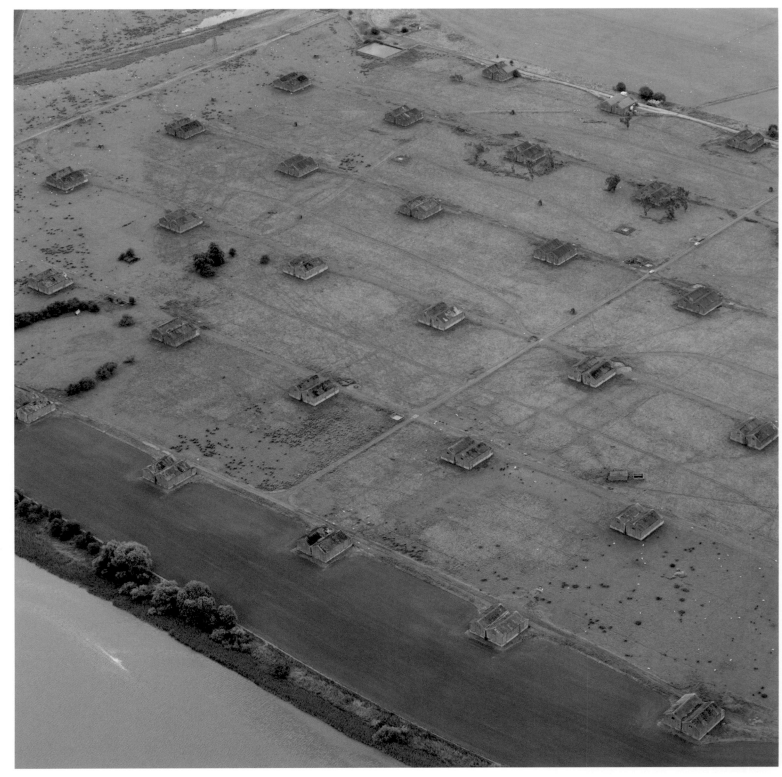

Against the bank of the River Forth, the buildings
of the Royal Naval Armaments Depot at Throsk
are spaced at regular, deliberate intervals to
minimise collateral damage should any munitions
accidentally explode. The same concern can
be seen at Dalbeattie, near Dumfries, as heavy
embankments enclose the individual buildings
of this sprawling armaments complex.

ABOVE **THROSK DP017098** 2006

RIGHT **DALBEATTIE DP052258** 2008

SCOTLAND AT WAR

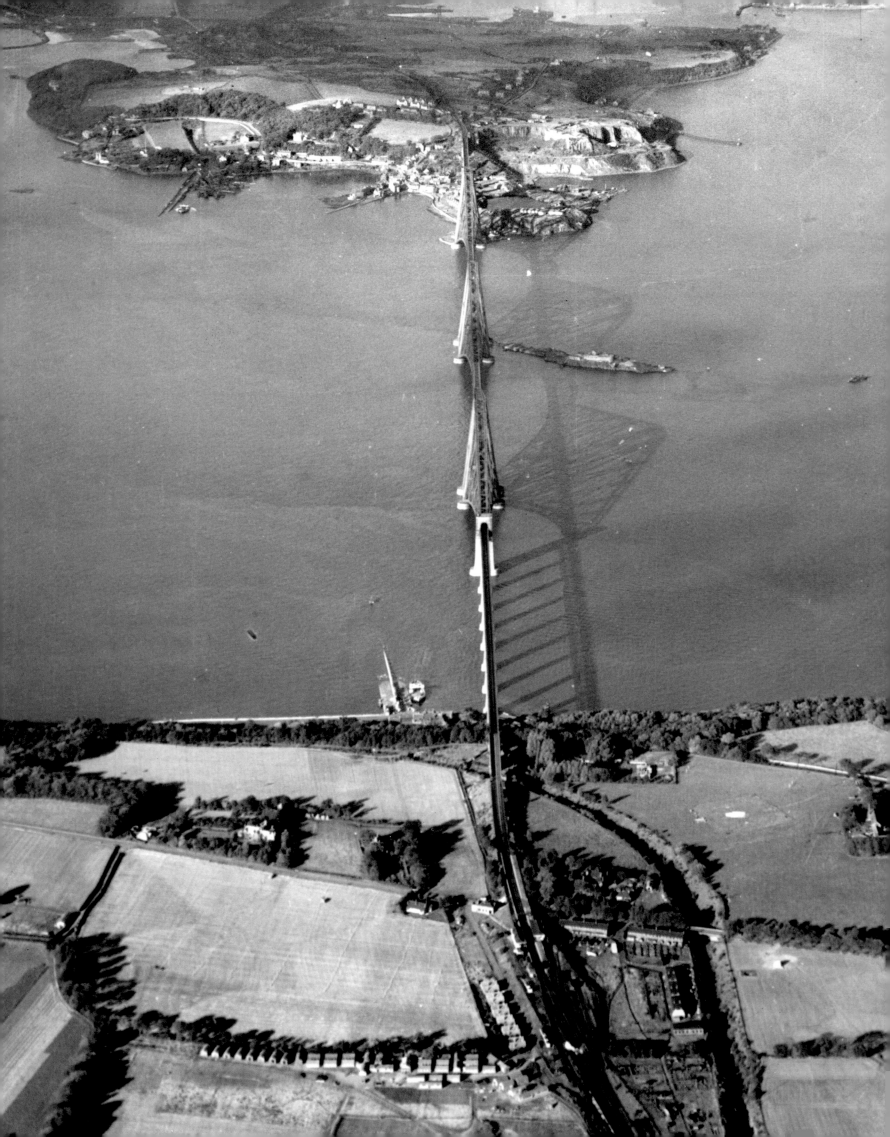

The Engineering Challenge

In a special cable to the *New York Times* published on Friday 21 February 1913, it was announced that, the previous day, Sir William Arrol, 'biggest of British bridge builders', had died. The son of a cotton-spinner who left school aged nine to work in a mill, Arrol had become one of the world's most famous and accomplished civil engineers. That his death was reported across the globe was a tribute to a lifetime of incredible achievement.

Born in 1839 in Houston, Renfrewshire, Arrol trained as a blacksmith in his teens, studied mechanics and hydraulics at night school and was an established bridge builder by his early twenties. At the age of thirty-three he had his own business, the Dalmarnock Iron Works, and was building bridges throughout Scotland, many of them for a rapidly expanding railway network that often required ingenious solutions to the challenges presented by the landscape.

Prolific and innovative, Arrol would go on to be responsible for the construction of two of Britain's greatest bridges. The first, built between 1882 and 1890, was the Forth Railway Bridge,

1 Forth Bridges

2 Clachan Sound

3 Glenfinnan

4 Loch nan Uamh

5 Mound Bridge

6 Skye Bridge

7 Neptune's Staircase

8 Crinan Canal

9 Ardrishaig

10 Shira Dam

11 Cruachan Dam

12 Laggan Dam

13 Loch Tummel

14 Brough of Birsay

15 Barra Head

16 Buchan Ness

a true masterpiece of Victorian engineering. At that time the largest rigid bridge in existence, its 54,000 tons of distinctive red steel rise up over the waters of the Forth estuary in three, iconic double cantilevers, like the ridged back of some mechanical monster. When originally completed, it was widely regarded as the eighth wonder of the world. It so impressed Queen Victoria that it earned Arrol – the once teenage apprentice blacksmith – a knighthood.

Four years later, his legacy as a virtuoso bridge builder was ensured with a second world-famous structure – Tower Bridge in London. But Arrol's engineering expertise extended well beyond bridges, and also included the massive Titan Cranes that were the strong-arms of the shipbuilding industry, and even Bankside Power Station – better known today as London's Tate Modern art gallery.

Arrol was a pioneer who regarded no difficulty as insurmountable, and Scotland was the proving ground for his ingenuity, a test bed for solutions that were exported as far afield as Egypt and Australia. A century before, another figure in Scotland's remarkable lineage of inventive engineers shared the same philosophy – Thomas Telford. The son of a shepherd, Telford would become the first president of the Institution of Civil Engineers, and, in tackling the challenge of opening up access to the rugged and unforgiving landscapes of the Highlands, he bridged hundreds of rivers, laid over 900 miles of roads, and completed the astonishing construction feat of the Caledonian Canal.

The work of Arrol and Telford continues to motivate today's engineers as they grapple with the hard realities of building within Scotland's landscapes. New bridges rise to connect communities, reservoirs are created by the construction of colossal concrete dams, and giant turbines harness hydro-electric power. The engineering challenge remains as strong – and as inspiring – as ever.

PREVIOUS PAGES
The Forth Railway Bridge arrows out over the estuary to meet North Queensferry sitting like a small island at the top of the photograph. This unusual view shows the bridge as a thin, dynamic line, but the intricate framework of its double cantilevers still casts long, impressive shadows out over the water. SC458736 1941

OPPOSITE
Pictured here under construction, an isolated segment of the Forth Road Bridge reaches out from a support tower towards the shore. Officially opened by the Queen on 4 September 1964, at that time it was the largest suspension bridge in Europe, and the fourth largest in the world, with a main span of 1.05km and an overall length of 2.5km. The construction of the bridge brought to an end the 800-year history of a ferry-boat service crossing the Forth between North and South Queensferry. SC1114210 1963

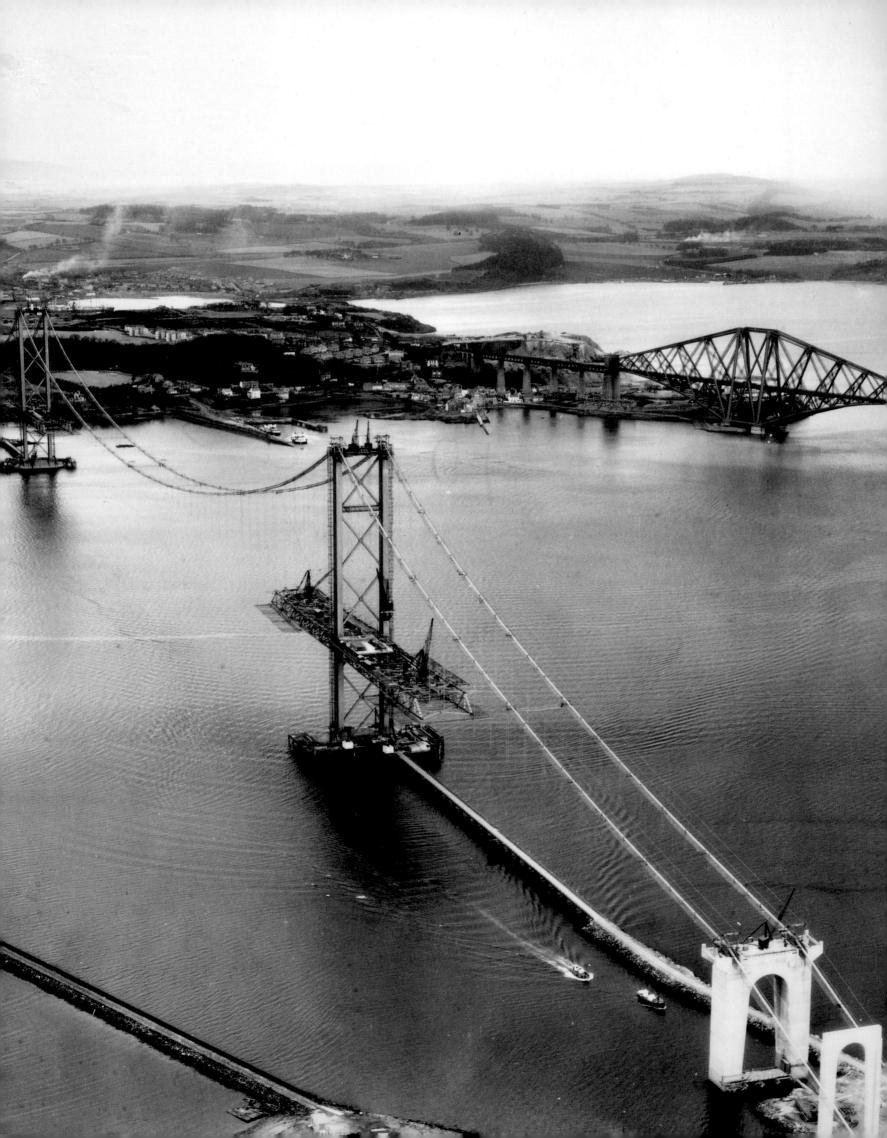

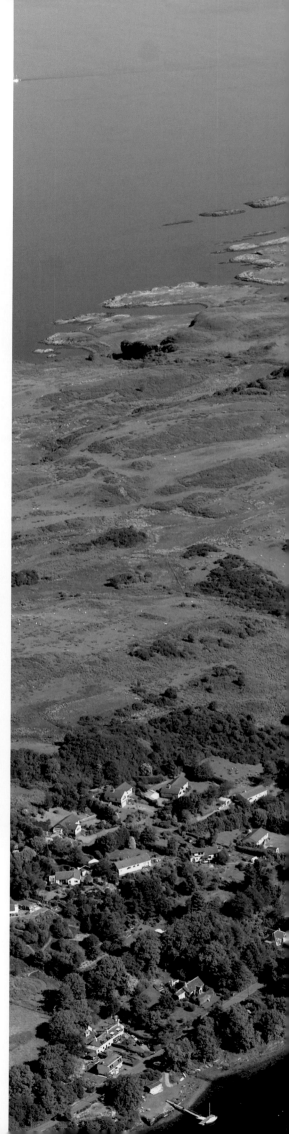

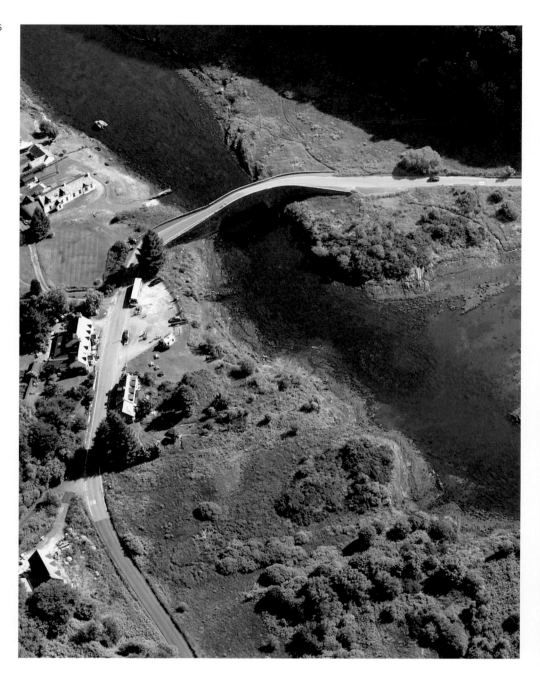

A small bridge with a big reputation. The single-arched, hump-backed masonry bridge spanning the Clachan Sound near Oban, which links the west coast of the Scottish mainland with the island of Seil, is known as the 'Bridge over the Altantic'. Built in 1792, the bridge was the work of the pioneering civil engineer Thomas Telford, one of a great many that he designed in his crusade to improve transport and communication links throughout the remote regions of the nation.

ABOVE DP018023 2006
RIGHT DP018020 2006

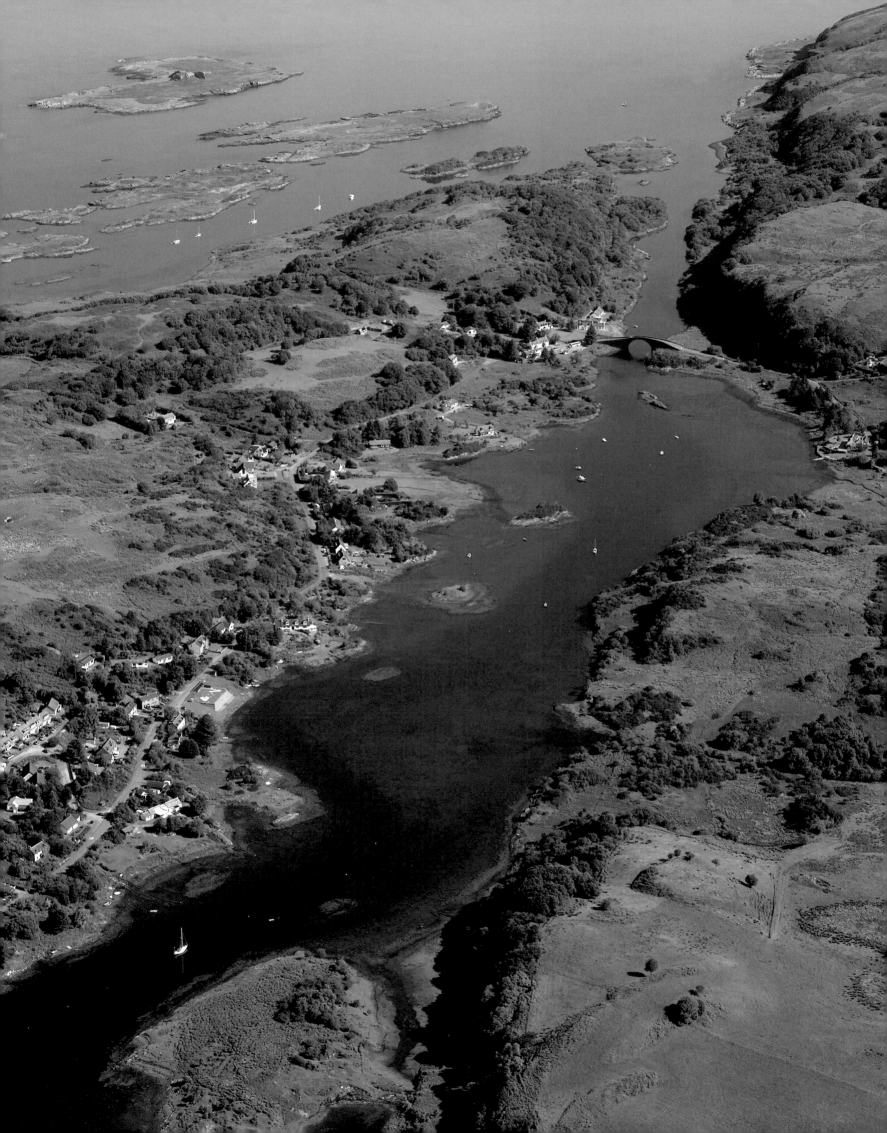

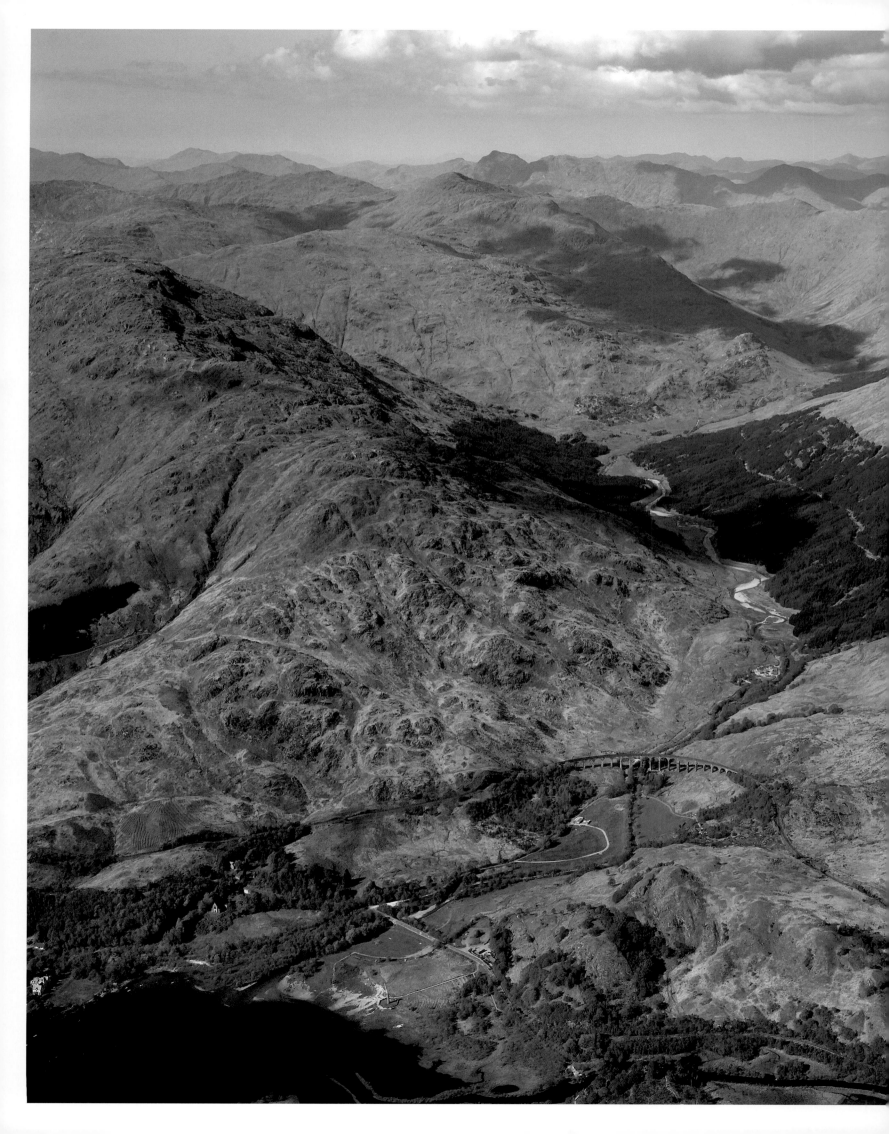

The strong arc of the Glenfinnan viaduct – part of the the spectacular 'iron road to the Isles' on the Fort William to Mallaig extension of the West Highland Railway – looks almost delicate against the brooding knuckles of Lochaber's mountainous landscape. Built by Sir Robert McAlpine between 1897 and 1901, this outstanding feat of concrete engineering was the first and longest mass concrete viaduct in Britain, its 21 arches supporting a 380m-long crescent that carries the railway 30m above the River Finnan. DP031320 2007

190 Some 20km further along the tracks from Glenfinnan, the West Highland Line extension slices through the rocky shoreline of Loch nan Uamh to cross the valley of the Beasdale Burn. In 2001, attracted by a story from local folklore, a research team used scanning technology to send radio waves through the 3m-thick concrete walls of the viaduct's central pier and discovered the clearly preserved and permanently encased remains of a horse and the splintered debris of a wooden cart. It is thought that the cart slipped into an open cavity and dragged the animal down to its grisly fate during a construction accident around 1899. DP031328 2007

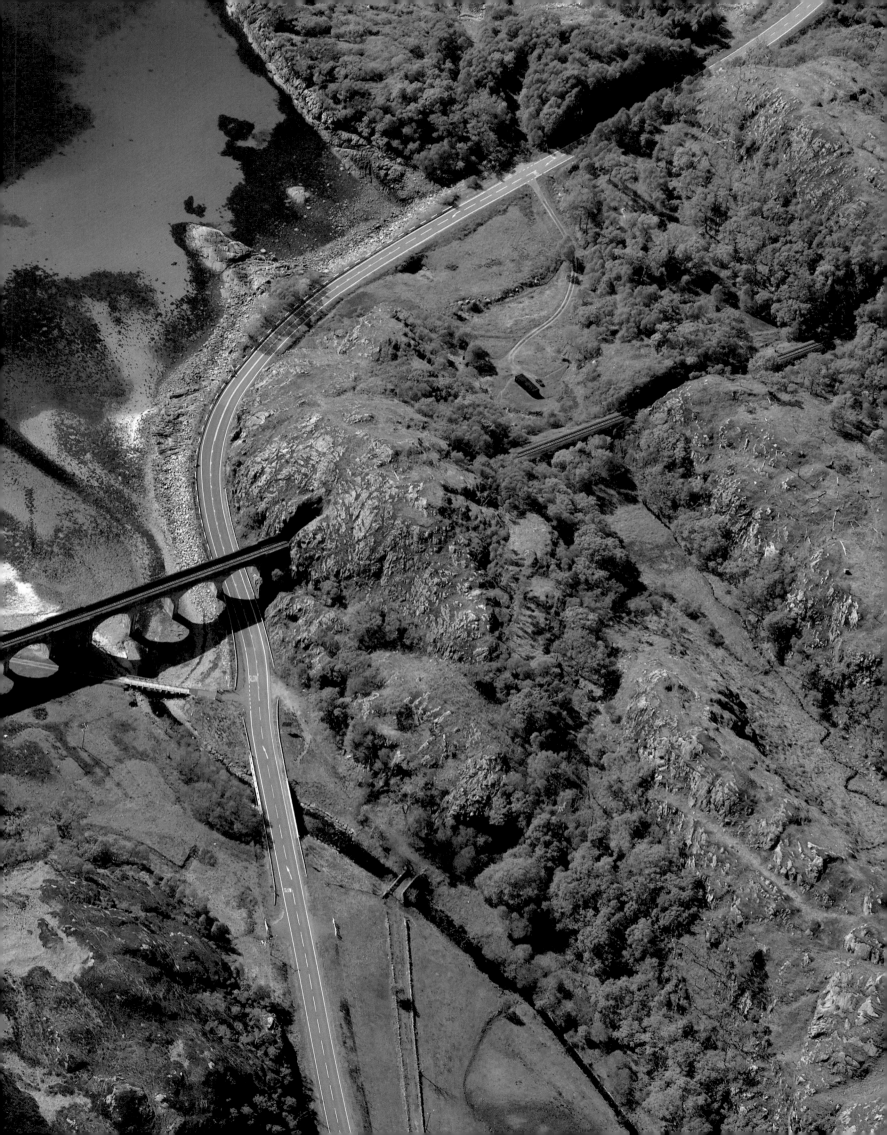

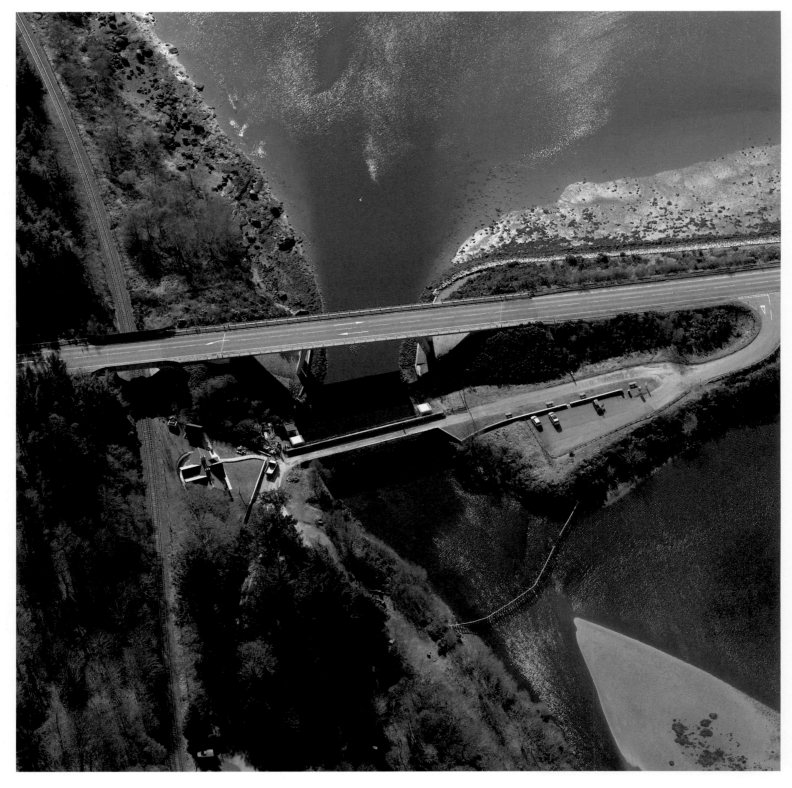

ABOVE

At the end of Thomas Telford's huge earth causeway built to cross Loch Fleet, and now almost permanently in the shadow of the modern A9, is the Mound Bridge. Originally completed in 1816, the bridge's six arches contain sluice gates that prevent sea water travelling any further upstream when the tide is high, but allow the river water out as the tide falls. DP024238 2007

OPPOSITE

Beneath a drifting cluster of cumulus clouds, the Skye Bridge rises out over the Kyle of Lochalsh. A bridge linking Skye to the Scottish mainland had been mooted since the end of the nineteenth century, but it wasn't until 1995 that the idea became a reality, replacing a ferry service that had operated in one form or another since the 1600s. DP031386 2007

THE ENGINEERING CHALLENGE

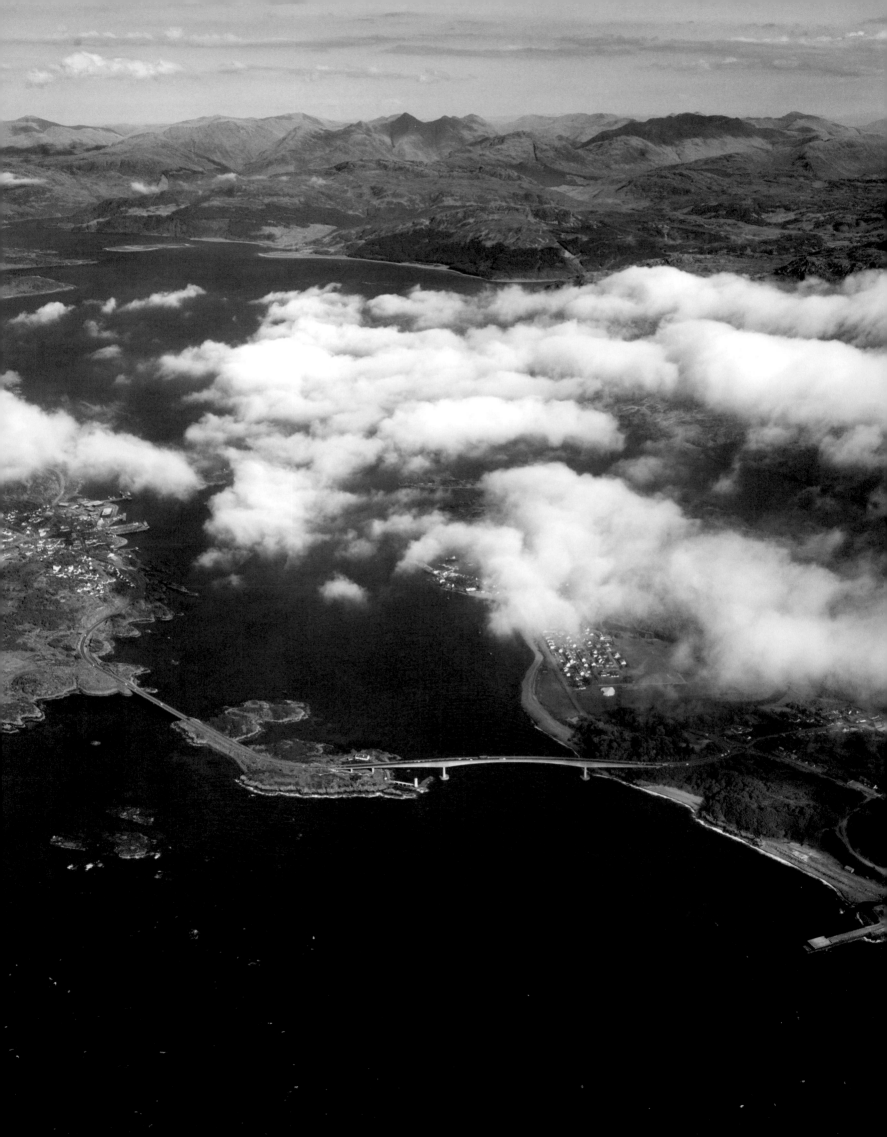

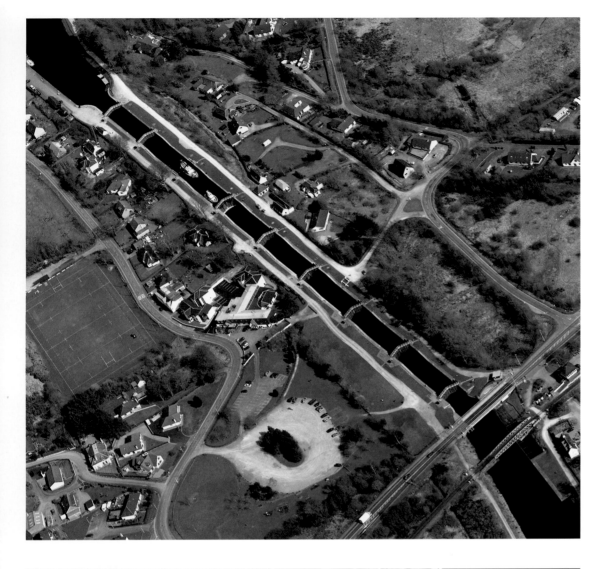

The idea of using the natural corridor of the Great Glen as a shipping route linking the east and west of Scotland was first raised in 1773. Work eventually began on the great Caledonian Canal in 1804 under the direction of Thomas Telford. This bold engineering vision required excavations and earthworks on an incredible scale and the construction of a great many aqueducts and stone-lined locks. Neptune's Staircase is perhaps the Caledonian Canal's most famous feature. Situated near the Canal's western opening at Loch Linnhe, this remarkable ladder of eight locks allows vessels to rise or drop 20m. DP023910 2007

The thin blue margin of the Crinan Canal cuts between the flood plain of the River Add and the undulating hills of Knapdale. Designed by John Rennie, the 15km long canal opened in 1801 as a link between Ardrishaig and Crinan, allowing the Loch Fyne and Clyde fishing fleets access to the Sound of Jura without having to sail around the Mull of Kintyre. DP017929 2006

The entrance to the Crinan Canal, the 'most beautiful shortcut in the world', at Ardrishaig on the banks of Loch Fyne. DP032081 2007

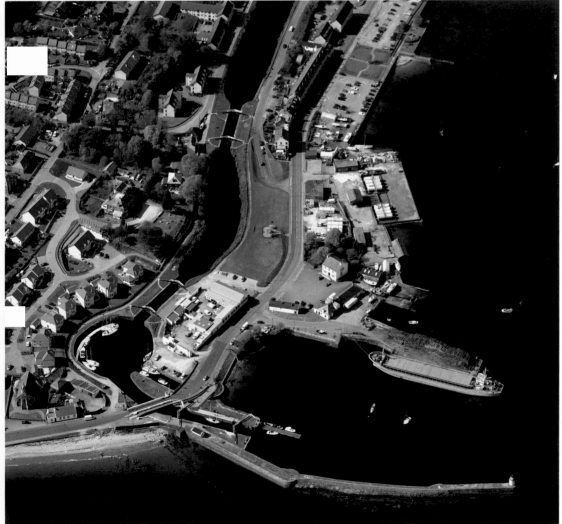

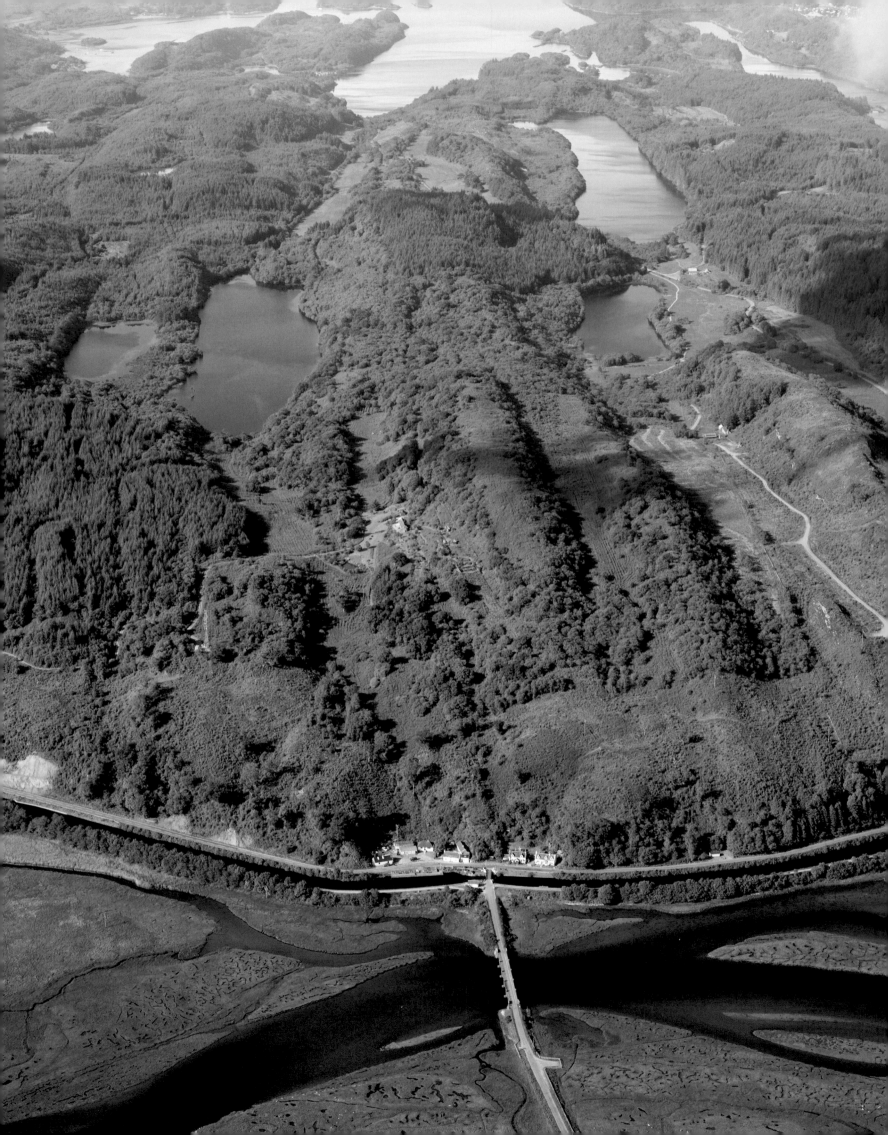

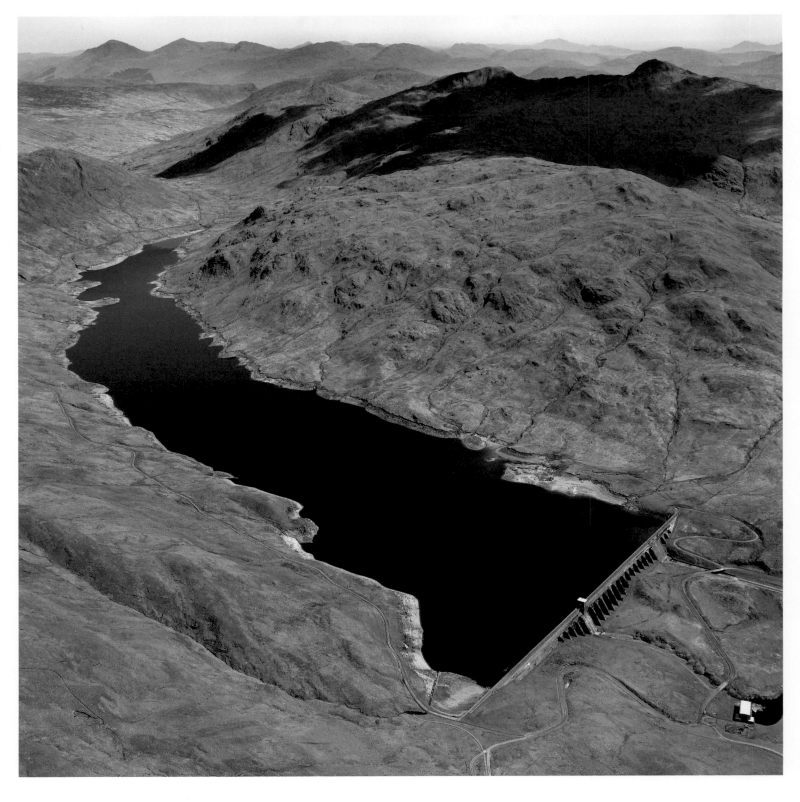

196

ABOVE

The construction schemes of the North of Scotland Hydro-Electric Board changed the face of the Highlands and brought electricity to almost the whole of the country north of the Highland Line. By the time the last scheme was opened at Foyers in 1975, engineers had conquered the geography and geology of northern Scotland, building some 50 major dams and power stations, about 300km of tunnels, 640km of roads and over 32,000km of power lines. The dam pictured here stretches across the sweeping curves of the Shira Glen to harness the waters of the Shira and Fyne rivers and the many streams between Loch Fyne and Loch Awe. DP029584 2007

OPPOSITE

Huge, solid and imposing, Cruachan Dam rises up out of the rocks above Loch Awe as if it has always been a part of the landscape. Constructed between 1959 and 1965, Cruachan power station was the first reversible pump hydro system to be built in the world. DP017797 2006

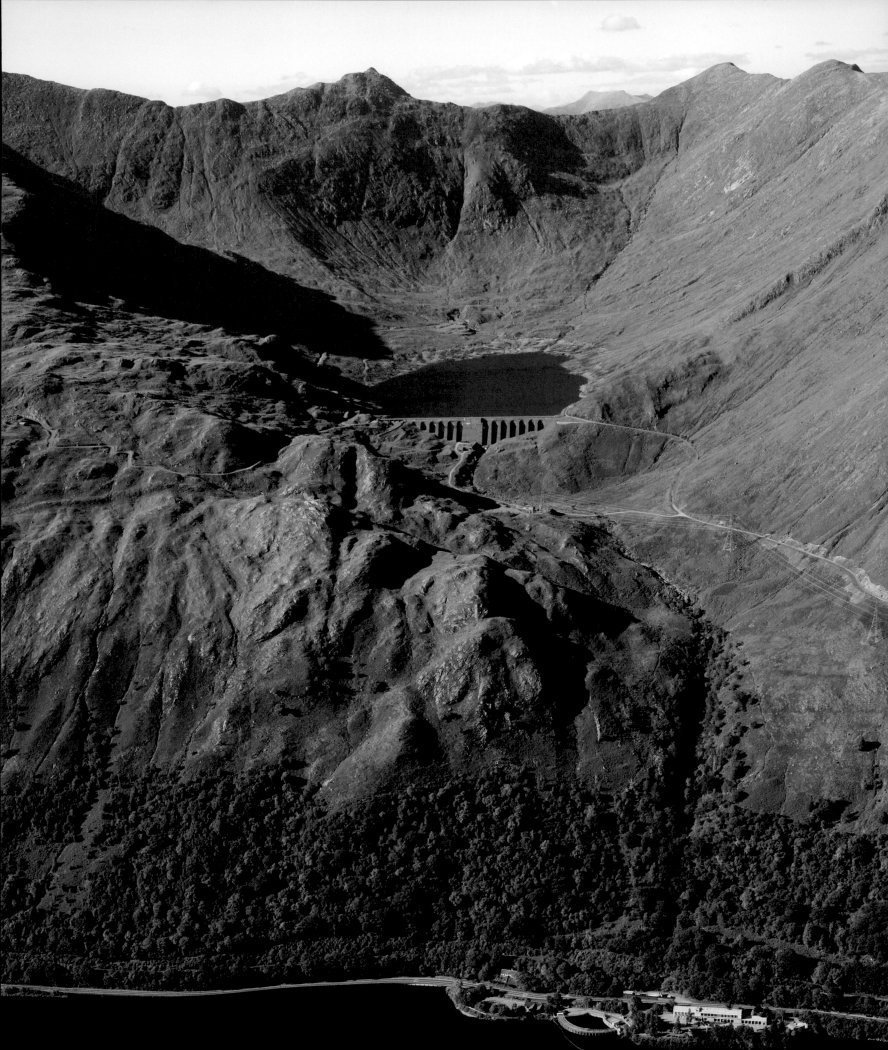

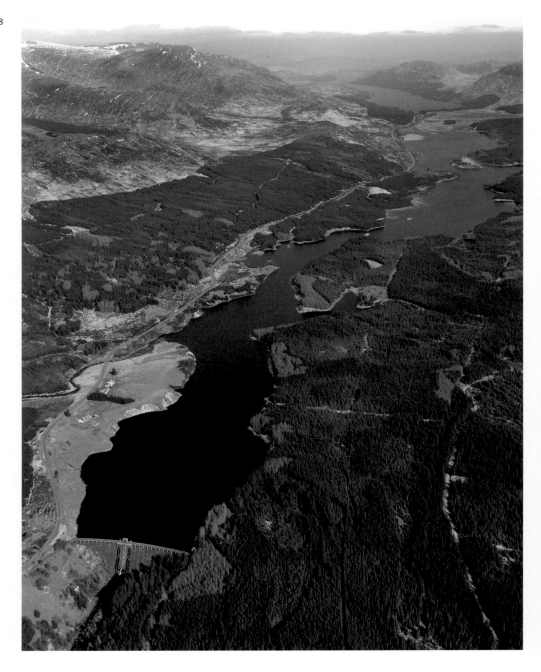

At the eastern boundary of Lochaber, the heavy blue waters of the River Spean meet the colossal curve of the stone and concrete wall of the Laggan Dam. 213m wide and 52m high, the Dam was built for the British Aluminum Company in 1934 to provide water for Fort William's hydro-electric plant.

ABOVE **DP023887** 2007

RIGHT **DP023880** 2007

THE ENGINEERING CHALLENGE

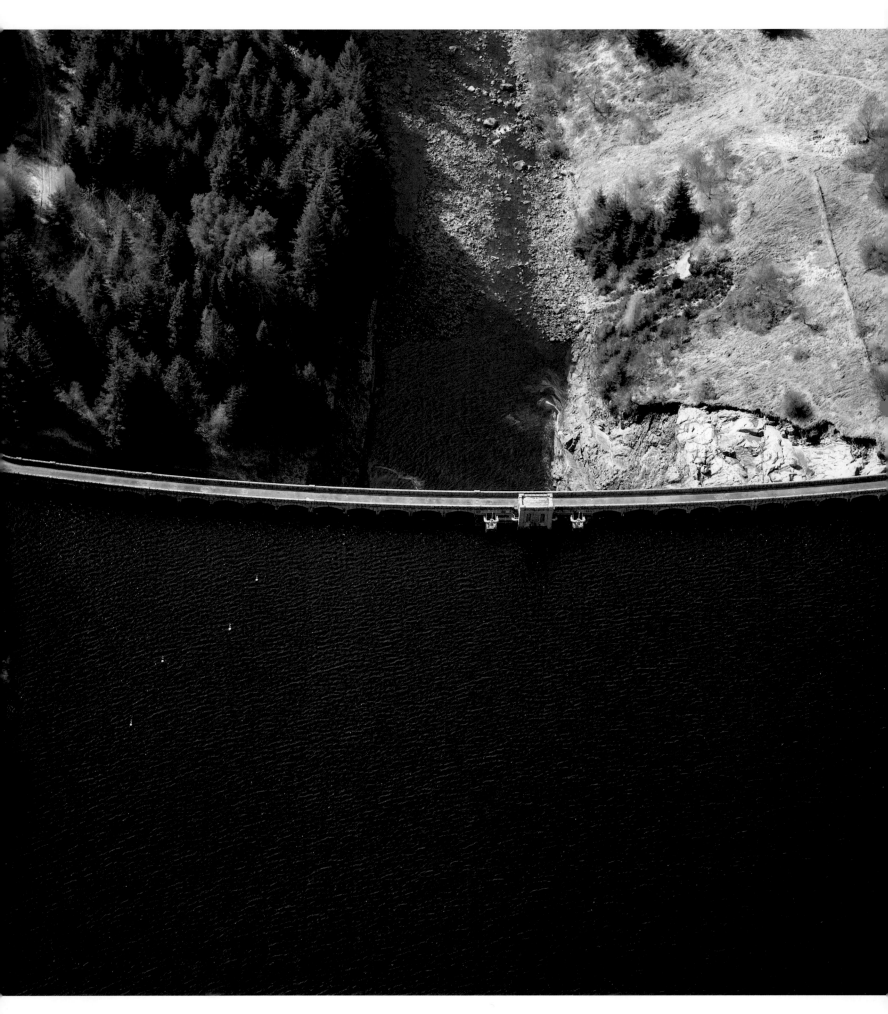

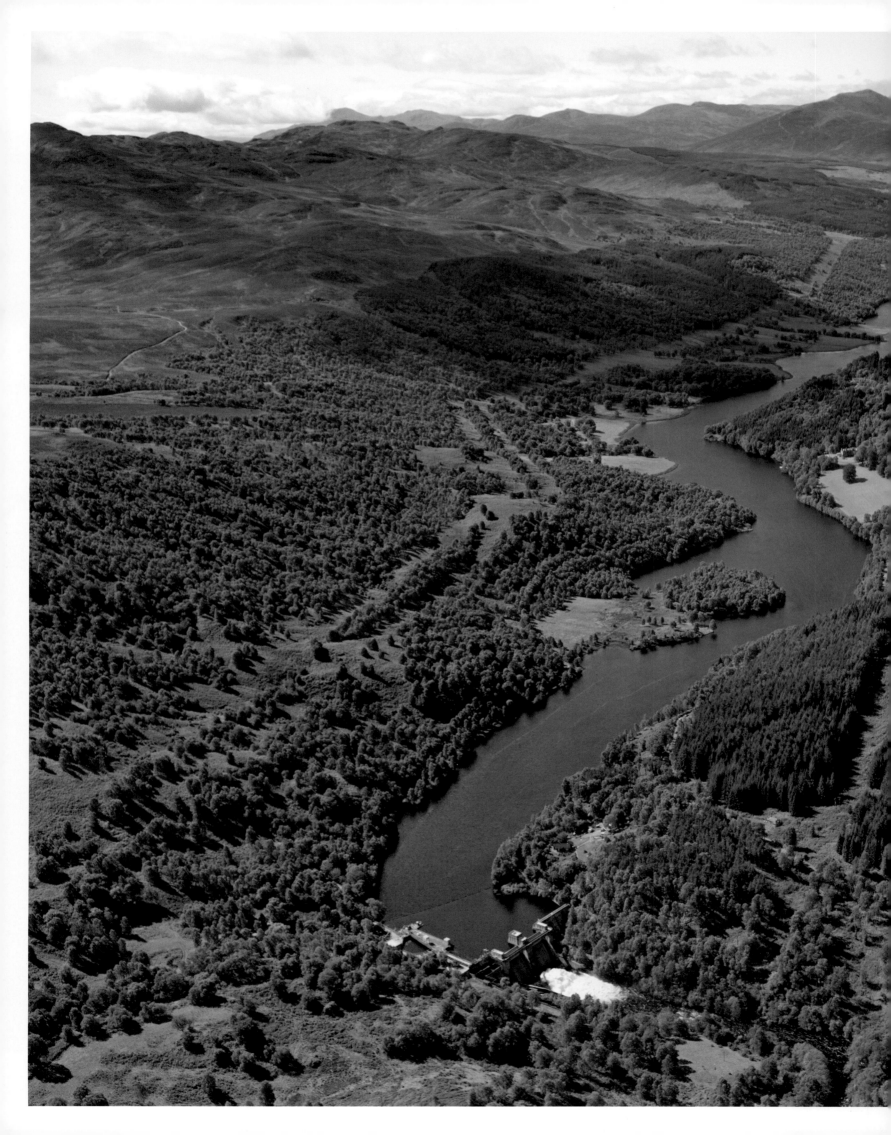

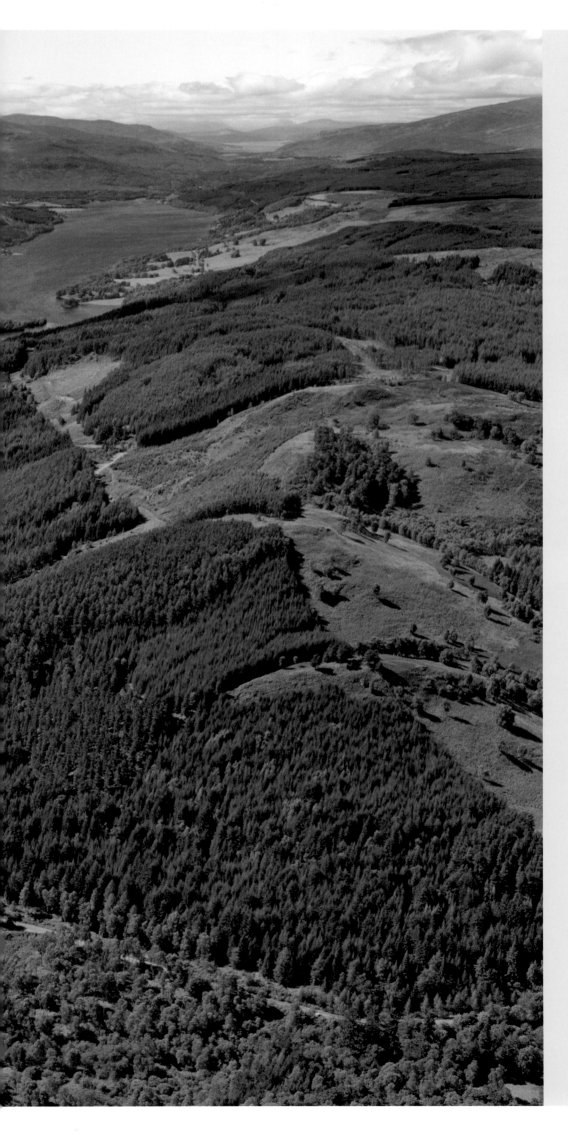

The long, narrow waters of Loch Tummel drift through a Perthshire strath to meet the blocky barrier of the Clunie Dam. The Dam was completed in 1950 as part of the North of Scotland Hydro-Electric Board's Tummel Valley scheme. With a catchment area taking in over 1,839 sq km of the Grampian Mountains, the scheme includes nine dams and nine power stations. DP034259 2007

With an importance out of all proportion to its size, the automatic lighthouse on the Brough of Birsay, off the northwest of Orkney Mainland, was built in 1925 by engineer David A. Stevenson. DP059278 2009

At the very edge of the Hebridean archipelago, the lighthouse of Barra Head on Berneray casts its light 210m down from the cleaved rocks of the Sròn an Dùin promontory, out over the relentless surge of the Atlantic Ocean. Completed in 1833, Barra Head was the work of the renowned lighthouse designer and builder Robert Stevenson, grandfather of the famous writer Robert Louis Stevenson. SC1056455 2003

Another of Robert Stevenson's constructions, the distinctive red-and-white-striped tower of Buchan Ness lighthouse stands 32m high on a rocky islet beside the village of Boddam in Aberdeenshire. DP011673 2005

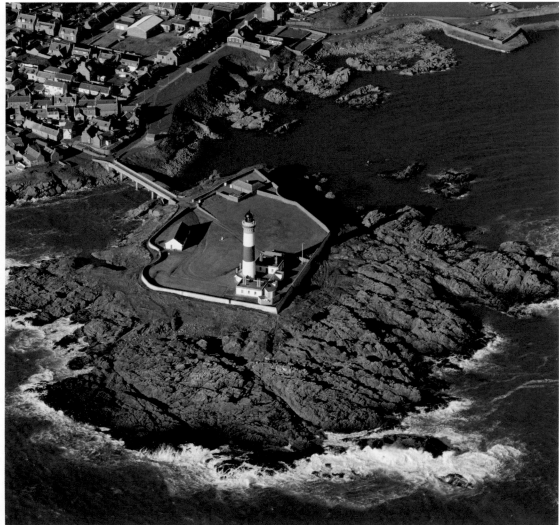

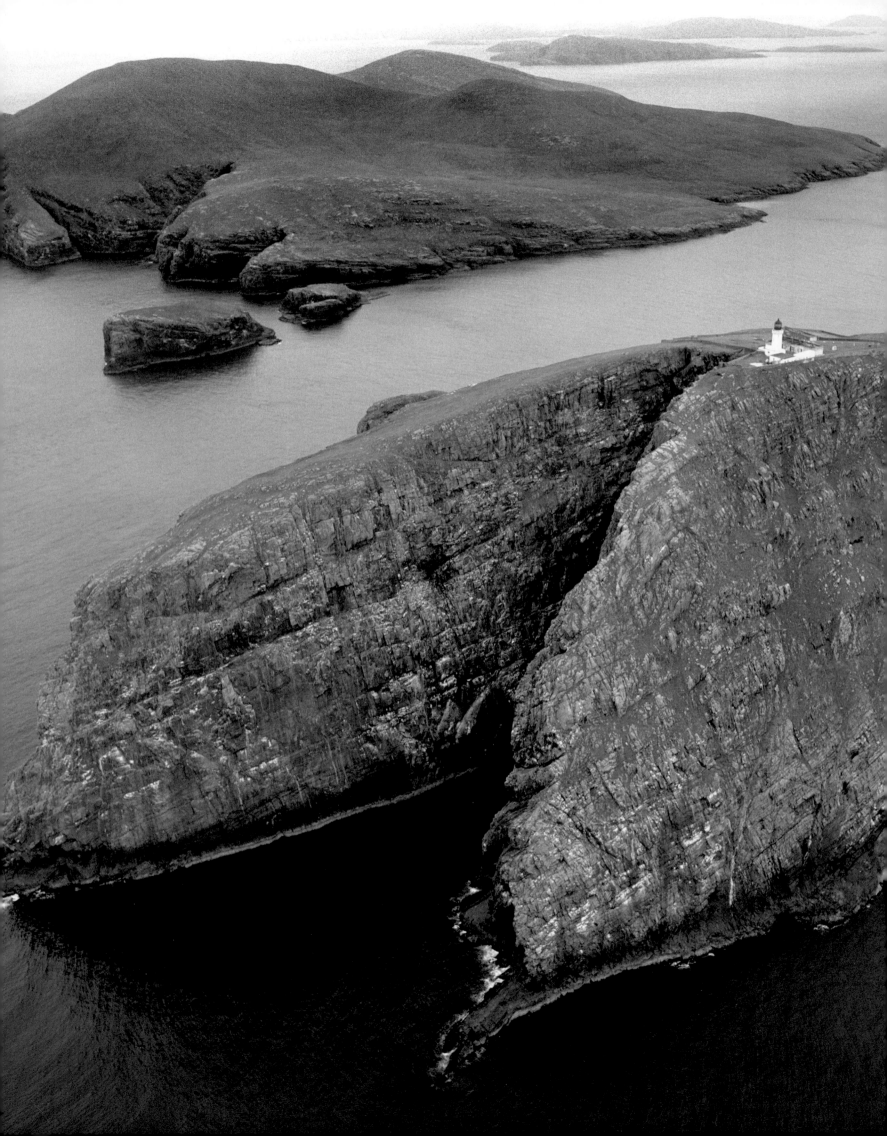

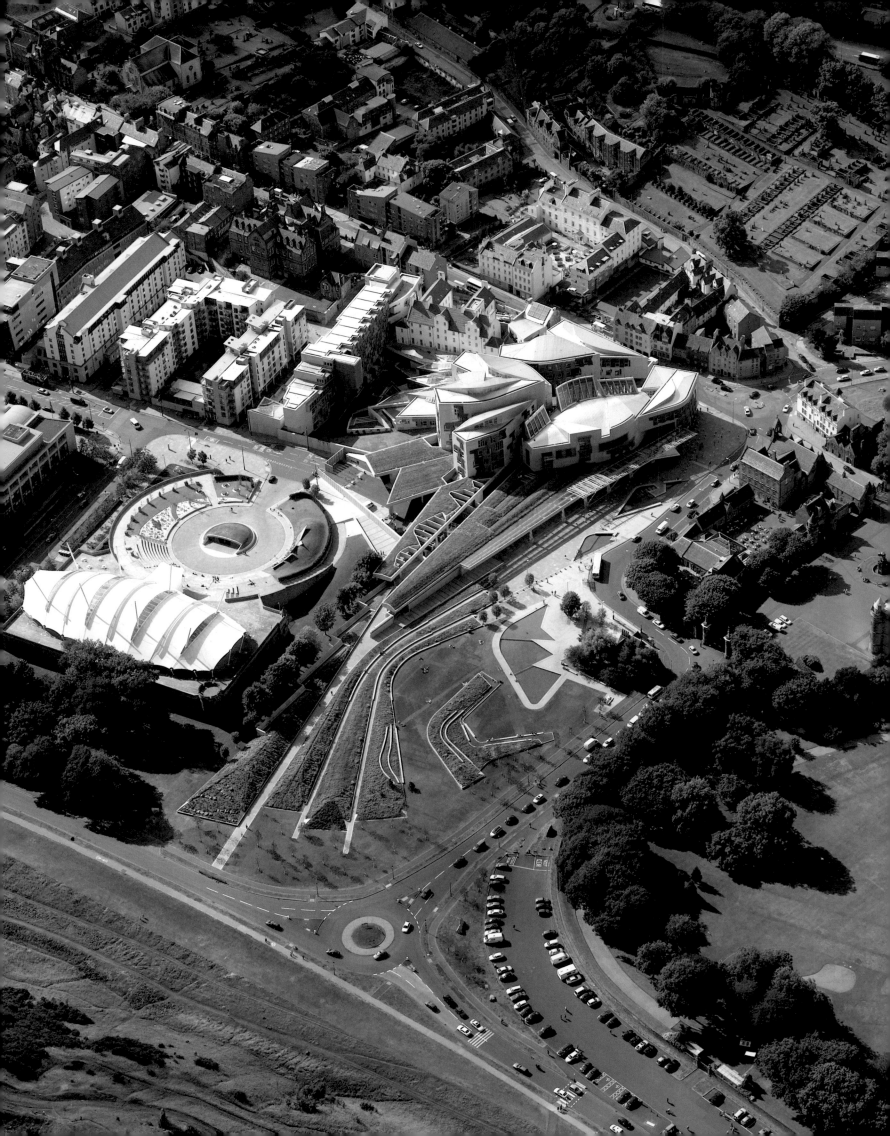

Modern Scotland

In a set of design proposals produced in 1998 for the new Scottish Parliament building, the presentation by Catalan architect Enric Miralles contained a bold, recurring phrase: 'The building should be land, built out of land.' Considering a site positioned at the base of the Royal Mile's medieval spine, between the grand facade of Holyroodhouse and the imposing basalt wall of Salisbury Crags, Miralles had a clear vision of the kind of structure that would capture the character of a nation: 'The building should arise from the sloping base of Arthur's Seat and arrive into the city almost surging out of the rock.'

Miralles died four years before the Parliament's completion in 2004. But his idea of a structure growing organically out of the land is an elegant metaphor for the whole history of the nation's built heritage up to the present day. Modern Scotland is a remarkable mixture of old and new – complementing, overlapping and sometimes clashing. Throughout the Central Belt, brownfields abandoned by heavy industry are overlain with luxury housing and monolithic shopping centres.

1 Edinburgh
2 Hairmyres
3 Pencaitland
4 Glasgow
5 Perth
6 Fort William
7 Deer Sound

In Edinburgh, the compact jumble of the Old Town faces-off with the sweeping, ordered patterns of the Georgian New Town. Along the River Clyde, on docklands left behind by Glasgow's once prodigious shipbuilders, gleaming towers of steel and glass emerge as temples to leisure and entertainment. Today's architects reference the past in their interpretations of the future, integrating developments into historic street plans, or depart completely from what has gone before, creating new visions for the places where we live and work. The imprinting on the land never stops, and the fascinating story of how we have got to where we are, told so vividly by the changing shapes of our countryside, towns and cities, grows even richer.

The people of Scotland have been carving their lives out of the landscape for thousands of years, from the first prehistoric settlements planted in a virgin earth, through cliff-top castles in the Middle Ages and nineteenth century towns built around intensive industrialisation, to the oak, granite and steel statement of the new parliament. The remains of our ancestors may stand proud as lasting monuments to the past, be transformed into tourist attractions and conserved for future generations, face redevelopment, or fall into ruin, but, as we move through the twenty-first century, the great many accumulated layers of this history are a play on Miralles' mantra – the land is its buildings, and the buildings are the land. The two cannot be separated.

PREVIOUS PAGES
The gleaming roofs of Scotland's parliament building reach a point at the foot of the Royal Mile, the backbone of medieval Edinburgh's town plan. DP014137 2006

OPPOSITE
Next to the serene presence of Holyroodhouse, a gang of cranes rises above a busy construction site. The parliament was over five years in the making – work began in June 1999, and the official opening, attended by the Queen, was held on 9 October 2004. SC797317 2001

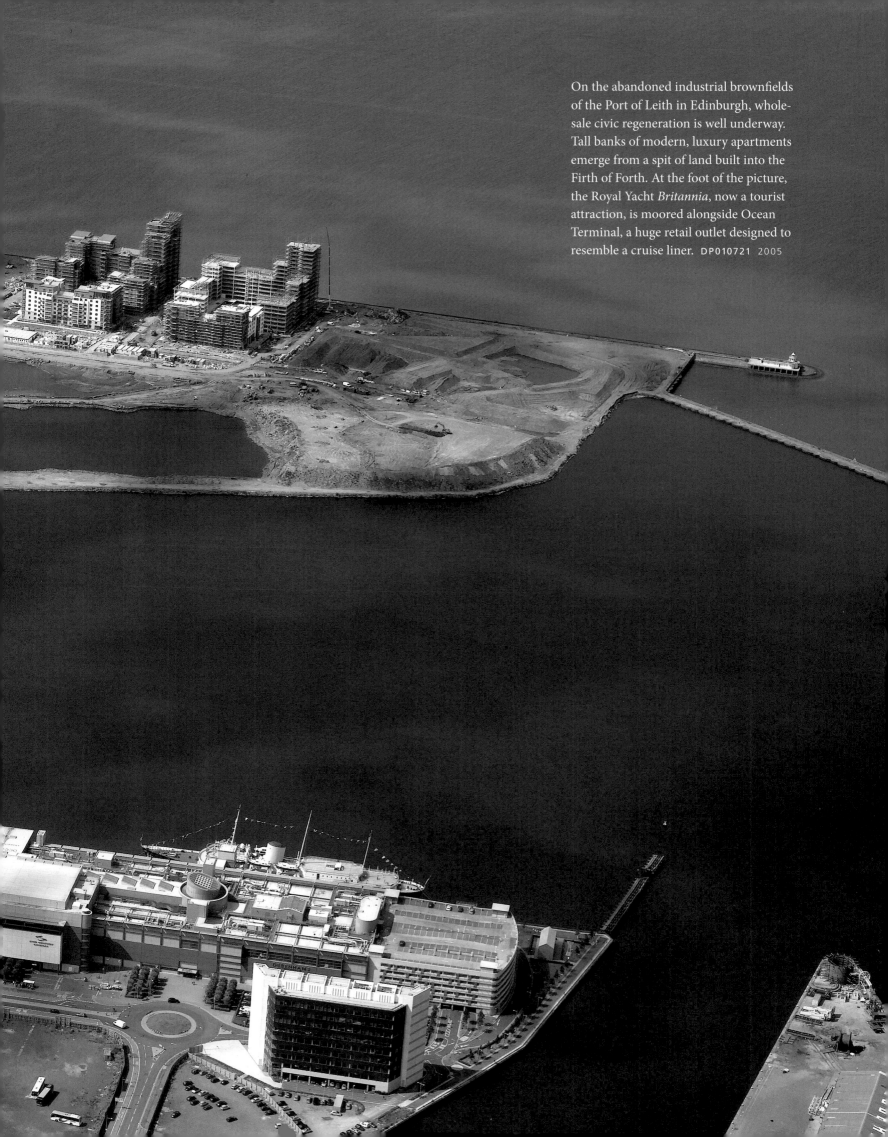

On the abandoned industrial brownfields of the Port of Leith in Edinburgh, wholesale civic regeneration is well underway. Tall banks of modern, luxury apartments emerge from a spit of land built into the Firth of Forth. At the foot of the picture, the Royal Yacht *Britannia*, now a tourist attraction, is moored alongside Ocean Terminal, a huge retail outlet designed to resemble a cruise liner. DP010721 2005

Modern research looking at the relationship between human behaviour and the built environment suggests that, with the right design, the buildings we live and work in can make us happier and more efficient. In business, considerable sums of money are spent on creating offices that improve productivity, creativity and staff retention. Completed in 2005 at a cost of £335 million, the design of the international headquarters of the Royal Bank of Scotland at Gogarburn on the outskirts of Edinburgh has already received praise from the Building Research Establishment. Modern hospitals, like Hairmyres in East Kilbride work to similar principles, attempting to create environments to improve patient recovery times and responses to treatment.

LEFT RBS HEADQUARTERS DP007709 2006
BOTTOM LEFT HAIRMYRES DP009591 2005

On the fringes of long established villages, towns and cities, rapidly appearing suburban estates like Easter Pencaitland in East Lothian meet growing housing demands and create new, custom-built communities. DP008812 2005

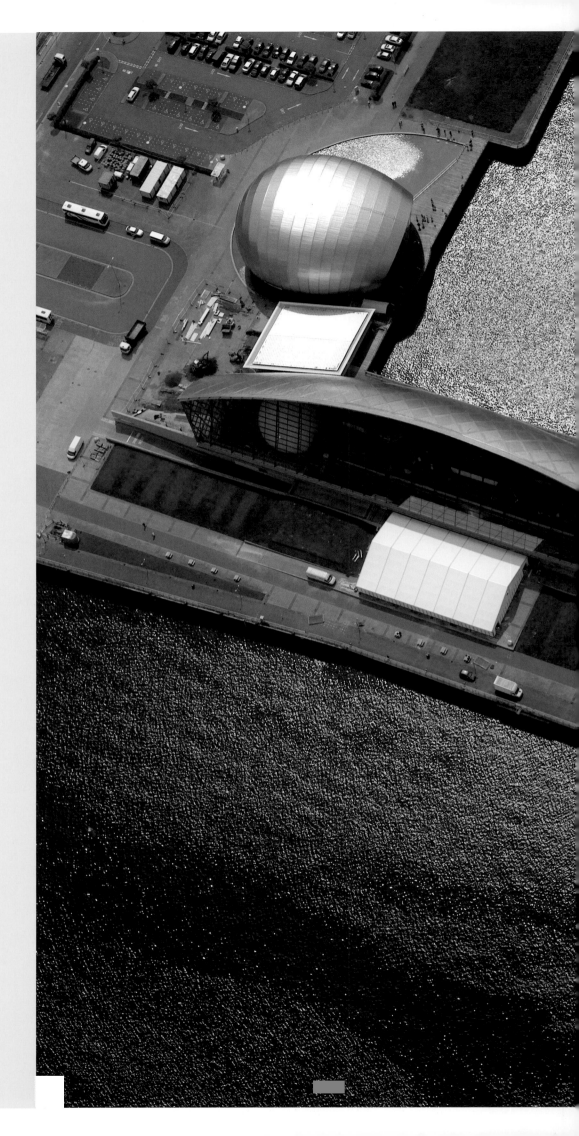

212 The Clyde Waterfront regeneration scheme in Glasgow is one of the largest urban renewal projects in Britain. Built at the heart of what was once Britain's shipbuilding capital, the bold shapes of the titanium-clad Imax Cinema and Science Centre deliberately work with the strong lines of the old docks and quays.

DP015678 2006

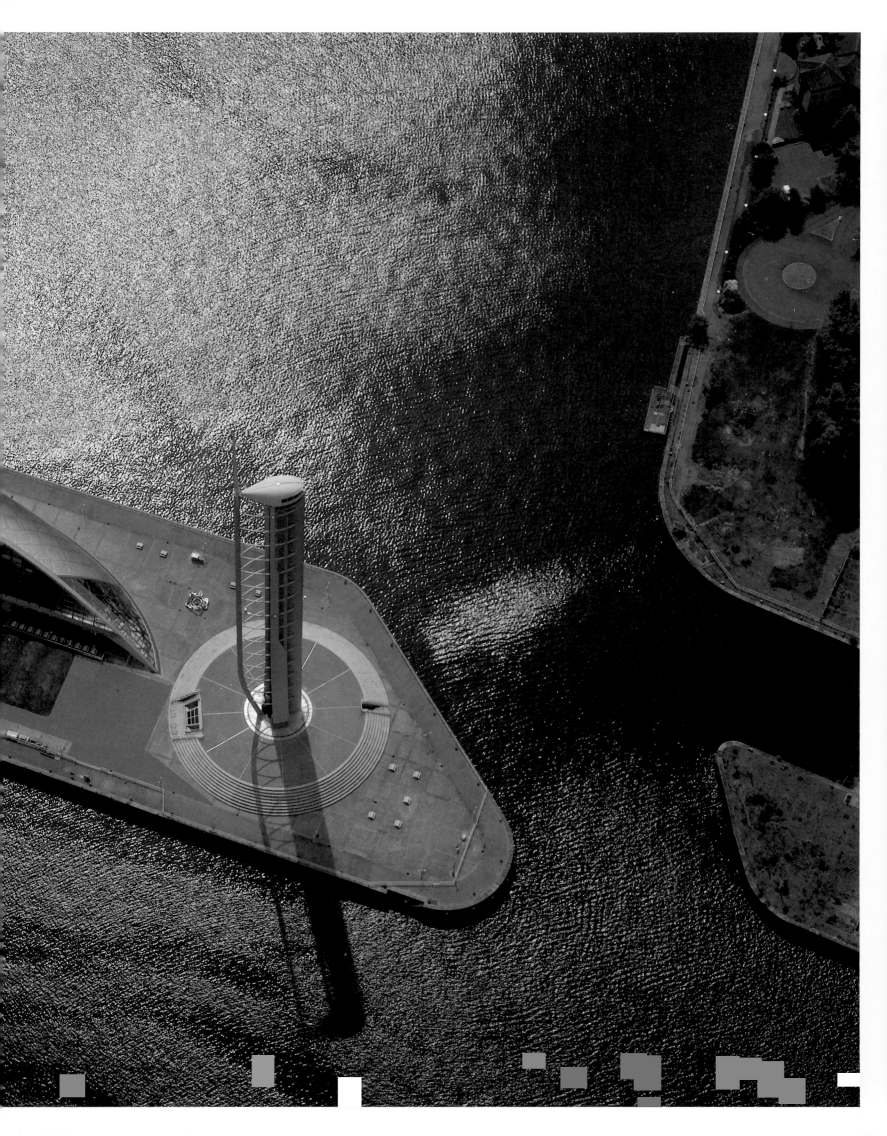

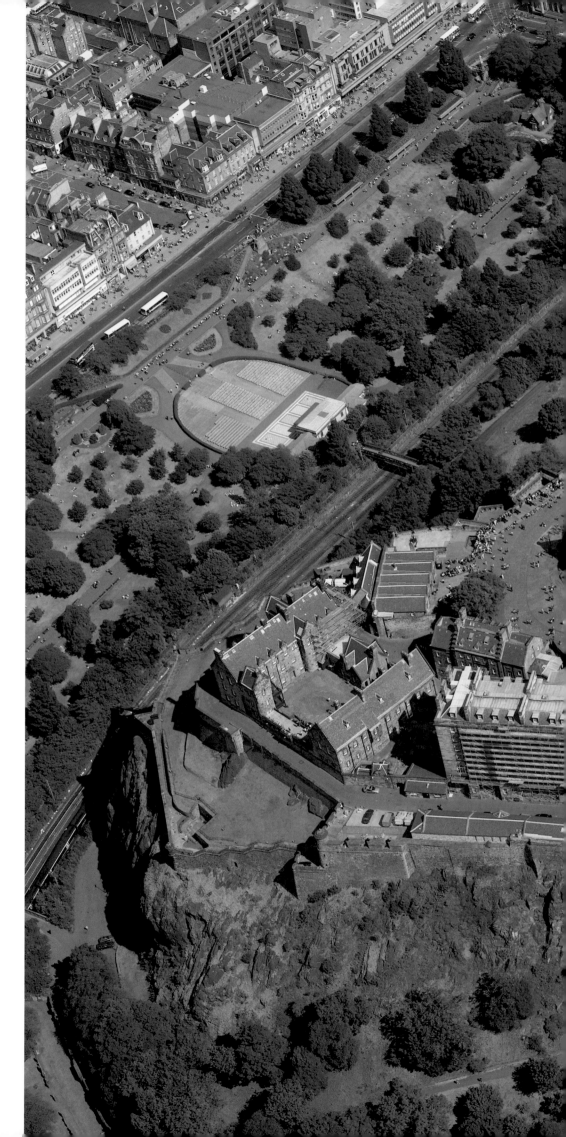

214 Edinburgh Castle is thronged with tourists on this sunny August day, its esplanade bolstered by the grandstands of the military tattoo. One of Scotland's most popular attractions, the Castle welcomes over a million visitors each year. DP012635 2006

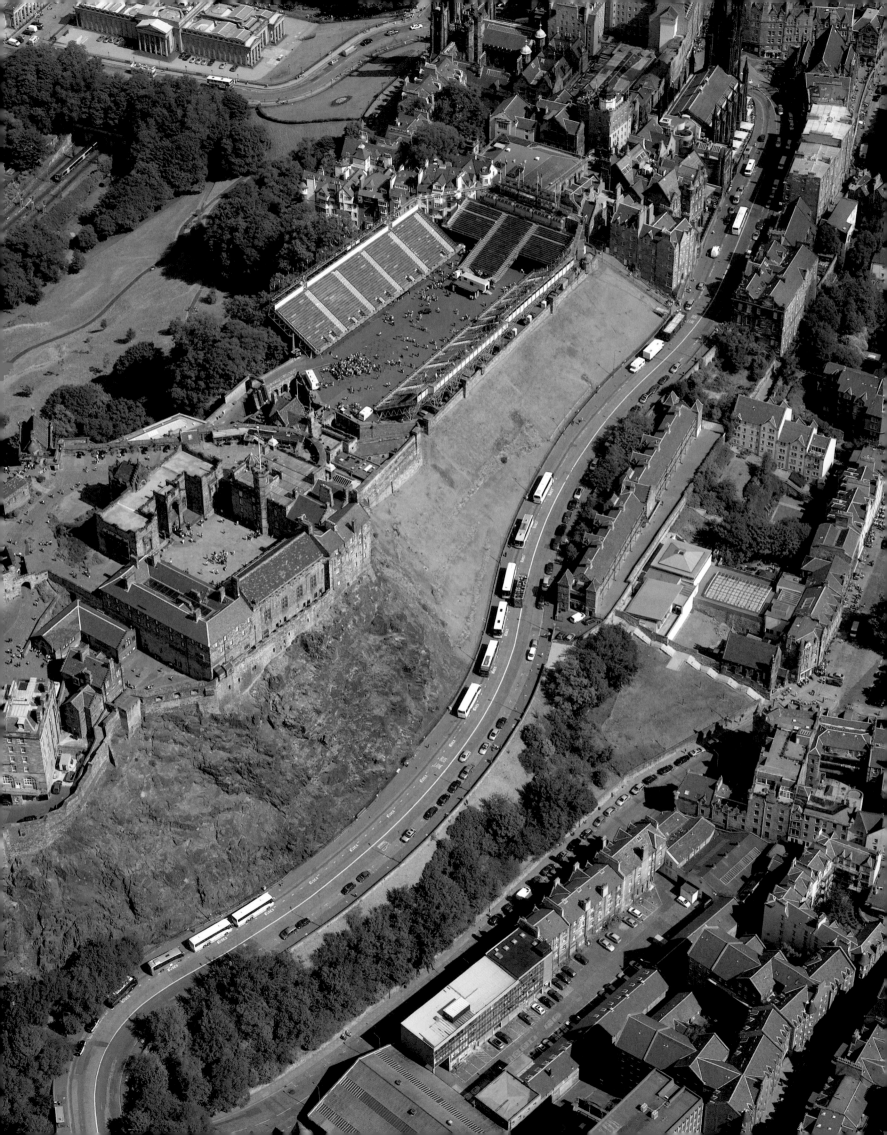

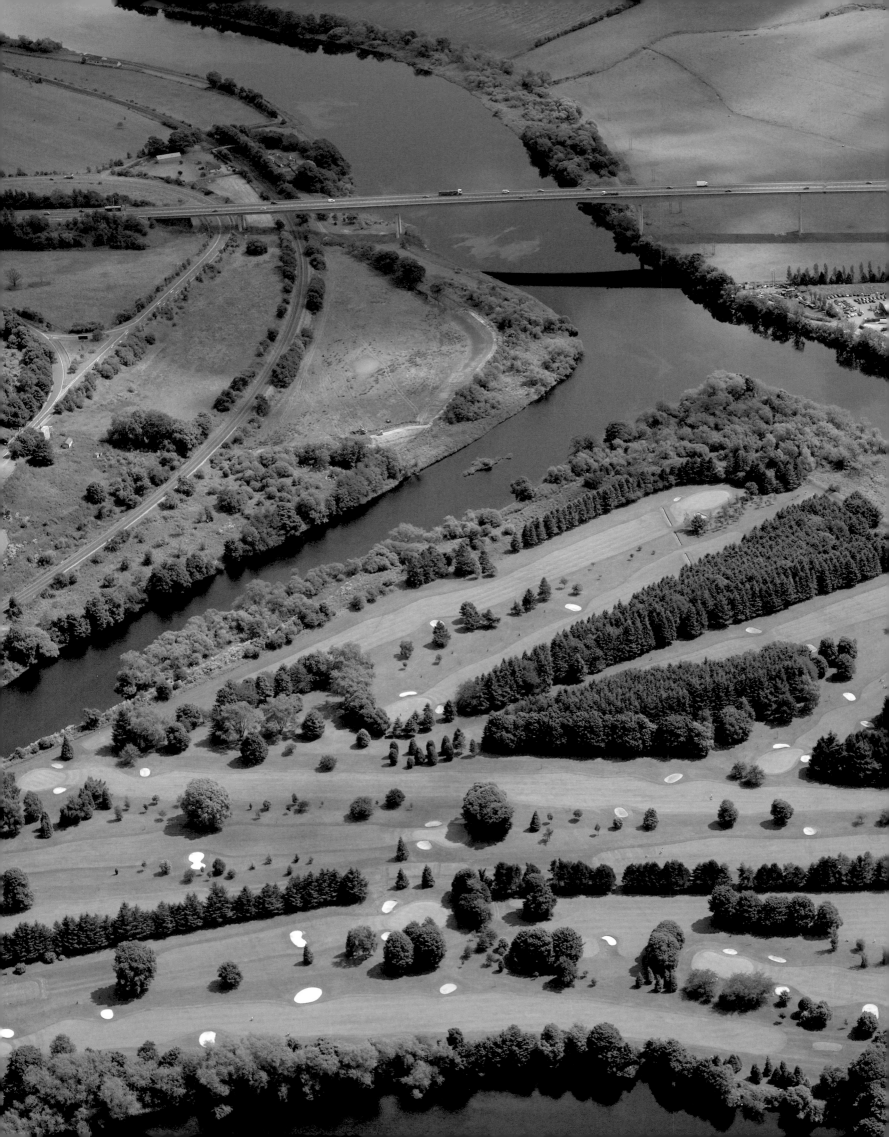

OPPOSITE
Recognised worldwide as the home of golf, over 550 courses can currently be found shaped out of the diverse landscapes of Scotland. Like a specially designed 'leisure island', the immaculately groomed King James VI Golf Club near Perth, is surrounded by the waters of the River Tay, and overlooked by commuters on the Friarton Bridge. DP032946 2007

TOP RIGHT
Hampden Park Stadium in Glasgow is Scotland's national football ground and home to Queen's Park Football Club. First opened in 1903 and built to a design by Archibald Leitch, the final redevelopment of the modern stadium in 1999 saw it awarded 'five star' status by UEFA, European football's governing body. As well as hosting Scottish domestic and international matches, Hampden was chosen as the venue for the Champions League Final in 2002 and the UEFA Cup Final in 2007. DP043958 2008

BOTTOM RIGHT
With its inviting arc of retail units encircling a tarmac expanse of 1,900 car parking spaces, Glasgow Fort on the eastern outskirts of the city is designed as a mecca for the modern shopper. Opened in 2004, and positioned to be easily accessible from the M8 motorway, it is one of a growing number of out-of-town retail parks. DP015569 2006

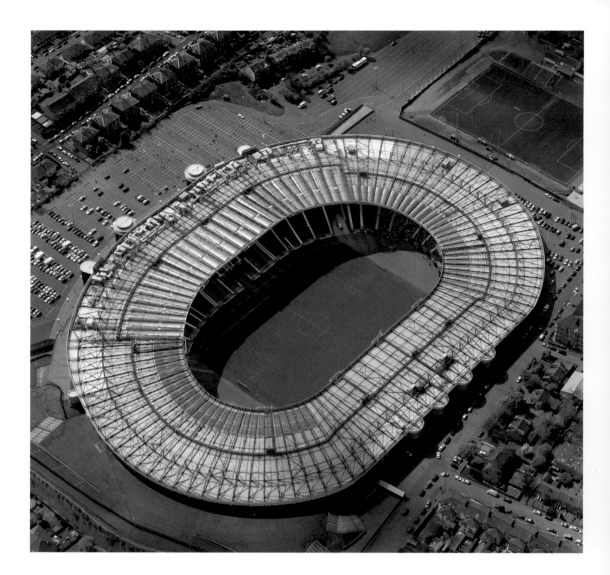

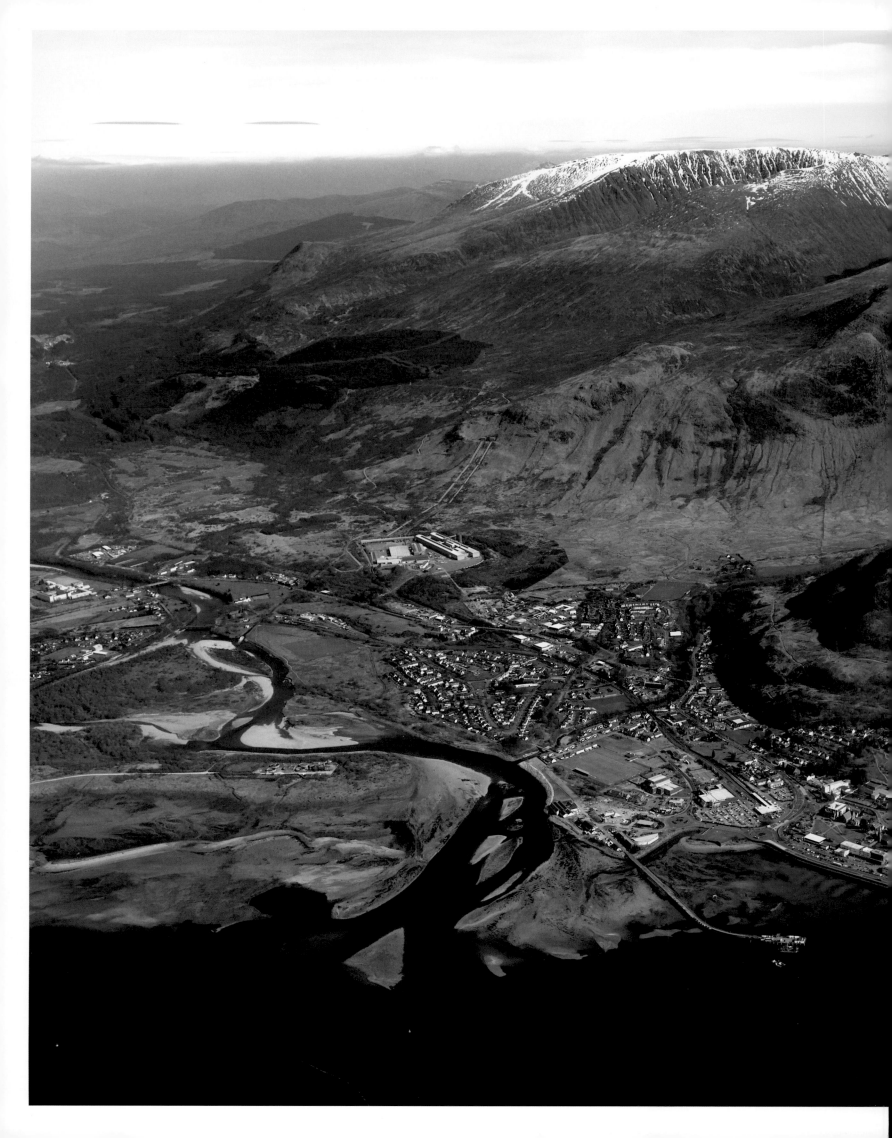

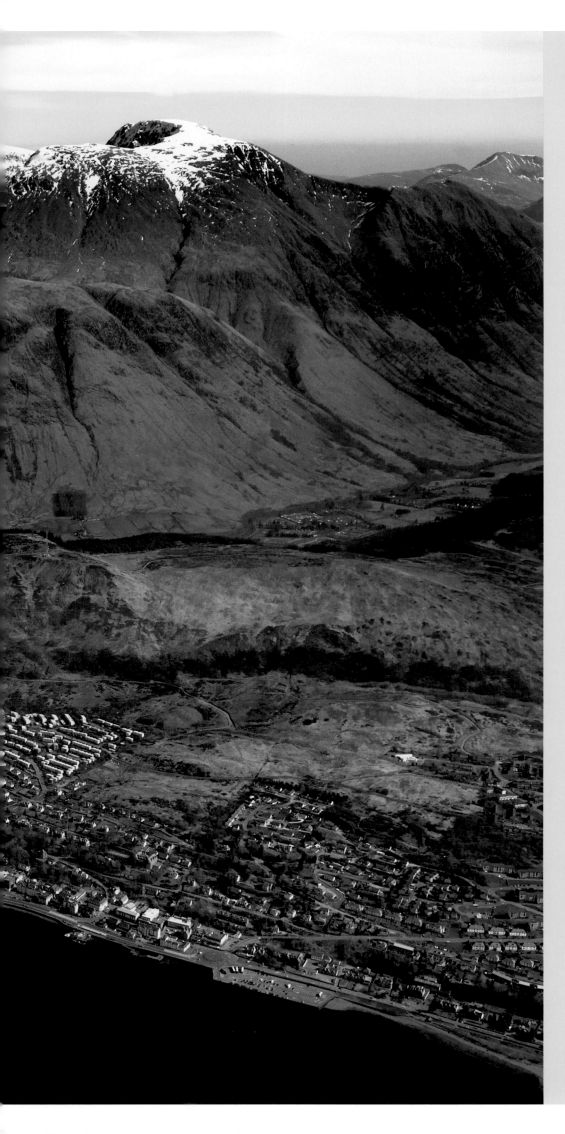

Capped by snow, the ancient, imposing 219
peak of Ben Nevis looms over the town of
Fort William on the shores of Loch Linnhe
– a stunning gateway to the north-west
highlands. Billed as the 'Outdoor Capital of
the United Kingdom', the apparently wild
and unspoilt landscape has itself become an
industry. DP023949 2007

Scotland's National Collection of Aerial Photography

Held by the Royal Commission on the Ancient and Historical Monuments of Scotland (RCAHMS), the National Collection of Aerial Photography is one of the largest and most significant in the world. Often created for more immediate commercial or military purposes, these images have become an invaluable historical tool for everyone from archaeologists, geographers and conservationists to local and landscape historians. This unparalleled resource is made up of a number of distinct parts and is divided into two geographical areas – Scottish and worldwide imagery.

IMAGERY OF SCOTLAND

RCAHMS has amassed 1.6 million images of Scotland from a number of different sources:

- The Aerofilms Collection contains some of the earliest aerial photographs ever taken of Scotland, and dates from the 1920s up to the 1990s – 80,000 images

- The Royal Air Force Collection dates from the 1940s through to the 1990s, with more imagery added as it becomes declassified – 750,000 images

- The Ordnance Survey Collection – produced to assist map making – features imagery dating from 1955 through to 2001 – 500,000 images

- Since 1976 RCAHMS has run an annual programme of aerial reconnaissance and photography to record the archaeology and buildings of Scotland, capturing changing urban and rural environments throughout the country, and leading to the discovery of thousands of archaeological sites – 125,000 images

- The All Scotland Survey dates from 1987–9 and was commissioned by the then Scottish Office to assess land use – 17,000 images

In addition to these, numerous smaller collections have also been added to the National Collection.

WORLDWIDE IMAGERY

In 2008, The Aerial Reconnaissance Archives (TARA) were entrusted to RCAHMS. Dating from 1938 onwards, the archives are made up of over 10 million military intelligence photographs from around the world.

ACCESS

All images in this book, and a rapidly expanding selection of other photographs from the National Collection of Aerial Photography, are available to browse and buy online at www.rcahms.gov.uk. Full access to the Collection is available in the RCAHMS public search room in Edinburgh.

OPPOSITE

A yacht rests in the clear waters of Deer Sound on the west Mainland of Orkney. Remarkably, beneath its fibreglass hull is a drowned landscape on which our prehistoric ancestors once lived and walked. In this remote, secluded bay – just as in the busiest city centre – Scotland's varied landscapes never stop changing. But with each photograph – each moment of time – that is added to the National Collection, the memory of where we have been, where we are, and where we may be going, is maintained for all. DP058592 2009

Scotland's National Collection of Aerial Photography is a legacy of many unsung heroes – archivists, photographers, pilots and navigators – who have worked over a period of more than 70 years to capture imagery and to preserve and interpret it.

Although this volume has two author credits, its preparation has benefited from the input of many colleagues within RCAHMS. These include Robert Adam, Iain Anderson, Rebecca Bailey, Oliver Brookes, Alasdair Burns, Susan Casey, David Easton, Lesley Ferguson, Philip Graham, Simon Green, Neil Gregory, Allan Kilpatrick, Lynn Kilpatrick, Kevin McLaren, Miriam McDonald, Anne Martin, Jessica Monsen, Alan Potts, Graham Turnbull, Derek Smart, Jack Stevenson, Steve Wallace, Kristina Watson and Allan Williams. Also thanks to Mairi Sutherland for proofreading, Wendy Toole for indexing and Angharad Wicks at English Heritage.

Index